Beautiful Beasties

A Creative Guide to Modern Pet Photography

Jamie Pflughoeft

WILEY

John Wiley & Sons, Inc.

Beautiful Beasties
A Creative Guide to Modern Pet Photography

Published by
John Wiley & Sons, Inc.
10475 Crosspoint Boulevard

Indianapolis, IN 46256
www.wiley.com

ISBN: 978-0-470-93227-8

Manufactured in the United States of America

10 9 8 7 6 5 4 3 2 1

For general information on our other products and services or to obtain technical support, please contact our Customer Care Department within the U.S. at (877) 762-2974, outside the U.S. at (317) 572-3993 or fax (317) 572-4002.

Wiley publishes in a variety of print and electronic formats and by print-on-demand. Some material included with standard print versions of this book may not be included in e-books or in print-on-demand. If this book refers to media such as a CD or DVD that is not included in the version you purchased, you may download this material at http://booksupport.wiley.com. For more information about Wiley products, visit www.wiley.com.

Library of Congress Control Number: 2010941220

Credits

Acquisitions Editor
Courtney Allen

Project Editor
Dianne Russell, Octal Publishing, Inc.

Technical Editor
Alan Hess

Copyeditor
Bob Russell, Octal Publishing, Inc.

Editorial Director
Robyn Siesky

Business Manager
Amy Knies

Senior Marketing Manager
Sandy Smith

Vice President and Executive Group Publisher
Richard Swadley

Vice President and Executive Publisher
Barry Pruett

Proofreading and Indexing
Octal Publishing, Inc.

About the Author

Born to an artist mom, in a family of animal lovers, one could argue that pet photographer Jamie Pflughoeft's path was predestined. A self-professed dog fanatic, Jamie became passionate about photographing pets in 1999 after seeing never-ending camera-worthy moments happen in front of her while working as a dog walker and pet sitter. She attended the University of Washington as an adult student studying animal behavior as part of her psychology major, Jamie was able to take the knowledge she gleaned from her university classes and apply it to her photo shoots with animals. Jamie graduated shortly after September 11, 2001, into what was a poor job market in which she was competing against Ph.D. holders for entry-level positions, a friend recommended that she turn her pet photography hobby into a business. "Is that even a job?" Jamie asked. After a little bit of research, a six-week business training class, some homemade business cards, a $500 loan and a switch from a film camera to a digital camera, in July

Jamie and her dog, Fergie.

of 2003, Jamie's business, Cowbelly Pet Photography, was born. Jamie established the business to meet a growing need of pet owners to have high quality photos captured of their pets for posterity.

Since the inception of Cowbelly Pet Photography, Jamie has worked with over 500 private clients and has provided commercial and editorial photography for several large companies and magazines. Editorial clients include *The Bark Magazine*, *Modern Dog Magazine*, *Cesar's Way Magazine*, and *CityDog Magazine*. Some of her commercial clients include Purina, Wal-Mart, Nutro, PetSafe, ABC Studios, AAA, Signature DNA Unleashed, Pinnacle, and more.

Along with blogging on topics such as photography, digital editing, business, dog-friendly travel, and more, Jamie has taught 14 workshops to over 150 budding pet photographers in cities around the United States, with plans to teach internationally starting in 2013. Jamie has developed a large following on Twitter, Facebook, and the Cowbelly blog, and sold out a Master Class at WPPI in 2011. She is largely considered one of the foremost leaders in the pet-photography industry.

When not photographing dogs in Washington and California, you can find Jamie with her beloved Lab-mix pooch, Fergie, by her side, enjoying all that the Emerald City has to offer.

Like the dogs she photographs, Jamie believes life is best lived playing, sleeping, eating, loving, daydreaming, having regular adventures and being sure to feel plenty of joy every single day. "A Picture is Worth a Thousand Woofs"™!

You can connect with Jamie on Twitter at @cowbelly; on Facebook at her page for pet photographers, www.facebook.com/BeautifulBeastiesByCowbelly; or her website for pet photographers, www.beautifulbeasties.com. You can see more of her work on her portfolio site at www.cowbelly.com, which she tries to update as frequently as possible with photos of cute, funny animals just being awesome.

By the way, the name Pflughoeft (pronounced "flew-hoff"—you're welcome) is of German origin. It is used as a nickname for farmers.

Acknowledgments

I would like to thank Bill and Nat of Photo Lab Pet Photography for providing input on the cover design as well as the information about twentieth-century photographers who captured pets. A big thank you to Moira McLaughlin of Dog Art Today for also providing information on twentieth-century photographers who trained their lenses on animals.

To Courtney Allen, my editor at Wiley, for believing in me enough to take on this project, inviting me to write for you, and for being so patient with me during the process. Thank you for understanding my bizarre notions about human energy fields affecting electronics. (I'm still waiting to hear the story about the Mexican food and the microwave!)

Thank you Alan Hess, my technical editor, for understanding and sympathizing with my ongoing software and computer issues, and for challenging me to be a better, more technical photographer. I learned a lot while writing this book, and it was largely because of you! To Bob Russell, of Octal Publishing, Inc., who copyedited the book, thanks for straightening out the fragments and untwisting some of the more abstract language! Thank you to Dianne Russell (also at Octal) for making me bust out loud laughing in the middle of the night many times during our review phase. Your comments had me cracking up, and it was such a nice reprieve from my software issues.

Thank you to the many Cowbelly Pet Photography clients with whom I've worked over the years, for entrusting me with the honor of creating memories of your beloved animals. Working with you and your pets is the best part of my job, and I wouldn't have a business were it not for you.

To my many fans and colleagues on the Cowbelly blog, Facebook fan page, and beyond, thank you for entrusting me as your guide and teacher. I will always feel humbled that you look up to me as a leader, because the way I see it, "I'm just a girl."

To Denis and Robin's late pooch, Scout, thank you for being my muse for this book, and reminding me during the most challenging time in the process of just why I do what I do. The photo of you in your booties and red vest with your mom holding you touched my heart right at the moment it needed touching the most, and you made me realize a profound purpose behind writing this book.

To my mom, who I felt was looking down over me during the process, saying "you can do it kid," and who always believed in me, no matter what I did. I know you never got to finish your own book before you left us, but hopefully, now you can enjoy being a published author vicariously through me. I love you and miss you, and I hope I made you proud.

Thank you to my incredible father, Larry, for coming over every weekend to mow my lawn, bring me food, and check on me to make sure I was still alive. You are the best Papabear any girl could ever wish for.

Thank you to my super-sweet sister Michelle, for listening to me drone on and on about work and book stuff; for smiling and nodding your head politely when I knew you had stopped listening long ago. Those epic chats were like food for my soul, and your support of me during the process was invaluable.

And last, but certainly not least, to my furry girl, Fergie. I have no words to express the impact you have had on my life. You are the true love of my life, and every day I get to spend with you is an absolute gift. I love you with everything I have and everything I am.

This book is dedicated to my mother, without whom I would not be an animal lover, an artist,
a teacher, a nature lover, a business owner, a photographer, a writer, a student, an adventurer,
or a compassionate and loving person who finds pure joy in the simple things in life.
Thank you immensely for all of these gifts that you gave me, for your unwavering support of me
and my business, and for always accepting and loving me for who I am.
I love you with everything I have and I miss you every day.

This book is for you, Mom.

Contents

Introduction

· ·

I'll never forget the day that started my journey on the path of pet photography. The year was 2000, and I was working part time as a dog walker and pet sitter while finishing my animal psychology degree at the University of Washington in Seattle. The place was a pet-sitting client's house. I was sitting on the carpeted floor in a hallway with their giant, ancient, goofy mutt and frisky young kitty. This unlikely pair were playing, and cuddling, and teasing, and loving each other, and I watched silently in awe of their special relationship. "Man, I wish I had a camera," I said out loud under my breath, feeling a familiar and characteristic urge to create things that I had felt since I was born. I wanted to create visual memories of the interplay between the dog and cat. I wanted to capture for all eternity, this special moment caught between two creatures that could not have been more opposite; to pay tribute to the relationship they shared, and be able to show people what I had witnessed. I wanted to capture the expressions, the emotion, and the personality of these two animals. Ultimately, it was as simple as just wanting to document what I saw and share it with others.

I ran home and returned with my old, full-manual Pentax P3 film camera that I learned how to use in the sole photography class I took in high school in 1989. I loaded it up with some black-and-white film and started what was to be the beginning of a surprising and rewarding career.

Shortly after my impromptu photo shoot, the big 'ol mutt passed away, and to say that the photos that I captured of him were meaningful to the dog's owner would be an understatement. In those simple moments, in that hallway in the dying light of a summer afternoon, I was able to capture a moment in time that was forever lost when the dog passed on. What I gave to its owners was a profound and powerful gift: a gift that I now have the incredible honor of sharing with clients, friends, and family every time I go to "work."

My hope is that by reading this book, you too can learn to develop the skills to offer that same gift. A gift that will bring you more joy and more of a sense of meaning and reward than you could have ever imagined. It's a gift that literally changes people's lives. To some, it might seem to be "just a dog" or "just a cat," but to those of us who deeply, truly love the animals with which we share our lives and our homes, great photos of our furry family members are beyond any meaning that one can put into words.

Although I was excited about my newly chosen *métier*, within a few years of starting my little pet photography business, I felt quite alone in the world. Pet photography as a business was still in its infancy. I had no educational resources or anywhere to turn for knowledge about photography as it applied to domestic animals. Sure, there were some books for consumers on how to take cute pet photos, and forums filled with cheesy, horribly lit pictures of kittens and puppies in baskets with fake flowers in front of muslin backgrounds, but there was nothing for the aspiring pet-photography professional wanting to do more polished, contemporary work. No workshops, no PDF guides, no comprehensive manuals, no forums or networks. So I continued to trudge along on my own, learning how to position my body and my camera in relation to the animal, figuring out to hold treats in my hand, and determining what pet owners wanted and what they liked for shots. I began to understand how to use my knowledge of

· ·

animal behavior in a shoot to capture ever-more interesting images, and then eventually, I figured how to price those images and other products so that pet owners could and would buy them. I found ways to market my business, discovered creative locations in which to feature pets, established the best kinds of lenses to use during the session, and on, and on, and on. I did all this without a guide, without someone holding my hand and showing me how it was done. It was tough, and I learned it all the hard way. In some respects, I am grateful for that hard road; in others I wish it had been far easier.

Since I started my business in 2003, pet photography has not only become a popular form of photography, but a very viable business model, as well. No matter where you are in your journey, my hope for you through this book is to be that guide, that person holding your hand, showing you how it's done: a good friend answering your questions and helping you out along the way. In fact, you even "ask" me questions (you'll see them in quotes) throughout the book. My hope is to provide you with the knowledge that I was desperate for when I started; knowledge that has accumulated from an all-encompassing love of photographing pets.

Pet photography is still a nascent industry, and that makes it challenging in many ways. There is still so much to be learned. But it's exciting at the same time. It's a time when photographers who point their lenses at dogs and cats and horses and birds and frogs can pave new paths and truly help shape an industry that is still in its youth.

Pet photography for me goes so far beyond taking cute photos of pets. In psychology, there is a term called "flow," which is used to describe when a person is feeling their happiest: when everything seems to just *flow*. For some people, it's gardening, for others it's playing music, for me it's pet photography. I get lost in it. It gets me out of my head. It enables me to create and express the love I have for these amazing creatures that grace the space in front of my lens. And the fact that the owners of these special animals are moved by the images is just icing on an incredibly large and delicious cake.

If someone had told me back in early 2003, that someday I would run a successful business photographing dogs and cats and sharing my passion with other photographers, I would have looked at them, rolled my eyes and said, "Yeah, right." Even though it took a lot of hard work to get where I am today, I still feel supremely lucky. Lucky that I get to be paid for something I am so passionate about, including turning around and sharing that passion with others. It's a privilege for which I am eternally, deeply, profoundly grateful. Thank you for allowing me to share my passion with you. I hope that you find this book to be a rich resource of information and knowledge for you that you can return to and use again and again.

Getting the Most Out of This Book

First, you might be asking yourself, "Who is this book intended for?" I wrote this book for passionate hobbyists and professional pet photographers alike; those with a little technical knowledge and a lot of desire to make great photos of your own pets or those belonging to clients. My goal is for this book to be just as valuable for the professional pet photographer as it is for those practicing pet photography as a hobby.

Chapter 1 provides an overview of the history of pet photography and the modern day influencers. If you are super passionate about pet photography and are either involved in the industry as a professional or hope to make it a career, you'll enjoy taking a read through this, and you'll probably learn something new about the industry.

If you already have all of the equipment you need and are happy with how it performs, with no plans to upgrade, you can skip over Chapter 2, which covers the equipment you need to do a great job capturing pet photos. You might want to take a read through the lens section, nonetheless, because it provides some detailed information on the advantages and disadvantages of using certain lenses for pet photography. If you are a casual shooter, never fear, I talk about "prosumer" (translation: affordable) cameras that will get the job done, and I explain that you don't need fancy gear to create beautiful images.

Chapter 3 delves into how to work with animals from a behavioral standpoint and instructs you as to what to look for when it comes to desirable appearances for various animals. It also explains how to avoid capturing photos of them when they aren't at their happiest or most relaxed, regardless of the type of animal. I also look at the unique challenges of photographing your own pets, and how best to approach this for optimal results.

Chapter 4 goes over your pre-shoot inventory; the process and steps you should take prior to each shoot to ensure that each shoot goes smoothly. Along with this, I go over the importance of using shot lists, and give you examples of how to creatively develop a shot list and define goals for each shoot.

Regardless of your level of experience, and especially if you have minimal experience with the technical aspect of photography, you should read through Chapter 5, and then re-read and re-read it again. One thing that is very important to keep in mind is this:

The quality of your results can be directly measured by the breadth and depth of your knowledge of the technical workings of photography.

In other words, the less you know about how aperture, shutter speed, and ISO settings work, the harder it will be to produce quality results. Sure, you can pop your camera into Auto mode or a preset program, but it will be a lot harder to produce professional-looking images that way. Knowing how cameras work from a technical standpoint opens up doors so that you can be more creative and confidently handle lighting and situational challenges. Although I have been photographing pets for more than 12 years, I learned some new information just writing this section, so I hope the technical information I share helps you see the left-brained stuff in a whole new light.

Chapter 6 addresses lighting; from natural light sources to auxiliary lighting, including flash and studio lights, plus all of the accompanying accessories. I present the pros and cons of each type of lighting, and give you examples of when to use each type. I also show you what to avoid when it comes to lighting and give you tips on how to light difficult situations and avoid the lighting PET-peeves.

The fun really begins with Chapters 7 through 10, in which we delve into the creative aspects of pet photography, and learn how to allow your personality and those of your subjects to really shine through your work, both while you are photographing them and during image post-processing. You will also

learn how to handle the many challenges that can arise when photographing pets, including the dreaded "black dog/white dog" issues. Chapter 7 includes tons of eye-candy, and gives you more ideas on how and where to photograph a pet than you will be able to do in a lifetime. Chapters 7 and 9 both lay out lists of pet photography "don'ts," which are compendiums of things to avoid, both while shooting *and* in post-processing. These are the mistakes many new pet photographers make that should be avoided. In chapter 10, I give you tips on how to define and develop your own style (I call this "Photodogstyle"), and how to edit your photos to match your style. I also show you how and where to find inspiration for your work.

Lastly, Chapters 11 and 12 are designed for the professional and are filled with business information that you need to know in order to make your passion profitable. There is information on how to build your portfolio for those who are still working on developing saleable skills; expenses that show you how much you can expect to invest in your business now and into the future; information on pricing and branding and marketing; and a detailed list of the top-five biggest keys to success. With the technical, creative and business information in this book, you should have all you need to make your business flourish.

Be sure to read the captions under each photo in the book, as oftentimes I include information that tells you how or why I got the shot.

The technical information under most of the images in the book includes the camera settings and the lenses I used, which I think can be very helpful in understanding how a photographer created an image. (You're welcome, ha!)

There are exercises at the end of each chapter, and I recommend that you set aside time each week to do each of these exercises because they are all designed to help you improve on your skills and learn and grow experientially.

Note

You can access online bonus content at the following web address:

www.beautifulbeasties.com/books

Here, you can find useful information about photography-related resources as well as a great synopsis on the characteristics and behavioral traits of many common (and not-so-common) dog breeds.

With all that said, young pet photographer, let's get started! Happy reading!

Chapter One

The History of Pet Photography

- ☆ The Backstory on Pet Photography
- ☆ The True Value of Pet Photos
- ☆ The Pet Photography Industry
- ☆ Classes, Schools, and Workshops
- ☆ Forums

The Backstory on Pet Photography

Photos of pets have been taken since the inception of the camera. The oldest known photograph of a dog is a *daguerreotype* of a white poodle titled *Poodle with Bow, on Table*, taken by an unknown photographer in the 1850s. A daguerreotype is a direct positive that's made in the camera on a silvered copper plate. The process involves a long exposure time that makes our modern day shutter speeds of 1/1000 second and faster pale in comparison when it comes to time commitment. To take the shot surely must have required one very patient photographer or one heavily sedated dog—or both. This piece sold at Sotheby's for $8,125 in 2009.

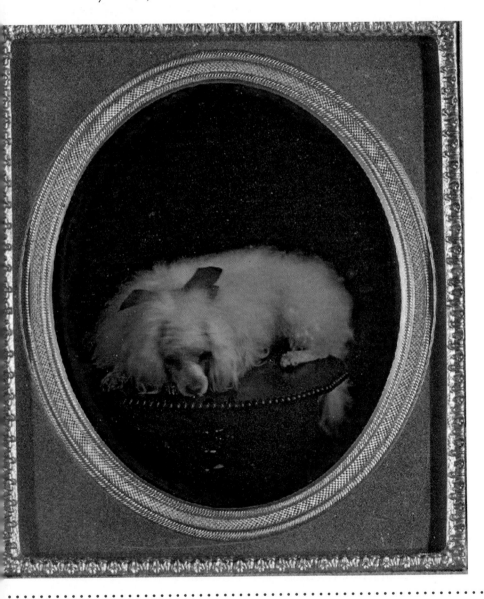

The first photo of a dog, created by an unknown photographer in the 1850s.

Since then, both technology and the relationship between humans and their animals have evolved dramatically. As domestic animals have continued to become more and more entrenched in our everyday lives, our cameras have spent more and more time focusing in their direction.

In the 1950s, Elliott Erwitt, a French-born American photographer, came onto the scene and captured photos of people with their pets on the streets of New York City, focusing much of his work on dogs. Perhaps the most iconic photo Erwitt created was a black-and-white image titled *New York City, 1974*. The photo is of a miniscule Chihuahua standing next to its high-heeled owner, flanked on the other side by the legs of a mountainous Great Dane. All the viewer can see are the legs from the knees down of the woman and the Great Dane, and the little sweater-clad Chihuahua on the right. It's a humorous look at the relationship between man and beast, and an ironic and unusual capture on the part of Erwitt.

Along with Erwitt, many other twentieth-century photographers aimed their lenses at domestic animals. William Wegman became known for his humorous portraits of Weimaraners in unlikely scenarios. Ilse Bing included dogs in her portraits, including the photo of a Terrier next to a shadow of the photographer in *Self Portrait with Stacatto, New York*. Robin Schwartz has photographed dogs as pets and strays; canines inform a large part of her work. Eadweard Muybridge's work, a photo series of race dogs in motion titled *Animal locomotion: an electro-photographic investigation of consecutive phases of animal movements, 1872–1885*, was groundbreaking for its time and became a study in its own right. And famed photographer Irving Penn was known to include dogs in his portraits of humans.

It wasn't until the 1990s that pet photography became a career unto itself. It was during this time that a small cadre of photographers decided to specialize in pets as a niche, photographing more for private clients and everyday pet owners rather than for gallery shows and artistic projects, as their predecessors did.

This "new" old-school breed of pet photographers became well known in the 1990s. Their ranks include Jim Dratfield, who became famous for his romantic, traditional sepia photos in New York City; Deborah Samuel, recognized for her moody, abstract black-and-white shots of dogs in her books *Dog and Pup*; Kim Levin for her emotive and candid work of both dogs and cats in books such as *Why We Love Dogs: A Bark and Smile Book and Cattitude*; Amanda Jones for her now iconic, highly influential, clean, modern studio shots on white backdrops; and Rachel McKenna (*nee* Hale) for her endearing commercial photography of kittens and puppies. Other notables from the 1990s include Joe and Healy Grisham, and Bruce Weber. Before I started my business in 2003, I looked up to and highly admired the aforementioned photographers; they were taking the time and care to capture my favorite creatures and publish books of their photos. Those books lined my bookshelves and provided me with inspiration when I made the move from hobbyist to professional.

Yet more modern-day pet photographers who started their businesses in the late 1990s and early 2000s while the industry was still young include Bev Sparks, a Seattle photographer whose black-and-white work was featured on *The Oprah Winfrey Show*; Sharon Montrose who became successful for her clean-lined commercial work of cats, dogs, and all manner of wild and exotic animals; Emily Rieman, whose photographs conjure up old Hollywood glamour; Kendra Luck, a San Francisco–based photographer who coined the term "Dogumentarian" and is known for her black-and-white documentary-style photos; and me, Jamie Pflughoeft (also known by my business name, "Cowbelly"). My specialty is colorful, candid, documentary-style photos of dogs and cats on location.

All of the early pioneers of pet photography have helped shape the look, style, feel, and trends in the modern pet photography industry as it exists today. They have helped to produce a movement of visual art that is filled with variety, creativity, uniqueness in both concept and execution, and styles that are as diverse as the photographers that create it. Now, it's not uncommon to find business names attached to the photographer's names that often contain a pet element as well as work that is as niche as it comes.

Today, influential modern pet photographers who specialize in domestic animals include (among many others) Illona Haus of Scruffy Dog Photography, Sarah Beth Photography, Tim Flach, J. Nichole Smith of dane + dane studios, Carli Davidson, Serenah Hodson, Grace Chon of Shine Pet Photos, Stephen Dodd of Fidojournalism, Margaret Bryant of Bryant Dog Photography, Jesse Freidin, and Paul Walker of Paws Pet Photography. These photographers all dedicate their businesses to capturing photos of their client's cats, dogs, horses, goats, and birds. They capture moments that will last a lifetime. From candid to studio, from abstract to photojournalistic, every style is represented. These photographers influence their colleagues and work hard to elevate the art form that is pet photography.

Along with the innovators who came before them, there are many wide-ranging factors that influence modern-day pet photographers. Many find inspiration in wedding and engagement photographers such as Jasmine Star and Jose Villa, pulling shot ideas from poses of couples under trees and in urban settings that might include alleyways and train yards. Others find inspiration in fashion and catalogs, perusing the pages of *Vogue* and Pottery Barn looking for ideas for color and design. Still others look to landscape photography to inform locations and settings. The greatest influence in my own work has been commercial photographer Stephanie Rausser, whose fresh, joyful, happy images can be seen in ad campaigns all over the world as well as several covers of *The Bark* magazine. Of course, the greatest influences on all pet photographers are their furry, feathered, and scaled subjects and the humans who care for them.

Inspired to create higher-quality, more unique, and more engaging photos of pets, modern pet photographers are also inspired to take on personal projects, the likes of which the photography industry has never seen before. A short list of pet photographers and their projects follows.

Brooke Mayo: the Underwater Dogs project; Diving Doggies
Mayo's project, Underwater Dogs, is captured in colorful, engaging, bright, sharp photos of dogs underwater in pools, diving down for balls and other toys in her book, Diving Doggies. The book was a trendsetter at the time, creating a wave (pardon the pun) of other photographers who followed the concept of shooting dogs while underwater.
www.brookemayodoggiefriends.com/

Carli Davidson: the Shake series
Davidson garnered a huge following on Facebook after her high-shutter-speed studio photos of pets shaking off were featured on the Animal Planet television network.
http://carlidavidson.photoshelter.com/gallery/G0000s_trsF9CDFI

Cowbelly Pet Photography: Graffiti Dogs project
A personal project, just for fun; I head out to the most urban of urban settings—under freeways and behind train yards—to capture dogs in front of colorful graffiti-covered walls.
www.cowbellyblog.com/category/graffiti-dogs-project/

Jesse Freidin: the Doggie Gaga project
Singer Lady Gaga's outlandish costumes and headpieces inspired photographer Freidin to dress his furry charges in similarly zany attire to create humorous studio shots filled with irony and fun.
http://jessefreidin.com/album/the-doggie-gaga-project/

The 52 Project
Inspired by a movement among portrait photographers to take on a new photography assignment every week of the year, and then post the photos in a "blog ring" with their colleagues, the 52 Project was created by photographer Dana Cubbage. It was soon joined by more than 40 members of the Beautiful Beasties Network, an online assemblage created for pet photographers. Weekly assignments range from noses, to motion, to textures, and tributes.
www.cowbellyblog.com/52-project/

Serenah Hodson: Rocco and Ralph series
Hodson's work with her late Mastiff, Rocco, and Daschund, Ralph, are cutting edge in their sometimes odd, frequently comical, always simple, vintage-looking photos of Ralph stuffed into a hot dog bun or Rocco with an Afro wig on his head.
http://serenahphotography.com.au/

Along with personal projects done for fun, pet photographers are working tirelessly on projects designed to give back to the animal community at large. Projects include those designed to help shelter or rescue animals or bring awareness to a cause. Examples of these philanthropic projects follow.

Claire Bow of Rouxby Photography: Portraits of Greatness
Bow's stunning photos of rescued Great Danes reflect the poignancy of this breed of gentle giants, sometimes wounded, always graceful, and always beautiful. Proceeds from the book go to Rocky Mountain Great Dane Rescue.
www.blurb.com/bookstore/detail/709827

HeART's Speak
HeART's Speak is an organization of professional pet photographers dedicated to helping find homes for shelter animals throughout the United States by means of high-quality photography, education, and gear. The goal is to increase the numbers of adoptions of animals through the use of captivating visual art.
http://heartsspeak.org/

Smile for a Cure
Smile for a Cure is a fundraiser for the National Canine Cancer Foundation. Participating pet photographers donate a percentage of their session fees to the organization to help raise money toward the goal of ending canine cancer.
www.smileforacure.org/

Melissa McDaniel: Deaf Dogs, Rescued in America and Pit Bulls & Pit Bull Type Dogs
McDaniel's books, filled with portraits of deaf dogs and pit bulls, help raise awareness and money for the "underdogs" of the canine world: deaf dogs and Pit Bull Terriers.
www.thephotobooks.com/

Traer Scott: Shelter Dogs and Street Dogs
Scott's books highlight the plight of abandoned and abused dogs with heartwarming sepia and black-and-white images of man's best friend. Proceeds benefit the American Society for the Prevention of Cruelty to Animals (ASPCA) and World Society for the Protection of Animals (WSPA).
www.traerscott.com/books

Pet photography has come a long way since that first photo of a dog was taken in 1850, and the future of this growing industry is exciting and filled with possibility. As long as we have pets in our lives and in our homes, we will be capturing them with our cameras for all eternity.

The True Value of Pet Photos

As I mentioned in the previous section, the role that pets play in our lives has undergone drastic transformation over the past few decades, specifically the past 10 to 15 years. The percentage of households acquiring pets has risen exponentially. The nature of the relationship between man and beast has also changed. There are several reasons for this, including the following:

♦ Couples are choosing to wait to have children, so their pets become their surrogate children while they prepare for parenthood. Many choose not to have children at all and decide to share their homes with animals, instead.

♦ With human adoption being a lengthy and expensive process, more gay and lesbian couples adopt or buy animals to have as pets.

♦ Pets provide comfort and companionship during rocky times, which are not infrequent given the tumultuous nature of our modern culture.

♦ Specialized food, products, and pet services have expanded in numbers, increasing visibility of pet ownership in general.

♦ The pet industry has remained stable amidst an economic recession, with overall spending on the part of pet owners increasing exponentially.

Parallel to the change in people's reasons for acquiring pets, the rates of pet ownership in households in industrialized countries have increased significantly.

According to the American Pet Products Association (APPA) 2011–2012 National Pet Owners Survey, 62 percent of American households, or 72.9 million, have a pet. There are more than 78 million dogs, 86.4 million cats, 151.1 million freshwater fish, 8.61 million saltwater fish, 16.2 million birds, 16 million small animals, 13 million reptiles, and 7.9 million equines owned in the United States. Approximately four out of ten pet owning households in the United States are multiple-pet owners, and three quarters of households with pets own a dog or cat.

This is a huge number of domestic animals living in the average American home, and these animals are loved nearly as much as human children are.

Note

According to the American Pet Products Association (APPA), owners site reasons such as companionship, affection, relaxation, stress relief, and love as reasons for owning a pet. In 2011, $73 million was spent on gifts for pets, "just because," as part of a staggering $50 BILLION in pet expenditures for that year. That figure is up from $17 billion in 1994.

The statistics don't lie. People love their animals. REALLY love their animals.

This love, this deep, unconditional, unwavering, widespread love, is what imbues photographs of pets with their true value.

I was talking to a colleague recently who had attended a dinner party at which she told a fellow guest what she did for a living. "Ohhh, how cute," was the response. My photographer friend and I both groaned when she told me this, knowing how great of an insult that was to her profession and how little the partygoer understood or respected the true value of the service my friend offers to her clients.

To the recipients of heartfelt, emotive, artistic photos of their furry loved ones with whom they share their homes and lives, these images are so much more than just cute. They represent a profound connection that the owners feel with their companion animals. These images embody an unconditional love so deep as to mimic that for a family member or spouse. Just as many families feel compelled to capture photos of their human group for all eternity, so too do many pet owners, who are painfully aware of the short lives their pets live. Call it a kind of attempt at creating immortality for their animals, there is one thing that is for sure: photos of pets help to keep them connected to their loved ones long after they are gone from the physical plane. When memories have faded, and the smells and sounds of our pets have dissipated, all we have left of them are their photos. Photos, if done well, can bring back to life these animals we love so much. Photos can remind us of their spirits, their personalities, their very essence, and can bring us right back to a time and place and make us feel like we are right there with them, once again.

I photographed my dog, Fergie, on the shady side of a large orange metal sculpture, smiling up at her mama. This is my all-time favorite photo of her.

20mm 2.8 lens @ 20mm, f/ 3.2, 1/200 second, ISO 1250, aperture priority, evaluative metering

Outstanding photos of pets can take their owner's breath away and make them cry. That is nothing short of profound, and as a photographer holding a camera aimed at a dog or cat or rabbit or horse, that is both a great responsibility and an incredible gift.

As a professional pet photographer for the past nine years, I have seen firsthand the true value of the images that I have created reflected in the eyes of my clients. I have received many an e-mail after pets have passed away, informing me how grateful otherwise empty-hearted owners are to have those prints or that canvas hanging on the wall as an eternal reminder of "Cooper" or "Lady." I feel grateful, even honored, to have the opportunity to provide this service to my clients and friends and family; to create lasting visual memories for them that help them remain close to their animal loved ones. The following is an example of just such a correspondence:

"Hi Jamie,

I'm sorry to tell you this, but Zeus passed away yesterday afternoon. I wish it was better news, but I thought you might like to know since you guys seemed to be great buddies right off the bat. I am so glad we were able to spend that morning with you, and get so many wonderful photographs to remember our beloved friend Zeus by. And I know that Zeus had a wonderful time, as well. I look forward to enjoying your work, and want to thank you so much for working with us.

Sincerely, Jessica"

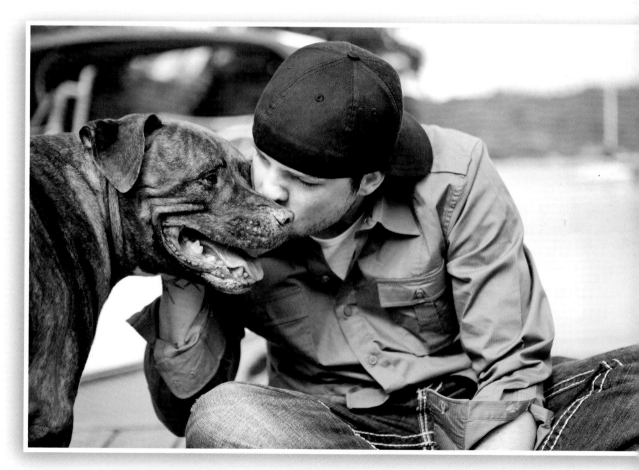

Zeus and his owner, shortly before his death. Best buddies for life.

24–70mm 2.8 L lens @ 70mm, f/2.8, 1/1600 second, ISO 250, manual exposure, evaluative metering

I never really understood the meaning behind what I was doing with my business until one of my best dog friends passed away. He was a Black Lab named Knuckles—goofy as all get out. Knuckles and I spent many days over many years, exploring the neighborhood and the environs, checking out the sights, enjoying one another's company, with me as his dog walker. At the age of eight, Knuckles had a serious stroke and became very sick, very fast. His health spiraled quickly downward; he was bleeding internally, and was unable to walk, eliminate, or eat. His owners, his veterinary caretakers, and I all believed it was the end for him. So I went to his bedside to say my goodbyes. He ended up surprising us all by coming back to life and living—no, thriving—for another nine months. Days later he was running down the street with me, his tongue wagging, with a huge smile on his face. That was one of my most memorable moments, and it taught me a lot about life and love and the unpredictable nature of it all.

The day his owners called to tell me my buddy had passed, I wasn't surprised, but I still missed him terribly. And of course, I cried. I was sitting on my bed; I looked up, and through my tears, I noticed the triptych of black-and-white photos of Knuckles hanging on my wall that I had taken before he became sick. The photos were two profile shots of him and one straight on shot, and in each shot, Knuckles was beaming with his big, goofy, characteristic Lab smile. His eyes sparkled, and I recall the excitement he displayed over the tennis ball I was holding above the camera, which was his reward for working for me as a model.

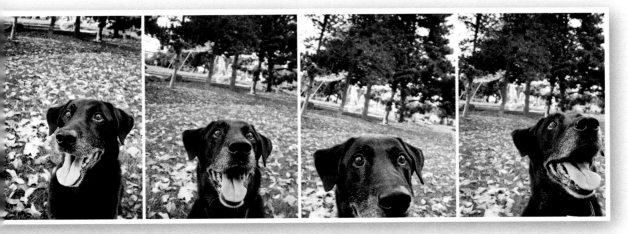

Knuckles photographed in succession while moving the camera from one side of his face to the other.

7.8mm (macro) lens, f/2.8, 1/100 second, ISO 200, auto exposure, evaluative metering

Through my tears, I laughed. I realized at that moment that I would be forever connected to my canine buddy through those photos. It was then that I got it: I truly realized how profound and meaningful these images I was creating as a pet photographer were. My work became infused with a sense of meaning and importance that I hadn't experienced before. And although my shoots were, and are, as fun as they come, underlying all of them is the sense of long-term meaning; the sense of connection that binds us with these magical creatures.

The story of Knuckles was just one of many like it. Numerous pets I have photographed have passed on. And then there are the pets I hear about that I never had the chance to photograph before it was too late. But there's still a way for me to capture their essence.

Along with doing pet photography I also create art called *Decopaw*. Decopaw is digital art created from pet photos that either I take or clients send to me. I have had more art clients than I remember contact me, saying that they had planned to have me photograph their dog/cat/bunny, but sadly, the pet died suddenly and I never had the chance. Instead, they ask me to make artwork of the few photos they do have of their departed companions. These e-mails are always filled with sadness, because in almost every case, the only photos these pet parents have are poorly lit, blurry shots that were taken in cluttered scenes, usually with a cheap old point-and-shoot camera or phone. In most cases, these are the only visual memories they have of their buddies. I sense the longing and overwhelming wish to go back in time and do it all over again. But unfortunately for us humans, we have yet to figure out a way to stop time on these precious short lives to keep our animal companions around forever.

The closest thing we have to a time machine is a photograph. And there is never a more poignant lesson about the brevity of a pet's life, or the meaningfulness of these photos, then when they die and we don't have any images by which to remember them. My ultimate dream in life is that every human being who shares his or her home and heart with an animal has just one decent photo of that animal. As the reader of this book, you have the power to help me make that dream come true. You have the power to create lasting visual memories of furry loved ones that can be cherished for all posterity. Whether they are of your own pets, your neighbor's, your client's, or your co-worker's, you have the power to create something incredibly meaningful just by using your camera and the knowledge available to you.

Along with the ultimate goal of capturing photos of a pet that can be cherished for decades to come, there is a smaller, yet no less important goal, which is to capture milestones and stages in the pet's life. All domestic animals go through at least four stages (some would argue five, as listed a bit later on). They start off as babies, become children, turn into young adults, mature to adults, and then finally, seniors. The look, features, details, and temperament can vary wildly in just one animal in these different stages. In an ideal world, we will capture them all in photos that will tell a complete story of the pet's life in much the same way as photos of ourselves, our family, and our friends convey a story of our own lives. As photographers, we have the power to capture a moment and place in time, preserving the memory forever. Maybe that moment is the first time a puppy steps foot in the water on a beach, or a kitten learns how to climb its cat tree, or a foal makes its first run on wobbly legs. Or, perhaps it's an adult dog, finally past its gangly teenage phase, exploring in a field with a little less clumsiness and curiosity than it did when it was young. Maybe it's an elderly cat who has outlived all expectations on the part of its owners, now old and frail but still ticking, still hissing, still harassing its feline roommates. For photographers seeking to create printed photobooks of a pet's life, photos from these different stages can be invaluable to the pet's owner. It is the ideal case: a collection of visual memories taking place over the lifespan of the animal. It is the ultimate tribute to a furry family member.

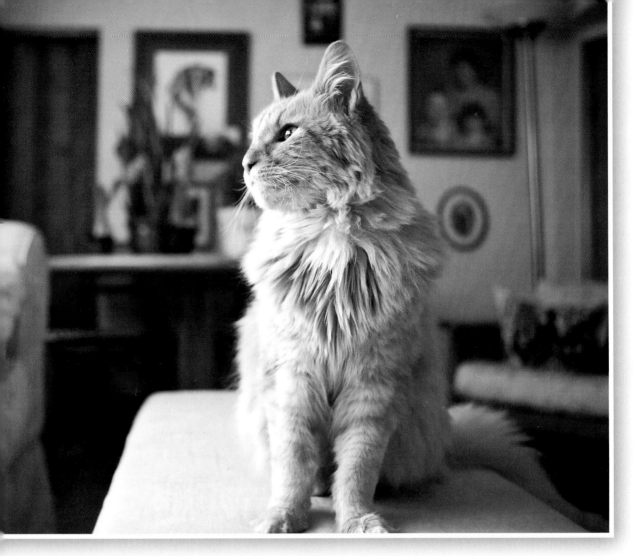

Seventeen-year-old Willow the kitty, relaxing in his owner's living room.

24–70mm 2.8 lens @ 32mm, f/2.8, 1/500 second, ISO 1600, aperture priority, partial metering

As an owner of an animal with whom you share your life, having just one incredible photograph of that animal is precious; it's worth more than any amount of money. Being able to give the gift of pet photography to a client, friend, or family member (or even yourself) is an incredible honor and joy, and one with a lasting impact. The true value of pet photos can only be measured by the amount of love we feel for these amazing animals.

The Pet Photography Industry

In the past five years, the pet photography industry has exploded, riding the tremendous rise in pet ownership. Part-time and full-time, amateur and professional pet photographers are springing up in every city, in every developed country in the world. Ten years ago, a Google search for the term "pet

photography" turned up a mere handful of pages linking to websites of professional pet photographers, how-to articles, and photo galleries. Now, that same search returns over two million results. Major metropolitan areas in the United States, such as New York, San Francisco, Los Angeles, and Seattle, have no fewer than 40 or more professional pet photographers, with the numbers growing by the day. To say it has become a wildly popular subject for photography would be an understatement.

On the Beautiful Beasties Network, an online forum that I created and run, we have no fewer than 350 professional pet-photographer members around the world, whose sole focus of their business is domestic animals. Twenty to thirty photographers are added every few months, and I expect the number to reach 500 by 2014.

The Beautiful Beasties Network home page.

But, for all of those pet photographers and those yet to get started, there are plenty of animals to go around.

I recall a time early on in my business when I panicked a little whenever a new competitor came on the scene. I was still new to pet photography and didn't understand my limits or have any knowledge about volume. I decided to take the time to determine, through statistics, how many pets lived in Seattle (where I live and work), what percentage of those pets might qualify as potential clients, and then figure out how many years it would take me to photograph all of them. I recall I came up with a figure somewhere around 10,000 animals. I very quickly realized that not only would it be impossible for me to photograph that many pets, I had no desire to even try. In other words, I realized that there were more than enough pets to go around—for a very long time.

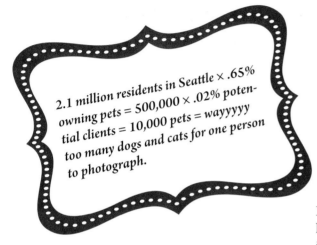

2.1 million residents in Seattle × .65% owning pets = 500,000 × .02% potential clients = 10,000 pets = wayyyyy too many dogs and cats for one person to photograph.

Today, no matter if a dog owner lives in Atlanta, or a cat owner lives in Tampa, or a ferret owner lives in Portland, for the most part, they can have their pick of photographers who specialize in pets. They can decide if they'd like studio shots, traditional, romantic shots taken indoors in their home, outdoor environmental documentary style work, or even abstract or fine art work. Often times, the hard part for pet owners seeking a photographer is deciding whose images resonate with them the most.

In each style or genre of pet photography, you have entire movements of photographers, banding together in their own groups, networking, sharing knowledge and resources, as well as an affinity for the same style. You have modern studio photographers who shun the use of fake muslin backdrops and cheesy props in favor of clean lines and photos filled with emotion. There are documentary-style crews who love colorful, vivid photos of dogs, filled with energy and emotion and captured outside in natural light. You have the fine-art camp, whose members produce more traditional work. Adherents look to portrait and children's photographers for inspiration, using props such as couches, old suitcases, and clothing selectively, both in the studio and outside in nature. Lastly, there's the ultra-modern style group, which places as much importance on backgrounds as expressions, and frequently produces clean, simple, sharp, neutral-colored photos on location, where the emphasis is more on an overall beautiful aesthetic than emotion.

Apart from the common love of animals and photography, the one thing that all of these photographers share in common is a need for education. Because the industry is still so new, and because thus far there has been a lack of significant educational opportunities, these resourceful photographers have found knowledge and education anywhere they can.

Classes, Schools, and Workshops

Here's a brief list of various educational resources that you might want to try.

Professional Photographers of America webinar: The Fine Art of Pet Portraiture
www.ppa.com/education-events/webinars/fineart_petportraiture.php

Cowbelly Pet Photography Workshops
Four-day intensive workshops on business, photography, and processing
www.cowbellyworkshops.com

Passport
International destination pet photography workshops, co-instructed by Jamie Pflughoeft and
J. Nichole Smith
www.passportworkshops.com

Margaret Bryant
Webinars, Dog Posing Book, and Coaching
www.bryantdogphotography.com/classes-workshops-seminars-instruction.php

Paul Walker UK Workshops on photographing dogs on location
www.pawspetphotography.co.uk/pet-photography-training/uk-pet-photography-workshops/

The Perfect Picture School of Photography online class by Jill Flynn
www.ppsop.com/petp.aspx

Focus On Rescue
Webinars and tips for photographing shelter animals
http: //focusonrescue.wordpress.com/webinars/

Forums

And finally, here are a few forums in which you might want to participate.

Beautiful Beasties Network
www.cowbellyblog.com/category/beautiful-beasties-online-network/
http://beautifulbeastiesnetwork.ning.com/

Nature Wildlife and Pet Photography Forum
www.nwpphotoforum.com/ubbthreads/

ProPhotogs Forum
www.prophotogs.com/forum/forumdisplay.php?140-PET-ANIMALS

Flickr Group for Pet Photographers
www.flickr.com/groups/professional_pet_photography/

Exercises

1. List the pet photographers who are the most inspiring to you (do some online research first if you aren't familiar with the work of other pet photographers). List the qualities of the work from each photographer, and see if there are any parallels between them.

2. Write a list of reasons why it's meaningful for you to create pet photos. This can help you to decide what's important to remember for each shoot you do.

3. Take a look at several of the personal projects and/or fundraising projects listed in this chapter for inspiration.

4. Sign up for a new forum if you aren't already a member of one.

Chapter Two

Equipment

☆ Cameras, Lenses, Bags, and Accessories

☆ Computers, Software, and Computer Accessories

Cameras, Lenses, Bags, and Accessories

Before we delve into techie-talk about gear, I'd like to share a little anecdote with you. The story goes that famed photographer Helmut Newton attended a dinner party at the house of an acquaintance. The host/cook approached Newton and said, "Your photos are very good. You must have a great camera." After dinner, the host/cook turned to Newton and asked what he thought of the food. Newton's reply was, "It was really excellent. You must have great pots and pans."

The point of this story is that cameras and lenses are mere tools that help you to get the job done. How well the job is performed is entirely up to the person using those tools. You can place a cheap, crummy camera in the hands of a skilled, creative artist and she can produce incredible images. Conversely, you can place the finest digital single-lens reflex (dSLR) body in the hands of a person who lacks even a basic understanding of exposure and composition, and you will end up with awful, poorly exposed photos. It's always a better idea to place more emphasis on capturing expression, creating artistic and interesting composition, and nailing proper exposure than trying to get the latest and greatest gear. With that having been said, there are important things to keep in mind when you select equipment for use in pet photography, starting, of course, with cameras.

High-quality pet photography is defined as an image that is evenly exposed; portrays a faithful (neutral) reproduction of colors; exhibits limited or non-existent highlight or black clipping; contains no noise at lower ISOs; and displays good clarity, contrast, and sharpness.

Although cameras in every price range will capture an image, arguably the best cameras to be used for high-quality pet photography are mid-range, full-frame dSLRs. Although you certainly can create pet images with your point-and-shoot, camera phone, or prosumer fixed-lens camera, the challenges of blur created by slow shutter speeds, grain from low-maximum ISO capabilities, poor color reproduction, and flash lighting limitations might still remain. With that caveat out of the way, there are cameras in every price range that are good to use for pet photography.

Here, I will attempt to break down the different camera options into categories and weigh the pros and cons of each as they pertain to pet photography.

In Chapter 9, I show you how you can improve the look of your images by using post-processing software, but ideally you want to get it right in the camera first.

Digital technology is changing by the day, which means that what is current today might not be current tomorrow as the major camera manufacturers can change the industry on a single day with the introduction of a new camera. If you are in the market for new gear, it is always a good idea to do extensive

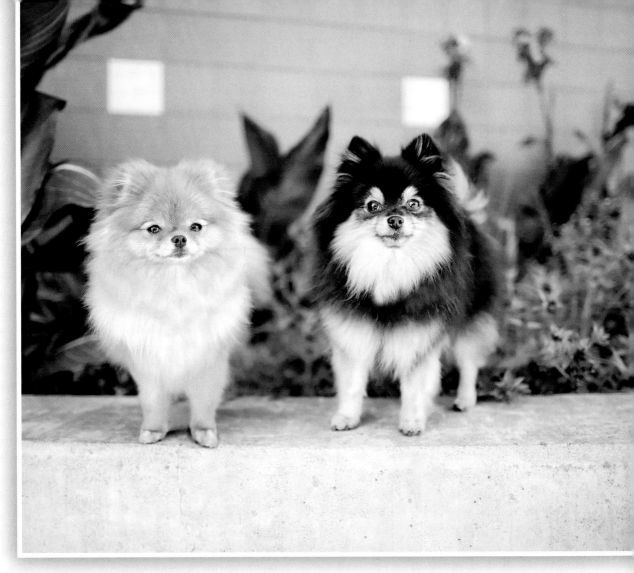

Sasha and Shelly paying attention to the camera in full shade on the backside of a building at the Seattle Center.

24mm 1.4 L lens @ 24mm, f/1.4, 1/1250 second, ISO 320, manual exposure, partial metering

research on what is available on the market at the time you make your purchase; you want to invest your money wisely. Unfortunately photography is not an inexpensive activity, and it's best to know your dollars are going toward something that will really help you to achieve the end results you are looking for, based on the type of shooting you do.

Cameras

Regardless of what kind of camera you have, the most important thing you can do to improve your photography is to *read your camera manual*. Every camera has its own unique quirks and its own distinct features, and if you don't know how to do something, your manual can instruct you. I'm always shocked at how few photographers—both amateurs and pros—have actually read their manuals cover to cover. I challenge you to read your camera manual not once, but twice. Spend a few hours with it, reading the manual and playing with the settings. I promise you it will pay off.

Here, is what you really need in a camera for use in pet photography:

Outstanding focusing abilities Fast moving subjects require a camera that can nail the focus when *you* want it to, not when the camera decides it wants to. Having multiple focus options as well as being able to set focus points and having many focus points to choose from is critical when photographing pets.

Fast shutter speeds and shutter response times One of the most common complaints about cheap point-and-shoot cameras, particularly when it involves photographing pets, is that when you push down on the shutter, the camera seems to think, "Hmmm, do I wanna snap the photo? Ohhhhh, okay…" When photographing pets that move around quickly, you simply do not have the luxury of time. You need a camera that says, "Allright, let's do this!" the instant you push the button.

Light weight When you are out in the world photographing a spastic Terrier or a climbing kitty or a galloping horse, you are doing quite a bit of moving, bending, crouching, and lifting, and you need a low-weight camera that you can handle for many hours that doesn't fatigue you. Don't buy more than you can comfortably hold (with a lens) without needing to implement a weight-lifting program.

Good low-light capabilities, high ISO options When photographing pets indoors, natural light— or more accurately, the lack of it—is often a challenge. Unless you want to use a flash for brighter light so that you can use somewhat faster shutter speeds, you need a camera that is capable of providing an ISO of at least 1600 or higher with low noise. Newer dSLR cameras are capable of high ISO values from 3200 to more than 52,000, with acceptable noise in the range of ISO 1600 to 3200. This is a real boon to pet photographers when shooting indoors, such as indoor kitty shoots or photographing dogs in a poorly lit shelter or any other low-light environment.

Intuitive camera controls When working at a fast pace on the fly, as you often are when photograph- ing pets, you need to be able to change your camera settings quickly and easily. Using a camera with non-intuitive controls or buttons that are poorly placed can have a negative impact on your results. Pet photography requires enough patience as it is; the last thing you need is to be continually frustrated with your camera, having to stop and look every time you want to make one simple adjustment.

Ability to shoot in RAW (if you own a dSLR, you already have this capability) In Chapter 5, I extoll the virtues of shooting and editing using the RAW format, especially for those who are new to pet photography. You should look for a camera that gives you the flexibility to decide what file type (JPEG or RAW) to use and when.

So, here is a breakdown of cameras into several categories, based on price (from most expensive to least expensive) and features as well as the pros and cons of each.

Pro-level dSLRs
Average price range: $6,000–$8,000 (body only)

Pros

♦ This category produces arguably the highest image quality (IQ) available.

♦ Fast burst modes and frames per second (FPS), which is excellent for capturing any kind of fast activity and agility-type pet photography.

♦ Great for studio work, as their extended functions are ideal for controlled environments where the photographer can use the camera on a tripod and take his time getting the setup right.

♦ Compatible with a wide variety of different lenses.

♦ Very fast shutter response times and excellent multiple focusing modes and focus points, which make preventing blur easy.

♦ Excellent for stock photography, as their high resolution makes printing at very large sizes possible.

♦ Most have very high maximum ISO ranges, which is invaluable for pet photography.

Cons

♦ Very heavy, making them hard to lug around to outdoor photo shoots with pets.

♦ Very expensive, and thus usually out of range for the average pet shooter.

♦ Some pro bodies don't come with a full-frame option, which means a buyer is paying through the nose for a cropped sensor on a pro body (you can read more about full-frame versus cropped sensor later in this chapter).

♦ More expensive to replace in case of damage, which is a possibility when you're photographing unpredictable subjects such as pets. (You'd want to ensure that you have good equipment insurance if you own a pro body).

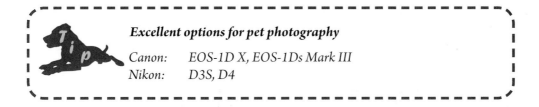

Excellent options for pet photography

Canon: *EOS-1D X, EOS-1Ds Mark III*
Nikon: *D3S, D4*

Midrange dSLRs
Average price range: $2,000–$3,000 (body only)

Pros

♦ Certainly more affordable than pro-level dSLR bodies.

♦ Versatile for a wide variety of different pet photography styles.

♦ Lighter weight than pro-level bodies, which makes them easy to carry around during on-location shoots.

♦ Compatible with a wide variety of lenses.

♦ Often available in full-frame models (you can read more about full-frame versus cropped sensor later in this chapter).

♦ Most produce excellent quality pet photos.

♦ Most have very high maximum ISO ranges, which is invaluable for low-light pet photography.

Cons

♦ Midrange dSLRs often lack the extended focusing options of the pro bodies.

♦ Limited FPS, especially when shooting in RAW, which might be a consideration for agility, fast-action, competition, and trial pet photographers.

♦ Some, but not all, have limited low-light capabilities, unable to produce low-noise shots at ISOs higher than 1600. You'll need to look carefully at the specifications before you buy to ensure that the body you're looking at provides high enough ISO for what you intend to shoot, especially if you are buying a used body or an older model.

♦ Much more expensive than entry level dSLRs.

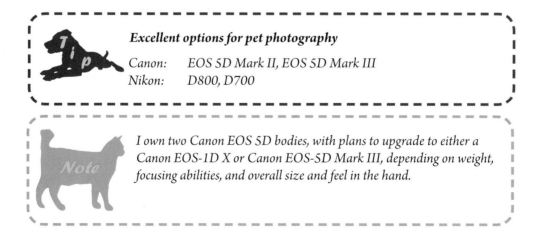

Excellent options for pet photography

Canon: *EOS 5D Mark II, EOS 5D Mark III*
Nikon: *D800, D700*

I own two Canon EOS 5D bodies, with plans to upgrade to either a Canon EOS-1D X or Canon EOS-5D Mark III, depending on weight, focusing abilities, and overall size and feel in the hand.

Entry-level dSLRs
Average price range: $800–$1,500 (body only)

Pros

♦ This category is usually much lighter in weight than a midrange dSLR, so they're easy to move around during an active pet shoot.

♦ Entry-level dSLRs are smaller and more compact, thus they fit more easily in a camera bag and are more convenient to carry.

♦ Much less expensive than a midrange dSLR, so they're a great "starter" body.

♦ This category often ships with a lens in what's called a "kit." Also, they can be used with off-brand, less-expensive lenses from manufacturers such as Sigma and Tamron.

Cons

♦ This category offers lower IQ than a midrange dSLR.

♦ Often limited focusing functions, such as focus points.

♦ Cropped sensors, which means a loss of pixel data.

♦ Limited custom functions.

♦ Some entry-level dSLRs provide lower maximum ISO, so they're typically less effective for low-light shooting compared to pro bodies. Again, you'll need to look carefully at the specifications before you buy to ensure that the body you're looking at provides high enough ISO for what you intend to shoot. The latest, newest models usually have very high ISO capabilities, but if you are buying a used body or a new one that came out a few years ago, this is something to consider.

♦ Usually purchased with kit lenses which often have aperture values between f/3.5 and f/5, which are often too slow for pet photography (more on lenses in the next section).

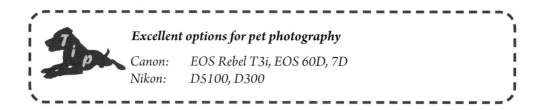

Excellent options for pet photography

Canon: *EOS Rebel T3i, EOS 60D, 7D*
Nikon: *D5100, D300*

"Prosumer" fixed-lens cameras
Average price range: $600–$800

Pros

♦ The prosumer category boasts very lightweight and compact construction. They are easy to bring to location shoots, move around with, and hold with one hand.

♦ Inexpensive. A great option for someone with limited funds.

♦ More manual controls than a traditional point-and-shoot camera, which produce better results when photographing pets.

♦ Prosumers are a great investment for a person who wants a camera that is a step above a point and shoot but isn't sure if she wants to do pet photography professionally yet.

Cons

♦ Prosumers are often limited to a fixed lens, which limits the variety of types of shots that you can take.

♦ Less professional look than a dSLR, so they're not an ideal choice for business owners trying to impress clients.

♦ Lower IQ than a typical dSLR.

♦ They frequently have higher low maximum aperture values such as f/3.5 to f/4.5, lowering the maximum shutter speed, which can make it hard to prevent blur in moving subjects.

Excellent options for pet photography

Canon:	G1 X
Nikon:	COOLPIX P15
Panasonic:	Lumix DMC-3G
Fuji:	Fujifilm X100, Fujifilm X-S1

Point-and-shoot cameras (compact digital cameras)
Average price range: $300–$600

Pros

- Point-and-shoot cameras are the smallest and lightest weight of all, and they're very easy to carry around.

- Easy for amateurs to use.

- Many automatic settings; some even have custom settings specific to photographing pets.

- The least expensive and most readily available option.

- Most households have at least one point-and-shoot camera available.

Cons

- Point-and-shoot cameras offer limited manual settings, which can make it harder to control characteristics such as aperture, shutter speed, ISO, and metering, all of which are critical for creating properly exposed, professional-looking images.

- On-camera flash, which is not appropriate for use in pet photography.

- Lack of high ISO settings, which makes shooting in low light challenging, producing grainy, high-noise shots in dark photos.

- Limited shutter speeds, which makes preventing blur difficult for moving subjects.

- A significantly cropped sensor, which decreases considerably the quality of your images, because there is a direct correlation between sensor size and quality.

Excellent options for pet photography

Canon:	*Powershot S100, G12, SX-40*
Nikon:	*COOLPIX P510*
Leica:	*D-LUX5*
Panasonic:	*DMC-FZ150K*

As you can see by the features and pros and cons, a dSLR is really your best bet for creating high-quality pet photos. If cost is a factor, consider buying an older model body with an affordable kit lens, or purchasing a used camera.

Full-Frame versus Cropped Sensors

So, what is the difference between full-frame dSLR camera bodies and cropped-sensor (APS-C) dSLR camera bodies? In a digital camera, the sensor is the equivalent of the film in a film camera. A full-frame sensor is the same size as a 35mm film frame (36mm × 24mm). A cropped sensor is a smaller sensor (the size of an Advanced Photo System "classic"-sized film negative), usually 1.3 to 1.7 times smaller than that of a full-frame sensor, which gives them a smaller field of view. Take a look at the following chart for a comparison of sensor sizes.

Image Sensor	Size	Camera types
Medium format	50.7mm × 39 mm	High-end pro digital medium format (Hasselblad, Mamiya, Leaf)
Full frame	36mm × 24 mm	High-end pro-level dSLRs
APS-C	24mm × 16 mm	Entry-level and mid-range dSLRs
4/3"	17.3mm × 13 mm	Four-thirds system
1/1.8"	7.2mm × 5.3 mm	High-end compact cameras
1/2.5"	5.3mm × 4.0 mm	Consumer-based compact cameras and high-end cellphone cameras

In the sections that follow, I provide a list of the benefits and disadvantages for a full-frame versus APS-C type of sensor in a dSLR camera body.

Full-frame sensor cameras

Pros

♦ Full-frame cameras are great for wide-angle work, especially close up shots of pets. Those fun and playful big-nosed shots can easily be achieved with a wide-angle lens on a full-frame sensor body.

♦ A full-frame lens can capture a large scene when photographing outside.

♦ There are no mathematical calculations one needs to do with their lens to determine field of view. See the chart that follows for a comparison.

	35mm "full frame"	APS-C "crop" with 1.5× crop factor
Telephoto	100mm	66mm
Normal (portrait)	85mm	56mm
Normal lens	50mm	33mm
Normal-wide	35mm	23mm
Wide	24mm	16mm
Super wide	20mm	13mm
Ultra wide	16mm	10.5mm

For example, if you'd like to capture a 24mm field of view on a 1.5× crop Nikon camera, you'd need to be using a 16mm lens. If you have no desire to shoot at the wide end and prefer using portrait-length lenses (50mm, 85mm), this isn't that big of a deal. But considering that a lot of the time you will be in close proximity to the pet (within 5 to 6 feet)—especially when shooting in a house—not having a wide field of view can be a real disadvantage. If you have a cropped sensor, you can remedy this challenge by purchasing an ultra-wide-angle lens, or by using a 17–55mm zoom at the wide end.

♦ Excellent ISO and low-light performance due to larger pixels receiving light and capturing data

♦ Higher IQ due to the larger size of the pixels on the sensor and lower pixel density (in equivalent megapixel cameras).

Cons

♦ With full-frame bodies, vignetting can be significant when using wide-angle lenses shooting wide open. This can be a either a pro or a con, depending on the look that you're trying to achieve.

♦ Given equivalent focal lengths, edge distortion is greater on a full-frame sensor shooting with a wide-angle lens.

♦ Full-frame cameras mandate the use of high-quality lenses, which are also significantly more expensive.

♦ Full-frame cameras are significantly more expensive than cropped-sensor bodies.

♦ Full-frame cameras are often heavier than cropped-sensor bodies.

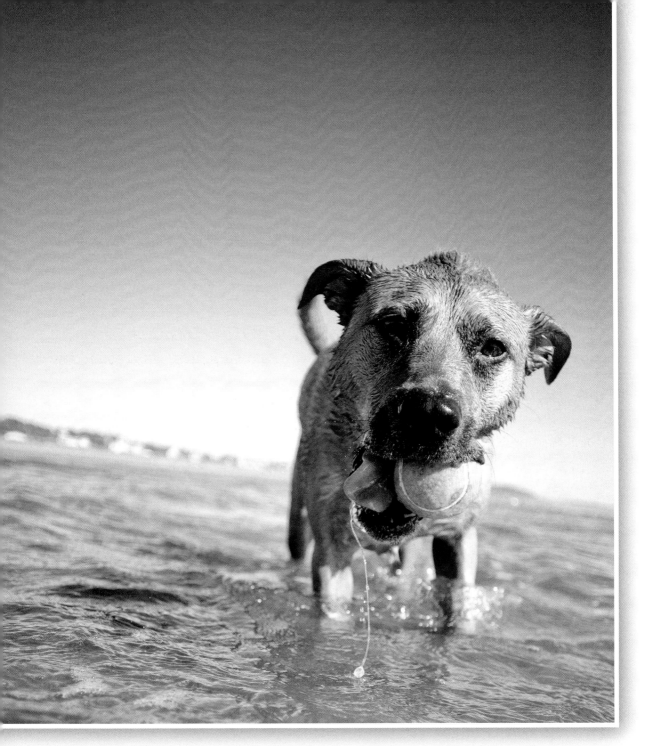

Ferguson playing ball in the surf on the Washington coast. I waded in the water and held the camera low to capture this shot.

20mm 2.8 lens @ 20mm, f/2.8, 1/1250 second, ISO 160, manual exposure, evaluative metering

Cropped-sensor cameras

Pros

♦ Cropped-sensor cameras are more readily available and thus easier to buy.

♦ More varied options exist in terms of the basic camera.

♦ They are lighter in weight

♦ They are significantly less expensive.

♦ Excellent for very high depth-of-field photography; shooting faraway subjects with a telephoto will produce excellent results

♦ You can use inexpensive and lightweight lenses

Cons

♦ Cropped sensors trim the actual size of the image through a narrower angle of view.

♦ Depending on the specific model, they can suffer from low light absorption due to tightly packed pixels, which results in poor low-light shooting.

♦ You need to purchase much wider-angle lenses for basic focal lengths.

♦ You need to purchase ultra-wide-angle lenses for true wide focal lengths (a 15mm lens equals a 24mm focal length with a cropped sensor).

Imagine standing on a bluff overlooking a vast ocean beach with the tide far out. With a full-frame sensor, you would be capturing the scene from the top of the bluff all the way out to the tall, breaking waves. With a cropped sensor, you'd be getting just the base of the bluff, the sand immediately ahead of the bluff, and the low waves in the shallow part of the water only. The following photos of Fergie offer an example.

The first photo is an example of an image taken with a full-frame sensor camera.

In the second photo, you can see what the same image would look like if it were taken with a cropped-sensor camera.

I recall when I made the switch from a cropped-sensor camera to a full-frame sensor, the first time I looked at my images I felt like I was breathing in fresh air for the first time. All I could say was "ahhhhhh," with a smile on my face.

Which sensor type is best for you will depend on your budget, the style of pet photography you intend to do (more on style in Chapter 10), and the lenses that you currently own or hope to buy.

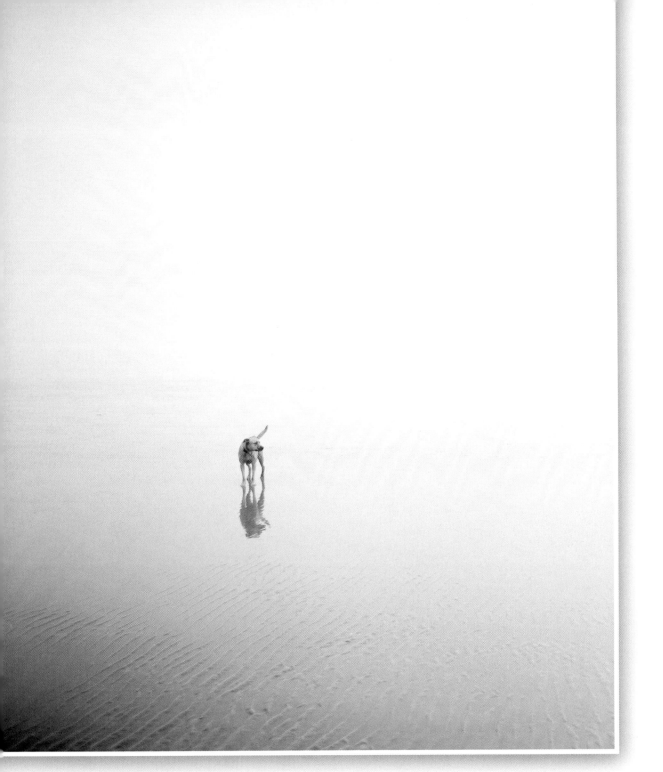

The fog made it difficult to see, but it provided some drama in this photo of Fergie.

24–70mm L lens @ 24mm, f/2.8, 1/2500 second, ISO 200, manual exposure, evaluative metering

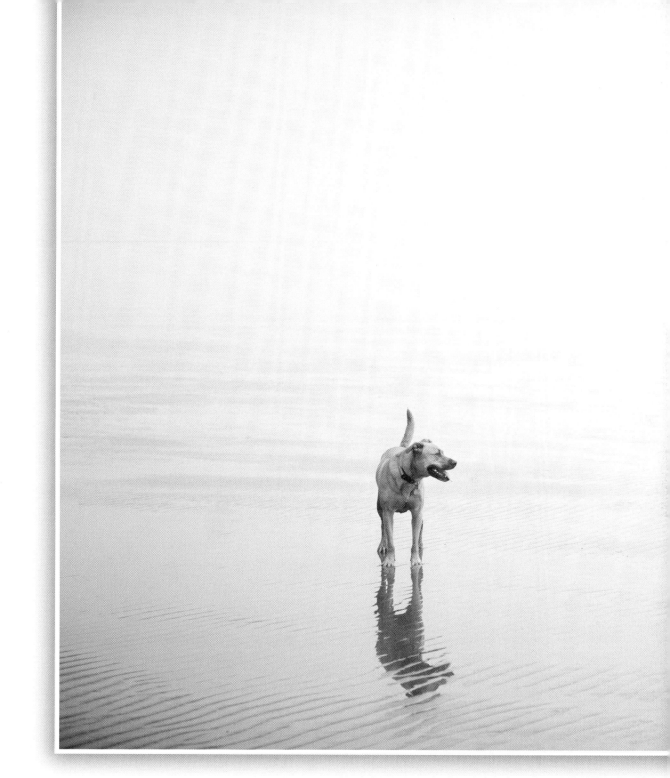

Similar to the previous shot, I wanted a more intimate feel so I zoomed all the way in on my subject.

24–70mm L lens @70mm, f/2.8, 1/2500 second, ISO 200, manual exposure, evaluative metering

Note *In the preceeding two shots, I went from zoomed all the way out at 24mm for the first image, to zoomed all the way in at 70mm for the second one.*

Some Thoughts on Medium-Format Cameras

If you are one of these photographers with tons of money to blow, (in which case you most likely aren't reading this book but instead are paying to fly me to your home for a week of private schooling), and are considering purchasing a medium-format camera ($35 thousand and up) instead of a traditional dSLR to use for pet photography, my suggestion is don't.

The problem isn't with the cameras themselves, which many argue produce digital photographs that are unparalleled in modern photographic times; it's with the options for lenses. Medium-format cameras are designed for portrait work, and the most common lenses you'll find available are in the 50mm to 85mm range. This is great if you want to create very narrow field-of-view photos, but for most pet work, for which you want to be up close and personal, the lenses would produce a challenge at best, and be incredibly frustrating at worst. The only situation in which I can see these working is very controlled studio pet photography, in a large studio, in front of a cyclorama wall, where the pet has a bit more freedom of movement than standing on a small paper backdrop, and the photographer can have the medium-format camera mounted on a stable tripod.

Some Thoughts on Film Cameras

Film cameras can be an excellent albeit challenging option for pet photographers of all experience levels. Using film and not having the benefit of immediate post-view can be a great exercise for a new photographer looking to get the basics of exposure down without having as much margin for error. It can also be an exciting practice for the seasoned pro who feels confident with her camera controls. The biggest caveat to using film is cost; unlike a memory card in a digital camera that you pay for once and forget about, every shot you take with film costs you money. There is also the cost of processing the film and having contact sheets and prints made, which, when running a business, needs to be transferred to the client.

Film photos are arguably more beautiful than digital prints and definitely carry a kind of vintage appeal that is hard to reproduce with digital cameras. For the three years I did pet photography as a hobby prior to starting my business, I used film exclusively because at that time digital cameras were still pretty expensive for what you got. Thus, I learned on film, so I decided to go with what I knew. I loved the look of the film prints, and still do, but for a business, I knew that digital would be more practical and feasible. I still prefer the look of film to digital, but I continue to shoot digital professionally due to cost and convenience.

Whether to use film or digital is a personal decision and not one on which I can advise you. I applaud any photographer who has pets as their subjects and decides to shoot film. The challenges are many, but the rewards are great, and the photos and the prints make the challenges totally worth it. If you have been shooting digital and are looking for a fun and stimulating challenge, try renting a film camera, loading it up with some fast-speed film, work on getting your manual settings right, find a dog or cat to play with, and then go to town. You might just discover something new that transforms the way you see and the way you shoot.

Lenses

There are more lenses available on the market than the space of this book allows me to include, so I am going to provide a quick overview of what I think you need to successfully engage in pet photography. Chapter 7 presents a more in-depth look at lenses. In that chapter, I show you examples of different pet shots that come from different lenses. Lens manufacturers range from the camera brands themselves, such as Canon, Nikon, Fuji, and Pentax, to third-party brands such as Tamron and Sigma. Excellent lenses can be found in every category, so it's up you to decide what is going to provide the best results for what you are trying to achieve.

For those who are just getting started it's a great idea to try before you buy. Companies such as lensrentals.com and borrowlenses.com have affordable rental options, by which you can try out a lens for a week or a day to see what you like best before investing money in new "glass."

I would be remiss to not talk about f-stops before getting underway with the list of lens types; the importance of lens aperture in any field of photography cannot be overstated. But many pet photographers have learned the hard way that the narrower the aperture, the harder it is to get decent shots of moving animals. I believe there are few hard-and-fast rules when it comes to pet photography, but one I am passionate about is that you need at least one fast lens that is capable of shooting at f/2.8 or quicker. I can tell you from extensive personal experience that often f/5.6 or even f/3.5 just won't cut it. You *need* f/2.8 (or even f/2.0) to be able to obtain fast enough shutter speeds to prevent blur, *especially when photographing animals indoors in natural light.* For more information about lighting, go to Chapter 6, in which I talk more about aperture and its importance in pet photography. But now, on to lenses.

Midrange Zooms

Midrange zooms are your general-purpose zoom lens, usually in the 24–70mm or 18–55mm range with a 24–70mm focal length being ideal for pet photography (18–55mm lens on a cropped-sensor camera). These lenses provide a lot of variety for their options in focal length, allowing the user to capture wide shots at the 24mm end, zoomed-in shots at the 70mm end, and everything in between.

Do you need one? Yes. A midrange zoom is going to give you the most flexibility from a lens, and when you are frequently walking into situations in which you don't know what to expect, this can give you the freedom to experiment with different focal lengths as dictated by the environment.

But be aware that the fast midrange zooms can be pretty expensive, with the Nikon 24–70mm f/2.8 topping out around $1,900, and the Canon equivalent at around $1,400. If you need a fast zoom lens and can't afford a Canon or Nikon, you can purchase a Sigma or Tamron ($500–$900), which can yield the equivalent IQ to their more expensive counterparts. Until you can afford to invest in high-quality glass, the flexibility you will get from having a midrange zoom from manufacturers such as these will offset any reduction in IQ.

For this category, I own a Canon 24–70mm 2.8 L USM.

Some of the first photos I ever took of pets. Sadly the negatives for the black-and-white shots are long gone.

Wide-Angle lenses

Wide-angle lenses are those in the 16–24mm range that produce a very wide field of view that allows a very large part of a scene to be captured. Landscape photographers frequently use wide-angle lenses.

Do you need one? Maybe. It really depends on the type of look you are going for, but a fixed-prime wide-angle lens can be a great option for the photographer on a budget who doesn't mind "zooming" with his feet. Great wide-angle primes can be purchased for under $500, and because there are no moving elements involved, often the lenses are of higher quality than you'd find in a comparably priced zoom lens. If you want even better flexibility in your prime lens, get a 35mm f/2.8 lens, which you will use for a long time during your pet photography career.

Of course, the disadvantage of wide-angle lenses is that they can introduce a lot of distortion in your image, especially on a full-frame camera. It also increases the vignetting that occurs in the camera, which is something you need to consider if you don't like the look of distortion or vignetting. (I tell you how to easily remove both in Adobe Photoshop Lightroom in Chapter 9).

In this lens category, I have a Canon 20mm f/2.8.

Telephoto Lenses

Telephoto lenses are those that can zoom in on distant objects, usually starting at 70mm and going up to 400mm or more (most are in the 70–200mm range). These lenses allow you to be far from your subject and still capture detailed shots of it. Telephotos also allow you to pull a large scene in behind your subject when shooting at narrow apertures.

Do you need one? Maybe. It really depends on the type of pet photography you are doing. If, for example, you are doing a lot of rescue work and you photograph pets in shelters or animals who have

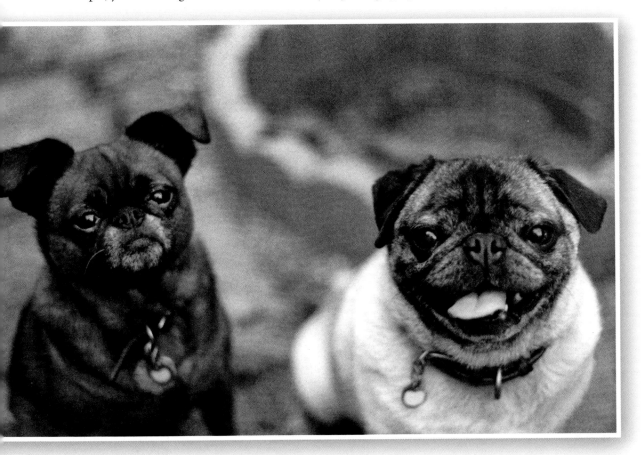

Lucy the shorthaired Brussels Griffon and Willa the pug; two of my favorite dog-walking clients.

been abused, are fearful, or are aggressive, getting close to them might not be an option, in which case, if you use a telephoto lens, you can get great shots of an animal without intruding on their personal space and causing them unneeded anxiety. The same holds true for a professional pet shoot, for which most animals are not used to having a camera in their face. A telephoto can help pull you out of many difficult situations for which you would otherwise not have gotten the shot.

Keep in mind that fast telephoto lenses, such as the f/2.8 glass you need in low-light situations, can be very heavy. Make sure you know what the overall weight in your camera bag will be if you add a fast telephoto, and also ensure that you can hold the camera in your hands with the lens on without any problems. Two pounds on your camera might not seem like much, but when combined with the rest of your gear, you could end up with one very sore shoulder after two hours of shooting in a park or at a shelter. Consider purchasing a slower telephoto such as an f/4 as an alternative.

My telephoto lens is a Canon 70–200mm f/4.0 L IS USM.

Macro Lenses

Macro lenses are designed to capture detail in your subject at a very close range (for example, less than a 12 inches, generally). In pet photography, you can use a macro lens to capture details such as paws, tails, ears, tongues, eyes, collars, noses, pet tags or charms or accessories, claws, hoofs, and so on.

Do you need one? No. If you have a good, sharp midrange zoom lens, you can mimic a macro shot by getting close to your subject and zooming all the way in to 70mm so that the item you want to focus on fills the frame.

Another thing to consider is that macro lenses can be tricky to learn how to use and frequently come with a high price tag for good quality glass ($1,000 and up), so make sure that you really want to do macro work in your pet photography before investing in this lens.

Fixed–Focal-Length Lenses

These are fixed lenses (also known as *primes*) that come in a variety of maximum apertures and depth of field. Fixed–focal-length lenses can include 20mm f/2.8, 24mm f/1.4, 34mm f/1.4, 35mm f/1.8, 50mm f/1.8, 85mm f/3.5, and many more. These lenses arguably provide the sharpest images, and often have higher IQ than their zoom counterparts. Fixed lenses are also lighter, which is important for the active pet photographer.

Do you need one? Yes, if you have an idea of what style of photography you would like to achieve (see Chapter 10 for information about developing your style), and you have enough experience to know how you like to work. These lenses can be very affordable compared to their zoom counterparts, and they can enable you to experiment with different types of glass without having to invest thousands of dollars. Third-party lenses from Tamron and Sigma can be great for photographers who are just getting started with lenses.

Keep in mind that it can be easier to justify a $350 investment than a $1,350 investment, so you run the risk of ending up with lenses you don't use, or use so infrequently that it's not worth the price you paid

for them. Because of this, it's best to rent before you buy. Because of their nature, fixed–focal-length lenses also require you to "zoom with your feet." If you are not used to moving around much in your photo shoots, this can be a difficult change for you.

Also, if you are a portrait photographer who is used to shooting with an 85mm or 50mm lens, you will probably find them too narrow for pet photography. At a minimum, you'll want one lens that is at least as wide as 35mm for your pet shoots. I personally love fixed–focal-length lenses because of the dynamic nature of most of my shoots. I move around a lot and enjoy interacting with the pets, and when I know what the depth of field of my lens is at any given time, this makes it easier to capture what I really want.

I own a Canon 20mm f/2.8, Canon 50mm f/1.8, and Canon 24mm f/1.4 L USM II.

Another lens in the fixed–focal-length category that might interest you is the shallow-depth-of-field prime. These lenses come with a very large maximum aperture value, usually between f/1.2 and f/2.0. Because of their large aperture openings, these lenses let in the most light and also have the shallowest depth of field. For this reason, they are outstanding for low-light photography and make excellent general-purpose lenses when used outside at smaller apertures. They also often have very close minimum focusing distances, which is great if you like to get *really* up-close-and-personal with your subjects. Good quality primes in the f/1.2 to f/1.4 range can produce gorgeous *bokeh*, which is the soft, blurry background you see in many professional photos. The difference between a high-quality f/1.4 and an f/2.8 is that the background and edge of your subject will be soft and buttery, but the center part will be crisp and sharp with incredible detail. "Dreamy" is the best word to describe these images.

Do you need one? Yes, if your budget allows. These lenses produce gorgeous, shallow-depth-of-field photos with loads of bokeh. Images produced by using these lenses practically scream "professional," so if you have the dough to invest and want to make your images look more professional, go for it.

Always be aware that lenses can be broken by wily dogs and clumsy cats, and these little babies can be very expensive, indeed, so make sure you have insurance on your gear before blowing $1,800 or more on what I call a fun lens.

Note The Canon 50mm f/1.8 retails for around $100. That makes it a great introduction to shallow-depth-of-field lenses.

Another caveat is that these lenses can also be very tricky to focus because of their ultra-shallow depth of field, so nailing the focus on the pet's eyes or face can take some practice when shooting wide open. The last thing you need is a pretty photograph in which the focus is in entirely the wrong place.

For this category, I own a Canon 50mm f/1.8 "nifty-fifty" and a Canon 24mm f/1.4 L USM II.

Fisheye Lenses

Fisheye lenses produce shots that appear to have been taken through a large, round looking glass. You will sometimes see photos of pugs and other bug-eyed or funny-looking breeds taken with a fisheye lens. They can produce humorous, unique looks and make otherwise normal scenes look more interesting.

Do you need one? No. If you love the look and want to use it for fun, go for it; otherwise, it's certainly not required to do pet photography.

Fisheye shots are very much an acquired taste, so if you are shooting someone else's pet or doing pet photography professionally, you will want to ask pet owners first if they would like you to take some fisheye shots (show them examples) before you pull out that funny dome-shaped glass and slap it on your camera. You might love the whimsical look, but the client might not.

Tilt-Shift Lenses

Tilt-shift lenses feature selective focus. The area in focus is a thin sliver of the frame, running either vertically or horizontally, with the rest of the frame appearing very blurry. Often the rest of the scene looks miniaturized, as if out of a storybook or fairytale.

Do you need one? No, unless, you want to create really unique, artistic-looking photos that is different than most everything else out there. You might decide to rent a tilt-shift lens and play with it for a week, trying it out on a special project involving dogs. Who knows? Maybe you start a new trend with your new look!

Before you put too much thought into acquiring one, tilt-shift lenses are the ultimate in what I call "fun" lenses. These are the lenses that you really (really) don't need, but really want because you know they'd be fun to use. These lenses are just as expensive as a high-quality midrange zoom or telephoto; for example, a Canon 45mm f/2.8 tilt-shift lens is priced at around $1,400, and a Nikon 45mm f/2.8 will relieve you of a whopping $1,800. That's a lot to pay for a lens you probably won't use as your go-to glass, so you'll have to really (really) love it before you buy it.

To sum up the gear that's currently in my bag:

- Two Canon EOS 5D bodies
- Canon 20mm f/2.8 prime lens
- Canon 24mm f/1.4 L USM II lens
- Canon 24–70mm f/2.8 L USM
- Canon 50mm f/1.8
- Canon 70–200mm f/4.0 L IS USM
- Canon 580 EX II flash plus off-shoe cord (more on light in Chapter 6)

At this point, you might be asking, "Cool, so now we know what's in your bag. But what is your favorite lens? Which one do you use most often during your shoots?"

The answer is all of them! Which lens I use really depends on the look that I'm going for and the composition I'm trying to achieve for the shot. For one shot, my favorite lens might be my 70–200mm f/4. For another shot, only my 20mm f/2.8 will do. What I will tell you is that I would never be without my 24–70mm f/2.8 L lens. Although I could do shoots without it, this is truly the gold standard when it comes to pet photography; it's a lens that I feel every pet photographer needs to have in their gear bag. Or, put another way, if you can have only one lens, this should be it.

Bags, Accessories, and Other Fun Stuff

Bags

Once you have all that fancy gear, you'll need something to put it in, right? So what kinds of things are important in a camera bag for pet photographers? There are some simple features to look for that can help to prevent an aching shoulder or back after marching around a park for several hours with a pack of hyper dogs and a fully loaded camera bag.

- ♦ Comfortable to wear with nice, thick padded straps
- ♦ Easy to get in and out of
- ♦ Secure from prying pet noses. (Strong hook-and-loop fasteners usually do the job)
- ♦ Multiple interior compartments for small items
- ♦ Impervious to dirt, grass stains, slobber, urine, and other animal stuff

Accessories

Other accessories you should consider for your pet photography bag include the following:

Hoodman lens loupe This is a little magnifying loupe with a rubber gasket that you hold over your viewfinder. This is indispensable on bright sunny days when seeing your viewfinder is hard, if not impossible.

Flash-shoe level When your focus is on the pet and you are shooting without framing up through the viewfinder, sometimes it can be difficult to determine if your horizon is level. This nifty little level makes it easy to do so.

Dry lens wipes An absolute necessity when working with pets because you will get all manner of gunk on your lenses. Carry multiples on your person and in your camera bag. Toddy Gear makes the best, in large sizes and fun patterns. If you are tired of the old boring camera lens wipes, then these will be perfect for you.

Wet lens wipes When you have dog snot/saliva or other debris on your lens, you need a wet wipe to get it off. E-wipes makes individually wrapped wipes that are easy to stow in a camera bag or pocket. I always keep a bunch of these available. Hoodman also makes a great single-use, eco-friendly wipe.

Extra memory cards One day you will be photographing the cutest little Akita puppy that you ever laid eyes on, getting some of your best shots ever. That's when your memory card will fill up. On top of that you will discover, much to your horror, that it's the only one you have. Don't let this happen to you. Also, get in the habit using multiple smaller cards (for example, 4GB and 8GB) versus one larger card. This way, if you lose a card, you only lose some of your images instead of all of them. And buy the best quality memory card that you can afford. The fast read and write speeds will be a benefit when it comes to fast-action pet shoots. There are many brands from which to choose. I've had many memory cards fail on me but have never had a problem with SanDisk or Lexar Professional cards. Hoodman is a lesser-known but no less reliable brand.

Extra batteries It will never fail that when you have that kitty in the perfect position in the perfect setting, your battery will die. It's a good idea to keep an extra one on your person to limit the amount of moving around you need to do to replace it when this happens.

UV filters to protect your lenses When photographing animals, your lenses will be licked, sneezed on, jumped on, and be subject to a whole list of other random insults, and if you are investing in expensive glass, you need to keep it protected. I once had a hyper dog's tooth nick my filter to the point that it was visible. I was just glad it was the filter and not my $1,600 lens.

Pet Accessories

Another important tool in the pet photographer's toolbox are toys and snack for your subject. Here are some suggestions for those and a few other accessories that you should always keep on hand:

Dog treats and cat treats Try to always have small, soft, stinky treats in your camera bag. Zuke's Mini Naturals in salmon flavor are a great option for dogs; they work well for tiny dogs with bad teeth, but you can also use them for bigger dogs with larger mouths. (They make them for cats, too). For extra-stubborn dogs, bring string cheese with you, and in desperate times, Beggin Strips are like catnip for dogs. Be careful with treats like this though because they can cause digestive upset.

Dog toys and cat toys For dogs, Cuz rubber toys are a great option; they come in different sizes and dogs love the squeak. Bright-yellow rubber tennis balls made by Kong are also great because they too contain squeakers and can be incorporated into the shoot. Most cats love the Kong Cat Cozie catnip toy, and it's always a good idea to bring cat toys to your cat shoots because even though most cat owners already have toys for their cats, often the novel stimulus of a new toy is all you need to make a photo shoot exciting and interesting for cats.

Squeakies and other noisemakers There are all manner of squeakies on the market, but the ones I prefer are the little mini Kong squeaker replacements that you find inside plush toys. They are sold separately in packs of five, and that's good because you will go through lots of them as a pet photographer. They are great because they're small enough to be held in a hand and squeaked without the dog being able to identify where the noise is coming from. Duck calls, dog whistles, and other noisemakers work, too, but use them sparingly as loud noises can scare some dogs or cause them to tune out quickly.

Poop bags Invariably, owners will be so excited to have photos of their dog taken that they forget poop bags at home. You can save them the embarrassment of having to leave their dog's waste behind by graciously handing them one of your poop bags.

Organic catnip I've shot some of my funniest and most interesting kitty photos using catnip. Organic is best because it shows you care about the animal's health. I have a small cloth bag filled with cat treats, catnip, and various cat toys that I always bring to kitty shoots with me.

Extra collars The pet might show up with a collar that doesn't fit the look you are going for (old and dirty are two words that spring to mind), or they might only be wearing a harness that you'd like to remove for the photos, so it's always good to have some spare collars in your car, just in case.

Other Essential Tools of the Pet Photography Trade

Finally, here are a few more items that you'll find very helpful when you're out in the field:

Extra towels and rags Certain breeds of dogs, such as Mastiffs, Bulldogs, and some larger Labs, tend to get slobbery, so having a rag on hand can help cut down on the time you spend in Photoshop editing "mouth foam" out of the image. Towels are great for dogs that like to go for impromptu swims in the middle of winter in freezing cold water. Dog owners usually bring these things, but in case they forget, it's always great if you can help out.

A thin, black retractable leash Most dogs need to remain on leash in public, not just because of leash laws but also to keep them safe. Thin retractable leashes are the easiest to edit out in Photoshop, so you can save yourself a lot of time later on just by having the right leash.

A collapsible water bowl In the summer and in warm regions, dogs can get hot quickly, especially the short-nosed breeds such as Pugs and Bulldogs. Carrying a collapsible water bowl is a great idea because it can help prevent dehydration and heat stroke, two things you definitely don't want involved in any of your photo shoots. Ensure that you know where the nearest drinking fountain is if you're shooting in high heat.

Spare rolls of poop bags Yes, I know that I already listed this, but these are for when you run out of the ones you already gave to the pet owners two hours earlier.

Now that you know what kind of gear you need, let's move on to the computers and software you need to process your images.

Computers, Software, and Computer Accessories

The limitations of this book don't allow me to endlessly debate the long-running Windows versus Mac rivalry for photography applications or discuss at any length the myriad computer options, so I will tell you what I think is best for pet photography and what I personally use. The most important point is that you have a computer that works reliably, runs relatively fast, and can hold *a lot* of photo files. I can say from experience that having a decent computer does make a difference when it comes to processing and editing digital photographs, because you end up spending more time in the "digital darkroom" than you do actually shooting the photographs themselves.

Here's a list of my current computer setup:

♦ 27" 3.06 GHz Intel Core 2 Duo iMac with 8GB RAM and a 1-TB hard drive

♦ 2008 15" 2.4 GHz Intel Core 2 Duo MacBook Pro with 4GB RAM and a 200-GB hard drive

♦ 2011 17" 2.3 GHz Intel Core i7 MacBook Pro with 8GB RAM and a 750-GB hard drive

Each computer runs the latest version of Mac OS X Lion.

♦ Three external hard drives: La Cie d2 Quadra. Two 750-GB hard drives with mirrored content, and one 1.5-TB hard drive with current iMac content used as a Time Machine

♦ Wacom 4" × 6" Intuos 4 graphics tablet

♦ Lexar Pro Firewire 800 compact flash memory card reader

What You Need for Digital Pet Photography

The following is a descriptive list of what you should expect to have to run your pet photography business:

A computer I personally recommend Apple computers because they are truly designed for visual artists. The graphics on the displays are measurably superior, the operating systems are highly intuitive, and as far as visual aesthetics of the operating system, Apple can't be beat. I used a Windows-based PC for the first two years of my business. Later, I switched to a used Apple desktop that a client donated to me, and even though it was a cheap, older model, I was stunned at the difference it made in my work in terms of ease of use, quality of visuals and color reproduction, and intuitiveness of the operating system. You can buy refurbished or used Apple computers for a price that is comparable to a Windows-based PC, and they maintain their value over time, so they make a great investment.

Lots of RAM Those big photo-processing applications you will be using need a lot of RAM (operating memory) to run in tandem, and the more memory your computer has, the happier you will be and the less frustration you will have. I currently have 8GB of RAM in my iMac, and it runs great.

Processor speed The "clock speed" of your central processor unit (CPU) is important, too, but unless you are doing video editing, don't get too carried away with this. Most processors operate at speeds between 1.7 GHz and 2.0 GHz, which is usually fine for the average user.

(Ideal) Firewire, USB 3.0, or (ideally) Thunderbolt port(s) You can use a USB 2.0 memory card reader or cable to transfer files from your camera or memory cards, but they are slow. If you are shooting RAW, this will become a bottleneck because these files are quite large.

A large internal hard drive, and/or multiple external drives to store your image files An ideal hard drive will be 750GB or larger, although 500GB will suffice as well, with 1TB or larger being the ideal. I can tell you from experience that a hard drive that is only around 250GB will fill up very quickly, so if you have a small hard drive, be sure to get multiple external drives for file storage. I talk more about exernal drives and archiving in Chapter 9.

Simple but workable surroundings at the Cowbelly Pet Photography headquarters.

The largest display that you can afford to buy Often, you will be editing photos side by side, and sometimes referring to a website or e-mail when doing so, so the more screen space you have to do this, the easier your job will be.

If you use a laptop as your primary workstation, you might want to consider a slightly less expensive alternative. All laptops come with the ability to attach a separate monitor in addition to the laptop's built-in monitor. You can then configure your laptop to "extend" the desktop to the external monitor (or use the monitor as your main viewing device and extend the desktop to the built-in monitor of the laptop). Depending on the size of your laptop, this option allows you to buy a smaller, less expensive monitor, but still gain quite a bit of screen "real estate."

Computer Accessories

In addition to your basic setup, you'll probably want to get the following accessories to enhance your work environment:

USB hub You will find that once you plug in your USB tablet, point-and-shoot camera, card reader, speakers, and every other USB device you accumulate, you will quickly be completely out of USB ports on your computer. To get around this, I use a Satechi 12-port USB hub that is attached to the back of my iMac with Velcro, and it's indispensable.

Graphics tablet for editing This is a personal choice. Some photographers are more comfortable editing photos using a mouse because it's what they have the most practice with. I personally cannot do any detail editing, such as cloning leashes or selecting areas, without the use of a graphics pen on a tablet, so I use a Wacom Intuos tablet, which, at $200, was one of the best investments I've ever made for my business.

Fast memory card reader If you take a lot of photos, you will have a lot of megabytes worth of image data, and being able to ingest those images into your computer quickly will save you hours of time that would be better and more profitably spent, not waiting for files to transfer.

External computer speakers It can get lonely editing photos for hours in front of your computer. Having some nice music to listen to through good speakers via Pandora or Last.fm helps to make the time go by more quickly and enjoyably, which is important if you plan to be doing digital pet photography for the long haul.

Software

If you are involved in digital photography, some sort of photo-processing software is essential, for several reasons. First, photographing pets can be very challenging, and it's not uncommon to capture a photo of an incredible expression or scene but have issues with the exposure or other technical details. With the proper software, you can fix a multitude of sins. Second, all digital files come out of the camera with a kind of grayish haze, almost as if they are covered with dingy plastic wrap. You need to process images to remove that haze, improve clarity, and make them pop. Third, if you are shooting in RAW (which I address in Chapter 5), you need software to convert RAW files to JPEGs, which is the most common file format used for printing and on the web. Here are some of the applications that you should look into for photo processing:

Adobe Photoshop Elements This is a great bare-bones version of Photoshop CS, and at $75 retail, is far more affordable than the full version, which prices out at around $600. With Photoshop Elements, you can adjust exposure, color balance, crop, do selective dodge and burn, and prep for web and print. Elements is designed for consumers, and as such, its controls are simple to use, whereas CS is designed for professionals.

Adobe Photoshop CS As of this writing, Photoshop is at level CS6, but older versions are great, too. That having been said, I recommend going with CS3 or newer, because of the drastic improvements made from CS2 to CS3. Photoshop CS6 is designed for professionals and has extensive editing options, including layer masks and comps, customizable actions and menus, presets, color spaces that you need for print profiles, content-aware lens correction, and much, much more. Essentially you can do pretty much anything with Photoshop; whereas with elements you are limited to basic editing options.

If cost is an issue, there is a fairly new and interesting option that you might want to consider. Photoshop (and the entire Adobe Creative Suite) can now be purchased as a cloud-based subscription service for a monthly fee. Instead of purchasing the package outright and loading it on your computer, you work over the Internet, accessing the software "in the cloud." This can represent a substantial savings for a single user. Plus, you get the benefit of never having to be concerned about buying upgrades or your software up to date, because upgrades are implemented automatically.

Adobe Photoshop Lightroom Currently at version 4.1, Adobe Photoshop Lightroom (typically referred to as simply Lightroom) is modeled after film darkrooms and is built around easy-to-use sliders which control every adjustment that you'd likely need to manipulate on a photo. Extremely user friendly, very powerful, and about half the cost of Photoshop CS6, Lightroom is an excellent choice for pet photographers. Although Lightroom allows you to do selective editing, unfortunately it is inferior to Photoshop when it comes to things such as leash removal, cloning, and sharpening (although these things can be done with time and practiced skill).

My image editing software of choice: Adobe Photoshop Lightroom 4.

Apple Aperture Apple's Aperture is similar to Lightroom in that you can sort, organize, edit, retouch, and share images. It is compatible with iCloud and priced similarly to Photoshop Elements at around $80.

Photoshop free online version After you upload your image file, you can use auto correct to fix exposure and color, dodge and burn, add fun filters, crop, rotate, resize, sharpen, convert to black and white, and more. Here's the address:

www.photoshop.com/tools/expresseditor?wf=editor

So what should you have for pet photography? In an ideal world, you will own and use both Lightroom and Photoshop CS. If you can't afford both programs at first, invest in Lightroom and Photoshop Elements, and then work your way up to Photoshop CS.

To see all of the gear I recommend for pet photographers, from cameras and lenses, pet gear, computers, software, and more, visit the Amazon Beautiful Beasties gear store at:

http://astore.amazon.com/beautifulbeasties-20/

Exercises

1. Write a list of the shortcomings you feel your camera has for pet photography, so you have an idea of what you need when you are ready to upgrade.

2. Rent lenses and camera bodies from a company such as borrowlenses.com or rentlenses.com; experiment with different looks and settings to get a feel for what looks best to you.

3. Purchase several different bags of pet treats to have on hand for your next shoots.

4. Download trial software if you don't already have a good photo editing program. Adobe Lightroom and Photoshop or Photoshop Elements are a great place to start.

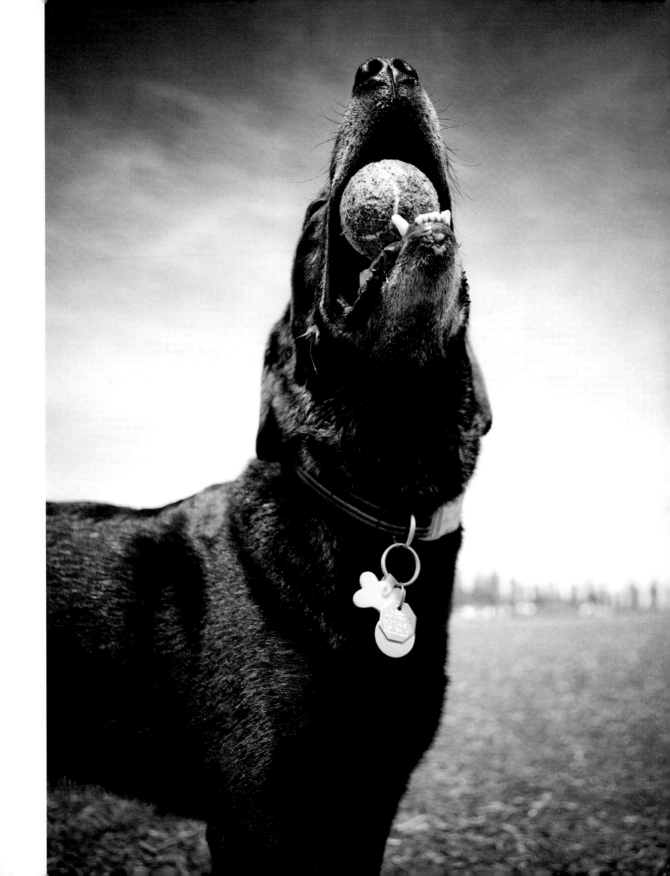

Chapter Three

Working with Pets as Models

- ✪ Animal Behavior, Body Language, and Communication
- ✪ Working with Dogs
- ✪ Working with Cats
- ✪ Working with Other Animals
- ✪ Learning About the Individual
- ✪ Photographing Your Pets

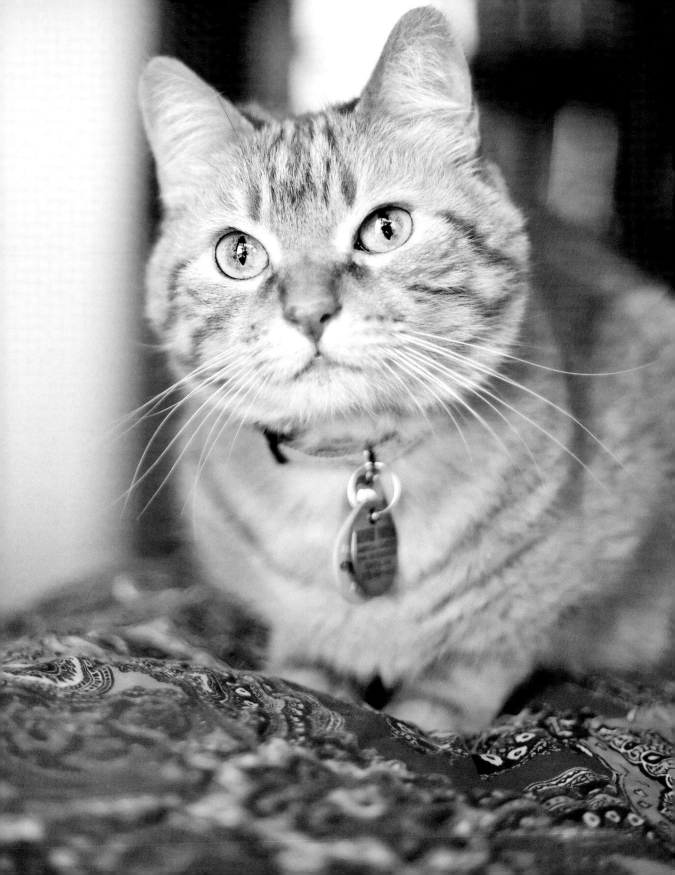

Animal Behavior, Body Language, and Communication

I majored in psychology with an emphasis in animal behavior at the University of Washington. During my studies, I was privileged enough to have professors who allowed me to focus on domestic animals, recording actions at off-leash dog parks and observing behaviors exhibited by my furry pet-sitting charges. I have always felt that this experience has given me a huge advantage in my pet photography career, because I believe that the better you know your subjects, the more accurately you will capture the essence of who they are, and the easier it is to work effectively with them.

Because of the space constraints of this book, an in-depth look at every type of animal you might point your camera at isn't feasible, but I will attempt to give you a basic overview that will help you to understand what to expect. The focus here is on cats and dogs because they make up the bulk of animals most photographers specialize in, although I do touch a bit on horses, other furry creatures, and reptiles, both in this chapter and throughout the book. I also provide creative shot ideas for different types of animals throughout the book, specifically in Chapter 6.

Every species has a communication all its own. For dogs, it might mean a certain look out the side with their eyes that says "watch out." For cats it might be a position of their ears signaling fear; for birds, feathers ruffling is a way to let you know that they are the boss. The more you understand these unique communication cues, the easier your job will be to photograph animals. The shoot will not only go more smoothly, but you also increase the odds of capturing shots of that animal's unique personality. And, of course, the more you understand your subjects, the more comfortable and confident you will feel around them.

Working with Dogs

By far, dogs account for the largest group of domestic animals photographed by amateurs and professionals alike, which makes them the central focus of this book. Dogs can be one of the easiest nonhuman species to photograph, but not always. There are wild and unruly dogs; there are disinterested and distracted dogs; and sometimes, there are downright dangerous dogs.

"So, how do I know how a dog is feeling when I photograph it?"

There are several things you need to pay attention to when you are photographing a dog. Over time, these things will become second nature and you won't really even need to think about them, but in the case of an aggressive dog, such as with a traumatized dog at a shelter, you need to be extremely aware of canine body language and communication at all times, keep your ears and eyes open, and ensure that your animal instincts are in tune.

Dogs don't use words, but they do use other methods that serve to communicate to you just like words do.

The Eyes
Direct stares between two canines are seen as a threat, but dogs use their eyes to communicate with humans, and they expect us to communicate with them by using our eyes, too, because that is what thousands of years of evolution have taught them to do. Think of when your dog loses a toy under a

dresser. It might try for a minute to get it out on its own, but eventually, it comes over to you and stares into your eyes, being sure to make eye contact. "Get my toy for me. Now, please," is the message it's sending. It works because you usually will do it! (Dogs are so smart). A dog that is sick or injured or feeling threatened will often have its head down, looking up at you with "sad eyes." It's in pain and feeling frightened and this may be a plea for sympathy or affection. The normal state for a dog's eyes is for them to be open but relaxed, without much of any whites showing beyond what you can normally see.

Fergie was depressed here, hiding in the bathroom from scary noises outside.

24–70mm L lens @ 30mm, f/6.3, 1/500 second, ISO 1250, manual exposure, evaluative metering, 580 EX II flash fired off-camera.

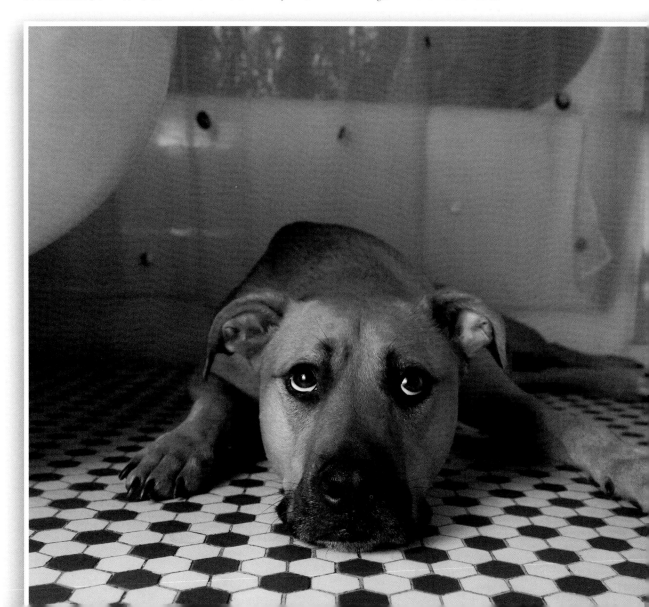

The Ears

The most ideal look in dog photography is with the ears up and forward or whatever the normal relaxed position is for the particular breed, taking into account how they are shaped (Basset Hounds and Basenjis have very differently shaped ears). Ears up and forward (or in their normal state) indicates interest, alertness, and being engaged with what is in front of them. Ears back or to the sides indicate uncertainty or feeling uncomfortable, or worse, borderline aggression. It is also often a sign of submission, which, although it's desirable in canines, you don't necessarily want to capture that particular look on film.

The Body

There are as many different body types in canines as there are different dog names, and every breed has its own norm. But, there are some commonalities when it comes to canine behavior that you can look for.

Generally, a dog crouched low to the ground is either afraid, acting very submissive, or becoming aggressive. A dog that is crouched low to the ground with hackles raised, ears pulled back and teeth bared is preparing to strike. If it is showing its teeth in a sort of smile, crouching, squinting, with its tail tucked or even urinating on the ground, it's feeling very submissive or even fearful.

A dog holding its head high, with its tail straight up in the air, ears up and forward, and legs straight is being either very dominant or wants to play. This posture can go either way: It can turn into a "play bow" (which I'll describe in just a moment), or it can turn into a fight. A fight can be precipitated by hackles (the fur on the dog's neck and back that stands up when it's aggressive), growling, shoulder shoving, and behavior that generally looks like it's meant to intimidate.

When a dog is bending at the waist with its front legs and head down, looking up at you with its butt up in the air asking to play, it is in what's called a *play bow*. This sometimes follows the aforementioned posture in which the dog is standing with its head high and legs straight. If it's panting or doing what we call *smiling*, with relaxed-looking eyes and ears, and tail in a relaxed position or wagging gently, then the head held high, straight legs posture will often be followed by a play bow, if the dogs decide that they are friendly with one another or want to play with you.

The Tail

Dogs communicate a lot of information to each other (and hopefully you) by means of their tails. There are as many different tail designs as there are breeds, and the more you get to know different breeds, the better you will understand what is normal for them. Generally, a long-tailed dog that is relaxed and happy will leave its tail hanging about midway down its hind legs. A wagging tail can signify many different emotions. Often, it means that the dog is excited or happy to see you. Sometimes, though, it can be an indication of nervousness and feeling like "I'm not quite sure what's about to happen next," or even a precursor to aggression, if all of the other aggressive signs are present (ears pulled back, teeth bared, and head held low).

A tail held very high like a flagpole combined with a stiff body pose is a sign of dominance; it's an "I'm better than you" pose. When you see this kind of posturing and it's followed by the dog standing with its head held high over another dog's neck, this can be a precursor to a fight. The dog on top is trying to assert its dominance over the dog on the bottom in a not too subtle or gentle way. Growling and raised hackles are a sure bet that the "better than you" dog means business or is trying to fight. This behavior is a threat, and when it happens during one of your photo shoots, you need to grab the dogs—*fast*.

On the other end of the spectrum, a dog holding its tail between its legs or even tucked up underneath its body is feeling extremely submissive or fearful. Some breeds are more prone to doing this, such as Labs and Golden Retrievers. Although this isn't necessarily a bad thing, you will want to put the dog at ease, being gentle and moving slowly until it feels more relaxed and confident in your presence.

Sometimes it's merely the environment that will bring about fear or anxiousness in some dogs, especially those that don't venture outside very often, and suddenly you all show up at a busy park to do your shoot. (You can avoid this by following the tips in the upcoming section "Learning About the Individual").

I recall seeing an image several years ago on a well-known dog photographer's blog of a little Chihuahua, standing behind its owner's legs, front foot picked up in the air, tail tucked between its legs and ears to the side. Sure, the little guy was cute, but when I looked at the shot, all I could think was that the poor dog looked terrified. It's important to understand dog behavior when trying to capture them looking happy and relaxed; it goes without saying that you don't want your animal subjects to be feeling unhappy during your shoots. It's a simple equation, really:

Happy dog = great shots = a happy owner = a happy photographer.
Clearly, a win-win-win.

In the sections that follow, I'll use some photos to illustrate what some common dog behaviors look like, with the behavior followed by their human personality counterpart.

Happy/Relaxed: Fun-Loving, Easygoing, or Extraverted
In the photo that follows, notice that both dog's tails and ears are in their normal position: not too high, not too low. Their weight is evenly centered over all four legs, and their mouths are relaxed or open and panting slightly. Their eyes are big and bright or slightly relaxed.

Timid/Submissive: Shy, Quiet, or Introverted
They may be urinating submissively or combining some of the previously described postures with incessant barking, which can often be fear based. These behaviors are common among some small or toy breeds.

Fearful: Afraid or Shy
The body is lowered to the ground, the ears are pulled back, the tail might be tucked between the legs or curled all the way up under the body. The dog's head might be low and its eyes might be looking up at you to the point that you can see a lot of the whites under their irises.

Dog's ears are a little different. Tina's "propeller" ears are her normal, natural look. Robby's gently hanging ears are his normal, relaxed position. For both dogs, their slightly open mouths and bright eyes indicate that they are happy.

Left: 20mm 2.8 lens @ 20mm, f/2.8, 1/60 second, ISO 1000, aperture priority, evaluative metering. Right: 20mm 2.8 lens @20mm, f/10, 1/640 second, ISO 1250, aperture priority, evaluative metering

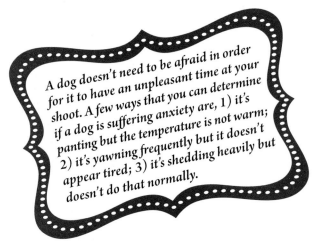

A dog doesn't need to be afraid in order for it to have an unpleasant time at your shoot. A few ways that you can determine if a dog is suffering anxiety are, 1) it's panting but the temperature is not warm; 2) it's yawning frequently but it doesn't appear tired; 3) it's shedding heavily but doesn't do that normally.

Dominant: Cocky, Loud, or Egotistical

This typically presents as the head held high, shoulders up, tail straight up, mouth relaxed or tense, and neck straight. Sometimes, this involves posturing above another dog by sticking its neck up over the other dog's neck and/or "punting" the other dog with its muzzle. Excessive urination can also be a sign of dominance because a dominant dog marks its territory on everything it can find. A direct stare-down with a human can be a sign of dominance, as well. Give a dog an intense, direct stare; if he stares back at you without looking away, he's most likely dominant. Thus, barking, pushing, shoving, posturing, poking, and urinating can be a sign of a dominant dog. This is the "bully" on the playground.

Aggressive: Mean or Tough

This characteristic is marked by the head held low, a deep, guttural growl, and the teeth might be bared. In addition, the body is stiff and tense, the tail might be up or straight out, hackles might be raised, ears are pulled back and to the sides, and it's looking at you out of the side of its eyes such that you can see a lot of white. This can also be what's called *resource guarding*—when a dog is guarding an object, such as a toy or treat or stick or even bowl of food. Be very careful if you see this because it's an indication of the dog's intent to strike at you.

Some more subtle but still serious sign might be when you are close to a dog and it has its mouth and lips closed tight, head slightly down, and staring intensely straight into your eyes. If you see its body go stiff, or hear growling, you need to avert your gaze away from the dog, relax your body position to show that you are not a threat, and then slowly back away. Never turn your back toward an aggressive dog or get lower than its level.

The good news with the last category is that most of the time when a dog owner is contacting you to photograph their pet, or even if it's a shelter or rescue dog, that animal generally isn't going to want to take your arm off. There are some exceptions to this, but most owners of aggressive dogs are smart enough not to bring a stranger into their house, much less try to do a two-hour photo shoot with their animal. And in the case with shelter pets, as sad as it is, usually dogs who are people-aggressive are euthanized instead of adopted due to the risks to humans. There will be times, however, when the "opportunity" will present itself to photograph a "somewhat" aggressive dog. I talk about this in Chapter 8, which can help you decide how to handle the situation—if at all.

Just like many other animals, dogs try to make themselves appear smaller and less threatening when they themselves are feeling afraid and submissive, and larger and more powerful (puffed up), when feeling dominant or aggressive. Dogs that are feeling relaxed, confident, and comfortable are somewhere in between, not exhibiting any extreme body language one way or another. It's this in-between stage that you are going for in your shoots.

Your Body Language and Behavior

The more relaxed and "soft" you appear to a new dog, the more comfortable it will feel around you. Relax your forehead, your eyes, and your shoulders. Take a deep breath, smile, and move slowly; this will change the environment around them and you.

The best way to approach a new dog is to extend your hand, palm up, fingers closed, and let it smell it, or offer a closed fist with your fingers tucked if the dog might be aggressive. Look at it indirectly or just off to its side, with your head tilted down. If the dog is not known to be aggressive, you can crouch or kneel and let the dog smell you that way. For very fearful dogs, I will usually sit down on the ground immediately, usually crossed-legged. I extend my arm, palm up, with my head down, not looking at it. I'll hold that position for as long as it takes for it to come and smell me and feel comfortable. Often times with most dogs, all it takes is for them to smell the treats you have in your camera bag and you have a new friend for life.

The more you gain a dog's confidence, the more likely it will be to reward you with great shots.

"Ok, awesome! So, now I've got some solid information on dog behavior. How do I work with them?"

Here are some do's and don'ts when it comes to working with dogs:

Do's

◆ Do let them warm up to you gradually, and give the shy, anxious, fearful ones time to trust you and your intentions. Spend several minutes letting them check you out, sniff you and your gear, and get to know your camera before taking any pictures.

◆ Do remember that if you plan to get dynamic playful shots and you are part of that play, you might get jumped on or have your jeans grabbed or pushed or shoved, or even have your hand bitten by accident. Dogs can get rough when playing, and you can get some of the most fun shots this way, but sometimes it's at the price of a few bruises to your person and your gear.

◆ Do ask the owners to tell you what their dog's personality (behavior) is like *before* the shoot so you can be really prepared. I talk more about this later in this chapter in the section "Learning About the Individual."

◆ Do exhibit your own relaxed, confident, and happy posture when meeting a dog and during a shoot. For the duration of the shoot, you are its leader. Take charge and act the part, but be calm and relaxed while doing so.

♦ Do be firm with your commands. Your role is part pet photographer and part dog trainer. When giving commands, be clear and firm, and don't give rewards until you receive the behavior you want. With new dogs who don't exhibit fear or aggression, I usually meet them, say hello, fawn over them for a minute, and then pull out treats and immediately start a little training session, asking them to sit, then down, then shake or any other command they know. This shows them I'm in charge and sets the tone for the rest of the shoot.

♦ Do be the one controlling the dog during the shoot. Usually, the less involvement on the part of the owner, the more successful the shoot will be. An overly involved or anxious owner barking commands at their pet is a sure-fire session killer. The best way to control dogs is with what motivates them. Use positive rewards to keep them in check.

♦ Do remember that dogs have a short attention span. Sitting in one place for more than a minute is like a lifetime to them. If you do very controlled shoots (a lot of sit/stay commands), break it up frequently by letting them run around so that you don't lose their attention or they start yawning, panting, or blowing their coat (or all three).

♦ Do let dogs be dogs. The more you try to control them and their behavior, especially if positive rewards are not given freely, the less inclined they will be to listen to you or enjoy the experience.

♦ Do remember that dog behavior is often a reflection of the owner's behavior. Neurotic human? That often means a neurotic dog. Aggressive and dominant humans that like to fight with others? Don't be surprised if their dogs are a nasty biter. And so on, and so on.

♦ Do ignore bad behavior if it's something that can't be remedied in the short time you have with an animal. Are you shooting a little Chihuahua that won't stop barking at you for one second after you've patiently tried to get close to it? Keep quiet and keep shooting. Take lots of shots and be ready for if and when it stops. Is the dog humping everyone at the dog park? Let it do its thing and be ready to fire the shutter when it starts behaving somewhat more gentlemanly.

♦ Do get as much information as possible on the individual *before* the shoot so that you know what motivates the pet and know what to expect.

Don'ts

♦ Don't call the dog's name unless you want it to come to you. We have trained our dogs to come when called. They hear their name, they come. Great dogs! Try using noises instead and get out of the habit of saying a dog's name to get it to look at you. And don't let the owners call the dog's name either. After Fluffy has heard her name 18 times in a row, she will tune her parents *and* you out and you've lost her attention for good. Don't crouch on the ground or kneel unless you are absolutely ready to capture the shot, because a dog will usually come to you when you crouch. The same goes for lying down.

♦ Don't yell "no" at a dog. This can be confusing and won't produce any desirable behaviors. Try a sharp "eh-eh-eh," instead, and only if and when the dog's safety is at risk.

♦ Don't put your hand up to pet a dog that might be aggressive. In this case, definitely keep your hands to yourself.

♦ Don't get in there with a bold "Hey boy, how ya doin??!" and a pat on the butt with a dog who is fearful, unless you want to scare the poor thing half to death. If you see the fear-based behavior that was described earlier, go slow, be gentle, be soft, be quiet, get down, and make yourself small. (I've been known to lie completely flat on the ground in a client's house upon meeting a very fearful dog for the first time. Of course, if the client also has a very dominant male dog, that dog might come over and urinate on you, but that's the risk you run to gain the trust of the scaredy-pants pup).

♦ Don't let dominant behavior escalate if you are with a dominant or somewhat aggressive dog and you're around other dogs (such as out in public). It's best to keep these types of dogs separated from all other dogs during your shoots. For this reason, I rarely like to do shoots at off-leash parks, unless I already know the dog very well. I touch on that more in Chapter 6.

♦ When photographing multiple dogs at the same time, if you are unsure of their personalities, don't drop treats on the ground. This can cause resource guarding and instigate fights.

♦ Don't get low and put your face near the face of a dog that might be aggressive. Dogs can snap quickly, and you want to protect your most precious resource. No, not your camera, silly; your face!

♦ Don't forget to love the dog! You can take many breaks to pet and snuggle and play with them for a few minutes. This only serves to enhance its experience, which will show in the shots you capture. This is the best part of the job!

♦ Don't let your desire for the perfect shot cause you to ignore important dog communication cues, such as if a dog is anxious or fearful. A dog's health and wellbeing, including its emotional wellbeing, are more important than any shot you can capture.

♦ Don't take an anxious or fearful dog out to a public place for your shoot if that dog rarely ventures outside. It's like throwing a mouse into vulture territory; it will only make the dog even more frightened. Stick to the comforts of home for these pets.

♦ Don't allow a dog that has known dog-aggression tendencies (aggression toward other dogs) off-leash for one second when out in public. All it takes is for one little Pomeranian to come walking around the corner and it might end up to be lunchtime for Bruno.

The bottom line is, the more experience you have working with different kinds of dogs—different breeds, different personalities, in different situations, with different owners—the better you will understand how best to work with them.

Left: Ramses was severely abused before his owners adopted him, which created aggression in him toward strangers. For my safety, I photographed him in his backyard by using my zoom lens, both telephoto and medium zoom. This shot is a good example of a dog who is borderline aggressive.

24–70mm L lens @ 43mm, f/2.8, 1/250 second, ISO 160, aperture priority, evaluative metering

Right: Five minutes later, Ramses was feeling more secure and relaxed. Notice the smile and half-closed eyes: a sign of a happy dog. He still wasn't 100 percent comfortable, though, which you can tell by the position of his left ear.

24–70mm L lens @70mm, f/2.8, 1/400 second, ISO 160, aperture priority, evaluative metering

Working with Cats

Some people might think that because cats move more slowly than dogs that they should be easier to photograph. This is soooo not the case! My experience has been that cats are far more challenging to photograph and require more time and patience than dogs. But they can also be one of the most beautiful animals at which to point you camera, and a good cat photography session will leave you feeling relaxed and happy, like a good yoga class.

Although showing up to a house to photograph a cat that is severely aggressive toward humans and animals is rare, and most kitties you photograph will be social and used to human interaction, you still need to be able to read their body language if for no other reason than to capture photos of them looking their best.

Knowing how a feline is feeling at any given moment during a shoot will help you know when to proceed or when to back off, giving the kitty some space and letting it come to you. This is important because, for many cats, once they become spooked or irritated thoroughly enough, it will be a long while before they come out of their hiding place and let you resume photographing them again. You really need to respect the limits a cat is setting with you, or it's game over.

Cats are often more sensitive than dogs; they are more sensitive to their environment, to noises, to touch, and to movement. They can become over-stimulated more easily from both nonthreatening stimulus and pleasant stimulus such as petting. They can also be more sensitive to upsetting experiences in their past and take longer to bounce back, such as the case with a cat who has been picked on by other cats in a previous household, or one that was once feral. For this reason it's important to be sensitive yourself when photographing them. Don't barge in like a bull in a china shop; instead, flutter in like a delicate butterfly, alighting softly nearby and letting the kitties come to you. Move slowly, talk softly, be gentle, and be patient.

Normal Cat Behavior

Like dogs, cats usually look a certain way when they're happy and at ease. Their posture is relaxed, their ears are up and forward or slightly to the side, and their eyes are soft and relaxed or partially closed. Unlike dogs, their tails are relatively still. They will approach you willingly and investigate you and your gear, sniffing everything carefully. A noise or sudden movement can still easily spook cats, but they are generally social and relaxed and friendly.

Mad Cat

Most people know what this looks like, because even if you don't own a cat, you've seen this behavior in the movies, from a friend or neighbor's cat, or on YouTube. This includes hissing, swatting, ears pulled back flat, crouching, fur puffed up, tail stiff and twitchy or tucked around the body, and wide eyes. This is a clear signal that says, "get away from me." If the warning isn't heeded, the next step for the cat is to attack. Cats are different from dogs in that they have several weapons. Dogs have teeth and jaws, but cats have teeth, jaws, and four paws with sharp claws. Each of these things can inflict damage on you.

If you are photographing a cat and get any of the aforementioned warnings, back way off and give the animal some space, and then wait 5 to 10 minutes before continuing. Before you start again, you might need to put some special motivators in place such as canned salmon or catnip to get the cat to relax again. But ideally it won't ever get that far, because you will be able to recognize the next set of behaviors, which I describe in the following sections.

Scared Cat

With most domesticated cats, aggression is defensive, meaning they feel fear before they lash out. If you can pick up on even minute signs of fear, you can avoid losing your subject in a cat-and-mouse game (sorry… I had to do it), wherein they find the darkest closet farthest from you to hide in for the rest of the shoot, or worse, attack you and then flee.

A scared cat will have a tense body and ruffled up hackles and might turn its body to the side to appear larger. It might stand up on its toes or make its body seem taller. Sometimes it bares its teeth in an open-mouth silent hiss. Its eyes might be appear big and wide in an "OMG" kind of look, and its back can be curved in an upward arch, with its tail puffed up.

The best way to deal with this is to remove the object or person that is causing the fear. That means you, if you're the one causing poor kitty to be afraid. If this happens, take a break as previously described and come back to it.

The "I'm Not Sure About You" Cat

If the cat is neither mad nor scared, it doesn't necessarily mean that kitty is cool with you. So how can you tell? Here are some "tell-tail" signs (OK, I'm really sorry about that one…):

♦ Tail swishing from side to side madly or flip-flopping. Kitty might be in a relaxed position, but a swishing tail means the cat is feeling uncertain or could flip to anger at any moment. Even a twitching at the end of the tail can signify anxiety or anger.

◆ Ears rotating back and forth or either one being held back. The faster the ear twitching and rotating, the less settled kitty is feeling. Ears are like barometers for a cat, and you can learn so much about how it's feeling based on the position of its ears at any given moment.

◆ Big eyes or dilated pupils. If the eyes become big or the pupils dilate while the aforementioned signs are present, it might be time to back off.

So what do you do if all of these signals are being sent? Physically back off. Move backward or move your camera farther away from the cat if you are close. Go to the other side of the room and change to a telephoto lens. Sit and take a break for a while. If the cat stays in one place, you might notice visible changes in its body language. The goal is to get it to relax a bit before you start back up again. I always watch the ears and tail while I am photographing a cat. It might be grooming or look relaxed with half-closed eyes, but if its tail is swishing and its ears are moving around like submarine periscopes, I slowly and quietly move back and out of its space, and we take a break.

How Best to Approach a Cat

Very similarly to how you would approach a dog, you should crouch down and make yourself smaller, extending your hand for the cat to sniff. Move slowly, be quiet, and take your time, letting it come to you. Don't try to pick up a cat or go after it if it's moving away from you, because this can frighten it. You can try sitting on the floor of and let it investigate you. Put your head down and be calm, take deep breaths, and talk softly. Pet it slowly and gently, just a little at first.

Of course, these tips are entirely unnecessary with some cats; they will approach you and start commanding that you pet them the moment you walk in the door. They will rub on you, pushing their body and head against you in a very affectionate manner. But don't take that affection too personally. Cats have scent glands in their temples between their eyes and ears that secrete hormones. When a cat rubs against an object, it leaves behind a scent marker that tells its competitors that this territory (or object) belongs to it. When they are rubbing that part of their head against you, they aren't saying "I love you," so much as they're saying "I *own* you." Ha!

But if kitty runs over to you, rubbing against your legs and head-butting you, purring madly, looking up at you with a half-lidded "I'm in love" look on its face, then you've got it made. Meet "Mr. Social," and welcome to the most fun type of cat shoot there is.

Working with Other Animals

Of course, there's a lot more companions out there in the animal kingdom to photograph than just cats and dogs. You might get a call sometime from the proud owner of a Cockatiel or an Appendix Quarter Horse who wants to capture some lasting memories of their little "pets." In the following sections, I'll pass along some tips on how to deal with some of the more common of the "other" pets.

Horses

Knowledge of horse behavior is important if you are going to be spending any time taking photos close to them. It's less of a concern if you always keep your distance; for example, shooting with long telephoto lens from well outside a training ring or at an event where you are at a safe distance. But most horse owners ideally want at least a few shots of them either interacting with their horse or close-ups of details of the horse itself, in which case you will want to know how to move around such an imposing and powerful animal. It's also important to know how a horse is feeling so that you aren't unwittingly capturing the animal when it's stressed or upset.

As hard as it is to believe because on their size, horses are prey animals, which means that they need to be cautious and guarded when in the wild. If they don't know you, they might perceive you as a threat; a predator to be avoided. It's really important that you have the owner's help when meeting a horse for the first time. A meet-and-greet will go much more smoothly if you have someone there who knows the animal well.

Horses are like people and other animals, in that each has its own unique personality, sometimes formed by nature (in the womb), sometimes formed by its environment (through experiences growing up), and often from both. Just as it's important to communicate with dog and cat owners about what their pets are like prior to the shoot, it's no less important to communicate with a horse owner about what her animal is like *prior to the shoot*, even more so because they are such powerful creatures, and the more armed you are with knowledge of that individual animal, the safer you will both be around one another. The last thing you want is for you or your gear to be kicked by a horse.

Just as with many other animals, the ears on horses speak volumes about what they are feeling. Ears pinned back means the animal is feeling irritated or unhappy. Pinned ears with head held low can signal an attack. Ears up and forward or in a neutral position are the most desired looks in photos because this

position indicates interest, curiosity, happiness, or relaxation. Similar to a cat's ears, horse ears that are flicking rapidly back and forth indicate uncertainty. The horse might not be feeling entirely comfortable with what's going on.

Just like a dog or cat, you can read horse body language by watching the tail. Unless it's trying to shoo away a big cloud of flies, a quickly swishing tail can be a sign of irritation or anger, and a highly held swishing tail is a sign of a challenge or dominance. A tail that is relaxed and moving slightly is a sign of a content and happy horse. A tail that is held down between the buttocks or back legs indicates fear, just like in a dog.

Eyes can also give you some insight as to how a horse is feeling. Visible whites to the eyes can indicate nervousness or aggression. Worry lines can form over the eyes in an anxious horse, just like worry lines on a human. A horse with its head up, worry lines, and eyes big and round such that you can see the whites is feeling fear. A horse that is relaxed and happy will have relaxed eyes.

A horse's nostrils can also communicate to you, as well. Horses can have "pinched" nostrils, which can take different shapes and mean different things depending on the shape of the pinch. A pinched nose can be spotted by looking for a small wrinkle in the skin on the top part of the nostril. Pinched nostrils indicate arousal. And by arousal, I'm talking nervous system. They are either annoyed, angry, or smell or taste something bad. Perhaps you approached them with too much perfume on. Or, did you arrive after photographing a pack of dirty dogs in a pond? These are but a couple of the reasons that you might get a pinched nostril. Relaxed nostrils are the ideal to capture in photos.

Also, pay attention to the muscles and the skin. Taught skin and tight muscles can indicate fear or irritation. A relaxed horse will have relaxed everything: muscles, tail, eyes, and ears. You get the idea. Ideally, you want the whole of the horse to look relaxed

The objective is to capture at least some shots of the horse showing interest and curiosity, with its ears up and forward. Of course, ultimately, how the horse appears depends entirely upon what the owner wants you to capture. If it's a competing Arabian in a ring, then all bets are off. You'll need to know exactly what body/head/tail/leg positions the owner wants.

Photographing Horses Safely

Interestingly, horses view humans much in the same way that they view their fellow herd members. You can learn a lot about horse behavior in a short period of time just by watching how they interact with one another and gauging responses between herd members.

When working in close proximity, a horse should never be allowed to lift it's back leg, especially if you are right next to or behind the leg; this can be the precursor to a kick. Similarly, a horse should never be allowed to push you with its back end. This is the horse's way of issuing a challenge, and it doesn't take much for a half-ton (or more) animal to knock you to the ground.

How Best to Approach a Horse

You should approach a horse in a very similar manner to how you would approach a strange dog. Come up to it slowly, extend your arm, in this case palm down, and let it smell you. Keep in mind that a horse's

vision is different from many other animals because its eyes are on the sides of its head. In fact, horses have a near blind spot directly in front of them. For this reason, you need to ensure that the horse sees you approaching by coming toward it from either of its sides, near its head. Don't look a horse straight in the eye when approaching it, and speak softly or make noises so it knows you are there. Or better yet, have the owner approach you with the horse. Of course, it doesn't hurt here if you are holding one of the horse's favorite snacks, such as carrots or apples. Never approach directly in front of or behind the animal. When you are moving around the hind quarters, do so far enough away that the animal can easily see you. Bear in mind that the back end of a horse is its business end; it's the most powerful part of its body, so be extra cautious in this area.

Avoid touching a horse on the face. With permission, you can pet its neck. Try not make any sudden movements, and just as you would with an aggressive dog, try to make your body look less threatening: position your head down with your eyes looking toward the horse but avoiding direct contact, and keep your shoulders and back relaxed.

Small and Furry: Guinea Pigs, Hamsters, Gerbils, and Ferrets

Small and furry animals all share a commonality that is important to keep in mind when working with them. They are all prey animals, which means that in the wild, they get eaten. Oh no! Who would want to eat a cute and fuzzy Guinea Pig? I assure you, if left to their own devices in a field with hawks circling overhead, their fight or flight responses would be kicking into overdrive. This means that these little guys can be skittish. Their genetic makeup creates a hyper vigilance about who or what is around them, even if they are safe inside a warm home with no predators. So, you'll want to tread carefully. Move slowly, and get them used to the camera. Watch their breathing and their movements. Stress might not be seen as clearly as with a dog, but that doesn't mean they don't still feel it.

Just because they are small doesn't mean they don't have the same feelings and reactions as larger animals such as cats and dogs, and they definitely deserve the same respect and careful handling.

Some small animals, such as gerbils and hamsters, will stand on their hind legs with their bodies upright if they sense danger. This can be followed by a quick retreat to a safe place in their habitat. Don't be surprised if this happens when your new friend meets you for the first time. Give them time (and incentive in the form of a treat) to come out and meet you. If they are playing dead, it means that they are very frightened. Squeaking, squealing, or shrieking can also be a sign of fear. Definitely proceed slowly and at their pace, and don't force a small animal to participate in something it finds terrifying. Make sure your subject feels calm and safe before you start your session.

Like cats and dogs, small animals each have their own unique personality. Ask any owner of multiple rats, for example, and he will tell you what each of their pets is like. "Templeton is grouchy and temperamental; Lucy is sweet and shy; Herman is outgoing and fun." Later in this chapter, I talk about using the pet owner's knowledge of his animal's temperament to your advantage. This can really help you here, especially if you have limited knowledge of that type of pet. Ask the owner of Frito the Ferret what he is like and she will tell you. She will tell you what he likes and doesn't like, and how to handle him.

Also, just because these guys are small, cute, and furry, doesn't mean they can't still inflict harm on you. Ferrets and rats have very sharp teeth and claws. Ferrets might bite you if they don't appreciate how

you are petting them (hint: always use a light touch), or if you are interrupting the their *war dance* play session to try to give them affection. (A "war dance" play session is when ferrets appear to have gone wild and are hopping and twisting about). Never reach out and grab a small animal unless you know for sure that it enjoys being handled. The good news is that most of these animals can be photographed from several feet away with a medium zoom lens, so you often don't need to handle them at all. When working with small furry animals, it's always best to leave the handling to the owners, because the pets are used to them and feel safe with them, and you want them to feel comfortable during your shoot. The challenge in photographing small furry animals is that you need to move fast. They might view you as they would a hawk circling in the sky, and their fast darting movements mean you'll be shooting at the fastest shutter speeds you can. Time to crank up that ISO and be ready for action! Few things can be more fun than capturing great photos of two guinea pigs playing.

Birds
Just like other domestic animals, birds are sensitive creatures and have feelings, too. They might at first glance seem emotionless and expressionless, but make no mistake, they are highly intelligent, receptive

creatures. Bird intelligence has been compared to that of two-year-old toddlers. In fact, many birds are capable of cognizant speech and conceptual learning, which is pretty amazing for such small animals, particularly when you consider that even among mammals, the only ones other than humans capable of these feats of intelligence are dolphins and apes.

Interestingly, unlike many other domestic animals who communicate primarily by nonverbal means, birds are similar to humans in that they employ a wide range of vocalizations to communicate with one another, and they can often use those vocalizations to communicate with humans, as well. Unfortunately, most of the time, most people have no idea what exactly birds are saying. But this doesn't mean we can't still learn when the bird is feeling happy, unhappy, curious, angry, or any other emotion.

A singing, talking, or whistling bird is a happy bird. A screaming bird is usually trying to get attention, make demands, or is unhappy about something. A softly chattering bird is feeling content. A growling bird is emoting aggressiveness or anger. Sound like another pet you know?

Pay attention to the head position and feathers on a bird, too. Ruffled or fluffed feathers indicate the bird is grooming (preening), is cold, sick, or trying to relieve tension. A shivering or shaking bird might be fearful or excited. Fanned tail feathers can be a sign of aggression. A bobbing head followed by regurgitation on you is a sign of love. You should feel highly honored if a bird does this to you; you are now firmly in his camp. If the bird is trained to allow its owner to pet its beak, you can really make friends by scratching the bird there.

Because birds are so sensitive and intelligent, treat them as you would a young child during your shoot. Praise them freely when they do something good, be patient when they do something bad. Encourage them to behave properly, and show them what you want them to do. Positive reinforcement will go a long way in your shoots with birds.

How Best to Approach a Bird

First, if you are going to handle a bird, you need to ask the owner how he has trained it. If the bird is trained to step on your hand or finger, it will do so willingly when you extend such. If the bird is trained to be put back in its cage when it climbs on your hand but it doesn't want to go, it might bite you when you reach out a finger for it to step on.

Second, unless the owner says it's acceptable, don't immediately put the bird on your shoulder, even though it's really cute. Birds have dominance hierarchies, which are dictated by height, with the more dominant birds occupying a higher place than subordinates. A bird on your shoulder might be more inclined to bite your ear or neck or face, especially if he doesn't know you and is trying to gain dominance over you.

Like any other domestic animal, let the bird explore your camera as well as you and your scent before you start snapping photos in its face. It might be naturally curious about the sounds your camera makes and the movement of your shutter in the lens. Or it might be completely freaked by the whole idea, viewing you as a predator. Take time to ensure that it feels comfortable with you being around before you even open the cage. The last thing you want is a poor bird outside of its cage that is completely unnerved at the situation and just wants to fly away and hide. Approach domestic birds as you would cats: slowly, quietly,

and with patience. And keep in mind that because of their intelligence and sensitivity, they will sense any fear or apprehension that you have in your approach, so approach with both sensitivity and a calm, confident demeanor so that they don't immediately try and dominate you.

As with any other pet, ask the owner questions about what the bird is like. Bird owners make some of the most dedicated pet parents because their animals can live as long as 40 years, and you can be sure that they will be happy to tell you all about Sparky if you just take the time to ask.

Reptiles

Reptiles might seem cold and scaly on the outside, but be assured that they have feelings just like other animals do. Just because they are lacking in fur does not mean that the gentle handling rules you exercise with other pets go out the window when working with reptiles. Each type of reptile has behavior that is unique to it, and I suggest that if you plan to photograph reptiles regularly, do some research on the behavior of the type(s) with which you will be spending the most time. And definitely use their owners as a resource for knowledge; most reptile owners are well educated in the care and behavior of their animals.

Reptiles are very instinctive animals; therefore, much of their behavior is hard-wired and has more to do with their genes than your interactions. But just as with cats and dogs, you want the reptiles you are working with to be relaxed and happy and not stressed.

So how do you know if a reptile is relaxed and happy, or anxious and stressed?

The first main indication of stress is if the animal tries to get away from you or out of your sight. They might squirm if you try and pick them up. They might also hiss, strike at you, or bite if they're cornered. They might breathe more heavily (watch their ribcage), dig their claws in, puff up, open their mouth, or even defecate.

Indications that they are comfortable with what you are doing include staying close, showing interest in you and/or your gear, falling asleep, tilting their heads, and allowing you to handle or pet them without trying to escape.

Never try and handle a reptile without both the owner's permission and some experience or a good breadth and depth of knowledge about what that animal is like, especially when it comes to snakes and other formidable animals. The biggest challenge when it comes to photographing domestic reptiles often has less to do with their behavior and more to do with their enclosures or habitats. In Chapter 6, I talk about ideas for how to creatively capture images of reptiles. I strongly recommend that when working with any reptile that can inflict serious injury, such as a poisonous snake, that you slap a telephoto lens on your camera and shoot from afar. This doesn't mean that you can't still set them up in interesting environments with the help of their owners; it just means that you can be kept safe while doing so. No shot is worth a trip to the emergency room

Learning About the Individual

Just as with humans, every animal has a different personality, and their owners usually won't be shy about telling you what that is. There are fun-loving yet hyperactive Australian Shepherds, lazy and stubborn English Bulldogs, and high-strung and anxious Papillions. These human characteristics can be attributed to any pet, and your job as a pet photographer is to capture that animal's unique essence. In fact, I'd go so far as to say that your job as a pet photographer isn't done until you do.

*"Ok, cool. So I know that each animal has a different personality.
How do I find out what that personality is?"*

Easy! Ask their owners. In Chapter 11, I provide guidelines on questions you should ask every pet owner before the shoot. Gathering this information can help you understand what the individual pet is like before you even pull your camera out of your bag.

Ask pet owners to tell you what their animals are like, and oftentimes you have a hard time shutting them up. They will tell you about their animal's activity level; how social they are with people; what things they like to do; what their favorite toys and food are; who their best friends are; what they hate or are afraid of; what they love; or you name it. You'll want to know if the animal has any health problems or any spots on its body that are sensitive to being touched. If the pet was adopted, it also helps to know what that animal's background was before adoption. Whether it is a horse or dog or ferret, knowing its past experiences can help you to understand its current behavior. Some dogs that came from shelters have an odd aversion to men in hats or will try and attack skateboards. Some previously feral cats will be far less inclined to let you come near them, much less touch them. Some birds that previously lived in houses with children who would constantly bang on their cages can be afraid of loud noises. You get the idea. The more information you have about the individual animal, the more you will understand what its personality is like, and more importantly, why. Once you know what an animal's personality is, your job is to capture exactly that.

Photographing Your Pets

Ahhhh, photographing your own pets. Such joy—and such a pain in the pattootie! It's natural to have higher expectations of your own pets than those of others because you know what they are capable of. And they know what they can get away with! It's also not uncommon for a pet to be on its best behavior with (if a dog) or show unusual interest in (if it's another type of animal) a stranger, because they present a novel stimulus, which you just don't have with your own pets. People will often marvel at how well behaved their pets are while another person is photographing them. This is not unusual, so don't feel bad or take it personally if they aren't perfect little angels for you.

If you have conditioned your dogs to always receive lots of treats anytime you pull your camera out of the bag, you might end up capturing nothing but what I like to call "treat face": that big-eyed, intent stare, sitting perfectly in front of you, perhaps with the tongue wagging expectantly. Sure, that's cute for a few shots, but ultimately you kind of want them to leave you alone so that you can capture something different. If you scare your kitty with strange noises every time you shove your camera in its face, you might have unintentionally conditioned it to be afraid of the camera. With other people's animals, that conditioning hasn't taken place, so they don't really know what to expect from you. This can oftentimes make your job easier because you can mold the photo shoot to be whatever you want it to be. However, with your own pets, you might have some unique challenges at hand.

Here are seven tips to keep in mind while photographing your own pets:

1. **Prepare**

 Just as you would prepare to photograph someone else's pets, you should prepare to photograph your own pets, too. Ensure that your batteries are charged, your memory cards have plenty of free room (or that they are formatted and ready to go), your treat bag is full, and your lenses are clean.

This will help reduce frustrations that can come up during your shoots. Get your treats, toys, objects, or any other motivators lined up and ready on a counter or table before you start. Ensure that you have all of the lenses handy that you want to use. The more smoothly you can go through a shoot with your own pets, the more successful you will be in capturing great shots of them.

2. **Pay Attention to Light and Location**

 You wouldn't show up to a paying client's house or a friend's house to photograph their pets in bad light at a bad time of day in a cluttered environment. Likewise, you shouldn't do that when photographing your own pets. Pick a time of day when the light is ideal, such as early in the morning or late evening in the summer. Pick a location that is going to highlight them beautifully, and pay attention to backgrounds.

3. **Be Patient**

 This isn't a race to the finish. Take your time, go slowly, and work at your pet's pace, whether that's slow and relaxed or fun and playful. Plan to spend at least an hour photographing to get a handful or two of great "keeper" shots. And if you find yourself getting frustrated, take a break. You can always come back to it tomorrow.

4. **Try New Things**

 If your dog is used to treats during your sessions, try using its favorite toy, instead. If it's your kitty, try introducing something novel, such as a new cardboard scratcher, or a catnip banana, or even a bag or box. Is your horse tired of you shoving your camera in its face or yelling the same commands? Try giving it a new fruit or vegetable. Make it fun and interesting for them. Change it up.

5. **Introduce New Foods**

 There is nary a dog around who doesn't like cheese—string cheese, cheddar cheese, any kind of cheese. The same holds true for treats like Beggin Strips and Pupperoni. Freeze-dried chicken can work wonders with dogs, and canned tuna or salmon can turn your kitty to putty in your hands. You can also get some really funny shots of dogs by using peanut butter or thin slices of cheese, which both tend to stick to the roofs of their mouths while they lick or chew. Put your camera in burst mode, make sure you are outdoors in good light with a shutter speed of 1/1000 second or faster, and then fire away. Experiment with small amounts of different kinds of food to see what motivates them the most.

Some foods can be toxic to pets. Be sure to always research pet-friendly foods (you can do this on line) before you hand them out as treats.

6. **Make It Fun**

 Animals and humans alike are less inclined to participate in an activity if it's painful, boring, stressful, or causes fear. Engage in the activities that you know your pet finds fun and enjoyable, whatever they might be. One trick that you can also try is to reward your pet for working for you with their favorite activities *after* your shoot. I photographed Fergie recently with new toys for a commercial client, and during the shoot she had to hold the toy in a certain way and sit in a certain pose and look in a certain direction, so it was very controlled and not entirely fun for her, but after the shoot, the toys were all hers, filled to the brim with yummy treats and ham. Condition your pet to expect something awesome after it works for you for a little while. Just ensure that you can deliver on what you promise!

7. **Undo Conditioning**

 Whether you intended to or not, you have most likely conditioned your own pet to expect certain things when it comes to photographing it. For Fergie, it's treats, and now all she'll give me is "treat face" when I pull out my camera. So, now we go outside with toys, instead, or head out to a public place like a park where she'll be distracted, or I wait until late at night when she's sleepy and then pull my camera out, sans treats. I try and teach her to expect the unexpected during our shoots in an effort to undo that conditioning I've unwittingly instilled.

The key with our own animals, who might behave worse for us (or more accurately who we have unwittingly conditioned to behave in a certain way that doesn't fit with our photography goals) is to make it fun and interesting for them. Give them a reason why they should work for you, and you might find that they are more cooperative. Take them to their favorite place, introduce one of their favorite buddies, or reward them with something unlikely, and they might reward you with awesome shots.

A Note About Printing Your Images

As sad as it is, many photographers who have captured tons of great images of their own pets fail to ever have those images printed, leaving them sitting on their hard drives where no one can see and enjoy them—not even the photographers themselves. Do yourself (and your pet) a favor: if you have captured a shot of them that you really love, have it printed. You don't have to go big or go crazy with it, but you'll be amazed at what joy a printed photo of your own pet on your wall can bring you, even when the real thing is right there with you. And if you want to go all out, get yourself a fancy gallery-wrapped stretched canvas of that favorite photo of Lucky, Sophie, Doc, or Tucker. I promise that you will cherish it for a lifetime.

I had three of my favorite images of my dog, Fergie, printed as a 15" × 30" canvas. It is now one of my favorite personal belongings.

The best advice I can give you when it comes to animal behavior is to spend as much time as possible with the type of animal that will be your most frequent subject. If you live in a horse community and know that horses will spend more time in front of your camera than any other type of animal, try to volunteer a day or two at a stable where you can work around them and get a feel for their behavior. If you know you will be photographing a lot of cats, spend time at a shelter working with them there; observe them and interact with them. You can even be a foster parent to all kinds of different animals through most rescue groups and shelters. They always have a need for temporary housing for their adoptable pets, and this is a great way to have some quality camera time with your new subject. The more time you spend with your subjects, the better you'll understand them. The better you understand them, the more skilled you'll be at capturing the essence of who they are.

Now that you are armed with knowledge about animal behavior and how to work with them to best prepare to photograph them, next up, we're going to talk about what you need to do to prepare yourself for every session from the perspective of gear and shooting.

Exercises

1. Visit a location that has many of the types of animals you plan to photograph to observe their behavior. This might be an off-leash dog park, a cat sanctuary, a horse stable, or other location. Spend an hour or two just observing, watching how they interact with humans and other animals.

2. Read books and articles on animal behavior (there are many online sources you can use). If it's horses you plan to spend most of your time photographing, read a book on horse behavior. If it's ferrets, do some online research to get an idea of what they are like. If it's dogs, familiarize yourself with different breeds.

3. Volunteer at an animal shelter. Observe the body language of the animals there.

4. Try photographing your own pets by using novel stimulus.

Chapter Four

Pre-Session Checklists

☆ Checking Your Gear and Accessories

☆ Shot Lists

☆ Defining Session Goals

☆ Twenty-Five Tips to Keep in Mind, Before and During a Shoot

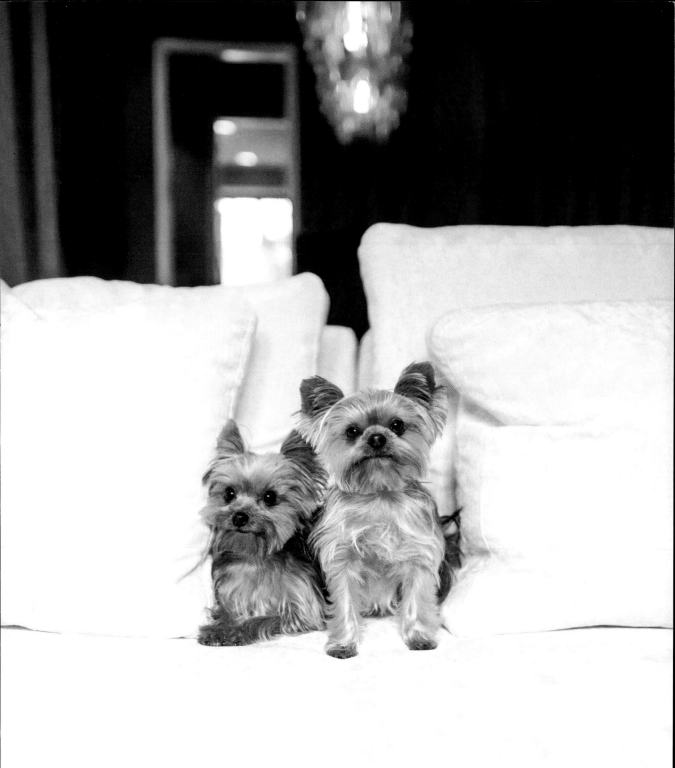

Checking Your Gear and Accessories

Every pet photographer can tell you a nightmare story that involves equipment, me included. Most are situations that could have been avoided with proper planning: dead batteries, missing memory cards, forgetting to bring an important lens, or a bag of empty dog treats.

In this next section, I'll help you to best prepare yourself from a technical and equipment standpoint, for every single session you do. Who knows? If you develop good habits early on, maybe you can avoid being among the photographers who end up telling nightmare stories.

I recommend doing these things the night before a shoot so that if you remember something at the last minute (the morning of the shoot), you'll still have time to get it together.

Equipment Checklist

Camera Equipment Item	Action Item
1. **Camera** And backup body if shooting with a digital single-lens reflex (dSLR) camera	Clean your camera sensor with a dust blower or sensor cleaner, if you don't have auto sensor cleaning.
A backup body is great to have in case your primary body goes haywire, although this isn't as important as it would be for wedding photography (which is, of course, a one-time event that can't be rescheduled because of your equipment issues). However, Murphy's Law would dictate that the day your camera quits on you is also the day you are photographing a dog dying of cancer with limited time and a shoot that can't be rescheduled due to equipment malfunctions.	
2. **Lenses** These can include: Midrange zoom: 24–70mm or 15–55mm Wide-angle: 16–34mm, 20mm, 24mm Telephoto: 70–200 Fixed primes: 20mm 2.8, 24mm 1.4, 34mm 1.4, 35mm 1.8, 50mm 1.8 Macro: 100mm 2.8 "Fun" lenses: fisheye, tilt-shift, 50mm 1.8 "nifty-fifty"	Clean each one of the lenses you intend to use on the shoot before you pack them. I recommend using a wet cleaning wipe followed by a dry wipe. Check both the front and back of the lens for stray pet hairs and dust.
Make sure you have all the lenses you need for the particular shoot. For example, if your shooting a borderline aggressive dog at a shelter, ensure that you don't forget your telephoto lens	

Camera Equipment Item	Action Item
3. Flash unit	Check your battery strength before packing your flash.
This is especially important for indoor shoots where you don't know what to expect with regard to the light quality. If your batteries aren't fully charged, grab extras just in case.	
4. Batteries	Charge them fully before packing.
It's a good idea to have two or three or more spare batteries with you; Murphy's Law dictates that the one battery you were *sure* was charged, will probably die anyway. Always have at least one more than you think you'll need.	
5. Memory cards	Format each card in your bag.
Just like with your batteries, it's a good idea to have at least one or two more memory cards than you think you'll need. You might put a card in your camera and discover that you haven't formatted it yet, and the images that are on it haven't been downloaded or backed up. Better to be safe than in a bind.	
6. Lens wipes	Place them in your bag and on your person (for instance, in your pants or vest/coat pocket).
As a pet photographer, you will need these—*lots* of these. Pack as many dry and wet wipes as you can manage in your bag. You'll be surprised how many you go through.	
7. UV filters	Clean the filters you plan to use.
In addition to their optical duties, filters are particularly important to pet photographers because they help to protect your precious lenses from tooth nicks and yucky animal stuff (replacing a filter is a lot less expensive than replacing a scratched lens). Place one on every lens that you intend to use.	

Accessories Checklist

Accessories Item	Action Item
1. Lens loupe	Wipe dust from the loupe, front and back.
This little item is indispensible for sunny shoots because it enables you to look at your LCD screen on your camera even in bright sunlight. If you rely on your histogram to determine if your shots are properly exposed, you'll want this accessory in your camera bag.	
2. Flash off-shoe cord	Check to ensure that the cable is still in one piece.
If you are shooting with your flash off-camera (off-shoe), you will need one of these with you. Read Chapter 6 for more information.	

Accessories Item	Action Item
3. Treat bag and treats	Fill your treat bag with treats and grab an extra bag.
Wrap your treat bag in a plastic poop bag to prevent the treat smell from permeating the rest of your gear.	
4. Poop bags	Roll up or put individual bags together in one bag.
Dog owners will often forget these at home, so it's a good idea to have a roll with you at all times in case you ever need one.	
5. Noisemakers and toys	Ensure that all of your noisemakers and squeakers work properly.
Bring at least several different kinds, plus an extra toy as a gift for the pet.	
6. Pen and model release forms	Bring extra copies in your accessories bag.
Whenever you photograph a pet, you will want to have the owner complete a model release form every time. See Chapter 8 for information about contracts and releases.	
7. Business cards or postcards	Secure the cards in a rubber band if you lack small pockets in your camera bag
If you are doing pet photography professionally, you should always have business cards on you, because you never know when you might meet a potential client.	
8. Flash modifiers and reflectors	Check for any holes or damage.
These would include Lightspheres, small soft boxes, and reflectors of various sizes.	
9. External flash battery pack	Ensure that the batteries are charged. Grab a spare set if low.
For events, these packs are indispensible if shooting flash.	

These are the 16 steps you will want to take a day or two prior to every photo shoot:

1. Charge your camera batteries.

2. Check if there are any images on your memory cards and back them up to an external drive if they haven't been already. (This is important because if your computer's hard drive fails, you'll have to go through the hassle of trying to recover the original images off the card. Backing up before formatting is just extra insurance).

3. Format your memory cards.

4. Clean your lenses and camera sensors.

5. Load your camera with a battery and formatted memory card. Take a few pictures with the camera to verify that everything is working.

6. **Important:** Check your camera settings. If you know that your shoot is outdoors, verify that you are at ISO 200 or similar, not ISO 1600. If you know that you will need to be shooting multiple pets lined up who all have short attention spans, ensure that your current f-stop is capable of creating the depth of field you need (f/8 or higher). The wrong settings straight out of the gate can be disastrous. Just ask anyone who has accidentally done entire shoots in bright sunlight at ISO 1600. Woops!

7. Print contracts or model releases if you don't have any handy and put them in your camera bag.

8. Print address and driving directions with client's phone number and put this in your camera bag. Map out the location by using one of the online map services so that you have a visual as to where you are going.

9. Ensure that you have a pen, treats, toys, and any client gifts in your camera bag.

10. Pack extra business cards or postcards.

11. Verify that you have enough gas in your tank to get to and from your shoot.

12. E-mail or call your client to confirm your shoot.

13. Check the weather forecast to confirm that you can proceed with the shoot and that rescheduling due to bad weather isn't likely.

14. Read through any pet questionnaires that your client has completed.

15. Create your shot lists (see the section that follows).

16. Put some mints and lip balm in your bag, and a bottle of water in your car. Your lips will dry out from chatting with the pet and its owner, and if you need coffee to get up and going before the shoot, the mints will ensure that you show up with fresh breath. And don't think seasonally: Even in the winter, you can get thirsty after shoots from all of that hard work and fun.

Shot Lists

If you're like me, you have a difficult time being creative on the fly during a shoot. If you find that your technical left-brain has a tendency to overpower your creative right-brain, it's a good idea to create shot lists prior to the session, at a time when you can be undisturbed in a quiet place to let your creative energies flow. With a shot list in hand, you can remind yourself of the creative visuals you dreamt up earlier, and free yourself to focus on the pet's expressions and your technical settings on your camera. This doesn't relieve you from the need to be adaptable and look for creative solutions during your shoots, but it helps to at least have an idea of what you are aiming to capture.

First, to create really good shot lists, you really need as much information as you can gather about your subject prior to the shoot. What is its personality like? What does it look like? What color is it? What

does it enjoy doing? Where are you going to be shooting? If it's at the pet's home, what kind of home is that? What details do you have on your upcoming shoot? Most important, what is the pet owner or client looking for in terms of the types of shots? If, for example, the client has indicated she would like a shot of her two kitties side by side, drinking out of the water bowl, this is the time to write that down.

Second, you need to capture your creative ideas in writing. What I usually do is use simple notecards, writing six to eight different shot ideas on the card in black indelible ink. The black text is easy to read, and I can keep the notecard in my pocket or camera bag during the shoot. I call it my "cheat sheet," and in my experience, my clients have appreciated my diligence to ensure that I capture everything they ask for so that I don't forget anything important. You can also use a note app on a smartphone, although I have found that the less fiddling I have to do with unlocking my phone and navigating screens during a shoot, the more time I can spend concentrating on my subject and its owner.

Third, make your list. Here is what a sample list might look like for pets based on the following known aspects of the subjects and the session:

> **Dudley & Eli**
>
> detail shots— nose, paws, belly, tag
> side-by-side with bobble-head
>
> with mom
>
> playing in backyard
>
> on beach with water/sky background
>
> on velvet living room couch with fireplace
> eli's long tongue
> dudley and monkey

An example of a photo shoot shot list for two Yorkies named Dudley and Eli.

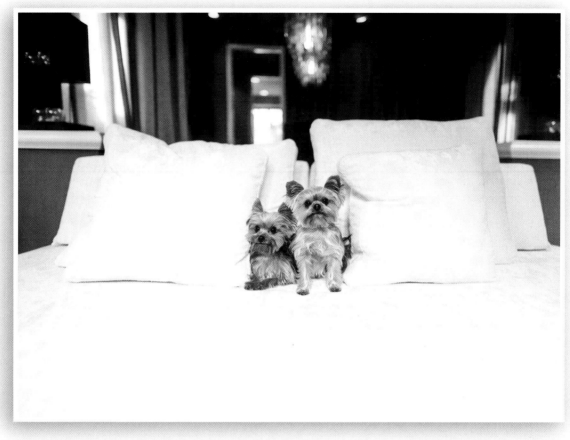

A photo of Dudley and Eli captured as part of the shot list.

Two youngish, black Lab males—best buds—named Sampson and Stony. The shoot is to take place at a park with wide-open meadows, forests, and beachfront. The owner wants action shots of dogs playing and shots of them together, not necessarily posed. He is interested in purchasing a photobook. He is also concerned that because his dogs are black, the photos might not come out right. You know that with Labs, they will probably end up in the water swimming. You also know that they might be very energetic and happy to fetch a Frisbee or tennis ball. You further know that when shooting black fur, you will need to concentrate on proper exposure, and you know that you will want great variety in the shots, and a great shot for the cover and back because they are going in a photobook.

Sampson and Stony Shot List

♦ Running through field of tall grass, each dog on its own

♦ Close-up detail shots of paws, tails, collars, eyes, noses, and tongues

♦ Swimming at beach and playing with one another in the sand

- Walking side by side with their owner on trails, shot from the waist down
- Abstract shots of dogs in tall yellow grass, focus on grass
- Catching balls or Frisbee in green field
- Sitting in forest on trail, shot from underneath
- Sitting or laying in solid light, full shade if sunny out, or full light if overcast

Don't worry about using proper grammar here. The goal is to be able to quickly read your list during a shoot. Obviously, the more information you have on both your location and your subjects prior to the shoot, the easier it will be to prepare.

Defining Session Goals

Defining session goals is somewhat different from shot lists, in that it forces you to define what's really important for each session. Is the priority to ensure that you capture at least one happy headshot of a dog up for adoption? Is it to capture a series of detail shots of a kitty for a storyboard that is to be a gift for the cat's owner? Is it to create a gorgeous, high-quality, detailed, and colorful photo of a reptile that the owner can use for her website? Whatever the most important session goal is, that's the one you want to keep in the forefront of your mind; the rest is gravy.

Here are some more examples of goals that you might encounter during a pet shoot:

- Capture at least one photo of a sick and dying dog looking happy and healthy.
- Capture a shy or fearful kitty looking happy and relaxed, to be printed as a large canvas.
- Get a head shot of an anxious foster dog looking calm and sweet for Petfinder.com.
- Create an image of three ferrets laying together on a couch in a family room.
- Create multiple detail shots plus one perfect posed shot (sitting or laying) of a Maltese for use as a large storyboard.
- Capture a moving photo of an owner interacting with his dog in an unposed, unscripted way.
- Capture an agility dog in mid-action—in air catching a Frisbee, jumping a hurdle or weaving around poles.
- Capture a photo of a horse at the proper point of a canter.
- Capture a shot of a snake with its tongue extended, "sniffing" the air.
- Capture a photo of a golden retriever on its back in a "scratch my belly" pose.

If you are pursuing pet photography professionally and have a website with lots of photos in your galleries, it's not uncommon for clients to refer to specific photos they saw on your site that they want you to capture of their own pet. They might ask, "I love that shot of that Airedale licking the ice-cream cone, can we try something like that?" Definitely defer to your client's wishes; they can often have ideas that are even more creative than yours. And don't forget that ultimately your biggest goal is to please the pet's owner.

An example of a comment you might get from a client after seeing a shot they love on your website.

Twenty-Five Tips to Keep in Mind, Before and During a Shoot

1. Use your voice during a shoot. Make funny noises, whistle, click with your cheeks, whatever it takes to get the pet's attention. Talk in your happy voice to dogs; use your calm voice for cats.

2. Don't forget to interact with both your furry subject *and* its owner.

3. Put most of your foremost mental focus on the pet, your surroundings next, and then the client, in that order.

4. If shooting in public, be constantly aware of what is around you, not only in terms of image backgrounds, but also to keep the pet safe.

5. Take a lot of shots. You can always delete them later, and as you get better, you can take fewer and fewer shots as you shoot a higher percentage of the "keepers" you're after.

6. Aim for energy, interest, and expressions over technical perfection.

7. Keep one backup card and one backup battery on your person. You don't want to lose a shot because you're wasting time rifling around in your camera bag.

8. Keep your lens wipes in your pants pocket for quick access.

9. Clip your treat bag onto your belt to free your hand to interact with the pet.

10. Aim for at least four to five different scenes (settings, locations) for good variety in the shots. I talk more about this in Chapter 7.

11. If you have multiple lenses, use them all. Change them out to get different looks, depending on what the setting calls for and what you are trying to achieve.

12. Don't get stuck in a rut of taking all of your shots looking down on a dog or with a super shallow depth of field. Variety is the key to pleasing pet owners. If you are a professional pet photographer, this is especially important because it will help you to sell more products.

13. Try to shoot on the pet's level. Photos taken from their perspective are usually more engaging to the viewer. I talk about how to do this in Chapter 7.

14. As I mention in Chapter 3, don't ever say the pet's name during a shoot when you are photographing it in a sit-stay, unless you want it to move and come to you. Make noises instead or even snap your fingers.

15. Ask that the pet owner not call the pet's name either while you have the pet in a sit-stay, because the same thing will happen; the pet will break its stay and go to the owner, or look in the owner's direction, which more often than not, is not the direction you want it to look.

16. Always ask pet owners at the start of the shoot what types of shots they would like you to capture and if there are any special looks or things their pets do that they want to capture.

17. Don't take all of your shots with the pet in a sit/stay position. This can result in static, boring shots, lacking any dynamic quality.

18. Shots taken at between 100 and 200 ISO will have the least noise and will render the highest quality.

19. Aperture priority is a good, no-fool setting to use if you are used to shooting in automatic settings and not totally familiar with your camera yet.

20. Always prepare your equipment the night before in case you forget to do something. Even if you forget the night before a shoot, you might just remember the morning of a shoot to grab that extra toy or collapsible water bowl.

21. Don't be afraid to shoot up from perspectives lower than a pet. Sometimes weird angles can produce the cutest or funniest photos. Just be sure you still have details in the eyes and they aren't just dark hollows.

22. Remember that just because you have envisioned a really cool shot doesn't necessarily mean it will go according to plan. Be flexible to different opportunities. You might even end up with a better shot than the one you envisioned.

23. If you get stressed during the shoot or things aren't going that well, take a break. Play with the pets or take a bathroom break and then return. Sometimes a five-minute reprieve can help change the energy completely.

24. If you are having a hard time holding the camera still, don't be afraid to use your other arm as a support, or your foot as a stabilizer. You can even set your camera on a ledge or other surface in front of you. Just be sure not to knock it off.

25. Don't forget to have fun!

Now that you know what you need to do to prepare for a shoot, we will talk next about how to actually capture images, covering the basics of exposure, focus, color balance, and file settings.

Exercises

1. Create a printable checklist or create a dry-erase board checklist that you can reuse before every session.

2. Create a shot list before your next shoot and put it in your pocket or camera bag.

3. Define your session goals prior to your next session.

Chapter Five

Photography Basics

- ☆ Exposure: ISO, Aperture, Shutter Speed
- ☆ Exposure Modes
- ☆ Focusing
- ☆ White Balance
- ☆ RAW vs. JPEG
- ☆ Quick-and-Dirty Pet Photography Settings

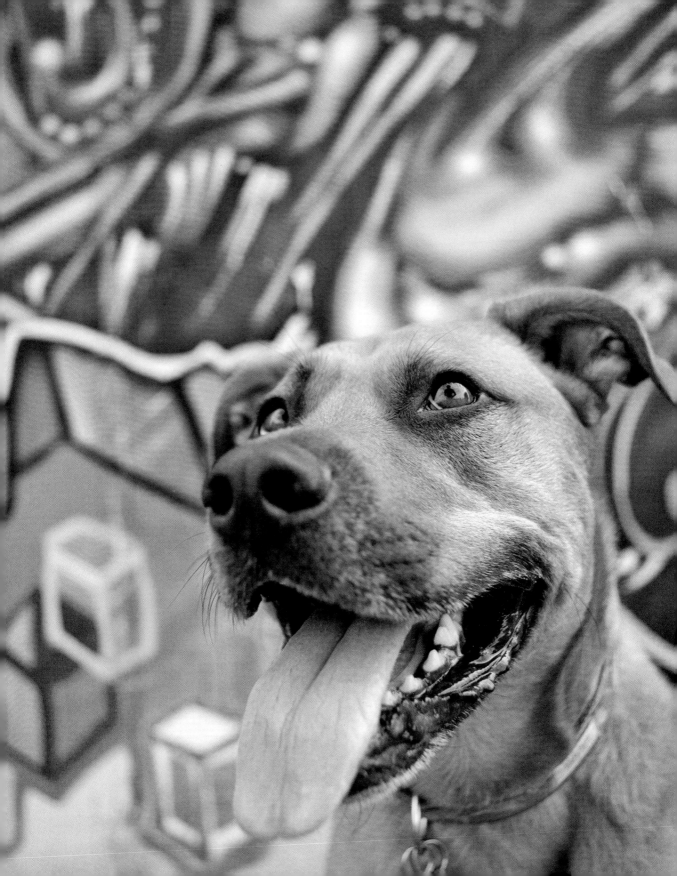

Exposure: ISO, Aperture, Shutter Speed

In this chapter, I will go over technical settings, such as ISO, aperture, shutter speed, metering, exposure, shooting modes, focusing, and color balance, which are all important elements of photography. They are also all necessary to understand in order to create high-quality images. If you get confused by the relationship between ISO, shutter speed, aperture, and metering, and you wish that all of these things didn't have to be so technical, mathematical, and, well… complicated. I am here to tell you it doesn't have to be! My hope is that this chapter will help you understand technical settings in a real life, practical way that will have you blurting out "Ah ha!" not only while you are reading the book, but during your photo shoots long afterward, as well. You will be amazed at how simple it can be. And the more you understand the concepts, the more easily and readily you will apply them in real life. And this can only mean one thing: Your photography will quickly and dramatically improve.

One note I want to make before talking about exposure is how I qualify and categorize a shoot as either *controlled* or *dynamic*. A controlled pet shoot is one in which you are controlling most of the elements of the shoot, such as the light, the pet's behavior, the setting, the position of the pet, and the composition. The pet is usually stationary in most of the shots. An example of this is photographing a pet in a studio with set lighting, only taking photos of the pet with it sitting or lying down. Similarly, if all of your shoots are of a dog that is sitting or lying in a confined area (such as on a couch or porch), you are using a reflector or flash, and the dog is not moving while you shoot, this is also a controlled session.

By contrast, a dynamic shoot is one in which, quite simply, the animal is moving around and you are following it, capturing the spontaneous action. This would include if you are photographing a dog running in a park, some kitties playing in their backyard, or a horse walking through a stable. If there's any significant movement, it's a dynamic shoot. It's often great to create both types of shots—controlled and dynamic—during a single photo shoot, with a heavier emphasis on dynamic shots. This is because dynamic shots are often more expressive and emotionally engaging, which pet owners usually find highly appealing. Also, knowing what type of shoot you are doing, will help you to begin to understand what settings to use for proper exposure.

With that said, let's start with the basics of exposure.

Inside of every camera there is an element that receives and captures light, turning it into an image. In a film camera, that element is, well… film; in a digital camera the element is called a sensor, which is simply a flat, light-sensitive plate.

Exposure is merely the process of allowing light into the camera that eventually comes into contact with the film or sensor to create an image. Perhaps you're old enough to remember how you were not supposed to open the back of your film camera in daylight without first rewinding the roll of film. That's because you would have exposed all of those lovely photos you so carefully crafted to a bright light source all at once and ruined them.

The Basic Elements of Exposure

The three basics of exposure are ISO, aperture, and shutter speed. I am going to describe each of them in relation to something we should all be familiar with: our eyes.

A camera works in much the same way as an eye, be it human or animal. The easiest way to think of ISO, aperture, and shutter speed is as follows:

♦ ISO is the equivalent of the retina (or more specifically, the sensitivity of the retina).

♦ Aperture is the size of the opening of the pupil.

♦ Shutter speed can be compared to how fast the eyelids blink.

Let's take a look at some photos to gain a clearer understanding of how these things work.

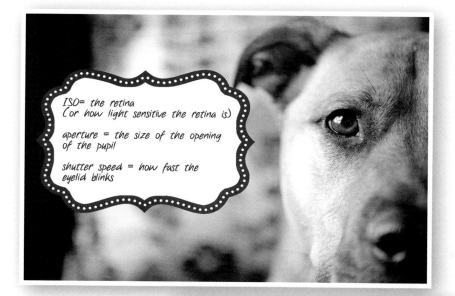

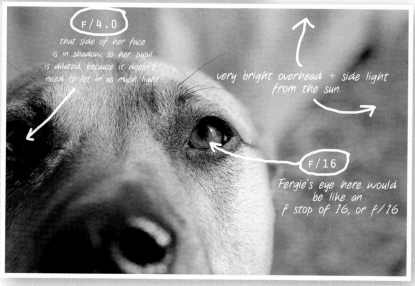

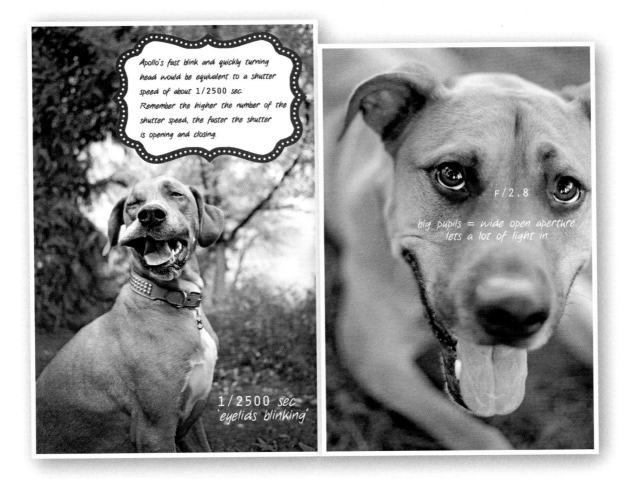

Apollo's fast blink and quickly turning head would be equivalent to a shutter speed of about 1/2500 sec. Remember the higher the number of the shutter speed, the faster the shutter is opening and closing.

1/2500 sec
'eyelids blinking'

F/2.8

big pupils = wide open aperture lets a lot of light in

ISO

ISO is the measure of sensitivity of your camera's sensor (for digital cameras) or film speed (for film cameras). Do you remember when you'd buy those little disposable cameras at the grocery story before a vacation, and you'd have to decide if you wanted the 200 speed, 400 speed, or 800 speed camera? Those numbers were the equivalent to today's ISO values. Are you shooting outdoors in bright light? Then buy the 200-speed camera. Will you be taking shots of everyday events in any situation? Buy the 400-speed camera. Are you capturing nighttime activities, perhaps at parties and restaurants? Then get the 800-speed camera. Although these are fairly crude ways of determining what speed (or sensitivity) you need, the same basic rules still apply.

On most cameras, these ISO values range between 100 and 3200 (although some digital single-lens reflex (dSLR) cameras can be expanded to as low as 50, and as high as 52,000). The values will typically read 100, 200, 400, 600, 800, 1600, 3200 (and up, especially for new cameras, which frequently go up to ISO 6400—some even higher). The higher the number, the more light-sensitive the sensor is; the lower the number, the less light sensitive it is.

Let's talk about ISO as it relates to human and animal eyes. Do you remember the last time you had the flu, and you were sleeping in a dark room? Suddenly someone came in and turned on the light, and you cringed, with the light literally hurting your eyes. The "ISO" of your eyes at that moment would have been 1600 or higher, which means that they were very light sensitive. At that moment, you really only would have needed a fraction of that bright light to see. (In this same example, your pupils—or apertures—would have shrunk down to a narrow f/16 or less).

On an animal or human, the ISO is how sensitive the retina is. In a dark environment, you need to be more sensitive to the limited amount of light that's available in order to see properly (ISO 1600); in a bright environment, such as bright sunlight that hurts your eyes, you don't need as much sensitivity (ISO 100). Similarly, if you were trying to photograph in a dark room at ISO 200 (reduced sensitivity), your shots would either be too dark or very blurry because the shutter speed would need to slow way down to allow more light in to the sensor. The sensor isn't responsive enough to available light at this ISO setting to prevent blur.

Here are some general rules of thumb regarding ISO settings and pet photography:

♦ If the light source is very bright, such as midday sun, use a lower ISO. For example, will you be photographing a dog outside at high noon in the middle of the summer? Then use ISO 100 or 200. If you are creating action shots, you might need to use ISO 400 or even 800, depending on how fast the subject is moving.

♦ If you are indoors in a very dark area, use a high ISO so that you can maintain fast shutter speeds. Are you photographing kitties playing or a guinea pig shuffling around in a dark room? Then bump your ISO up between 1250 and 1600, and use a wide aperture (f/1.4–f/2.8) to allow more light to contact the sensor.

Seamus was happy to camp out in front of the window of his townhouse, for which I was lucky, because it was quite dark inside and I needed the extra light.

20mm 2.8 lens @ 20mm, f/2.8, 1/500 second, ISO 1600, aperture priority, spot metering

♦ If your light source is somewhere between bright daylight and a somber room, use an ISO in the 200 to 400 range. This is a happy medium that will usually allow you to get the kind of shutter speeds you need in average light, without producing undesirable noise.

Aperture

Now that you understand that ISO relates to the light sensitivity of your camera's sensor, let's talk about aperture, which happens to be my favorite component of exposure because this is where the creativity starts to come in, and aperture plays a huge role in pet photography.

Aperture is the size of the diaphragm or opening in your lens (think of the iris in your eye). The diaphragm of your lens is the same as the pupil in your (or your pet's) eyes; it can open and close to allow more or less light in, as the situation warrants.

Aperture settings (the size of the aperture or opening) are defined as *f-stops*. In a somewhat confusing inverse relationship, a small aperture number, such as f/2.8, refers to a large or wide opening in the diaphragm, whereas a large aperture number, such as f/16, refers to a small or narrow opening.

One trick you can use to make it less confusing is to not think of the f-stop number in terms of how much light it's letting in; rather think of it in terms of how much light you have available to you in your setting. A small number means that you don't have very much light with which to work, and a larger number meaning you have lots of light available. So in this case, f/2.8 means that you have very little light available; f/16 means that you have a lot of light. This is a totally imperfect science, but it might help you to remember.

Low aperture settings that let in a lot of light are generally between f/1.2 and f/2.8; high aperture settings that let in just a little bit of light are between f/16 and f/22.

Ok, so we know that aperture controls how much light hits the sensor, and the ISO controls how sensitive the sensor is, so where does the creativity come into play with aperture? It comes with a little something called *depth of field*.

Depth of field (often referred to as DOF) quite simply refers to how much or how little of the scene, both in front of and behind the focal point of your shot, is in focus. Depth of field can be either *deep* or *shallow*.

A very deep depth of field has most everything in front of and behind your subject in crisp focus, where you can see lots of detail. By contrast, *shallow depth of field* makes everything that is not at the same distance (the focal plane) as your subject appear out of focus, or soft and fuzzy. An extremely shallow depth of field produces what's called *bokeh*, which is the beautiful, creamy-soft backgrounds you see in many professional photos.

The photo of Henri (on the next page) demonstrates a very deep depth of field. The Space Needle was a good mile behind him, but using the very narrow aperture of f/32 pulled the scene in and maintained focus.

The photo of Shelley (on the next page) was taken at f/1.4; it has lots of creamy bokeh. I had her hold very still while I was careful to focus on her eyes. Because the depth of field was so incredibly shallow, if I were a mere half-inch off, the focus would have been on her ears or neck, instead.

Let's get back to the creativity aspect of aperture. Along with helping you to control the light that hits your sensor, aperture also allows you to determine exactly what you want the central focus of your photo to be. In other words, it helps to highlight the star of your photo; the element to which the viewer will pay the most attention. Do you want your kittie's eyes to be the central area of focus? Use a wide aperture such as f/2.8 and allow the background to fade into blur. Are you photographing a dog in front of a national monument where you want the entire scene to be in focus? Try an aperture of f/16 to capture the monument and the dog. Are you photographing multiple small dogs sitting together on a couch? Then, use an aperture of f/5.6 to have each of their little faces be in focus, with a slightly soft background.

By using aperture together with exposure control, you really get to shape how your photos look in terms of style and aesthetics, and this is where you begin to display your creative expression through your photography.

Now, I'll tell you a little secret when it comes to pet photography and aperture values.

Narrower aperture settings mean less light is hitting your sensor, which, in turn, slows your shutter speed because your camera is thinking, "uh, oh, I don't have enough light at f/22, I need to

A far stretch from my normal style of close-up, pet-filling-the-frame photos, this photo was captured for an editorial client and required the use of a telephoto lens and a very deep focal length in order to clearly see the city behind Henri the Airedale.

70–200mm 4.0 L lens @ 187mm, f/32, 1/40 second, ISO 250, aperture priority, evaluative metering

I wasn't sure if there would be enough contrast between Shelley's fur and the gold metal wall behind her, but the colors blended beautifully at f/1.4.

24mm 1.4 L lens @ 24mm, f/1.4, 1/800 second, ISO 500, manual exposure, partial metering

slow the shutter way down to let in more light to expose this image properly." Now, what do you think that does to your image of your moving subject? Yep, that's right. It creates blur!

You know that dog that you were photographing at f/16 in front of the monument? The dog isn't running; it's sitting still. It pretty much has to be to be in focus at f/16, unless you are shooting at a very high ISO. And if you're shooting at a very high ISO, you might be introducing a lot of noise into the image.

For this reason, many pet photographers use wider apertures like f/2.8 or f/3.5 liberally, which allows more light in, thus permitting the faster shutter speeds you generally need for pet photography.

So, what is an acceptable range for aperture for pet photography? Well, it really depends on the look you are trying to achieve, the movement of your subject, how much of the background you want to be

in focus, and how much available light you have, but generally you should be happy shooting between f/2.8 and f/8. With pet photography, it's not uncommon to notice a very large difference in blur between apertures as close as f/2.8 and f/4.5.

> *Note* Lenses that are f/2.8 or larger openings (such as f/1.4–f/1.8) are known as "fast lenses" because they allow you to obtain very fast shutter speeds. Fast lenses are often used in pet photography to achieve the quick shutter speeds that pet photographers frequently use.

Unfortunately, this means that you might need to sacrifice a deep depth of field to capture motion; sometimes, you can only have one or the other, not both. In other words, if Rufus is running across a field with a big barn in the background that you want to be sharp and pulled in at f/22, you might have a blurry Rufus, depending on your light and ISO. Using a camera that has high maximum ISO values gives you some freedom here, because you can bump up your ISO to 3200 or higher and increase your depth of field by increasing your aperture number (to perhaps, f/11) without completely sacrificing shutter speed. The best thing to do with pets is experiment. Every situation calls for different settings, and the better you get to know your camera and its limitations, the easier it will be to produce the kinds of shots with the levels of creativity you are going for.

Shutter Speed

Shutter speed refers to how long the camera's shutter is open, and thus, how long the sensor is exposed to light—the exposure time. Shutter speed is expressed in fractions of a second, with larger numbers equaling smaller time increments for which the shutter is open. Speeds range from several seconds (or minutes for night photography using a tripod), to 1/10 second (or one tenth of a second—very, very slow), to 1/4000 second (one four thousandths of a second—very, very fast). The longer the shutter is open (slow shutter speeds), the more light it lets in; the quicker the shutter opens and closes, the less light it lets in (faster shutter speeds).

In the shot on the following page, the shutter speed of 1/2000 second enabled me to capture his action, freezing the ball above his head. Had I used a slow shutter speed with Sam sitting still, you would have seen blurred movement in the ball.

Many pet photographers prefer to use slower shutter speeds, and drag the shutter, or *pan*, to create blur. One great example of this is a dog running across a meadow, in which you want to blur the background to convey speed and motion, while still keeping the dog clear and crisp. For a shot like this, you can select a slower shutter speed of 1/50 second and pan with the dog as it runs. This blurs the background but keeps the dog sharply in focus. Slightly faster shutter speeds can capture the movement of a paw "waving" or a tail wagging. Slower shutter speeds are also fun to use for photos that include moving water, such as a kitty drinking out of a faucet or a dog prancing in a fountain.

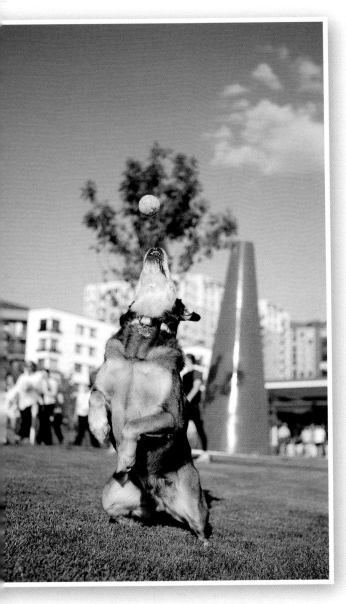

Producing creative blur through slower shutter speeds can communicate movement and action, which can make a pet photo very dynamic. Using shutter speeds strategically is another way that you can infuse creativity into your shots, and by producing the perfect combination of ISO, aperture, and shutter speed, you can learn to create combinations that you really fall in love with.

Adobe Bridge gives you the option to sort by ISO, shutter speed, and aperture. So, for example, if you only want to see the shots that were taken at 1/250 second at ISO 500 with an aperture of f/5.6, Bridge will only show you images with those settings. Or, if you only want to see those taken at f/11, it will show you those, and so on. This is a great practice for visualizing the variations in these different camera settings and understanding how you can use them creatively.

In the photo of Simba (on the next page), I faced all manner of challenges: a multicolored dog with white and brown and black fur, partially lit by bright window light, flanked on the other side with dark furniture and a dark room, and with multiple patterns thrown in for good measure. I set my camera to f/1.8 to allow more light into the dark areas, set my ISO to 500 for more light sensitivity, and used evaluative metering to try and get even light across the scene, weighing the middle part of the frame first. I added a vignette and vintage preset in Adobe Photoshop Lightroom during post-processing to make the shot more dramatic.

When Mannfred's owner told me that her cat liked to drink water out of the faucet in the sink, I said, "We've gotta capture that on film!" I was glad we did and she loved the shots. But I definitely needed to use ISO 1600. It was dark in that bathroom.

20mm 2.8 lens @ 20mm, f/2.8, 1/30 second, ISO 1600, aperture priority, spot metering

The vintage look was requested by Simba's owners, a choice selected from multiples options that I give them for editing photos. I was unsure at first, but in the end, I was very happy with how it turned out. I did all of the editing in Lightroom.

50mm 1.8 lens @ 50mm, f/1.8, 1/40 second, ISO 500, aperture priority, evaluative metering

A Little Information About ISO-Generated Noise

Always use the lowest ISO settings you can get away with and still avoid blur at handheld (non-tripod) shutter speeds. The reason for this is that higher ISOs can produce noise in some cameras, which is best described as an undesirable speckled look. In film photos, it's called "grain" and often looks sexy; in digital photos, it's called noise, and it's not so sexy. Most newer cameras will have invisible noise at ISO settings of 1000 to 1600 or even higher, depending on the model. (This varies from camera to camera, and it also depends largely on how used your camera is because noise increases over time with use.). In Chapter 9, I show you how to remove noise by using software if this is an unavoidable issue for you.

Exposure Modes

Now that you have a good understanding of aperture, ISO, and shutter speed control, let's talk about how to put them all together.

Exposure modes are represented by little icons on your camera. Although every camera is different, in general this is what these modes will look like, whether they are in the menu of your fixed-lens prosumer camera or the top dial of your dSLR body.

In the following, I list each exposure mode

M: full manual You choose the shutter speed, ISO, and aperture.

A (Av on Canon cameras): aperture priority You select the aperture and ISO; the camera selects the shutter speed.

T (Tv on Canon cameras) shutter priority You select the shutter speed and ISO; the camera selects the aperture.

P: program The camera selects all settings but you have the ability to override them

Auto: fully automatic The camera selects everything and you are stuck with the settings it picks

"This looks like Latin to me, Jamie. How do I know which mode to pick when shooting pets?"

My answer is a simple, "it depends!" I know, don't hate me; I'll be giving you that answer a lot in this book. But ultimately it really does depend on the look you are going for and the setting with which you prefer to work.

Let me break down when and where you might want to use each of these settings with pet photography.

M: Manual

If you have mixed lighting and/or difficult lighting situations, such as a black or white dog, and you need more fine-tuned control over exposure, manual exposure will enable you to choose each setting that will be appropriate for your situation. The biggest challenge to using manual exposure is speed, or lack thereof. Unless you are one of these photographers who has his camera settings down by feel and can quickly change settings on the fly, it's very hard to shoot in full manual when photographing moving subjects, especially in a highly dynamic shoot. If you are photographing an animal that is moving in and out of areas that are illuminated differently, you might find that by the time you have adjusted your shutter speed, aperture, ISO, metering, and exposure compensation (and color balance if needed), the opportunity to capture that perfect expression or perfect composition or cute/funny/awesome behavior is long gone.

If all of your photo shoots are controlled, and your shots of pets are of them sitting or lying in one place in every shot, manual exposure should be easy for you. If this is your regular shooting style with pets, use manual exposure, spot metering, exposure compensation, and a light meter, because these will give you the best results. Of course, this necessitates that your subject remains stationary long enough for you to get all of your settings right, but this can be easy with a slow-moving or obedient pet. Shooting in full manual will require that you slow down, concentrate on your settings, adjust them as necessary, and really understand how the light changes as you move around. This mode will usually produce more even exposure and more professional looking images once you have the process down. It's unfortunate that the exposure mode that produces the most gorgeous results is also the most challenging to use when photographing pets dynamically, and of course, dynamic shots are usually the most engaging shots. But with time and practice, you can learn how to take great gorgeous photos in any exposure mode. If you feel overwhelmed with where to start with your settings in manual, you can take a few shots in aperture or shutter priority, note the settings that produce the look you like, and then switch over to manual and duplicate the settings.

A: Aperture Priority (Av on Canon)

This setting provides the most control over your depth of field. You can control how soft and blurry the background is, or how sharp or deep you need your focus to be when shooting multiple subjects or objects. Aperture priority is a popular setting among pet photographers, because oftentimes a photographer is looking to isolate her subject from the background and put the focus on the pet, and this can be achieved when shooting at a wider aperture such as f/2.8, when it really doesn't matter if the background is blurry or not. Shooting at wide apertures also enables the camera's shutter speed to open and close faster, thereby stopping action and preventing blur. And if you need to photograph multiple subjects who aren't lined up next to each other (on the same focal plane), or draw a background in behind your subject, or ensure that the background is crisp and in focus, you can use a smaller aperture like f/11 or f/16. The downside to doing this is it slows the shutter speed. But often that problem can be solved by increasing the ISO and using exposure compensation, which I talk about shortly. Aperture

priority gives you great control over your creativity because you control the depth of field. Unless you are using your shutter speed for creative or dramatic effect, aperture priority is a great semi-automatic setting for pet photography.

T: Shutter Priority (Tv on Canon)

When the most important element in your shot is slowing or stopping movement, shutter priority is a great setting to use. Suppose, for example, that you want to take some shots of a dog running through a field of grass or across a beach with sand flying. Or perhaps you want to photograph a horse running through the pasture with its mane sailing in the wind, and you want to freeze every hair as it blows. You could set your shutter speed to 1/2500 second and get incredibly crisp, sharp images, stopping the motion of the animal. The depth of field here is less important than freezing the action, although you'd most likely need to be shooting at a very large aperture, such as f/2.8 to f/4.5, in order to get those shutter speeds, unless you crank up your ISO. I've been known to shoot at ISO 1000 in broad daylight to get super fast shutter speeds. Conversely, if you want to photograph a dog drinking out of a water fountain, like I did with the shot of Neva that you can see later in this section, and you want to slow the flow of the water, you could set a slow shutter speed of 1/100 second and capture the water as it flows out of the fountain. You can experiment with different shutter speeds in shutter priority to see what kinds of effects you get. Just make sure your aperture isn't too far off from where you want it to be. You can adjust that by controlling your ISO.

P: Program

If you are fresh off the boat from using full auto, this can be a great rest stop until you get your "manual legs." With this setting, you get the benefit of having the camera give you a starting point, but you can override the settings. If you don't feel ready to do a shoot in aperture or shutter priority, this is a good setting on which to start. Pay close attention to the settings for different shots in different lighting; they can help you to learn what decisions the camera makes for exposure, and you can see what works and what doesn't.

Auto: Fully Automatic

This setting is a no-brainer. Seriously, you don't have to think about a thing! For all of the aforementioned reasons, if you are now a professional or are planning to be one, it's great to get out of this setting as soon as you can because you will be able to produce better looking images. But if you only want to photograph your own pets and couldn't care less about whether the shot is perfectly exposed or looks professional, this is a really easy setting to use. But don't expect miracles, and remember that full auto is a guessing game for the camera, and sometimes it guesses wrong.

Metering

Every camera has different metering types, which also inform it how to expose an image, based on where the light is in the scene. So much of photography can be explained by simply understanding that your camera is merely capturing reflected light. Metering refers to an actual light meter in your camera that determines how much light is available and where it's coming from. All cameras attempt to do the same thing when metering: exposing for an average of *middle gray*, or *18 percent gray*. It's called

18 percent gray because subjects of this tone reflect about 18 percent of the light that they receive. Conversely, pure white and pure black reflect more and less light, respectively, with pure black reflecting nearly 0 percent of light, and pure white reflecting nearly 100 percent. Remember this when you are in a scene with highly contrasting areas that are close to white or black. Are you starting to understand why a solid black dog or a solid white dog or a dog in snow, or heaven forbid, a black and white dog in part sun and part shade (eeek!) is tricky to get exposed properly?

> *When you're shooting in full automatic mode, the reason why you aren't getting professional-looking photos is because the camera is making all of the decisions about which settings to use—aperture, ISO, shutter speed—to achieve that 18 percent gray. Unfortunately the camera can often be wrong because there are many things that can throw this system off, which negatively affects exposure. When you're shooting in full manual (you control the aperture, shutter speed, and ISO), and semi-automatic settings, such as aperture priority and shutter priority, you choose how the camera exposes an image, and you can adjust for elements in the image that can throw off your exposure, providing a more even exposure all around.*

Although a camera functions in fundamentally the same way as your eye, anyone who has taken digital photos knows that the camera often doesn't "see" things the same way we do. Photography is as much about us instructing the camera *how* we want it to see things as it is about *what* we want it to see.

One thing that is very important to note here is that in an ideal world, the photographer is adjusting for the light by using a light meter, metering off the perfect spot in the frame, and he has the time to do all of these things in every photo shoot, with every shot.

Unfortunately, this is often not the case when doing dynamic pet shoots, wherein the animal is constantly moving around, going from one lighting condition to another. Unless you are taking all of your photos with the pet in one place and not moving, you will be constantly adjusting to different input that the camera is registering—different light qualities, different color tones, and different contrasts. Elements that influence your exposure can change by the second in a pet shoot, so this will be one of the areas in which you will need to experiment the most to see both what works to create the look you desire, and also what works best with your camera. If you are new to pet photography, don't worry too much about getting the perfect exposure just yet. In Chapter 9, I teach you how to deal with some of those exposure issues that invariably arise when photographing pets dynamically. And if you are a professional pet photographer, you probably already know that nailing perfect exposure is one of the most challenging parts of your job.

Now, let's move on to metering types.

The most common metering types are the following:

♦ Evaluative or pattern or matrix (also known as multizone)

♦ Center-weighted

♦ Partial or spot AF area

♦ Spot metering

Evaluative, Pattern, or Matrix Metering (Multizone Metering)

This metering type evaluates the entire scene and attempts to provide an even exposure across the entire view. This mode works really well if your scene consists a wide variety of tones from dark to light, such as an outdoor scene that includes grass, a blue sky, dark trees, bright flowers, and tan dogs, but it doesn't work as well for scenes with less contrast between shades, such as a white Dalmatian lying on a cream-colored rug, or a black cat inside a dark bedroom. Extremes in tone can also throw off your exposure when using evaluative metering. Examples of this include a very light/bright sky with a dark horizon and dark dog, or bright window light falling on a white rug inside a dimly lit home with a cat on a mid-toned sofa. Now, here is where evaluative metering gets really tricky, especially when photographing pets: it's tied to the active focus point, assigning it the most "weight" when determining the overall metering. Essentially it starts there and then goes through the zones in the camera's viewable scene before finally coming up with an average. If you are like me, you constantly change the location of your focus point; thus, this can be very tricky, particularly if you *do not* want to meter off the pet. Coming up, I talk about exposure lock and exposure compensation, two things that will come in handy for your pet photography. Don't start to panic yet! I promise I'll help you come up with solutions to problems and help you figure out how to make the best exposures you can under varying circumstances.

Try to remember evaluative metering as the following: If you have a lot of variety in tones of light from light to dark, evaluative or pattern metering should work well; if you have less variety in tones of light from light to dark, try a different metering mode. Most modern digital cameras do a great job with evaluative metering, but for trickier situations in which proper exposure is challenging, it helps to know how the other metering modes work. For most situations, if you aren't that familiar with how your metering modes on your camera work, I suggest starting with evaluative metering, taking some shots, and then adjusting with exposure compensation (or changing your aperture, ISO, or shutter speed) if you need to adjust your exposure.

Situations for which evaluative metering works well include:

♦ Light-to-medium–toned dogs photographed outdoors on a flat light/overcast day.

♦ Tan horses photographed in a pasture surrounded by trees and mid-toned blue sky.

♦ A tabby kitty indoors in an evenly lit living room with good natural light and no overly bright spots.

Center-Weighted Metering

Center-weighted metering is weighted at the center of the frame and then averaged for the entire scene. This means that it gives greatest weight to the light in the middle area of the frame and then exposes out from there, also taking into consideration the light in the rest of the frame, but placing the heaviest emphasis on the center area. You might want to try this metering option for scenes that exhibit extreme brightness for which you want to correct.

Situations in which center-weighted metering works well include the following:

♦ Outdoors shots with a sky full of bright clouds, or the sun is shining brightly through the trees and you want to expose for the trees, ground, and your subject.

♦ Group pet portraits.

♦ Sunset shots for which you aren't looking to create a silhouette (in which case, you'd use spot metering, described in a moment).

♦ Shots in which the pet and surrounding area are in full light but the edges of the frame are dark.

Alex is an indoor/outdoor cat, and as soon as he made his way outside I knew I'd need a telephoto lens to capture him. Kitties like to hide in bushes, and it's easier to zoom to the bush than crawl through it to get the shot.

70–200mm 4.0 L lens @ 200mm, f/4.0, 1/125 second, ISO 400, aperture priority, evaluative metering

The red of Max's collar contrasted nicely with the red of the sculpture against the bright blue sky.

24–70mm 2.8 L lens @ 24mm, f/2.8, 1/1250 second, ISO 200, manual exposure, center-weighted metering

Partial or Spot AF Area Metering

Partial metering reads the light from a slightly larger area than spot metering—approximately 10 to 15 percent of the scene in the middle.

Situations in which partial metering works well include the following:

♦ When you have a broad swath of color or light off of which you can meter that will give you proper exposure results. Suppose, for example, that you have an off-white kitty in a dark room, and you want to expose for the kitty and not worry about the exposure on the dark green furniture around it, you would use partial metering on the cat only, to properly expose for the cat.

♦ A scene in which you have darkness around the edges of the frame and you don't want the camera to try to expose those areas properly. (If you change your mind later, I can show you how to remove vignettes with software).

♦ A backlit subject that is in silhouette, but you still want to be able to make out some detail in the eyes and collar area.

In the shot of Brie on the next page, I wanted her entire body and face to be exposed properly in the frame, without worrying too much whether the light fell off on the edges because the depth of field was so shallow at f/1.4.

Brie's lip was stuck in this shot, and I had just a second or two to nail the focus and fire the shot. The colors of her fur blended beautifully with the fall leaves in the background.

24mm 1.4 L lens @ 24mm, f/1.4, 1/2500 second, ISO 320, aperture priority, partial metering

Spot Metering

Spot metering reads only the inner 2.3 percent of the camera's viewable scene and exposes for that narrow "spot." When you have really tricky lighting, and you want to expose precisely on one area, this is a great mode to use, although, because of the precision needed, it's best for controlled shoots.

Spot metering is ideal for a situation in which you want very specific exposure on a very specific part of the scene.

Situations in which spot metering works well include the following:

♦ Sunset shots in which you want the dog and owner to be a black silhouette, but the sunset and sky to be perfectly exposed. Spot meter off a midtone in the sky, recompose, and then frame up and fire the shutter. If you prefer the subject to be properly exposed and the background ignored, spot meter off the subject and set the proper exposure on it instead of the sky.

- When you are doing a controlled shoot and have the time to meter off of an area that reads as mid-tone gray. In other words, an area that is not too bright and not too dark. You can look around, find a small area that appears to be close to 18 percent gray (I'm talking light here, not color), meter off that small area, lock in the exposure, recompose, and then fire.

- Exposing for a very small portion of the image, such as when zoomed in on a silver kitty name tag that is lighter than the surroundings.

- Exposing for a solid white or solid black dog or cat. This can be crucial for getting these creatures properly exposed.

- In the shot of Mr. Jones that follows, he was backlit by a very bright window, and I wanted to ensure that he was properly exposed, not caring if I blew out the highlights on the window area (that is, lose any detail in the highlights, making them completely white), because I wanted him to be the main focus of the image. So I used spot metering and metered off his face.

Spot metering can be very tricky with pets, in that even a small movement can throw off your exposure. Having some photos of motionless pets in your portfolio is great, but ideally you don't want all of your shots to be of Fluffy or Rufus looking like a statue, so it's often easier to give yourself some more leeway when it comes to exposure by using one of the other metering types, instead.

The more you get the hang of each mode and understand how your specific camera operates, the easier it will be to decide which mode to use when you enter a scene.

Mr. Jones was sitting in a very brightly lit window in this shot. I knew the only way I'd get him properly exposed was to use spot metering.

24–70mm 2.8 L lens @ 43mm, f/2.8, 1/25 second, ISO 250, aperture priority, spot metering

Exposure Compensation

Exposure compensation (also called *EV*), is a neat little feature wherein if you want to keep your settings the way they are in a semi-automatic mode—such as aperture priority, shutter priority, or program—but your image is still under or overexposed, you can increase or decrease the global exposure by up to two f-stops. This changes the setting that you *didn't* set (shutter speed in aperture priority mode, aperture in shutter priority mode, and either or both in program mode). You access exposure compensation by a little button with a plus and minus symbol on it, or through your camera's menu. Take a look at your camera manual to find out how to control exposure compensation. On most dSLRs, there is a button that you hold while you move a dial to increase or decrease your exposure. There are many situations in pet photography in which doing this comes in handy. Here are a few of them:

♦ Photographing a solid-black dog

Remember the 18 percent gray the camera is trying to create? Here, it is throwing the overall exposure off by overexposing the image because it's trying to compensate for the black. The camera might overexpose by up to two f-stops, which is pretty significant. You can use exposure compensation and dial it down by a stop or two to attain proper exposure.

♦ Photographing a solid-white dog

The inverse is true here. The camera wants to underexpose the image because the brightness of the white fur throws it off. The result is dirty, dingy photos in which the fur looks gray, not white. Bump up the exposure by as much as two f-stops (I often do one-and-a-half f-stops) to get nice, clean white fur.

♦ When you are dead set on specific aperture or shutter speed setting while using aperture or shutter priority, and you really don't want to adjust your ISO but you are still over or underexposed. "No, no, no, camera! This is what I want!" you may cry in desperation. Never fear, exposure compensation is here.

Note

When you move from the scene in which you are currently shooting, be sure to check your EV settings because you might want to reset or adjust them for your next location. I've found that many times when I'm griping at the camera for not working for me, it's because I failed to revert the EV settings back to normal.

Also, some photographers do what's called "exposing to the right." This is when your histogram curve weighs heavily on the right side (that is, the light side) without clipping the highlights. You can create really rich-looking images by taking your slightly overexposed images, pulling them into Lightroom or Photoshop, and then manually adding in blacks and darks. This also helps photographers whose sensors have become noisy with age, because it prevents the issue of needing to lighten darks in an image. You can easily achieve this by using exposure compensation and bumping up your exposure a full one to two f-stops.

Fergie lounges in her second-story guest bedroom window—her favorite perch from which to watch the world go by. In the after shot, the blacks are increased and the mid-tones made darker in Lightroom 4. This shot was taken at 9:30 at night in the summer when there was just a little bit of light left outside.

Before shot: 24–70mm 2.8L lens @ 24mm, f/2.8, 1/60 second, ISO 2000, manual exposure, spot metering

Another exposure option that is afforded to landscape and still photographers is called bracketing, whereby the camera creates three shots, all at different exposures, and then you pick the one that is most properly exposed. However, I challenge you to find a pet that doesn't split in the time it takes to create three identical shots with your camera. You can try this when you are doing a controlled shoot with the pet in one place, and then pick the settings on the shot that came out looking the best. But don't be disappointed if your subject runs off just as the shutter is firing for shot three. Remember what I said about speed. Post haste pet photographer! Post haste!

AE Lock, or Exposure Lock

The problem with many shots is that you don't necessarily want to be metering off your subject. If you are using center-weighted metering or evaluative metering, and your metering is tied to a focus point you have set, you'll be hard pressed to meter off the tan wall on the side of the cat, and not the cat itself. If you are fast with your fingers and learn how to use the buttons on your camera like the back of your hand, you can lock in your exposure if you have an AE lock on your camera, which is something most dSLRs can do. What this enables you to do is to frame up, expose on whatever spot/area you want (particularly spot or partial metering), push the AE lock button to lock the exposure, reframe for composition without losing your desired exposure, and then fire the shutter. I love doing this, but it takes some practice because there are so many things going on at one time. Can you say multitasking? Here you need to, 1) envision the composition you want, 2) know what spot you want to meter off of, 3) hold the shutter down halfway, 4) push the AE Lock button, 5) reframe, 6) fire the shutter, all while making sure nothing has changed—your subject hasn't moved, the light hasn't changed, a kid with an ice cream cone

didn't just run into the scene, and so on. And you must do this for every single shot. It's tricky when you're working with erratically moving subjects who like to do whatever they want, but it can be done. And once you know where the AE lock button is by feel and you make a habit out of these six steps, it can really transform your images into something *you* create, not just something the camera wants to see.

Remember: expose, AE lock, recompose, fire!

A Word About Histograms

When you are learning about exposure, metering, and exposure modes, it can be very helpful to study the histogram on your camera's display. The histogram tells you what the weight of dark to mid-tones to light is, from left to right, in a curve on a graph. Although many photographers would argue that a "perfect" histogram looks like the shot shown here, a good-looking histogram depends entirely upon what you are trying to capture.

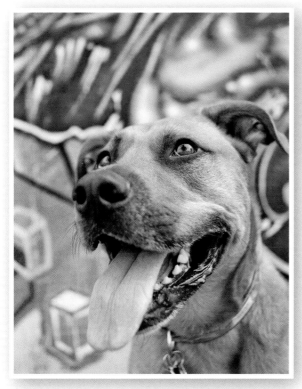

24–70mm 2.8L @ 24mm, f/2.8, 1/640 second, ISO 200, manual exposure, partial metering.

Now take a look at this histogram, which was taken from the low-key photo beside it, in which most of the shot is extremely dark, with just a small amount of very light tones.

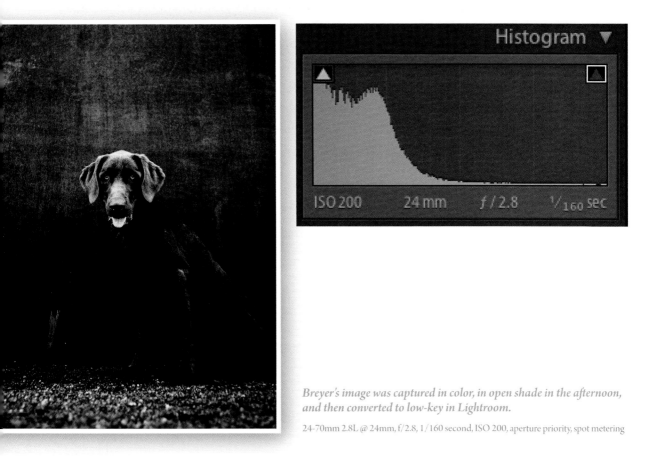

Breyer's image was captured in color, in open shade in the afternoon, and then converted to low-key in Lightroom.

24-70mm 2.8L @ 24mm, f/2.8, 1/160 second, ISO 200, aperture priority, spot metering

The histogram doesn't look happy according to the standards of some people, but I personally think the shot looks awesome.

Where the histogram can really be helpful is showing you areas of your shots that are clipped—that is, the blacks or whites are so dark or light that they're lacking any detail or data. This is where the light reflected is either 100 or 0 percent, neither of which you want in a shot in an ideal world. When the curve goes all the way up the side on each side it means you have clipped areas in your image. This is one of the hardest problems to fix with software, and one of the signs of an amateur or low-quality photo, especially if you have clipped your light tones, which results in pure white areas of your image. This is called "blown-out highlights." On the flip side, if you have shadows that are solid black, and you try and lighten those areas with software later, it will produce ugly noise. The lighter you need to make those areas, the noisier they will become, and if you are also shooting at a very high ISO, the shots can be goners. If you see clipping happening on your histogram as you are shooting, it's a good idea to adjust your settings to stop it. I always check and recheck my histogram when shooting in full manual,

usually leaving the info screen up for each post-view so that I can quickly glance at the histogram after each shot. If you make adjustments and still can't get the best exposure, my best advice is to ensure that you don't have any clipping; don't worry about perfect overall exposure; keep shooting, even if the shot is too dark or light; focus on capturing expressions and personality; and make adjustments later with software. You can fix an overly dark shot with software, but you can't add a dog's smile in later on.

Focusing

There are as many different focusing systems as there are cameras, and the constraints of a single book prevent me from going into detail on the nuances of every single one of them, but what I will do is give you an overview of the main types, which are as follows:

♦ Manual

♦ One-Shot AF/Single-Area AF/AF-S

♦ AI Servo/Continuous/AF-C

♦ AI Focus AF/AF-A (one-shot-AI Servo hybrid)

Manual Focus

Manual focus is simple! It's simple because you will rarely use it with pet photography. In some cases, such as when you are shooting a very still subject close up at an extremely shallow depth of field (for example f/1.2), and you're struggling to get the focus right where you want it, you can switch over to manual focus for more control. A situation in which this might come in handy is photographing a reptile in a very still state, and you want to nail the focus on an eye, or when you're photographing a napping dog and you want to capture its dog tag. The problem with using manual focus with pet photography is that as soon as you have the focus just exactly where you want it, your subject moves. It's Murphy's Law, yet again. There's a lot of that with pet photography.

One-Shot AF/Single-Area AF/AF-S

This is also fairly simple, in that it's focusing just once, and that's it. (Hence, one-shot, single-time, autofocus-single). You pick your focus point, and when you push your focus button, the camera focuses on whatever your point that is. The focus is locked after you push the button once and won't try and refocus if your subject moves. Each time you want to lock focus in, you need to release the button and then press it half-way down again, (or use your custom function button to focus—I have my focus set to * on my Canon, also known as back-button focusing). In some cameras, the shutter won't fire unless you have locked in your focus, although in some, such as my Canon 5D Mark III, you can override that setting. But really, it's nice to know you have nailed your focus before firing the shutter, so it's best to not override this. Although this focusing mode gives you the most control and is the most precise, it can be tricky to do with moving subjects, because every time the subject moves, the point you want in focus also changes. You can train yourself to hit your focus button intentionally and repeatedly every time you want to focus. Unless an animal is afraid of your focus beep if you have it enabled, there is nothing wrong with hitting that focus button so frequently you wear your fingerprint off. I know my right thumbprint is looking a little soft these days.

AI Servo/Continuous/AF-C

This focus mode adjusts the focus point as your subject moves, constantly tracking its motion. As long as you are holding the shutter button down halfway, the focus will track your moving subject. When you fully depress the shutter or take your finger off the button the focusing stops. For most modern dSLRs, you can pick either a single focus point or multiple focus points to be active, and you can even switch to different points on the screen. (Read your manual if you aren't sure what your camera's features are). When shooting in this mode, it might be easiest to try to select a larger quantity of active focus points versus just one or a few. This will increase the chances of getting what you want in focus. This mode can be really tricky to use when you are shooting at a very wide aperture because the shallow depth of field will make it more difficult to get a specific part of your subject in focus, especially the eyes, and especially if you are close to your subject. If you are shooting in this mode and your subject is moving around a lot and you are worried about getting the eyes in focus, try setting your aperture to between $f/4.5$ and $f/8$; that should help you nail the focus on the face and eyes. You can also try moving to the side of the subject to see if that helps. This mode is great for trial, agility, competition, dog-park shoots, and shooting action from afar in a photojournalistic style.

AI Focus AF/AF-A (One-Shot-AI Servo Hybrid)

This focusing mode switches back and forth between the one-shot and servo modes, depending on what your subject is doing. If your subject is sitting or standing still, the mode will be one-shot AF, but if your subject starts to move, the camera will automatically switch to AI servo/continuous/AF-C. Of the three modes this one offers you the least amount of precise control over focusing because you are you are ceding control to the camera to make more focusing decisions for you. This is kind of a "I dunno" focusing mode for pet photography, requiring less concentration and decision making than the other two modes. If you show up to an event and you aren't sure if the animals you are photographing are going to be sitting in front of your camera or walking by, pop your camera into this mode and you'll have one less thing to think about. From my own experience photographing pets, I prefer the precise control of one-shot focus or using AI servo strategically and deliberately rather than letting the camera switch back and forth between the two.

Some of the newest dSLRs have extremely complex focusing systems, giving you a wide range of options and many focus points from which to choose. The best way to learn which focusing system to use on your camera is to practice and experiment with the different settings. Take some shots for which it won't matter if the subject is in focus (your pet or a friend's pet), and spend an hour experimenting and exploring the different options your camera offers. Once you have a solid understanding of how your camera works, you can develop a system (a set of habits, really) that work best for you. If you are worried about exposure while focusing, switch to program modes so you don't have to worry about that part.

Drive Mode

Drive mode controls how many shots are taken when you depress the shutter button and whether a timer is engaged. You can configure the camera to take one shot at a time (single-shot), multiple shots

Fiona laughs at something I said while I capture her in burst mode.

20mm 2.8 lens @ 20mm, f/4.5, 1/400 second, ISO 320, exposure compensation +0.33, aperture priority, evaluative metering

in succession (continuous/burst mode), or you can set the timer for a specific delay. Usually, you will operate in single-shot mode, unless you want to capture a series of shots in a succession—perhaps a horse and rider jumping over a fence—in which case you will want to use continuous/burst mode.

Keep in mind when shooting in burst mode that if you are shooting in RAW or RAW + JPEG, because file sizes are so large, it takes longer to write the image data to the memory card, and you are limited as to how many shots you can fire in a row. If you know that you will be doing a lot of burst mode photography, such as capturing dogs at agility trials, or trying to nail the perfect stride on a horse in competition, and you plan to shoot in RAW, be sure to buy the largest, fastest memory cards you can afford; it will make a difference in how much time you spend waiting for your camera to "catch up" while it records images. To shoot in burst mode, you hold the shutter down for the period of time it takes to fire off the number of shots you want.

Timed photography is usually reserved for self-portraits, or if you want to get some shots of you with your pets. Bear in mind that you will need to have boundless patience to try to get the scene right with an unpredictable subject and you hopping into the frame, having to wait 30 seconds without your pet jumping off your lap.

A Word of Warning About Drive Modes

If you plan to use burst/continuous mode most of the time, be aware that you will fill up your memory cards a lot more quickly and have a lot more shots to go through during the post-processing phase of your photography, which will increase your workflow time. Even if you don't intend to take three shots in a row, it can be really easy to do when shooting in burst. My best advice is to always keep your camera in single-shot mode. Only use burst mode strategically to get specific shots and then switch back to single-shot before you keep shooting.

Hopefully, you now have a really good idea of how you can focus on your subject and expose an image. You can see how professional photographers combine all of this knowledge and experience to produce such great results. Now, let's move on to one of the more esoteric controls.

White Balance

Ahhh, white balance! One of the more confusing and tricky things to get right in pet photography. I have known many pet photographers who have complained about grass being too yellow, or a dog's fur being too blue, or a horse's coat being too orange, or a cat's eyes being a different color in the photos than they are in real life. Although white balance issues can't be completely eradicated when photographing pets dynamically in changing light sources, you can take a few steps before and during your shoot that can reduce the number of issues that do come up.

So what is white balance? It's the overall color tone, or temperature, of a photograph. Color temperatures are measured in Kelvin (a measure of the temperature) or "K."

Here is how the color temperature breaks down:

1,000–2,000k:	Candlelight
2,500–3,500k:	Tungsten light (regular household lightbulb)
3,000–4,000k:	Sunrise or sunset with clear skies
4,000–5,000k:	Fluorescent light
5,000–5,500k:	Electronic flash
5,000–6,500k:	Daylight (clear skies with sun overhead)
6,500–8,000k:	Overcast skies (moderate)
9,000–10,000k:	Heavily clouded or shade (I get a lot of that in Seattle)

Most cameras have no-brainer settings for white balance that might include the following:

AWB: auto white balance	3,000–7,000K. The camera decides what the color temperature is and adjusts the data accordingly to try and attain an 18 percent gray. (Yep, the white balance is trying to achieve 18 percent gray, too.)
Daylight	5,200K. Clear skies.
Shade	7,000K. Under a tree or on the side of a house.
Cloudy, dusk, sunset	6,000K. For the latter two conditions, this time of day will be different depending on the time of year.
Tungsten light	3,200K. Indoors, in a pet owner's home. Regular lamplight.
White fluorescent light	4,000K. Indoors, in some kitchens and business establishments.
Flash use	The K is automatically set.
Custom	2,000–10,000.
K- Color Temperature	User controlled and set, 2,500–10,000.

Matthew is too blue, cyan, green, magenta, red, or yellow in all but the shot on the left, which has the proper white balance, which was captured at 6,660K.

24mm 1.4L lens @ 24mm, f/1.4, 1/1000 second, ISO 400, manual exposure, partial metering

Now, here is where things get even trickier. Your white balance affects your overall exposure. In Chapter 9, I demonstrate how your exposure changes as you change the white balance with software. Having the correct white balance can sometimes help alleviate exposure issues.

Most modern digital cameras do a great job at automatically adjusting white balance (AWB mode). I usually leave my Canon set on AWB unless I am having an issue and need to make manual adjustments. So what kinds of things can throw off white balance? One example is photographing in the shade (especially a dog with black fur). Another is photographing an orange dog at sunset. A third scenario is photographing cats in a house with mixed lighting, such as incandescent, fluorescent, and natural lighting. Just ask any pet photographer what their worst shoot is and they'll say it was something comparable to a darkly lit house with a rambunctious eight-week-old puppy, two ancient grouchy multicolored cats, dark walls, white couches, lamps with different wattage bulbs, fluorescent light, and bright natural light coming in behind the pets in every scene. Oh, and the owner wants shots of all the pets together. Yikes! Here's one final example: photographing a pet that is side or backlit with one light source, and front lit with a different type of light source. These are just a few of the issues you might face, but the list goes on and on, which means there will be times when you will find yourself with your white balance thrown off.

So what can you do to try to correct these issues?

Here are a few ideas:

Use a gray card. The gray card is exactly as it sounds: a grey card that is designed to simulate 18 percent gray. These come in every kind of shape and size, and you can purchase them online inexpensively.

Place the gray card in the same light source in which you plan to photograph your subject. Photograph the card as if it were the subject. You then use the gray card image to set the white balance during postprocessing. Bear in mind, though, that every time the light changes, you need to take a new gray card photograph.

Set your white balance to K and then set the temperature yourself. This is the method I usually use if AWB isn't working for me. I find this much more desirable than shooting in one of the other auto WB modes, such as shade or tungsten, for example. Until you have the color temperatures memorized this might be best to save for practice shoots, because you certainly don't want the owner and his pet waiting there for you to get the color temperature number right via a "spin-the-dial" guessing game.

Use lens filters. You can buy warming and cooling filters and everything in between. I only recommend doing this when your entire shoot will be affected by a serious color issue, such as shooting at sunset; the last thing you want is to have to be taking glass parts off your camera every few minutes. It's better to use one of the other methods listed here.

Set a custom white balance by using a neutral white balance lens filter. The white balance filter is like the standard UV filters you put on your lens. White balance filters cost considerably more than gray cards, but they're usually easier to carry in a camera bag, and they work great when you're photographing pets because they don't require the help of an assistant. You use the filter by taking one shot, saving the white balance as a custom setting that's applied to all subsequent shots. The downside to this is that you need to use it every time the light and color source changes to create a new custom setting.

Use software. Lens filters can easily be reproduced with software, and white balance shifts can be fixed at the click of a button. Some software programs enable you to use a color temperature *picker*, with which you select a spot in the image that closely matches 18 percent gray. The application then immediately fixes the color temperature in the entire image. If you want one less thing to think about during your shoots, and like your pet photography quick and fun, leave the color fixes to the post-processing stage.

If all else fails, don't sweat it; we can fix these color issues later on by using software. I often fall back on the software solution because my photo shoots are usually so dynamic and filled with so much action and energy. I quite simply don't have time to mess with it if my white balance is being thrown off. I'd rather take a poorly exposed, wacked-out color, yet expressive and funny shot, capturing a fleeting moment in time, than a boring and static shot that is technically perfect, 10 seconds later, after all of the fun has passed. (I'll tell you why this is important later if you are trying to sell products to clients.) The ideal, of course, is to get all of your settings where you want them with every new change of scenery or light. But with pet photography, you do the best you can.

RAW vs. JPEG

Ahh, the great debate: RAW versus JPEG! Yet, I don't see this as even being worthy of an argument, let alone a debate for the ages; some photographers prefer to shoot in RAW, and some prefer to shoot in JPEG (and some in both). There, we're done. Both choices are completely valid depending on what works best for the individual photographer and the end product he is creating.

A Quick Overview of RAW and JPEG

A JPEG file is one in which the camera has captured data (the image), applied its own settings to the image (white balance, contrast, sharpening—all the things that you can control), locks those settings into the file, and then compresses the file down to make it smaller in size. JPEG is considered a *lossy* format because some data is discarded when the file is compressed.

A RAW file comprises raw data only, without any in-camera adjustments included. You could call it "WYSIWIG" (what you see is what you get). RAW is a *non-lossy* format because you don't lose any data when the file is saved.

Look at it like this: a RAW file could be considered to be a gourmet entrée filled with different complex ingredients, but without any wavering from the traditional recipe on the part of the chef. It is rich in flavor, and can be adjusted later on in myriad ways to suit the chef, without any negative impacts on its flavor. A JPEG file is a gourmet recipe with fewer ingredients (ingredients omitted); it shifts the ingredients to suit the particular tastes of the chef. It's quicker and easier to make because it requires fewer ingredients. But adjusting the ingredients even further later on might result in an undesirable taste.

My comparison here might not be perfect, but hopefully it gives you an idea of what the differences are.

Here's a breakdown of the pros and cons of each format as they pertain to pet photography:

JPEG
Pros

♦ Smaller file sizes.

♦ You can apply your own style settings in-camera (for example, increased contrast and sharpness, vibrance, and so on).

♦ There's less post-processing to do in software. It's basically "shoot-and-burn."

♦ JPEG is compatible with all photo-editing software.

Cons

♦ Data has been removed during compression so there's less of it to work with, which makes it harder to edit, especially in the case of extreme issues such as clipping.

♦ The lossy format means that images must be saved as copies after they're edited.

♦ It's much harder to fix issues with software later on.

♦ The camera makes decisions about how the shots should look with which you might disagree.

RAW
Pros

♦ Much more data means more to work with when editing.

♦ It's far easier to fix issues with software.

♦ Even serious issues can be corrected later on, including, overexposed highlights, over or underexposure by up to two f-stops, major color issues, and so on.

♦ It's easier to get professional-looking images when working from RAW data.

♦ It's easier to apply your own creative voice or style with editing.

Cons

♦ RAW files are much larger, which means that your hard drives fill up a lot faster, necessitating the need for external drives for backups.

♦ It takes longer to write data to memory cards and download to your computer (of course, depending on the read/write speed of your cards and the speed of your card reader).

♦ Not all RAW files can be seen or processed by all software programs, and software is changing constantly, which makes things more challenging. I went through this recently when I discovered I needed to download a special version of Lightroom (Lightroom 4.1 RC) in order to process the RAW files from my Canon 5D Mark III.

This horribly dark photo of Fergie on the left was captured in RAW. The exposure and darks were brought up in Lightroom and the noise reduced in Photoshop. These adjustments would not be possible with a JPEG file.

24–70mm 2.8L lens @ 54mm, f/2.8, 1/2500 second, ISO 250, manual exposure, evaluative metering

So, here's what I do and what I recommend.

I shoot in RAW exclusively. I never use JPEG or RAW + JPEG. I have found that shooting in RAW and processing the image files as I like gives me the most professional-looking results. It also gives me the most flexibility to fix issues that inevitably arise.

I recommend to anyone whose camera is capable of shooting in RAW and whose software can process the RAW files from *your* camera to shoot in RAW.

Not all camera's RAW files are compatible with all software types. Before you start shooting in RAW, you need to first verify that your software can work with the RAW files produced by your camera.

If you are still tied to shooting in JPEG, then try shooting in both. I think you'll find that the advantages far outweigh the disadvantages, and you will be free from worrying about getting everything perfect in camera. The biggest advantage to shooting in RAW for someone who is "JSO" (just starting out) with pet photography is you can fix myriad exposure and color sins, which you will most likely be producing while you are getting the hang of things. Look at it this way, shooting in RAW means that you can fix problems you create. If you used JPEG to capture a single shot of a dying dog looking healthy and happy with his ears up, and the image turns out to have issues that are so extreme as to be unfixable, I promise you that will wish you had photographed the dog in RAW. Another important benefit is if you ever hope to license your images commercially, many of your large clients and ad agencies will prefer that the file you are submitting came from a RAW file. It's best not to limit future opportunities because of how you are photographing today.

Quick-and-Dirty Pet Photography Settings

Do you have a shoot coming up, are you're overwhelmed with all of the information in this chapter and don't even know where to start? Then, try the following quick-and-dirty pet photography settings to get you up and on your way.

Outdoors	Indoors
ISO 200–400, depending on the amount of light	ISO 800–1600, depending on available light
Aperture priority	Aperture priority or manual, depending on how frequently your subject is moving
Aperture: f/2.8–f/4.5	Aperture: f/1.4–f/3.6 (higher if you have plentiful natural light)
Metering: evaluative	Metering: evaluative or partial
Focusing: one-shot/single area/AF-S, or AI servo/continuous/AF-C if shooting lots of action	Focusing: one-shot/single area/AF-S
AWB (auto white balance)	AWB (auto white balance), or K if you are struggling with multiple, different light sources

"Oh my gosh, Jamie! I feel overwhelmed.
How in the world am I going to put all of this together and
come up with great shots, especially if I have to be so focused on the
animal's behavior and safety at the same time? With so many
different details to remember, and a subject that moves around,
I feel like I won't get any keeper shots at all, ever!"

Here's what you do: take *lots* of shots, especially if and when the animal is moving, and even *more* especially when it's moving quickly. If I am running with a dog and trying to get some really great motion photos, I'll take 30 or 40 photos just to get a couple of keepers.

Keep in mind that you absolutely won't nail the exposure and focus on every single shot you take. Any pet photographer who tells you she does is either fibbing or she works in an extremely controlled environment with very obedient subjects and/or trainers who she is paying to get every shot perfect. When I started doing pet photography 12 years ago, I'd be lucky if 10 percent of my shots were keepers, but after a lot of practice over the years, now I'm between 80 to 90 percent. If 50 to 70 percent of your shots are keepers, you're doing great. The key to improving your skills and being able to put all of these elements together in a way that makes sense and works for you is practice. Practice, practice, practice, practice, and then a bit more practice. And then when you are done, go home, take a nap, get back up, have a snack, drink some coffee, and then go back and practice some more. You won't have all of these things down overnight, but in time you will. All it takes is patience and practice. Did I mention practice? And remember, it's pet photography. Have fun with it! Some of the very best pet photos in the world are happy accidents. Be open to having fun, don't be so hard on yourself, and those will happen. Those are usually the shots that pet owners cherish the most.

I ran back and forth with Seymour three or four times to capture a few shots of him with his ears flying, including this one, which made it worth the extra effort.

24–70mm 2.8L lens @ 32mm, f/3.2, 1/1000 second, ISO 400, aperture priority, evaluative metering

Exercises

1. Experiment with different aperture settings to control how much depth of field you have. Compare the results with software.

2. Use shutter speed creatively by producing, 1) "frozen action" images, 2) panning, and 3) those that imply motion.

3. Referring to the Exposure Value chart, try using an equivalent exposure to one of your favorite settings of aperture and shutter speed.

4. Try shooting in full manual exposure with spot metering.

5. Experiment with shooting in AI Servo/Continuous/AF-C focusing if you haven't already. A great place to do this is at an off-leash dog park.

6. During a single photo session in the same location under the same lighting, try using the different white balances on your camera and review the results. Then, try setting a K white balance, manually setting the color temperature. Take several shots with different color temperatures and then review all of the shots in software.

7. If you have limited or no experience photographing in RAW, try doing an entire shoot in RAW, or RAW + JPEG, and then process and compare the resulting shots in Lightroom or Adobe Camera RAW.

Chapter Six

Lighting

☆ Natural vs. Auxiliary Lighting

☆ Lighting Tools

☆ Studio Lighting

☆ Lighting Safety

☆ Lighting Pet Peeves

Natural vs. Auxiliary Lighting

Photography can be described simply as controlling and capturing light. In fact, the word photography derives from the Greek words photos (light) and graphos (to write), and literally translates to "writing with light." What this means is that no matter how fancy your gear is, no matter how yummy your treats are for the pets, it is light that is your most valuable tool—and also, often your greatest obstacle.

As pet photographers, we have a unique set of lighting challenges: We are often shooting in conditions that range from low-light interiors to bright daylight, and we are usually following moving subjects while trying to create a nice variety of dynamic, action, portrait, detail, and documentary-style shots, all while the light source changes. Whoever said this was easy obviously didn't have much experience doing it.

In this chapter, I'll provide an outline to the most common lighting scenarios you'll encounter. Eventually, you should be able to move comfortably between the different options available to you, choosing the option that will produce the best results for a given environment.

Natural/Available Light

Natural light, which is basically the light that emanates from our sun, and is often the light of choice for most pet photographers because, unlike auxiliary lighting such as flash or strobes, which have a cost involved, natural light is free, plentiful, and beautiful. Auxiliary lighting can be tricky to get right with pets, which you will understand as you progress through this chapter, and natural light often yields the most beautiful, and, well, *natural* results. There is nothing worse than an artificially lit animal with bright-green glowing eyes. Using natural light helps you to avoid this.

How and When to Use Natural Light

As near perfect as natural light is to work with, still there are times during the day when the light will be most flattering, and there are also certain techniques that you can employ to take advantage of different conditions.

Time of Day

Early morning and late afternoon are the best times to shoot, between the hours of 6 am and 9 am (depending on your location and the time of year), and between 4 pm and sunset (again, depending on where you live and the time of year). What you want to avoid is midday light, when the sun is directly overhead. Midday light, especially bright sun light, can produce harsh shadows, clipped highlights, and ugly contrast.

Positioning

Be aware of your light source and be purposeful about positioning you or your subject. I believe I had an advantage in pet photography from the moment I hung my shingle as a professional pet photographer in 2003 because I had already spent quite a bit of time working outside. Okay, *a lot* of time working outside. I was a dog walker for four years before starting my business, and I worked outside for four to five hours a day, every day. By my estimate, I spent a good 5,000 hours working outside, prior to starting my business. Because of this, I developed an intuitive sense of where the light is and its inherent

This photo of Bodhi was taken at 7:30 am, which provided good, even light.

24–70mm 2.8L lens @ 24mm, f/2.8, 1/1000 second, ISO 800, manual exposure, evaluative metering

qualities at any given time of day, and in any kind of weather. Even on overcast days (of which we get our share in Seattle!), I could still tell you where the sun would be in the sky if it were out. (I also developed a keen ability to predict weather, which also comes in handy photographing outdoors, but that's another topic). What I learned to do early on was to always keep my back facing the sun when photographing animals. In other words, I want the sun facing my subject at all times, whether it's cloudy or sunny. The times I deviate from this are when I am capturing a creative shot using the sun as a tool, such as for capturing silhouettes, halos, back-lighting, creating sun-flare, or strategic shadow shots (the dog's shadow, not mine).

> *To quickly and easily determine which direction the light is coming from in any situation with any kind of lighting, look at the catchlights in your subject's eyes (the white areas reflecting the light facing the subject). The placement of the catchlights will indicate from which direction the light is coming.*

The sun was directly behind Addy, creating some really cool lens flare, which was exactly what I was after with this shot.

24–70mm 2.8L lens @ 24mm, f/2.8, 1/2000 second, ISO 100, aperture priority, evaluative metering

Aperture

You can control how much of the available light reaches your camera's sensor by using aperture strategically. The darker the ambient light, the wider you can open your aperture to allow more light onto the sensor. If the conditions are bright, then you can make your aperture smaller—in effect, toning down the light. For a more detailed discussion about aperture, go to Chapter 5.

Shutter Speed

If you are shooting in an automatic exposure mode at an f-stop between f/2.8 and f/8, the brighter the lighting conditions, the faster your shutter speed is going to be to create proper exposure. The darker the lighting conditions, the slower your shutter speed will be. This is why on those really dark overcast days, you'll need a wide aperture to let in more light, to keep your shutter speed fast enough to prevent blur.

Natural Light Modifiers

You can manipulate, modify, and enhance the natural light that's available to you with just a little creativity.

Reflectors

Instead of using a flash as a fill-light on your subject, take advantage of the natural light by using reflectors. You can buy a five-sided reflector, which can warm, cool, darken, or brighten the light that you direct at your subject, or diffuse it if you position it between your subject and the sun. As you can imagine (for obvious reasons), this is easier to do with dogs and cats and small animals than with horses. You might be wondering how I'm expecting you to manipulate a reflector while

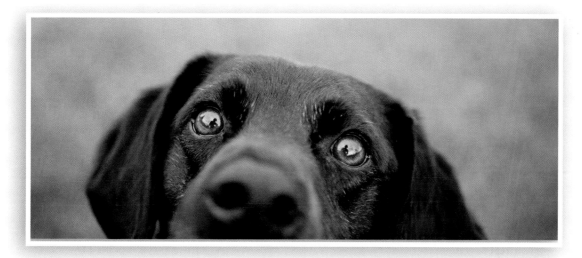

You can clearly see the catchlights in Cooper's eyes in this shot.

24–70mm 2.8L lens @ 52mm, f/2.8, 1/800 second, ISO 640, aperture priority, evaluative metering

you're actually taking the photos. Not to worry, you already have built-in assistants: the pet owners. Help them to help you by giving them the job of properly lighting their own pets. Most owners will be more than happy to help. Anything it takes to make great shots!

Clothing

Here's a simple but overlooked technique: wear a white top to help reflect some of the light that's hitting you back onto your subject. Of course, this will get dirty when photographing dogs, but it's a small price to pay for an easy reflector.

I really wanted to be shooting Eli at f/1.4 here, but it was so bright that it proved to be impossible, unless I was shooting at a negative ISO. I settled on f/2.0. This gave me a shutter speed that would have made a hummingbird look like a statue.

24mm 1.4L lens @ 24mm, f/2.0, 1/8000 second, ISO 200, manual exposure, partial metering.

If your budget's a little tight when you're starting out, there are plenty of other items that you can use as substitutes for photographic reflectors, such as sheets, towels, or drop-cloths. You can use anything with a wide expanse of white or black to help you modify the light around your subject.

Natural Light Pros and Cons

As with practically everything in life, along with the good sometimes comes the downside, even when it comes to natural lighting.

On the "pro" side of the ledger, natural light is typically the most flattering and emotive, and it's everywhere, so use it whenever possible. The downside with natural light is that you're totally at the mercy of the weather, and you're somewhat restricted as to the best times of day to get the best ambient light.

Lighting Tools

Flash

A flash is a device that produces a burst of artificial light, usually with a light output at a 5,500K color balance (daylight neutral). Flash is used to illuminate a scene and provide additional light for filling in shadows, for example. It can either be on-camera or off, using either an off-shoe cord or controlled wirelessly. Flash is a good alternative to natural light because it's portable and can produce light that looks quite close to natural light if used properly. Here, I provide some ideas on how to use flash to get the best results.

I used a gold reflector on my side of Charlie and Seymour to give them some fill light and open up the shadows. The sun was behind them and over their shoulders.

24–70mm 2.8L lens @ 34mm, f/3.5, 1/1000 seconds, ISO 100, manual exposure, evaluative metering

When and Where to Use

Outdoors

Use on or off-camera flash outdoors when the sun is behind your subject and you need to fill in the shadows in the subject's face (hence, why it's called *fill flash*). This allows us to have a bright blue sky *and* perfectly exposed foreground (instead of blowing out the sky in order to expose the face properly). Be careful not to get too close so that you don't get that "flashy" look. On overcast or muddy-light days, a little bit of flash can help brighten the scene. Use flash exposure compensation to either increase or decrease the brightness for natural results. Take a handful of test shots at different settings to see which one looks best.

Indoors

Bounce

Usually, the best way to use a flash is to angle it away from your subject, directing it toward the ceiling, the wall, or another neutral or white-colored surface (what ever color that surface is will be reflected onto your subject). This "bounces" the light onto your subject and avoids the harsh glare of the full-powered flash firing directly at your subject's face and eyes. This is a much more desirable way to use flash in pet photography than head-on. To do this, you swivel your flash to the side, or angle it upward. But make absolutely sure that the surface you are bouncing the flash off of is a neutral color.

Flash Modifiers

Diffusers

Gary Fong Lightsphere, LumiQuest, Honl, and Opteka, are among some of the brands that you will see often.

These are products made of white or semi-opaque plastic that either pop on, go over, or surround the area of the flash that emits light, diffusing it in such a way that instead of the light projecting forward in a strong linear fashion, it becomes scattered more widely across the scene. This can produce more natural looking results than direct flash, which can produce artificial-looking shadows and bright areas.

Addy gets the high-fashion look by using flash outdoors on a bright day. This is a great way to deal with sunny midday photo shoots.

24–70mm 2.8L lens @ 45mm, f/2.8, 1/1250 second, ISO 100, aperture priority, evaluative metering

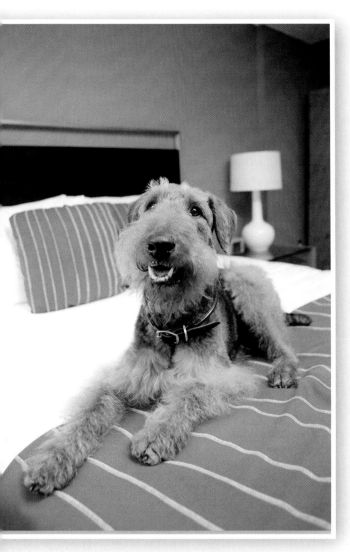

The flash I used during this editorial session with Henri the Airedale looks natural. You don't see any harsh shadows or bright lights, and I retained the detail in the white on the bed coverings. This is what you want to aim for when using flash with pets. For this shot, I used the Canon 580EX II.

24–70mm 2.8L lens @ 24mm, f/2.8, 1/50 second, ISO 200, aperture priority, evaluative metering, Canon 580 EX II flash fired

(One pro to using the Gary Fong Lightsphere is the top can double as a doggie water bowl while working in the field on hot days!).

Mini Soft Boxes

Mini soft boxes for flashes are small-sized soft boxes with brackets that hold them onto a standard flash. Similar in look and function to a large-sized soft box used in the studio (3' × 4', for example), flash soft boxes are smaller and more portable, thus they're easier to use when shooting on location in varying scenes. A 12" × 18" flash soft box can be a nice size to use when photographing pets indoors, but taken outside it can get a little unwieldy when chasing an animal around.

Mini Modifiers and Gels for Built-In Flash

There are many of these on the market. You just need to research your camera make and model to see what will fit. Similar to a modifier for a dSLR like the lightsphere, these are essentially pieces of plastic that diffuse and spread the light, creating a more natural look.

Off-Camera Flash

This is my favorite use of flash, regardless of the circumstances or setting.

With off-camera devices, you either use a cord that connects from the *hot shoe* on your dSLR to the base of the flash, or you can shoot wirelessly. This enables you to position and/or bounce your flash away from your camera, and allows your light source to be independent of where the lens is. This kind of flexibility makes it much easier to produce natural-looking results.

Flash Power

For pet photographers who do more than an average 90-minute shoot, batteries can drain quickly in a flash unit that's firing repeatedly. For this reason, it's a very good idea to carry backup batteries. You should also use rechargeable batteries to cut down on long-term cost. External flash battery packs are not a bad idea either, especially for long-event days.

Settings

Every make and model of flash is different. Most have a no-brainer "program" setting that takes the work out of your hands until you know how to use it properly, which is great for outdoor photography. Indoors, you will want to learn how to use your camera in manual, particularly if you want the background to be lit along with your subjects (try using the M [manual] mode, between 1/125 and 1/200 second at between f/2.8 and f/4.5). The best way to learn what works in the types of shoots you are doing most frequently is to experiment, adjust, and modify. Most flash units have educational CDs or pamphlets with which you can teach yourself the functions of your particular unit. It's a very good idea to understand how to produce natural looking results with your flash before using it continuously. Flash is very easy to get wrong in pet photography and one of the quickest ways to make shots look amateur.

The Pros and Cons of Flash

Most flash units offer many benefits, including lightweight and compact construction; they're easy to maneuver; they can be used "on the go"; they have a very neutral "temperature"; flash units are less expensive then strobes but provide most of the same benefits; they can fill dark shadows on bright days; and they can easily fit into a camera bag.

I had no idea the ceiling I was bouncing the flash off was painted red until my assistant told me it was later, upon hearing me gripe about the "awful color balance on the shots in the restaurant." Lesson learned—always look to see what you are pointing your flash at. It will save you a lot of work later on.

20mm 2.8 lens @ 20mm, f/2.8, 1/13 second, ISO 800, manual exposure, partial metering

Conversely, flash can ruin the shot if it's not used properly (remember the glowing green eyes I mentioned earlier?); they can cast unfortunate shadows; they can create unnatural eyeball glare; the batteries can die at very inconvenient times (there's that Murphy guy again!); and they limit your settings to slower shutter speeds (most flashes won't sync faster than 1/250 second). It's this last reason that I usually prefer natural light. In addition, there's the ever-present possibility that flash will frighten your subject. Some dogs are afraid of flashing lights, and others, although not outright scared, will be unsure enough that the coveted ears-up-and-forward shots aren't likely to happen. Take a few test shots with any new animal to gauge its reaction and body language before proceeding.

Studio Lighting

Additional Auxiliary/Studio Lighting: Strobes and Continuous Light

For pet photographers who plan to work in a fixed studio space or regularly photograph events in a set location for a lengthy duration for which you have the time and space to set up and tear down lighting equipment, so in the following sections, I have prepared some general tips to get you headed in the right direction. And here's the first one: If you are serious about investing money into a long-term studio setup, it's best to research the available studio lighting options, because the array of available lights, modifiers, and accessories is dizzying. The information on lights and lighting modifiers could fill a book in and of itself, but the more knowledge you have about equipment, the easier it will be to make a decision about what works for you. One recommendation I have is that if you want to try studio pet photography but you aren't sure if you'll like it, it's best to borrow a friend's gear or rent lighting equipment before you sink a lot of investment money into it. One of the very best photography lighting resources on the web is strobist.blogspot.com. Youtube is also a great resource for videos on studio lighting setups. Just do a search for "studio lighting tutorial," and you'll get over 6,000 results. You can devote an entire week, if not a month, to reading and watching information and how-to's about studio lighting. As with so many other elements in life, when it comes to studio lighting, you get what you pay for in terms of quality, durability, and reliability.

With that having been said, here are some lighting options and tips that you might want to consider for studio pet photography.

Strobe versus Continuous

Strobes are any kind of light that flashes. Continuous lights remain lit all the time. A household incandescent light bulb or fluorescent fixture is an example of continuous illumination.

Both types of lights can be useful, depending on the subjects and desired look you want for your images.

Strobes

Here are some of the features and benefits you can expect from strobe lighting:

♦ Strobes provide brighter light than continuous lights.

♦ That bright light can scare some animals who are naturally fearful.

- Most animals are comfortable with strobes, provided the strobes aren't right in their faces.

- Strobes produce a high light level.

- They offer great flexibility when it comes to light modifiers, which is a subject that could fill yet another entire book.

- Strobes are ideal for dynamic shoots and freezing action. (This is the studio version of an outdoor "let 'em do their thing" dynamic shoot).

- Because strobes can take some experimenting to get the light correct (what you see is not what you get), your subjects can get restless as you change your settings to produce the proper light output. Also, strobes can't be metered in camera.

Some brands that you might want to consider include Alien Bees, Einsteins, White Lightnings, and Bowens.

For a great starter kit, check out the Elinchrom D-Lite-4 IT 400Ws 2-Light To Go Kit (90-260VAC), which is available at B&H for around $800.00. The kit comes with two 400W flash heads, two 26" × 26" Portalite soft boxes, a Skyport ECO transmitter, a Skyport Wireless Receiver, two stands, sync cable, umbrella reflector, stand bag, and a tube bag. Don't want to spend that much? Check eBay for used strobe kits, which can often be had at significant savings over buying new.

To really determine the light output level of any given strobe/flash light, look in the manufacturer's information for the guide number. Information on power can be misleading, but this number will give you the true measure of power, which is not the same as consumed energy.

Continuous

In the list that follows are some of the characteristics of continuous lighting. Depending on the type of lights you're using—specifically, if you're using incandescent lights—continuous lights that aren't advertised as being "cool continuous" can be very warm, so panting tongues are common, and dogs with thick coats can overheat.

- Large floor fans are useful.

- Cool fluorescent continuous lights are a great option, which can be more expensive than traditional hot incandescent lights, but totally worth the extra cost.

- Continuous lights are also not very powerful when compared to strobes, so you might need more lights and the addition of flashes to achieve adequate lighting.

This was my first time doing a high-key photo session in my old studio. Parker was patient and fun and made a great model.

24–70mm 2.8L lens @ 57mm, f/10, 1/125 second, ISO 100, manual exposure, evaluative metering (I should have been using spot metering here, but the first time at anything you are bound to make mistakes.)

- ◆ Slower shutter speeds demand controlled shoots (of the sit/stay variety).

- ◆ Continuous lights produce a rather low output.

- ◆ With continuous lights, it's tough to get the coveted "high-key" look.

- ◆ Incandescents draw heavy power, so they can trip circuits when used at a client's home.

- ◆ Continuous lights can be great for those who are getting the hang of studio lighting, because "what you see is what you get." There is no need to repeatedly take shots and change settings as you often need to with strobes.

- ◆ They are best for subjects who can sit and stay close to the lights, because they aren't as bright as strobes. Of course, this can be difficult to do with dogs with heavy coats when using hot continuous lights, especially when shooting in a hot studio in the middle of summer, so you'll need to use your best judgment when it comes to how close your subject can be and still feel comfortable.

For a great starter kit, check out the Westcott 4822 Medium Spiderlight TD5 that uses common household spiral fluorescent light bulbs—fluorescent "cool bulbs," as referred to earlier (be sure to purchase the full spectrum bulbs for a more neutral white balance). This product produces beautiful, even lighting which is *always on*, taking all the guesswork out of how your shots will look, as opposed to when using strobe flashes. And the best part about them? They give of practically no heat, so your animal subjects remain comfortable. The kit comes with a single Westcott light, 10' light stand, tilter bracket, and a 24" × 32" soft box. It retails for around $550.

Modeling Light

This is a light mounted on a studio strobe that shows you a preview of what your light will look like when flashed. Although not always accurate, these lights give you a general idea of what your illumination will be like, but you will still need to experiment to get the settings right.

General Lighting Accessories

You can purchase most of this lighting equipment at Amazon or from your local Ritz Camera or other independent camera store. Ritz might not be the cheapest option, but the personal knowledge of its sales associates coupled with the elimination of shipping fees can make up for the extra cost. Other great resources for lighting gear are bhphotovideo.com and adorama.com. You can read product reviews on both of these sites, which can give you some insight as to what to buy.

Diffusers

Soft boxes and umbrellas will be your diffusers of choice with pet photography. Soft boxes vary greatly in size and shape; some even come in a large octobox shape, which can produce gorgeous light for capturing pets. When deciding what type of diffusers to use for your specific setup, it's very important to keep in mind where you will be using them. In a tiny back room of a pet store, a small 2' × 4' soft box might be perfect, but in a large studio where the pet is farther away from the light source, it probably won't give you as desirable a result

Reflectors

- Large sheets of 4' × 8' white and black foamcore sheets are great for blocking and reflecting light. Foamcore is available at most art supply stores, frame shops, or office supply stores.

- Tile flooring panels from any home building supply store (such as Home Depot). This creates a hard, shiny "floor" surface which reflects the subject. It's very professional looking and is Great for using on top of seamless paper if you are shooting on carpet.

- Sheets, curtains, paper, furniture, and so on. Look around you at what you already have. Anything that is solid white can act as a reflector.

Studio Lighting Accessories

Radio Slaves

Radio slaves are used with strobe lights (not necessary with continuous lights). Pocket Wizards are a favorite choice among photographers because of their high quality. An alternative to radio slaves are sync cords, but these are impractical if not downright dangerous when shooting pets. Purchase as many Pocket Wizards as you can afford (it's ideal to have two and nice to have three, but you'll rarely need more than that, and if you do, you can always rent). Go to your local camera store for advice on radio slaves. Ask them what brands they sell and what you need for your particular lighting setup.

Light Meter

Light meters are used with strobe lights (not necessary with continuous lights, because for those you can use in-camera metering). Prices, qualities, and capabilities range greatly. The Sekonic brand is good, but make sure it has radio trigger capability for strobes. Plan to spend between $250 and $800 on a light meter, depending on how much you use it.

Spring Clamps

These are used to hold your seamless paper rolls in place on the stands.

White Gaffers Tape

This tape is good for securing your seamless paper or tile board to the floor. You can also use it to tape large pieces of foamcore board together on the backside.

Setting Up and Positioning Lights

There are as many different lighting setups as there are breeds of dog, if not more. You can read any lighting guide for the proper set up of lights to achieve the effect you desire. For high-key, you'll need two strobes on the background and, ideally, two strobes for the subject (key and fill).

Note

Using two lights on the backdrop and just one light on the front can produce flat or dark light on the subject, depending on how bright your key light is. This is an undesirable look, especially when you can't clearly see the catchlights in your subject's eyes.

You will light the backdrop so that it is overexposed but not blown out. (The trick here is to prevent your backlights from affecting your key and fill lights). If you're not shooting high-key, then you have more flexibility with gear but you will battle with shadow. Practice, experiment, think outside the box, don't be afraid to try something new, and you'll come up with a look you love that is an expression of your own unique vision. See geofflawrence.com/studio_lighting.html for a great visual depiction on how the light changes depending on where you position it.

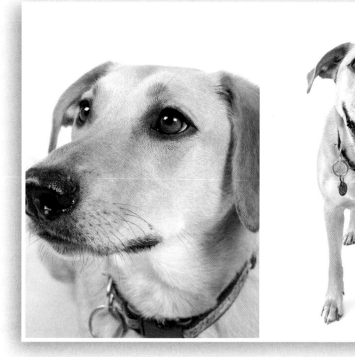

Libby came right after Parker, and she was just as fun and patient. Although I had a great time with these guys, studio photography never caught on with me. I am more in my element outdoors, using light from the sun.

24–70mm 2.8L lens @ 60mm (left), 24mm (right), f/11, 1/80 second, ISO 100, manual exposure, evaluative metering

This is what the behind-the-scenes looked like for Libby and Parker's shoot. This was a large studio I shared with three other photographers. The studio had a 30 foot long cyclorama wall—a studio photographer's dream.

Lighting Safety

DON'T TOUCH! As I mentioned earlier, hot continuous lights can become quite hot during operation. Many a photographer has knocked over a light and been terrified by the sparking and smoking, and sometimes even fire. Do not set up your hot lights near anything flammable. Because these lights will still hold a charge when broken (thus, the term "continuous"), they are still powered on even when lying on the floor in pieces. Unplug them if they fall, and immediately cordon off the animal so that you can pick up any broken glass. Honestly, in the worst-case scenario, I'd rather have to stomp out a small fire than attend to a dog's cut and bleeding feet and an upset owner. If you are shooting with bulbs, ensure that you have extras on hand in case one blows or breaks. The time when you don't have a backup bulb is the time when you can't reschedule a shoot due to pet illness or owner traveling. (Remember that Murphy guy?)

Tape your cords securely to floors and walkways, either in small strips or with caution tape. Make your human subjects aware of the locations of any cords and try to keep them out of the way of your pets as much as possible. Always be aware of where the pet is in relation to your light; you might have to quickly reach out a grab a falling stand!

Use sandbags to stabilize your light stands and backdrop to prevent your subjects from knocking them over. Place the sandbags on the base of each of your stands. This is very important, both to keep your subjects safe and to protect your expensive gear. Plan to use at least one sandbag for every stand you have that could be knocked over. You might want to cover them with plastic because some male dogs like to urinate to mark their territory, and those sandbags are the perfect spot for them to do it. Hey, that light stand just looks like a skinny black tree to them.

The Pros and Cons of Studio Lighting

There are many benefits that you can derive from studio lights. And, of course, there are always downsides.

Pros

They can make for very dramatic shots and can easily fill a whole room and add consistency to difficult lighting scenarios. Studio lights are great for events and mini-shoots, during which you'll be shooting lots of dogs, one right after another. You can achieve the high-key look (mostly white and light-toned images with white backdrops) with studio lights, which can be challenging to do with natural light. (There is a way to accomplish this in natural light. See the section "Natural Light Studio Pet Photography," later in this chapter.) You have great creativity and control over how you want your light to look, which direction you want it coming from, and what the background looks like, which can help you really create your own personal style of pet photography.

Cons

Studio lights are not without their faults. For example, it takes time to learn, study, and master them, and it can be expensive (there's a lot of additional gear required). It can be complicated and time-consuming to set up and tear down if you are not in a fixed location, which limits you to a "set," which

in turn limits your settings (sync speeds can dictate your camera settings, which can slow your shutter speed way down, unless your camera body is capable of shooting at higher speeds with flash).

Usually you are shooting on seamless paper backdrops, which get dirty, necessitating good detail editing skills with software. Even if you do have a fixed location, you might have challenges getting your setup how you need it if you aren't working in a large space with a tall ceiling. You need to be good at math to really get the process down, unless you have someone to walk you through it and show you exactly what you need to use in order to get the look you want. If power, electricity, and the potential for occasional broken glass and smoke scare you, as they do me, you might not ever feel 100 percent comfortable working with studio lighting. Those things are just a part of life in the studio.

Studio lighting is best for pet photographers who have a fixed location with plenty of space where they can provide ongoing studio pet photography services. Of course, the downside to having a studio is the monthly cost in rent and utilities as well as the travel time to work each day. If you have extra space where you can set up a studio in your home this can be an option, but you have to be comfortable with not having any separation between your business life and personal life, and you need to feel comfortable having clients come to your home and knowing where you live. (Murphy's Law dictates they'll show up unannounced on your day off, when you are in your undies, drinking a beer!) An ideal situation is one in which you share a studio space with another photographer, sharing the cost of rent, utilities, and lighting gear.

If you co-own lighting gear, make sure you have a professionally prepared agreement in writing that governs its use and covers contingencies such as damage and liabilities.

Natural Light Studio Pet Photography

You can mimic the high-key studio photography look with the right set up by using full, bright natural light—followed by a little bit of creative post-shoot editing.

Try setting up four large (4' × 8') thick pieces of foamcore, taped together on the backside (you can purchase these at an art supply store) and a single tile board. Place the setup near a large window with a solid swath of strong natural light.

You can also try this setup with your E-TTL flash. Try grabbing a couple more foamcore boards in varying sizes to use as bounce flash surfaces. Get creative and you might discover something totally new that you absolutely love. Take a look at strobist.blogspot.com for inspiration.

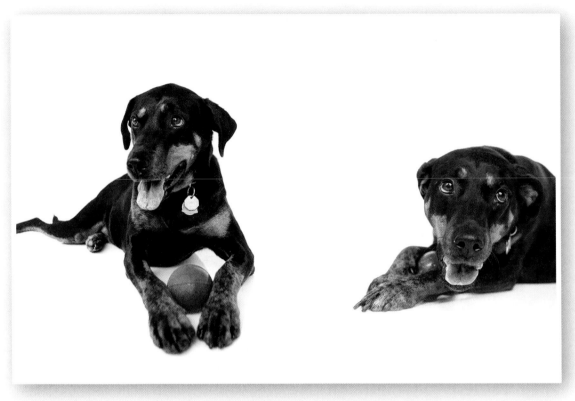

After breaking a strobe light on a studio shoot, I was spooked enough that I thought I'd try seeing if I could come up with similar results with natural light and post-shoot editing. It takes quite a bit of work with software, but you can get similar results by using some foamcore boards and natural light.

24–70mm 2.8L lens @ 25mm, f/2.8, 1/500 second, ISO 1600 (Note the difference between this and the strobe shots), aperture priority, partial metering. Lots of Lightroom work.

A Special Note on Ring Lights

Because animals have much more sensitive retinas than humans (this is how your dog is able to lead you down a darkened path, or your cat can see in a pitch-black room), it is not recommended to use ring flashes, which can be painful for an animal. It's best to use another type of lighting, because the last thing you want to do is damage your beloved subject's vision. It's much better to use a diffused light such as a strobe or continuous light shot through a soft box or umbrella. If you are in doubt, bring your ring light in and consult your veterinarian, who can provide medical information on the effects of ring flash.

A Special Note on Using Flash with Horses

Because horses are prey animals, they can startle easily, and one way you can accomplish this is to use flash photography while they are in the ring, especially if they are involved in a competition with a rider. Bright flashes of light can trigger fear-based reactions; to a horse, they can resemble lightning storms. Flashes of light can cause a horse to bolt, which would be a very bad and potentially dangerous thing to have happen during a competition. Don't be the cause of major disruption to a horse event. Put your flash away and use the beauty and power of natural light, instead.

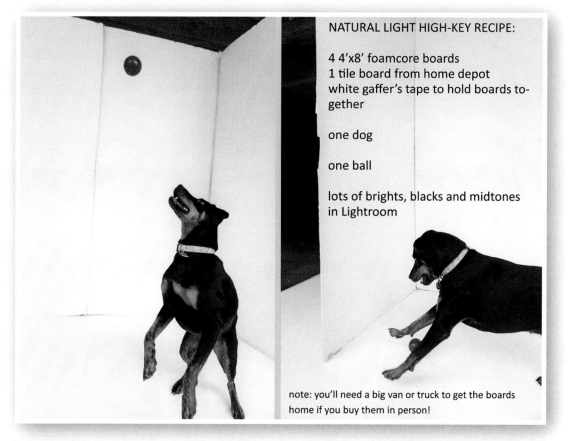

NATURAL LIGHT HIGH-KEY RECIPE:

4 4'x8' foamcore boards
1 tile board from home depot
white gaffer's tape to hold boards together

one dog

one ball

lots of brights, blacks and midtones in Lightroom

note: you'll need a big van or truck to get the boards home if you buy them in person!

This is what the behind-the-scenes looked like. Nothing much to it but some foamcore boards, gaffer's tape, a glossy tile board, a dog, and a ball.

Lighting Pet Peeves

For those of you keeping count, this section title makes the third bad pun that I slipped by the editorial staff. But, bad jokes aside, here are a few lighting issues that can really get under your skin, along with a few thoughts on how to avoid them.

Dark Eyes/No Catchlights

A catchlight is the little white reflection in an animal or human's eye. Look in the mirror at the catchlights in your own eyes if this is a new concept to you. Make sure there is always light reflected in the subject eyes; overlooking this is one of the biggest and easiest to correct newbie mistakes. Dark eyes lacking catchlights in an animal can make them look dead or haunted, neither of which are desirable looks to most pet owners.

Noise

If you're shooting in high ISO in low-light situations, you can end up with a great deal of noise in the image. Your objective is to try to keep your ISO as low as possible while keeping your shutter speed high enough to get a blur-free shot. But sometimes, in spite of your best efforts, your ISO might still be high enough that some noise is introduced. Don't worry about that, because as I regularly say, noise can be fixed later on in software but blur can't. Also, keep in mind that if you are underexposing shots that were created at a high ISO and need to brighten them later with software, the noise will be significant and visible in the dark areas. If you have to shoot at high ISOs, err on the side of overexposure for this reason.

Flashy-ness

Nine times out of ten, using a flash during pet photography is a bad idea (especially inside, at night, pointed right at the animal). If you use flash properly, the average person looking at the final image will not be able to tell there is a flash being used. Avoid this by turning off your flash, heading outside into natural light, or by using bounce flash.

Mixed Light

Because light has different temperatures, if you have multiple sources of light you will have mixed temperatures in your image. This can often happen when photographing pets indoors, where you can have natural light, incandescent bulbs, and fluorescent bulbs all in the same scene. Watch for this when composing your shot, and if it's a problem (you might notice it if there are weird white balance issues in different parts of the shot when viewing it on your LCD screen), then move to a different room or area, or shift your position to remove one of the offending light sources from your composition. Also keep in mind that whatever the animal is sitting on will reflect light back onto them.

Not Enough Light

Sometimes, you just don't have enough light. Sometimes, the only thing you can do here is open your aperture, try to steady your hand, bring up your ISO, take a deep breath when you depress the shutter, and then plan to print the image in black and white. But ask yourself first if there is a way to shed more light on this subject.

Ugly Light

Dull, dark, dirty, dingy, muddy light! We get a lot of that in Seattle a good six months out of the year. Occasionally, when I get home from a shoot and review the images, it looks like they have a hangover. I can show you how to fix this with software, but if you notice this ugly look during your shoot, try overexposing by an f-stop, spot metering off an 18 percent gray area or midtone, or shifting your color balance to the blue side.

You cannot avoid all lighting issues in pet photography, but hopefully with the knowledge you've gained from this chapter, you will be better armed to deal with problematic issues if or when they arise.

Exercises

1. Try creating silhouette images, wherein the pet (photographed outdoors) is backlit by the sun. Use spot metering to create the proper exposure for the sky, focusing on the pet.

2. Experiment with a reflector, positioning it so that it does the following: reflects the light, decreases the light, or diffuses the light (using a five-sided reflector).

3. Use your flash indoors, either bounced off a wall or ceiling or off-shoe with an off-shoe cord. Experiment with the exposure compensation on the flash and see how the results change as the flash output changes.

4. If you have an interest in studio pet photography and have yet to try it, rent a light or two from your local camera store or online and do a studio lighting shoot to see how you like it. If you already do studio photography and are used to using either strobe or continuous lights, try changing things up by using a light source you don't normally use, or try replicating natural light studio photography and see what you think of the results.

5. Try to capture the perfect catchlights photo: a close-up of a cat or dog looking up, with you either at their level or lower such that you can clearly see the catchlights in their eyes.

Chapter Seven

Composition

- ☆ The Rule of Thirds
- ☆ Negative Space
- ☆ Pet-Level Photography
- ☆ PLP in Motion
- ☆ Capturing Expressions
- ☆ General Ideas
- ☆ Using Lenses for Variety in Composition
- ☆ Photographing Pets with Their Owners
- ☆ Photographing Multiple Pets
- ☆ Location Ideas
- ☆ Ten Ideas for Getting Variety in Every Session
- ☆ Capturing the Stages in a Pet's Life
- ☆ Pet Photography Don'ts

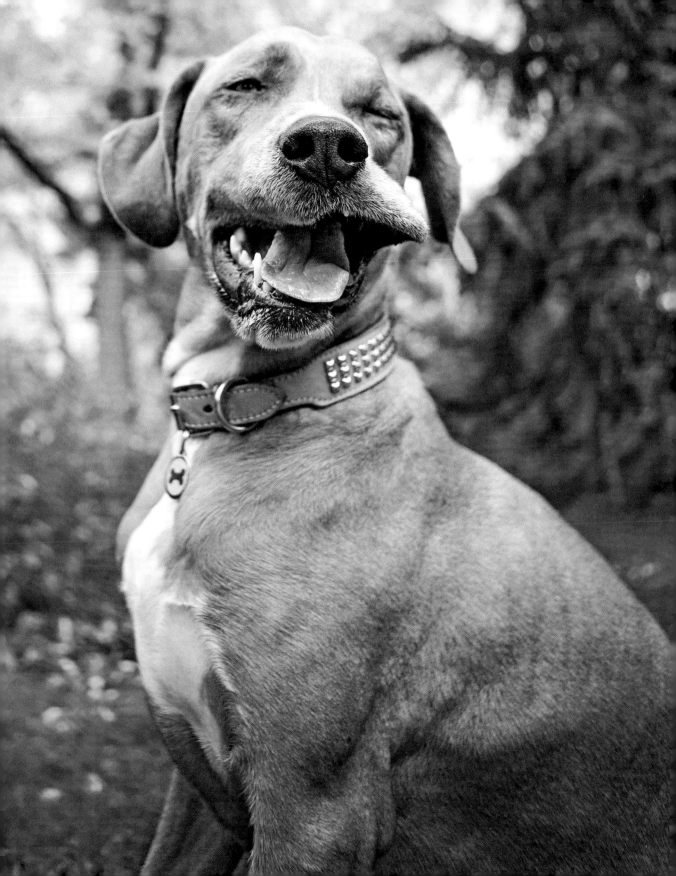

The Rule of Thirds

The *rule of thirds* in photography is a general rule, or guideline, that to create the most interesting, artistic, balanced, and dynamic composition, the image should be divided into nine equal parts, or thirds, both horizontally and vertically (think of a tic-tac-toe grid), and the subject of the photo—the most important or interesting part—should lie under one of the intersecting lines, such as in the photo of Mickey.

This might be easier to understand by visualizing the inverse of the rule of thirds: the subject is positioned smack-dab in the center of the frame (the center square or rectangle), which is usually, but not always, a less desirable look from the standpoint of artistic composition.

There are times when you decide that you do want your subject in the center of the frame, such as in the shot of Lucy on the next page, which technically breaks with the guidelines set forth in the rule of thirds. The focus of the viewer's eye is immediately drawn to the center of the frame (Lucy's little tongue), which is exactly where I wanted it to be when I captured this shot. When you place your subject in the center of the frame, this should be done intentionally and strategically to enhance the overall impact of the photo. Here, Lucy's tongue is dead-center, but the top of her head and ears are cropped off, which make the composition more interesting.

The upshot of the rule of thirds is that you get to decide for yourself if the composition of a photograph is compelling or not. But if you plan to break the rule, be sure you have a reason in mind for doing so. Veering from the standards of what looks good should be done deliberately and strategically.

Mickey's composition was achieved by cropping. I used rule of thirds when I was deciding how to crop the final shot.

20mm 2.8 lens @ 20mm, f/6.3, 1/320 second, ISO 160, aperture priority, spot metering

Willy's composition isn't very interesting because his face is in the center of the frame. If I had framed him so that his eyes were closer to the bottom line, it would have been more interesting. All I would have needed to do was move forward about a foot, and the composition would have been improved.

20mm 2.8 Lens @20mm, f/2.8, 1/3200 second, ISO 250, aperture priority, evaluative metering

Lucy's tongue proves that sometimes rules are made to be broken.

24–70mm 2.8L lens @ 70mm, f/2.8, 1/250 second, ISO 1250, aperture priority, evaluative metering

Negative Space

Another important artistic concept I learned from my artist mom while growing up is that of *negative space*. She explained it to me like this:

> *"The space around the subject—the empty space (negative space)— is just as important as the shape the subject itself makes."*

This shot of Astro creates interesting negative space, which is highlighted as the black area on the right side of the image.

With the dog cut out, the surrounding shape left behind is still visually interesting.

20mm 2.8 lens @ 20mm, f/2.8, 1/500 second, ISO 1600, aperture priority, spot metering

You can also use negative space creatively to frame up your subject in an unusual way by placing it on the edge or corner of the frame, thus allowing the background be a large part of the photo. This usually works best if you are shooting at a shallow depth of field so that your subject remains the focus of your image. If the subject and the background were both in sharp focus in the image of Seymour, it wouldn't have the same impact.

Learn to see your backgrounds as much a part of the composition as you do your subjects and you can find new and interesting ways to frame those subjects by using negative space.

20mm 2.8 lens @ 20mm, f/4.0, 1/4000 second, ISO 1000, aperture priority, evaluative metering

Pet-Level Photography

Also commonly known as "shooting from the hip," pet-level photography (PLP) is a phrase I coined specific to pet photography that describes photos that are captured from the pet's visual level, whatever level that might happen to be. For a Great Dane, it will be your belly button; for a Chihuahua or kittens, it will be shins or ankles; for puppies, your knees; for a giant of a horse, your forehead (or even higher). You get the idea. I came up with the phrase pet-level photography because it's a more flexible concept to visualize than is shooting from the hip. When you hear that phrase, you need to think of where you are actually shooting from. Is it the hip this time? Or is it the shins, or ankles, or from a step stool? So, I came up with a blanket phrase that I feel is more accurate—and applicable—for pet photography. The strategy with PLP is to capture your photos from the same vertical plane on which they experience and see the world—the same plane on which they explore, sniff, live, and play.

Most animals don't experience the world from the same perspective that humans do, and being able to get in their world and see it through their eyes will revolutionize your photography. One of the hallmarks of great professional pet photographers is photos taken on the pet's level, as if through the eyes of one of their buddies.

So how do you create photos that are taken on the pet's level? In the following subsections, I'll give you some ideas.

Elevate Your Subject

In the shot of Sienna (left), I placed her on a cool mosaic dining room table, so I was able to easily photograph her at her level. You could say that she was meeting me half way.

Sienna's devoted mom was just outside the frame on the left side, ready to grab her should she be inclined to jump.

I nearly flipped when I discovered that Sienna's eyes matched the color of her owner's dining table. I just had to have some shots of her on it.

24–70mm 2.8L lens @ 23mm, f/3.2, 1/800 second, +0.33 exposure compensation, ISO 500, aperture priority, spot metering

A Word of Warning About Elevating Your Subject

You should always try to avoid placing a pet at a level higher than from which it can safely jump down. If you feel any concerns about the how high your subject is, be sure to have an assistant (the pet owner, perhaps) available to hold it by the backend while you zoom in on the front. If the shot ends up capturing the assistant, too, edit her out by using software, later on. Even the most normally obedient and relaxed animals can freak and jump if placed in an unfamiliar or unstable situation. I have safely photographed many a pet while up on ledges, planters, tables, and so on, but never without a handler next to or under them, ready to catch them if they jump or fall. No image, no matter how cool, is worth risking injury to the pet.

When I saw the flowers in the planter at waist height, I thought, "Oh, he is so going in there." Luckily, he was a good boy and stayed still while I snapped a few shots.

24mm 1.4L lens @ 24mm, f/1.4, 1/2000 second, +0.67 exposure compensation, ISO 250, aperture priority, partial metering

Get Down to Their Level

You can kneel, squat (my favorite because you can quickly spring back up again), lie down, sit—whatever gets you to your subjects level. If you find yourself kneeling a lot, it might be helpful to invest in some gardening knee pads, or as a colleague suggested, the kneepads worn by volleyball players. Sure you might look like a dork but they can enable you to get shots that you otherwise wouldn't have attempted. (Ever knelt on concrete?)

I was lying on my belly while photographing Samantha. I lay still until the perfect moment when she was in mid-stretch on her back. Doing this with a social cat usually entails them coming over right away to sniff you, rub you, or even try to eat your hair, which can make it pretty hard to photograph them. Samantha is a very shy kitty, so I knew there was little risk of that happening. She was the perfect kitty and stayed right where I hoped she would.

24mm 1.4 L lens @ 24mm, f/1.4, 1/250 second, ISO 500, manual exposure, partial metering

Shoot Blind

This involves holding your camera down at the subject's level and framing up without looking through the viewfinder. You can do this by bending at the waist and holding your camera down in front of you, or doing a partial squat without actually getting close to the ground. This is the hardest way to accomplish PLP and takes a lot of practice for obvious reasons (you can't see your light meter; you don't know what you are focusing or metering on; you can't compose visually; your subject is moving around), but it can also produce some of the most engaging photos. Try holding a treat or other motivator above the lens so that the pet isn't looking up at you, and aim the center point of the lens at its face.

Photographing Olivia with her toy at this level gives the impression that the camera is a little canine buddy that Olivia is trying to engage in play. Can you say, "awwww"?

24–70mm 2.8L lens @ 24mm, f/2.8, 1/320 second, ISO 800, manual exposure, evaluative metering

If you do this, you really need to be shooting in an automatic setting. I always laugh when I hear snooty photographers say, "Oh you positively *must* be shooting in full manual with spot metering at all times." I always think to myself, "try producing PLP while shooting blind and then come back and let me know how that worked out for you." As I mentioned earlier, sometimes rules are meant to be broken. Learn what works for you and do it, no matter what anyone else tells you. The key to getting good at this shooting style is practice. Practice, practice, practice, and then some more practice.

When shooting PLP blind, try using an aperture of f/4.5 or above. Shooting with a very wide aperture such as f/2.8 can be tricky because the depth of field is so shallow that it's difficult to get the eyes in focus when you can't see what you're aiming at. In pet photography, *it's critical that you always have the animal's eyes in focus* unless you are strategically focusing on something else. The eyes are the most expressive part of an animal; they are the element of a photo that engages the viewer more than anything else. As far as focusing is concerned, that will be the most challenging. I recommend using whatever focus setting with which you have the most experience and feel the most comfortable. Try using single-shot mode with a handful of active focus points in the center.

PLP in Motion

Given the nature of their personalities and their penchant for running around and playing, this is a somewhat dog-centric section. With that having been said, consider the challenge level of PLP shooting blind and then multiply that by 50. Now, you're approaching the difficulty factor for PLP in motion. With PLP in motion, you are creating images on the pet's level while running, jumping, jogging backwards, and so on.

Mac and Mable were interested in me and my camera, which made it easier to shoot blind PLP.

24–70mm 2.8L lens @ 24mm, f/2.8, 1/800 second, +0.67, ISO 400, aperture priority, partial metering

You will want to hold the camera in front of the pet, keeping the distance even between the camera and the pet while you both move. Of course, it's best to run forward instead of backward so that you don't run into something or fall over something (or worse, someone). For camera settings, try these: aperture priority, f/4.5; ISO 400; a shutter speed above 1/1000 second; evaluative or center-weighted metering; continuous/burst drive mode (this is the perfect instance for this mode); and AI Servo/ Continuous/AF-C. Getting the right combination of focus settings and active focus points for this can be very tricky because you are so close to the animal, but the best way to get good is to practice. You need to be in pretty decent physical shape and also have quick reflexes and reactions so that you can jump out of the way quickly if a dog is charging toward you or about to knock your camera out of your hands. A young, athletic soccer player who is experienced with a camera ought to be able to knock this one out of the park!

Diza is a star in front of the Cowbelly camera. I've photographed her numerous times for workshops, graffiti shoots, and others, and she has always given me hysterical images.

20mm 2.8 lens @ 20mm, f/2.8, 1/3200 second, ISO 640, aperture priority, evaluative metering

I don't recommend trying PLP in motion unless you have equipment insurance covering your gear and personal insurance covering… well, you. It's very easy to have a camera knocked out of your hands, lenses scratched or damaged, your arms and hands cut up by sharp claws, poked in the eye, pushed down and bruised, run into walls or poles, and all other manner of accident or injury—usually to you. You don't want to be paying out of pocket for these things if they happen.

All 100 pounds of Black Lab that is Eli nearly plowed me down many times during our shoot. The only reason I was able to keep myself and my gear in one piece was because I have twelve years of practice darting out of the way. So much practice, in fact, that I'm probably ready to photograph a bull fight from the Toreador's perspective, with my camera as the cape.

> PLP in motion is easiest with dogs that are under 40 pounds or knee level or shorter. The taller and bigger the dog, the harder the challenge will be.

This shot of Bella is an exception to how you need to expose in order to properly capture these shots. Here, I used spot metering and manual exposure, which is extremely challenging to do when you a) are running, b) can't see the light meter in your viewfinder, and c) are photographing a black dog with spot metering. Somehow this worked for me, although it often doesn't, for obvious reasons. Don't try this at home, kids! Or do try it! And then pat yourself on the back when it works out.

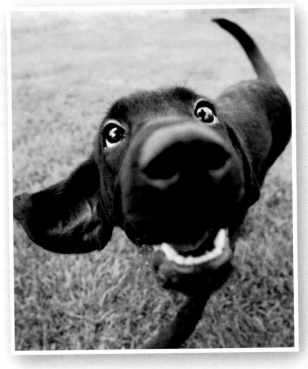

The fact that this shot of Bella was properly exposed has more to do with luck than skill.

20mm 2.8 lens @ 20mm, f/4.5, 1/1000 second, ISO 200, manual exposure, spot metering

Capturing Expressions

Expressions sell. Whether you are doing pet photography professionally and would like to sell products, "sell" an adoptable pet to a prospective adopter, or just want to make the owner fall in love with the images you created, expressions rule in pet photography. Being able to capture a variety of authentic, organic expressions will put you at the head of the pack when it comes to creating great pet images. Here are a variety of different ideas to help you accomplish this.

Let Your Subjects Be Themselves

Although we love them nearly as much as our own children, domesticated pets are still animals. Within reason, you need to let them follow their instincts, be free to behave in a way that's natural for them, and trust that humans will give them the latitude to do so. The less control you try to exert over an animal's behavior—any animal—the more natural and authentic your photos will be. Natural, authentic photos will capture natural, authentic expressions, whatever the animal is feeling in that moment. The best way to capture your subjects' most visceral expressions is to allow them to be expressed in the first place.

Put Your Subjects in Their Element

Their "element" will depend not only on the type of animal, but the temperament of the individual, as well. Some cats will come to life in a backyard filled with tweeting birds, whereas others might be terrified to venture past the sliding glass door. Some horses might love being ridden and like to show off for all who are watching; others would sooner be caught in a lightning storm than perform in front of a crowd with a rider on their back.

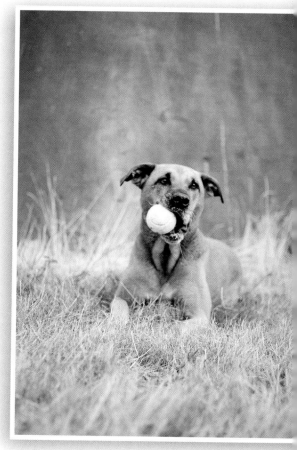

That said, for dogs especially, if you know the breed, you can make some good guesses as to how they'll behave and what kinds of expressions will be elicited in different environments. A small prey-driven Beagle will go nuts in a field of grass with rabbit holes everywhere or in a forest with squirrels scampering about.

Give a ball-hungry dog a ball and let it play and it will reward you with fun shots, such as this one of Bouncer.

24–70mm 2.8L lens @ 43mm, f/2.8, 1/2500 second, +0.33 exposure compensation, ISO 250, aperture priority, partial metering

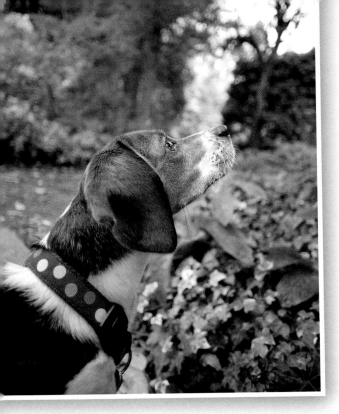

Hanalei stares up a tree, fixed on the squirrel she just chased.

20mm 2.8 lens @ 20mm, f/2.8, 1/320 second, ISO 1000, aperture priority, spot metering

An English Bulldog will be happy to give you some crazy-big smiley faces if you play tug of war with it, because this activity stirs its genetic memory of latching onto bulls in a ring. A swimming, ball-hungry Labrador Retriever will be similarly bright-eyed and smiley while fetching a ball thrown into a lake, which is reminiscent of going after the water fowl it was bred to retrieve.

Some pets just want to lie on their little bed on the couch and get snuggles; This is the environment in which they feel most comfortable and where they will be most expressive.

The best way to find out where a pet will feel most comfortable is to ask the owner. In Chapter 11, I give you some guidance as to what questions to ask prior to a shoot so that you can tailor each session to the individual animal. This will help you to determine when it will feel most in its element. For more information on the behavioral characteristics of various dog breeds, access the online bonus content at www.beautifulbeasties.com/books.

Talk to Them

Your voice is one of your most powerful tools you have at your disposal during a photo shoot with an animal. Whether you talk in happy, excited, loud tones; soft, soothing, gentle tones; or harsh, commanding tones, how you speak and your inflections will influence the entire shoot. With some animals all it takes is saying their name a certain way and you can influence their expressions—either for better or worse. I know that with my dog, Fergie, all I have to do is look at her and wag my finger, and she puts her head down and gives me sad eyes.

In general, when working with most dogs, you are going to want to talk to them with your "happy, excited" voice. This doesn't mean loud, it means how you might talk to a toddler who you are about to take on an outing to the zoo. When dog owners talk in their happy voice, this usually implies something desirable, and when you have a dog that is anticipating something desirable, it is more apt to behave the way that you want it to and interact and engage during the process. I often sound like a complete airhead during my shoots, saying things like, "ooooh, who's a good baby-buddy weetle doggie??; OH THUMPER's a good little doggie!! That's right Thumper!!; You havn' a good time little monkey baby boo-boo???; Oh, gooood doggie!!" I'm sure people passing by in parks think I have the IQ of a turtle, but I don't care, because it gets me the shots that I'm after.

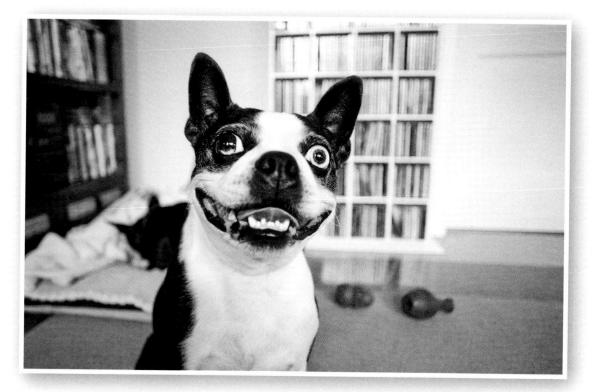

Bosco was listening to me ask him about his toys. Meanwhile, his sister plays in the background.

20mm 2.8 lens @ 20mm, f/2.8, 1/125 second, +0.33 exposure compensation, ISO 1250, aperture priority, evaluative metering

To do this, it's best *not* to talk to them while you are actively taking pictures, unless you are both moving. You don't want to have them shift position or move or walk away if they are in the place where you want them to be, which is likely if you are talking to them while taking pictures. But if they are doing a great job, and do a long sit/stay for you, be sure to praise them and soon as they break their stay! In Chapter 8, I talk about why this is so important when working with certain types of pet owners.

Make Noises

As a pet photographer, you will come up with some of the oddest noises you have ever heard emanate from your mouth and throat: a bird chirping, a kitten meowing, a puppy whining, a wolf howling, a duck calling; you name it. I remember seeing a YouTube video with a woman who was able to do impressions of around 50 different animals. I watched that and thought, "Wow, if she could operate a camera, she'd be a great pet photographer." Practice noises at home; see what your own pets respond to. Not all animals will respond to all animal noises, and the really, really smart ones will just look at you like you are completely out of your mind, but sometimes, all you need to capture one stellar shot is one perfect sound. Learn to nail a signature noise and you can coax alert/interested/excited expressions out of any animal.

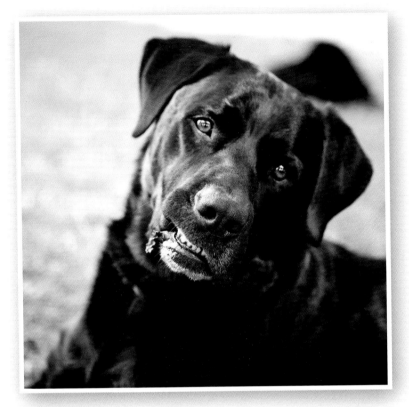

A few quick animal noises and I had Buddy looking my direction with an inquisitive look on his face.

24–70mm 2.8L lens @ 70mm, f/2.8, 1/160 second, +0.67 exposure compensation, ISO 400, aperture priority, evaluative metering

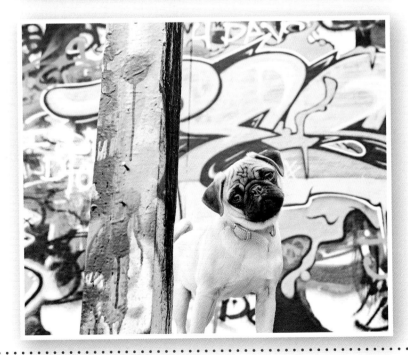

Pugs are notorious for giving you a head tilt. All it took with Mazzy was some kitten noises and she tilted her head every time.

24–70mm 2.8L lens @ 28mm, f/4.5, 1/1250 second, ISO 400, manual exposure, partial metering

Encourage Fun Play

Playing is something every animal does during its formative years. Watch any nature show and you'll see baby animals of all kinds romping, wrestling, tumbling, and just having fun. This is part of an animal's innate nature, and if you can find out what kind of play they find most enjoyable, you can be ready to capture those happy, fun, crazy expressions on their faces. Be sure to use a fast shutter speed while doing this so you don't end up with a bunch of blurry shots!

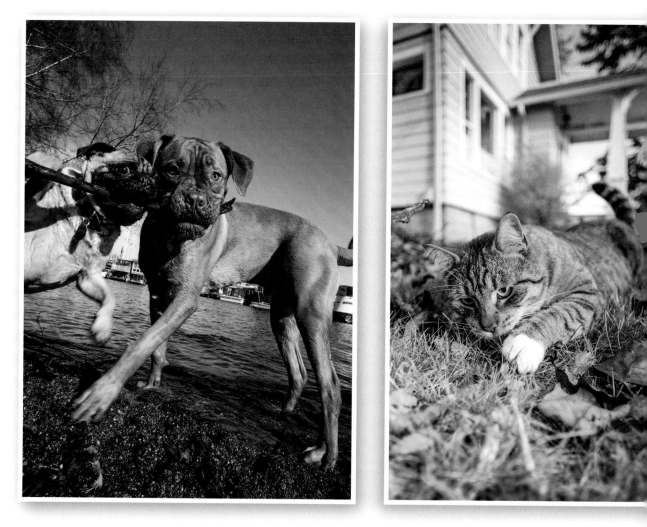

I had a pretty good idea that Kengo the French Mastiff would play with the stick. What surprised me was when his little Pug buddy Winston joined in on the fun.

20mm 2.8 lens @ 20mm, f/22, 1/160 second, ISO 640, aperture priority, evaluative metering

Kitties love to play, too! Here, all it took was rustling a stick in the grass to get SB's attention, which probably conjured the image of a snake or small rodent in his mind.

20mm 2.8 lens @ 20mm, f/3.2, 1/320 second, ISO 160, aperture priority, evaluative metering

Love, Snuggle, Pet, and Nurture Your Subject

Many domestic animals respond well to physical nurturing and will give you the sweetest expressions when they are being cuddled by either you or their owner. Plop a pet in its owner's lap, and be ready to capture some "awww"-inspiring expressions.

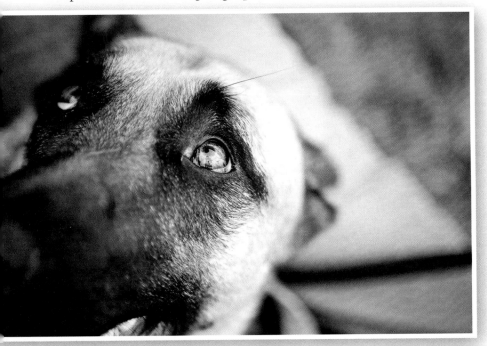

Janie had her head in her owner's lap and was looking up at her lovingly, and her owner gave her pets and love.

24-70mm 2.8L lens @ 70mm, f/2.8, 1/1000 second, +1.0 exposure compensation, aperture priority, evaluative metering

Tyson rested in his owner's lap at the end of a shoot, and his little lip pooched out in the most adorable way.

20mm 2.8 lens @ 20mm, f/2.8, 1/100 second, ISO 1250, aperture priority, evaluative metering

Increase Your Shutter Speed

A fast shutter speed allows you to capture moments that you wouldn't otherwise get. If you have good natural light and can bump up the speed, go for it. You never know what you'll get.

This shot of Apollo is what I call a "happy accident," but the fast shutter speed I was working with made it possible in the first place.

24–70mm 2.8L lens @ 24mm, f/2.8, 1/1000 second, ISO 200, aperture priority, evaluative metering

General Ideas

Let the Weather Work for You, Not Against You

Part of the challenge when photographing pets outdoors is that you're at the mercy of Mother Nature's whims, who might have different things in mind for your big shoot day than you do. Don't let this deter you; some of the cutest shots can be captured in bad weather. A long-eared dog on a windy day is pet photography gold.

Storms can make for really dramatic skies, and dogs romping in rainy mud puddles with muddy mugs can make for some really cute pictures. Don't let the weather get you down if you have a willing subject and easy-going pet parent. (Just make sure if you are shooting in the rain that you either have a weather-proof body or camera housing.) Of course, never venture out in a lightning storm or ask your pet parents to drive through dangerous weather (such as an ice storm) to meet you. It isn't worth putting yourself, the pet owner, or the animals in danger.

The weather was crummy that day and I was skeptical that I'd get anything worth jumping for joy, but when I saw what Hana's ears did when the wind blew, I ended up pretty excited. I have over a dozen shots like this one in different locations during the shoot.

20mm 2.8 lens @ 20mm, f/2.8, 1/1250 second, ISO 500, +0.67 exposure compensation, aperture priority, spot metering

A little bit of rain didn't deter Fergie and me from doing a shoot at her favorite park. Like Hana's bad-weather shoot, my expectations were low, but I will treasure this muddy dog shot forever.

20mm 2.8 lens @ 20mm, f/5, 1/800 second, ISO 1250, aperture priority, evaluative metering

Tell a Story

Tell a story with your images by putting the pet in a certain time and place so that its owner can look back upon it with fond memories well into the future. The shot of Ruby on the left shows her looking toward her beach house from the beach, waiting for her owners to come down and throw the ball for her. The shot of her on the right shows her heading up the stairs to her beach house, looking back as if to say, "are you coming?"

Ruby's beach house will be forever cemented in her owner's mind visually, now that she has these images to preserve the memories.

Left: 20mm 2.8 lens @ 20mm, f/5, 1/320 second, ISO 500, aperture priority, evaluative metering. Right: 20mm 2.8 lens @ 20mm, f/4, 1/50 second, ISO 1600, aperture priority, evaluative metering.

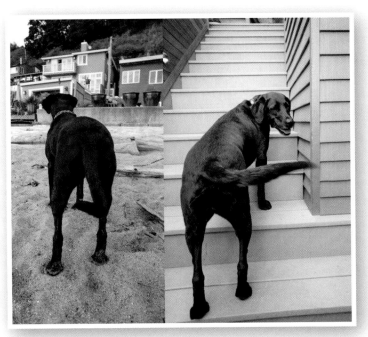

Put Your Subjects in or on Things

This is fun to do with small dogs. Be on the lookout for interesting/colorful/cool spots to stick them. Although I try not to be a flower killer, I've been known to stick a Chihuahua or two into a planter box to get a great shot. Just make sure it's either *your* flower box, or you have permission first. Some more ideas include red Radio Flyer wagons, metal bins, baskets, boxes, old bathtubs, old chairs, old couches—anything old, vintage, colorful, or interesting.

Make Use of Color

Using color is one of my favorite ways to create interesting photographs during a shoot. You can use color by placing a dog in a similarly colored environment and having just one standout color. You can place an animal in front of a backdrop that is the same color as its fur for dramatic effect, or use a contrasting color to make the fur really stand out. You can make the animal's eyes pop by placing it in front of a background of matching color. Play around with color during your shoots and you will come up with some really creative ways to use it.

Diablo looks pretty cute in a window box filled with flowers.

20mm 2.8 lens @ 20mm, f/2.8, 1/400 second, ISO 1000, aperture priority, evaluative metering

Use what's available to create interest in your shoots. Here I used a vintage pink chair and a toy.

20mm 2.8 lens @ 20mm, f/2.8, 1/80 second, ISO 640, manual exposure, spot metering

Henrietta looks great with her black and white fur in gray sand next to a bright red fire hydrant.

24–70mm 2.8L lens, f/4.0, 1/2500 second, ISO 1000, manual exposure, evaluative metering

The black in Ellie's fur looks great against the blue of the industrial container.

7.8mm, f/2.8, 1/640 second, ISO 160, manual exposure, evaluative metering

Tire Out Overactive Pets

Sometimes, all it takes to make a success out of shoot with a rambunctious animal that isn't going well is a little time to wear it out. When it has run out of energy and is relaxing, this can be the time you get those one-in-a-million shots, like the photo of Bean on the next page, on his back, smiling.

Stand Back but Act Fast

If you aren't sure what do to next, just sit back and wait. Hone those lightning-fast reflexes and be ready to capture the shot the split second it happens, such as I did with the photo of Ollie on the next page, licking his chops.

Enhance Your Shots by Using Props

Wherever you photograph pets, there are many props you can use to enhance your photos. For cats, you can include colored yarn, cat toys, paper bags, and boxes; for dogs try balloons, bubbles, brightly colored toys, collars, bow-ties, hats, ear muffs, and glasses. For small animals, you could try stuffed animals, blankets, colorful chairs, and colorful bowls.

After non-stop running and playing, Bean finally plopped down at the end of our shoot and gave me some great smiles while lying on his back.

7.8mm, f/3.2, 1/500 second, ISO 200, manual exposure, evaluative metering

I wasn't expecting anything specific from Ollie here, so I just stood in front of him and waited. I was ready for his big tongue lick when it happened!

20mm 2.8 lens @ 20mm, f/2.8, 1/125 second, ISO 1000, aperture priority, evaluative metering

This cute pink plush dog toy was Fang's favorite toy, and it made the perfect prop for a shoot.

24–70mm 2.8L lens @ 30mm, f/2.8, 1/1000 second, ISO 500, –0.67 exposure compensation, aperture priority, evaluative metering

Zoe nearly went berserk when I pulled my balloons out. Not only did it make a colorful addition to our photos, it also provided a super fun time for her.

20mm 2.8 lens @ 20mm, f/2.8, 1/1250 second, ISO 100, aperture priority, evaluative metering

Get Your Subject to Perform Tricks

Ask owners if their pet knows any tricks. And this isn't just restricted to dogs, by the way. I've encountered cats that respond to commands, too. If you can get a pet waving its paw or performing another "awww-inspiring" trick, you will win the heart of the owner with your photo.

Be Patient and Wait Them Out

I had only been in business for a year when client asked me to get a shot of her dog with his tongue out and another with his ears cockeyed. We spent the entire 90-minute shoot with his ears in place (non-cockeyed) and his tongue in. "But he does it all the time," she swore to me. I was about to head out the door, but I thought maybe, just maybe, I'd still get the shot, so I kept my camera out of the bag. That was when Josh lay down, cocked his ear over, and lopped his tongue out, exhausted from the shoot. It wasn't exactly what I had envisioned but my client was thrilled, and that was all that mattered to me. Sometimes, you just need to wait an animal out until the point when you think they aren't going to do it (whatever "it" is), and then they surprise you.

I had to get just the right angle to capture Eden's "shake."

20mm 2.8 lens @ 20mm, f/2.8, 1/2000 second, ISO 1000, +0.67 exposure compensation, aperture priority, evaluative metering

Diza balances a treat on her little pug nose.

70–200mm f/4 IS L lens @ 100mm, f/4.0, 1/200 second, ISO 320, +1 exposure compensation, aperture priority, evlautive metering

Even though he was on his side, I was very happy to get Josh's ear in its cockeyed position, and his tongue flopping on the ground.

9.7mm, f/2.8, 1/15 second, ISO 200, auto, pattern metering

You Might Need to Train the Hard Ones

Even dogs with little or no training can be conditioned to behave in a certain way in a short period of time. Start your session with some basic "sit" training, move onto "down" in another 30 minutes, and then work on "stay" in another 30 minutes, all done while you are photographing them. You'd be surprised to find that even unruly dogs will begin to listen to commands toward the end of a session, some of whom won't even break a sit-stay at the end of the shoot because they finally understand what is being asked of them. Dogs are smart and they're fast learners, and all they need is the opportunity to succeed. Even if the last 15 minutes of a shoot are the best you can get, 15 minutes is better than nothing.

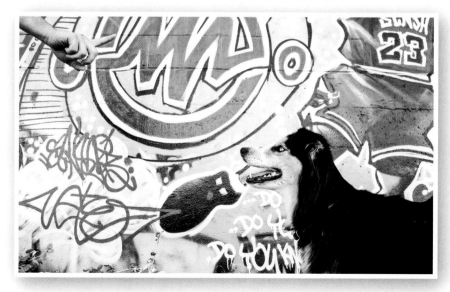

Jada was actually very well behaved, but we just wanted to make sure she didn't move an inch, because I had her right where I wanted her for this Graffiti Dogs Project shot.

24–70mm 2.8L lens @ 28mm, f/6.3, 1/100 second, ISO 200, manual exposure, spot metering

Take Advantage of the Pet's Owner

There will be times when you are in the perfect position to capture a shot and the pet is in the perfect position but facing the wrong way. You know if you move a muscle, the pet will move, but you need to focus its attention in a certain direction. One way to solve this is to have the owner stand behind, you looking over your shoulder, if you want the pet to look at you. If you want to capture the pet's profile, have the owner stand to the side of the pet, just outside the frame, which is what we did for this shot of Mylla.

As I mentioned in Chapter 6, you can also use the owner to hold a reflector in the perfect position if you can't manage it yourself. An owner can also be great for stepping in quickly to give a treat and then stepping back out of the frame. They can also help you accomplish head tilts or alert looks by saying key words to the pet. Oftentimes, owners can get their pets to do things that neither you nor anyone else can do, so don't be afraid to ask for their help. Dogs trust their owners and often pay far more attention to them, so put this asset to good use in your sessions.

Dress Up Your Subject

Some people think it's cheap and cheesy to put a pet in costume, but it can be done right and to good effect. Just ensure that the outfit matches the pet's personality and doesn't look completely out of place for the time of year (for instance, a raincoat in summer).

Mylla looks at her owner while I line up for the perfect composition.

24–70mm 2.8L lens @ 25mm, f/2.8, 1/1250 second, ISO 200, aperture priority, evaluative metering

Champ's bright yellow rain slicker was the perfect accessory for this rainy-day shoot.

24–70mm 2.8L lens @ 40mm, f/2.8, 1/400 second, ISO 1250, manual exposure, evaluative metering

Lucy's pink polo shirt was a perfect match for her sweet little personality.

7.8mm, f/2.8, 1/80 second, ISO 160, pattern metering

Using Lenses for Variety in Composition

Producing a great variety of different shots in every shoot is important if you are doing pet photography professionally; the more variety of shots the owner sees, the more inclined they are to purchase more products. Imagine a gallery filled with 30 images of a pet. In 10 of the images, the pet is sitting in the grass, with its head turned in different directions in each shot. In another 10, it's lying on a couch, with a slightly different angle captured in each shot. In the final 10 shots, it's sitting on the front porch, either looking to the left or right. My guess is that the pet owner will want three images—you end up selling just three products for all that work. Now imagine a gallery filled with 30 images of a dog, in which each captures a different scene with different colors, different backgrounds, and different expressions. Some are detail shots, some are action shots, some are controlled, static shots, some are taken from the side, some from the front, a few from behind, but all of them are different. How many photos do you think this owner will purchase this time? A hundred bucks says they want all of them. If you are selling a photobook or wall galleries of multiple prints, this will make your job easy for you. The upshot here is how you shoot can help dictate your sales. Your goal for every shoot should be to hear the client say, "I want them all!!"

One way you can get variety in each of your shoots, no matter the location, is to use many different lenses in each shoot. In the following sections, I describe various types of lenses and explain how you can use them to create many different looks. Even if you only have one zoom lens, you can still reproduce many of these shots.

f/1.2 and f/1.4 Shallow Depth-of-Field Primes

With these lenses, you can create that sought-after super creamy bokeh, which can give you an instant professional look. Focusing is tricky, but the extra work is worth it. Use these at the end of the shoot when the pet is nice and mellow and not moving around much. Shoot at an aperture between f/1.2 and f/1.6

Wide-Angle

Anyone care for some big animal noses? These lenses can be fun when used up close to your subject. And, of course, aside from their more whimsical uses, wide angle lenses help you to capture a wide scene such as a landscape or cityscape.

Mid-Range Zoom

Use these for your everyday shots. Mid-range zooms produce images that are appealing to most pet owners. Every lens has a sweet spot in terms of aperture (where it has the best sharpness, clarity and contrast). Find out what yours is, use it with your mid-range zoom lens, experimenting with different focal lengths, and you will fall in love with the results every time you hit that mark.

Macro

With these lenses you can capture the details that pet owners love so much, from the whiskers all the way down to the feet, hooves, or paws.

Telephoto

If you're Planning to capture the action from afar, (similar to how a photojournalist does), try using telephoto lenses. These are also great for pulling in a scene behind an animal. To do this you will want to stand back as far as you can and zoom all the way in on the scene.

These images were all captured between f/1.4 and f/1.8.

These images were all captured between 20mm and 24mm.

These images were all created between 45mm and 65mm.

These images were all created between 115mm and 200mm.

These macro-like close-up images were all created with a zoom lens at 70mm.

Photographing Pets with Their Owners

Before you point your camera at a pet's owner, you need to be sure that she wants like to be included in the photos. Many owners would prefer for you to simply focus on their pets, whereas some would like posed family photos with their pet, or shots of the two of them interacting organically in a more abstract way. Even if they are resistant, it's always a great idea to try to capture the connection between pet owner and pet, and there are ways to do it so that the person doesn't feel anxious or insecure. Here are some ideas you can try during your next pet/owner shoot:

♦ Pose the owner holding the pet in her arms, either holding it up or in her lap. This is a great thing to do at the end of a shoot when the pet is tired.

♦ Photograph the owner at a shallow depth of field, either from behind the pet or with the pet facing the camera so that the owner is blurry but the pet is in focus

♦ Capture one or two pets sitting between their owners on a couch or step.

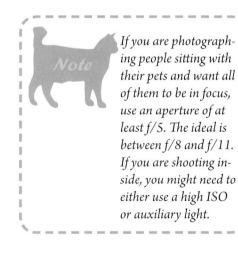

Note — *If you are photographing people sitting with their pets and want all of them to be in focus, use an aperture of at least f/5. The ideal is between f/8 and f/11. If you are shooting inside, you might need to either use a high ISO or auxiliary light.*

- Ask the owner to play with her pet, and capture the action as it happens organically. Tug-of-war is a fun activity to capture.

- Capture kisses from dog to the owner. A gentle lick on the nose is sure to amp up the "awww" factor of a photo.

- Capture the owner giving her pet a tender kiss on the head.

- Photograph owner and pet touching noses or foreheads. Cats love to do the "forehead bump," and being able to capture this between cat and owner can be very sweet.

- Photograph the pet nuzzling its owner (cats). Kitties rubbing against their owner's legs can show affection and connection in your photos.

- Capture the owner walking with her pet from in front or behind. This is great with a dog on a leash in a park or on a sidewalk.

- Place the pet's foot or feet in the owner's hand and capture photos of them "holding hands."

- Capture a child or multiple children hugging their pet. (Make sure the pet likes to be hugged first or its distressed look will show in the photos.)

- Pose the owner holding the pet over her shoulder and then photograph them from behind, with the pet looking over the owner's shoulder in the direction the camera.

- Ask the owner to wear colorful shoes, and capture the pet between the owner's feet. (Funny slippers with cats are a fun idea here).

- Photograph the owner brushing her pet (great with cats).

- Photograph the pet and owner interacting organically in their home, using a detached, photojournalistic style.

If the owner is feeling insecure about how she will look on film, try to capture most of the shots in which she appears from a higher angle looking down at her, and use a shallow depth of field to blur out any problem areas. You can also take all of your shots from her neck down, or even the waist down and focus on the owner's hands on her pet. Try to use a flattering focal length (for example, between 50mm and 85mm) to avoid the "big-head" look that wide-angle focal lengths produce.

Photographing Multiple Pets

Photographing multiple pets together can be tricky, whether it's just two animals or a household full of them. Photographing interspecies pets ups the challenge factor, as does bad light or pets that don't get along with each other. While capturing great photos of pets together isn't always possible, here are some tips that should help you to feel confident enough to take on the task the next time a multiple-pet owner asks, "Hey, can you get some shots of all of them together?"

Line 'Em Up!

The easiest way to do this with indoor animals is to pose them all on a couch. If some of the animals aren't playing nice, you can have one or more on the couch and one on the floor in front of the couch. Just make sure you are shooting at a high f-stop so that you get them all in focus. If the shoot is taking place in a dimly lit home, you'll need to crank your ISO way up to prevent blur. If you're shooting outside, find a place to line them up that makes it hard for them to run or explore, such as a short ledge.

Set Your Camera to Burst Mode

Take several shots of the same setup, even if it appears as though the animals haven't moved. You can do this by either waiting for a second between each shot, or setting your camera to burst mode.

Diablo wasn't too thrilled to sit next to his brothers, but he did it anyway.

20mm 2.8 lens @ 20mm, f/3.5, 1/2000 second, ISO 1000, aperture priority, spot metering

In the shot on the left, Ramon was blinking; in the shot on the right, Beau was blinking. The shot in the middle is just right.

20mm 2.8 lens @ 20mm, f/2.8, 1/8000 second, ISO 1250, aperture priority, evaluative metering

Recruit and Use Handlers

The more animals you are trying to wrangle, the more handlers you will need. Generally, two animals can be handled between you and the pets' owner, but once you start getting up to three, four, five or more pets, and you plan to pose them all together, you are going to need more hands on deck. If you are doing pet photography professionally and need to hire a handler or trainer to assist on a shoot with many pets, be sure to advise the owner ahead of time of the extra cost of the handler, and, of course, don't forget to include it in the bill. It can take as many as six or seven hours to photograph a litter of puppies lined up in a row.

Try Using High-Value Treats

Treats like string cheese, liver, or dried salmon for dogs, or canned tuna, canned salmon, or organic catnip for cats can turn normally finicky pets into putty in your hands.

Stick Them in Something

If the animals are small, like puppies or kitties, you can easily keep them corralled by sticking them in something that's hard for them to climb out of, such as a large basket or metal tub.

Be Patient and Take Your Time

This isn't a race to the finish. If the owner has his heart set on shots of all of his pets together, take your time and plan to spend a good chunk of your shoot making this happen. You will take many shots, and it might take five times longer than getting a great shot of a single animal, but the rewards will be worth it, especially if the owner would like to see the finished product blown up on a large canvas, and you are the business owner who would be happy to sell it to him.

Prepare for the Shoot

Communicate with the pets' owner prior to the shoot so that you have a good understanding of what all of the animals' behaviors are like and how they interact with one another. If you know the dogs are high-energy types, ask the owner to walk or run them ahead of time to wear them out a bit. If you know the cats are prone to napping all day long, ask the owner to keep them awake for several hours before you arrive. Sometimes, the best tool you have going into a shoot is knowledge.

I had just an hour to capture a shot of these puppies that would be appearing on bags of dog food worldwide for a major commercial client. Luckily, the breeder had the perfect basket to put them in, which made my job a million times easier.

24–70mm 2.8L lens, f/4.5, 1/200 second, ISO 100, manual exposure, evaluative metering

Use the Owner as a Prop

If the pets are reluctant to sit or stand near one another, ask the owner to get involved and use him as a prop. Just make sure that the focus of your composition is the pets themselves.

Mac and Mabel didn't want to stand next to one another unless their owner was close, so I positioned each of them on either side of her, and it worked out well.

70–200 f/4L lens @ 100mm, f/10, 1/1250, ISO 400, +0.33 exposure compensation, aperture priority, partial metering

Engage Your Subjects

If you can get engage the animals with you, their attention will be on you and not on each other, which is the goal. The closer you can get them to you, the better your chances will be of getting them lined up.

Some stinky treats was all it took to get these three silly characters to line up in front of my camera.

20mm 2.8 lens @ 20mm, f/6.3, 1/400 second, ISO 500, aperture priority, evaluative metering

Think Outside the Box

Pets don't need to be lined up side by side in order to make engaging images. Try photographing them as they interact organically with each other.

For important shoots with dogs for which you must nail the shot, always bring a pack of string cheese with you. In my twelve years of pet photography, I have yet to have a dog turn its nose up to string cheese.

When All Else Fails, Do It in Photoshop

If you're lucky, you'll end up with a handful of great shots of the pets lined up. However, most of your shots will likely be of the pets looking in different directions, but if you have at least one shot of each pet looking at the camera, you can create a composite in Photoshop by copying and pasting. Just make sure they are in the same position and lighting in each shot so that you don't end up with "frankendoggies". It's best to get a range of shots in burst mode each time you position them. Somewhere amidst the series of bursts, there ought to be one image that you can use for a composite image.

Wanda had a mind of her own, and the senior Nikita was content relaxing in the grass, so I captured a few shots during one of the rare moments when she walked over to see what he was doing.

20mm 2.8 lens @ 20mm, f/3.2, 1/250 second, ISO 160, aperture priority, evaluative metering

Location Ideas

You are only limited by your imagination when it comes to locations to photograph animals, both indoors and out. Here are 20 indoor ideas, and 40 outdoor ideas to get your creative wheels turning.

Indoor Locations

1. On a favorite chair
2. On an interesting patterned chair or couch
3. On the owner's bed
4. Looking out a window
5. Watching the owner open the fridge/cupboard expectantly
6. Lying on a colorful graphic rug
7. Lying on a favorite pet bed
8. In the bathtub
9. Drinking water out of the sink
10. On a bookshelf (small animals)
11. In front of a cool painting or poster
12. In front of a cool headboard
13. Lying in front of the fireplace
14. On a vintage couch or chair

15. Head or profile shot in front of wallpaper

16. Lying in its owner's lap on the couch

17. Standing on a kitchen counter waiting for food (cats)

18. In a colorful child's bedroom

19. At the top of an interesting stairwell

20. In a window seat surrounded by curtains

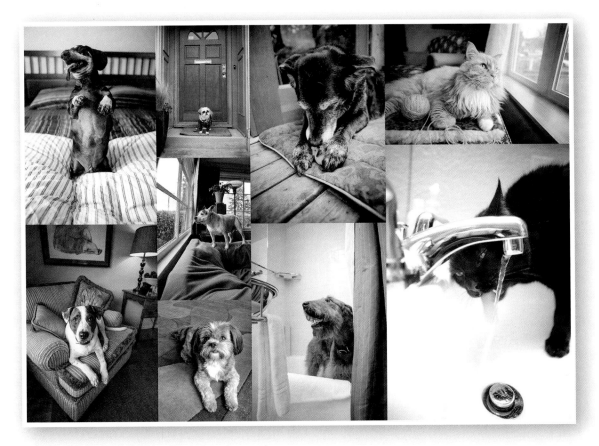

Outdoor Locations

1. In front of cool architecture

2. Lying in the grass

3. On a dock

4. In a tall field of grass

5. In the city

6. In a gritty alleyway

7. On a sandy beach

8. In an industrial building

9. In front of a colorful front door

10. On a cool bench

11. In a vintage car or truck

12. In front of a cool hotel

13. Nestled in with flowers at the market

14. In front of a cool sculpture

15. At a carnival/in front of a Ferris wheel or carousel

16. In front of a cool fountain

17. In a forest

18. On a scooter

19. In a field of wildflowers

20. In the sidecar of a motorcycle

21. Hanging its head out the window of a car

22. In a stable (horses)

23. In front of a sunset

24. In an old barn

25. At a winery

26. In front of a tourist attraction or landmark

27. In a pretty meadow

28. In a Japanese garden

29. In a downtown park

30. At a lake

31. Under a willow tree

32. On a sailboat

33. On the top of a mountain with a scenic view

34. In a sculpture garden

35. Lying by the pool

36. Behind an interesting fence

37. In a hotel lobby (note: you'll need to sign paperwork with the hotel for this)

38. On a pier

39. Next to a lighthouse

40. In a quaint beach town

Ten Ideas for Getting Variety in Every Session

No matter how restricted you are by your environment, regardless of how limited you are on time, or in spite of how uncreative you are feeling, if you employ the following ten ideas in every session, you are bound to get a nice variety in your shots.

1. **Use the PLP technique**

 Create engaging shots from the pet's point of view.

2. **Headshot in front of solid colored wall or backdrop**

 Use a profile shot. Play around with wall color in software.

3. **Head tilt**

 Try to capture the Inquisitive, alert, adorable look.

4. **Running or action shots (jumping, hopping, turning, and so on)**

 The objective is to capture energy, action, and fun.

5. **Pet with owner**

 You want to convey the connection, love, and affection in the relationships between pets and their owners.

6. **Cool backdrops**

 Go for the grand shot; the perfect image for a large canvas.

7. **Abstract**

 Create a mood, a feeling, and a sense of energy.

8. **Relaxing or sleepy pets**

 Look to capture sweetness, calmness, and relaxation.

9. **Detail shots**

 Gets some close-up shots of feet, tail, nose, fur, eyes, collars, tags, and other markings.

10. **Props**

 Include toys, balloons, bubbles, clothing, chairs, tubs, stuffed animals, and beds.

Capturing the Stages in a Pet's Life

If you plan to do pet photography for the long haul, one service you can offer is life-stages shoots. For this service, you photograph a pet as a baby, as an adult, and then finally, as a senior. Depending on the lifespan of the animal you'll be shooting, this could be a very long-term commitment; for example, with a dog, this could take you as much as 10 to 15 years, but the end result is that you have photos of the animal that span the course of its entire life. One abbreviated alternative is doing a photo shoot when the dog is a puppy and doing another one when it's around two years old. This can also be done for a kitten and then adult cat. Animals change so much from when they are young to full grown, and it's nice to capture the full spectrum of their appearance.

Kaya was photographed as a little puppy and again as a full-grown adult. It's really cool the see the striking differences in the same animal.

Pet Photography Don'ts

Here are 15 things you shouldn't be doing in your pet photo shoots. Of course, I've done them all, which is how I got these photos. We all have to learn somewhere, and hopefully, this will help prevent you from making the same mistakes that I have.

1. Don't get your hands too close to a dog's mouth while playing. The last thing you need is blood on your camera or lens.

2. Don't let dogs drink out of random puddles.

3. Don't fail to capture catchlights in the pet's eyes.

4. Don't leave a harness on a dog unless the owner is comfortable with it being in the prints. Harnesses are extremely difficult to remove with software.

5. Don't put your camera in the face of an aggressive dog.

6. Don't capture your photos with the black and white setting on your camera, unless you have a duplicate RAW file that's in color. Remember that Murphy guy I keep talking about? If you only have a black and white shot, I promise you the owner will want to see it in color.

7. Don't let people pet your subjects when you are in the middle of a photo shoot.

8. Don't capture your own shadows in the shot unless it adds to the artistic value of the photo.

9. Don't use too slow a shutter speed. Here, if I had just bumped up the ISO to 1600, I probably would have nailed the shot (it was set at ISO 200, which gave me a paltry 1/50 shutter speed in the owner's dark bedroom).

10. Don't position owners in such a way that you can't easily crop or clone them out of a photo later on if you don't want them in the shot. This shot of Phineas might look like it would be no big deal to clone the owner out because the background is blue, but it's actually a blue gradient, which can be very hard to clone without the right tools.

11. Don't let the pets you are photographing do anything you wouldn't feel comfortable with your own pets doing at home.

12. Don't use your on-camera flash with a dog.

13. Don't stick your hand in a dog's mouth to try to get a toy or ball.

14. Don't give up on shy or scared cats. This beautiful but extremely shy kitty took over an hour to come out of hiding once I arrived. I waited it out, and she learned to trust me. The resulting shots were worth the wait.

15. Don't stick an animal in a place from which you aren't sure it can get out.

Exercises

1. **PLP Shooting Blind**

 Try taking some photos without framing up through the viewfinder. Imagine a laser light level coming out of the center of your lens. (Never use a real one though, because it can be damaging to a pet's eyes.) Take lots of photos and experiment.

2. **Lenses for Variety**

 Try this little experiment to help you determine which settings with which lenses produce the visuals you find most appealing. Capture a range of images using different f-stops and focal lengths. After the shoot, load your images into Bridge or other software, sort or filter by focal length and aperture, and then visually compare the results. You might be surprised at what you find! A personal favorite setting of mine on my Canon 24–70mm 2.8L lens on a full-frame body is 45 to 55mm, f/4.0 to 5.6, about 5 to 6 feet from my subject. As a mnemonic, I say to myself "45 at 4.5." I frequently shoot at f/2.8 to get the speeds and light that I need, but whenever I have the freedom to do so, I love my "45 at 4.5." What looks best to you will be purely subjective and speaks to your own personal style, which I talk about in Chapter 10.

3. **Pets with Their Owners**

 Try one or more of the suggestions from the "pets with owners" list. Get creative and think outside the box and see if you can come up with something completely new.

4. **Location Ideas**

 Pick a location from both the indoor location and outdoor location lists at which you have never photographed before.

5. **Ten Ideas for Variety**

 Try capturing each of the 10 ideas for variety in a single shoot.

Chapter Eight

Pet Photography Challenges

★ Common Challenges

★ Behavior Challenges

★ Lighting Challenges

★ Weather Issues

★ Location Challenges

★ Elderly or Sick Pets

★ "Stage-Mom" Owners

★ Working in a Studio

★ Legal Considerations

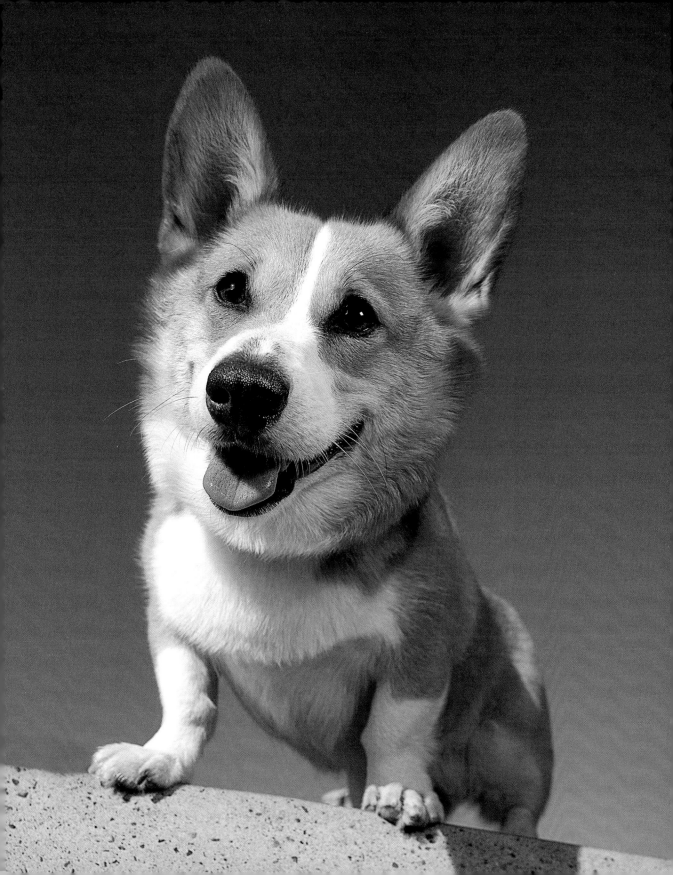

Common Challenges

Some of the most common complaints among amateur photographers are as follows:

"I've tried a million times to take pictures of my black dog or cat, but they never come out right."

"I can't seem to get a nice looking photo of my white dog or cat."

"Whenever I photograph pets, the photos are always blurry."

"My pet's eyes glow whenever I use my flash with them indoors."

I will address these one by one and provide solutions to each of them in the sections that follow.

Black Dogs

The problem Photographing black dogs or cats results in overexposed images. These are characterized by everything being too light, the shot looks washed out, and the fur appears as an ugly gray.

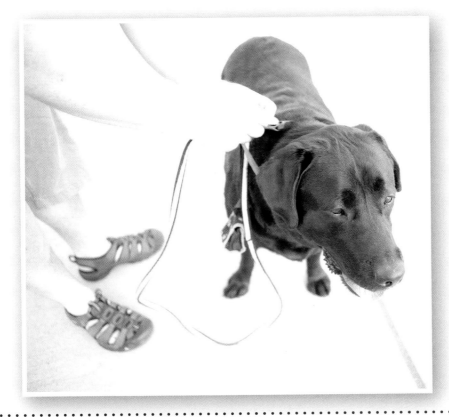

Spot metering off Sam's fur resulted in overexposure in aperture priority. To get the correct exposure for this shot, I should have used exposure compensation to make the shot darker.

24–70mm 2.8L lens @ 24mm, f/2.8, 1/400 second, ISO 800, aperture priority, spot metering

The reason When photographing black dogs and cats with an automatic setting on the camera using the default evaluative metering, the camera is attempting to create an 18 percent gray across the entire image. The presence of a large amount of solid black in the image fools the camera into thinking that the overall image is dark. Thus, it compensates (overcompensates in reality) by increasing the exposure (overexposing) of the image.

The solution In this circumstance, you are going to want to *decrease* the overall exposure. If you are shooting in an automatic setting such as aperture priority, shutter priority, or program, the easiest way to do this is to use spot metering, meter off the pet's fur and use exposure compensation to decrease the exposure by one to two f-stops, depending on the light.

The best way to avoid the problem is to shoot in full manual exposure, use spot metering, meter off the fur, and then create proper exposure by adjusting the aperture and shutter speed. Photographing a dark dog in bright sunlight or any other scenario in which strong contrast increases the challenge of achieving good exposure. Take the dog outside, and place it in a wide expanse of even shade, which will greatly improve your chances of getting properly exposed images of your black dog. Along with exposure issues, you might have white balance issues here, as well. If the pet's black fur is going too blue, you might need to try using a custom white balance on your camera to make the images warmer. Try adjusting the color temperature (K) first, and see if you can get a desirable color that way. If you still can't get it right in camera, never fear; in Chapter 9, I show you how to deal with fur color that has gone awry by using software.

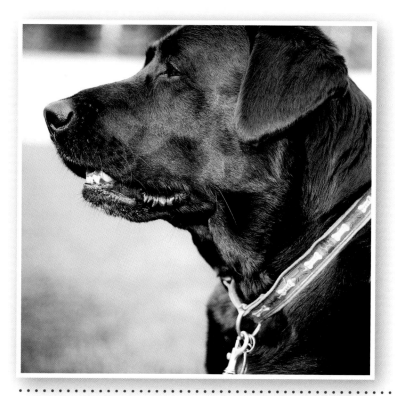

Sam is properly exposed in this shot and his fur is a nice neutral color.

24–70mm 2.8L lens @ 58mm, f/2.8, 1/1250 second, ISO 640, aperture priority, evaluative metering

White Dogs

The problem When photographing white dogs they tend to be underexposed. The shots are too dark, and the fur color can be all wrong.

The large amount of white in this image threw off the exposure which caused the whole shot to be too dark.

20mm 2.8 lens @ 20mm, f/5.0, 1/2000 second, ISO 1600, aperture priority, spot metering

The reason The reason is the inverse of the challenge of photographing a black dog. Again, the camera is trying to produce 18 percent gray, but it's thrown off by the large amount of white, so it underexposes the image because it thinks the scene is too bright. This results in images that are too dark. The fur is too dark, the eyes are empty black pockets, and there is an ugly gray cast over the entire image.

The solution In this situation you are going to want to *increase* the overall exposure on your images. If you are shooting in an automatic setting, such as aperture priority, shutter priority, or program, use spot metering, meter off the pet's fur, and then use exposure compensation to increase the exposure by one to two f-stops, depending on the light. The ideal way is to shoot in full manual exposure, use spot metering, meter off the fur, and then create proper exposure adjusting the aperture and shutter speed. Just as with photographing black pets, even exposure can be hard to come by if you are working with a white pet in bright, direct sunshine because of the harsh contrast. Move the animal to bright but indirect sunlight or wide, even shade, and you'll have better luck.

And as with photographing black dogs, you might have problems getting the white balance where you need it with white dogs, and you might end up with images in which the fur is muddy or has a brown or reddish tinge. The solution is the same as with black dogs: try adjusting the color temperature. With white dogs, however, you will want to make the images cooler instead of warmer. The goal is to have neutral, ever-so-slightly cool-toned fur.

I properly exposed Bert's fur in this shot without blowing any of the highlights out by using manual metering and setting the aperture and shutter speed manually.

24–70mm 2.8L lens @ 46mm, f/2.8, 1/1600 second, ISO 100, manual exposure, evaluative metering

Blurry Pets

The problem Photos of moving subjects come out blurry. Even photos taken indoors of non-moving subjects come out blurry.

The reason Although sometimes this can be caused by plain-old hand shake (ever had too much coffee? Yikes!), this is usually caused by a shutter speed that is too slow. A slow shutter speed will also amplify any slight shake in your hands, making the blur worse.

The solution Increase your shutter speed. To do this you might need to bump up your ISO or use a wider aperture. Ideally, with non-moving pets, you will want a shutter speed of at least 1/100 second (1/50 second could work if this is your only option and you have *very* steady hands.

To help to minimize your own movements and reduce shaking, take a deep breath just before you depress the shutter.

With moving pets, it's a good idea to keep your shutter speed at or above 1/250 second. With fast-moving pets, you should aim for a shutter speed of 1/500 second or faster.

Glowing Eyes

The problem An animal's eyes glow green when you take flash photos of it in a similar fashion as the "red-eye" effect you sometimes see when photographing people.

The reason Glowing green eyes are caused by an on-camera flash that is facing directly at the pet. The glowing is the light from the flash reflecting off the animal's retinas back to the lens.

The solution Turn off your on-camera flash. If your photos are too dark without it, increase your ISO to its highest setting, and open your aperture to its widest setting. If you find you are having this problem a lot, see if you can set your camera to an aperture of f/2.8 (if it's a point-and-shoot), or purchase an f/2.8 or faster lens if you own a digital single-lens reflex (dSLR).

A shutter speed of 1/50 second was way too slow to prevent blur in this moving image of Breasel.

24–70mm 2.8L lens @ 24mm, f/4.0, 1/50 second, ISO 400, aperture priority, evaluative metering

A super-fast lens such as an f/1.4 or f/1.8 comes in very handy for low-light pet photography, especially indoors. This will enable you to get low-light shots without using your on-camera flash. If using a wide aperture isn't an option, and you simply must use your on-camera flash, invest in an on-camera flash diffuser such as one from Opteka or LumiQuest. Diffusing the light from the flash scatters, or spreads the light out, so that it doesn't travel straight at the pet in a concentrated, linear fashion. This can make the shot look more natural and help prevent those awful glowing eyes.

Behavior Challenges

Ahhh, if only every animal we ever photographed were a sweet little angel, capable of doing every single thing we ask, and hanging on our every command. Anyone who has every pointed a lens at an animal knows that they have a mind of their own. There will be times during your pet photography career where photographing an animal will be so exhausting, physically and/or mentally, that you will return home in need of a drink or a hot tub or both. The really difficult ones will have you booking a flight to Cabo for a recovery vacation! In your professional endeavors, you will encounter hyper dogs, sleeping cats, shy dogs, aggressive dogs, and completely disinterested pets. There are ways you can make these situations easier, though, and in the next few subsections, I'll pass along some of them to you.

Hyper/Out of Control/Spastic/Neurotic Dogs

I recall a photo shoot I did for an owner of a little white fluffball of a dog who was one of the most—how can I put this nicely—*enthusiastic* little canines I had ever come across. The pooch jumped straight up in the air every few seconds as if she were on a springboard, and with each jump came a high-pitched bark. I'm pretty sure the pads of her feet were as soft as the day she was born, because they barely ever made contact with the ground. This was one extremely hyper puppy. This unusual jumping and barking activity lasted through the entire length of our 90-minute shoot. "Wow," I thought, more impressed than frustrated. But looking back on it, I made several very critical mistakes with this shoot that prevented it from going as smoothly as it could have.

♦ I failed to get information on the pet ahead of time. Had I known the animal wasn't used to going out in public, I never would have taken her out into the big, noisy, city world, which pushed her stimulation level through the roof and only served to amplify her hyper, neurotic temperament.

♦ I never asked the owner to exercise her dog prior to the shoot, which would have worked wonders for calming down the energetic pooch.

♦ I didn't pick the location with the dog's temperament in mind. I was trying to do a very controlled shoot in front of specific backdrops on city streets and in a busy urban park instead of a quiet location, away from noise and people, which would have been far better suited for this little girl. She really needed to be photographed at home, where she felt most comfortable.

So, it's essential that you get information from owners about their pets ahead of time. If you know the pet is hyper, ask the owner to take it for a long run or play session just prior to your shoot. Plan to do a more dynamic shoot instead of a controlled shoot. Pick a location where the animal would feel most comfortable. Play with them during your shoot; let them run; let them swim; let them be themselves; and then capture them doing just that. Your goal as a pet photographer is to capture the pet's personality, so if the pet is spastic and goofy, capture that in your shots. You can't turn a wallflower into the life of the party in your images, and likewise, you can't turn a wacky, zany, nut-case animal into a chill, easy-going one in your shoots. Use the pet's personality to your advantage.

Sleeping Cats

Sleeping cats look beautiful for one or two photos; a handful, at best. A sleeping cat in 30, 40, 50 or more images? Not so interesting. The best way to deal with this is to prevent it in the first place. Ask the owners to keep their pets awake during the time preceding your shoot. If the cat is an outdoor wanderer during the evening hours and sleeps indoors during the day, ask the owner to keep it inside the night before your shoot. The kitty meowing to go out all night might not be good for a restful sleep, but the resulting shots of an alert kitty looking out a window will be worth it. You can also bring novel stimuli to help to rouse the cat. This can include organic catnip, a plastic or paper bag or box, or a new feather toy on a string. If you are photographing multiple cats together, first work with the one that is more alert. You might find that by the time you are done, the other, less-interested (or even napping) kitty is up and ready for action.

Shy Dogs

Shy dogs are those that don't come to you readily, hide behind their owners' legs, run away if approached, or just never seem to feel comfortable around new people and environments. First, these pets are usually best photographed at home, where all of the sights, sounds, and people are

Bing was extremely shy, so I had his owner hold him in her arms for the first 10 minutes of the shoot while he warmed up to me.

24–70mm 2.8L lens @ 70mm, f/2.8, 1/160 second, ISO 1250, aperture priority, partial metering

familiar. Second, you will need to give the animal some time to warm up to you. Sitting on the floor for ten minutes, slowly and quietly offering some favorite treats can work wonders. Let the dog sniff you and approach you at its own pace before you attempt to pull your camera out of the bag. Ask the owner to ignore the dog if it looks to them for reassurance. You want the dog to know they are going to be fine, even if it's not "rescued" by its owner. Ask the owner to stay close by but remain standing and ignore the pet.

Often, shy dogs will be afraid of the camera—afraid of the noises it makes, how it looks, and the movements it sees in the lens. You might need to spend some time doing what I call *treat training*, whereby you are classically conditioning the animal to feel comfortable with the camera. After the dog is used to you and feels comfortable coming near you, begin the training by setting your camera down on the floor, a few feet away from you. Reward the dog with a treat if it comes close to you with the camera there. Slowly, over the course of several minutes, start inching the camera closer and closer to you, giving a the dog a treat each time it comes close. Once the dog is close to you and the camera, put treats on the floor near the camera. Repeat the process you did with the camera a few feet away from you, and each time the dog gets a treat, you place the next treat closer to the camera. Once the dog is right next to the camera, start placing treats on top of it, either on the lens or the body itself. Allow the dog several minutes of taking treats off of the camera. When it becomes comfortable doing this, start pushing the shutter button each time it takes a treat. You need to push the shutter button at the exact second the dog takes the treat. (You might need to set your camera to fire the shutter even if the shot isn't in focus, because some cameras have a setting that prevents you from doing this.) Allow the dog to become accustomed to the sound of the shutter. Then, try placing treats on the floor right in front of the lens and fire the shutter each time the dog takes the treat. Once it's comfortable with this, try holding the camera a little bit off the floor and firing the shutter when it takes the treat. You might need to just put your hand on the camera for several minutes before moving it off the floor if you're working with a really skittish little guy. If you go through this process with them, most dogs will become desensitized to the noises and appearance of the camera within 10 minutes, no matter how shy they are. From then on, it's fun for them, because there are rewards (treats) involved.

Aggressive Dogs
Whether or not you photograph an aggressive dog is a personal choice, and one that shouldn't be made without careful thought and planning. Unless you have both extensive experience with different canines

and a solid grasp of canine body language and behavior, I don't recommend taking on the task of photographing even a mildly aggressive dog. If you need to work with an aggressive canine, here's what you should do:

◆ Keep the dog on a leash during the entire session. Have the owner control the leash. This is for both liability reasons and to keep you (and others) safe. You should do this even for an indoor photo shoot.

◆ Use a telephoto lens. You will want to shoot between 70mm and 300mm to keep your distance.

◆ Move slowly, avoid eye contact, breathe deep, and remain calm.

◆ Use a soothing voice.

◆ Do not get close. Even if the owner says, "Oh, she's fine with you," dogs can feel threatened if you intrude in their space, and the second you crouch down to take a shot or extend your hand, they can lunge, regardless of what your body language is telling them.

◆ Keep your guard up. Never become complacent around a known aggressive dog. One sudden or wrong move can send you to the hospital.

◆ Keep others safe. Avoid doing a photo shoot in a location where the animal can potentially harm another animal or people. Keep it on leash at all times when out in public. Never, ever photograph a canine-aggressive dog in or near a dog park.

◆ Avoid using flash. This can heighten the dog's stimulation levels and increase fear-based aggression.

◆ Duck out if at any point in time you feel uncomfortable or unsafe. Rely on your own animal instincts to tell you how things are going. If you have a sense that something bad is about to happen, *remove yourself from the situation immediately*. Although most dogs are docile and loving, aggressive dogs can inflict severe, permanent, and sometimes life-threatening injury to your person if they attack.

Disinterested Pets

Some pets couldn't care less about you, barely deigning to give you a sniff, much less the time of day. The reason why this is an issue during a pet photo shoot is that typically the owner wants at least a few shots of the animal looking at the camera. If the pet isn't interested in you, not only will it not come near you, but it also generally won't look at you, either. In most situations like this you are going to need to use noises to attract the pet's attention, along with the owner's help. Gather your arsenal of noisemakers—squeaky toys, duck calls, whistles,and so on—and have the owner stand behind you, looking over your shoulder at her pet. Begin by having the owner call the pet's name, or say its favorite words, or ask if it wants a treat or cookie. If the pet still won't look in your direction, prepare yourself to nail the shot, get all of your settings where you want them, and then when you are ready, on your command, have the owner use your noisemaker right over your head or camera. One or two quick, hard loud squeaks, whistle blows, duck calls, or similar noise, and usually even the most disinterested pet will look directly at you for a couple of seconds. And that should be just enough time to fire off a few shots before it looks away. Set your camera to burst mode so that you can fire off a number of shots in succession and

ensure that you are ready to nail the shot when you do this. This might be your only time in the entire shoot that the pet looks your way. When you're not actively trying to get the pet to look your way, the best way to photograph it is in a photojournalistic style, from afar, capturing its behavior without being actively involved in it if it doesn't want to be near you. You can try using pet-level photography (PLP), and place your camera in front of the pet, with your lens directed toward its face, regardless of what direction it is looking. (For more information on how to use PLP in your sessions, go to Chapter 7.)

When photographing pets like this, it's also important that they are participating in something they enjoy. They might merely be bored or waiting for something interesting to happen. Sometimes all it takes is bringing out a ball or toy, and they come to life and will engage with you to your heart's content. And don't be concerned that an animal actively dislikes you. In fact, by the end of a shoot, even disinterested pets often come over and lean or rub against you, surprising you with their affection. Keep some Kleenex ready and be prepared to say "awwww" in unison with the owner. These can be some of the most rewarding shoots. Some pets just take a little while to warm up to you.

Poor Ramses had been chained to a tree and beaten with a baseball bat as a puppy before being rescued by a good samaritan. Because of this he had severe trust issues with humans, resulting in aggression toward strangers. But he had a very close loving bond with his owner, and that's what I wanted to capture. I photographed Ramses on the deck with his mom petting him. He was happy and felt comfortable, and I kept a safe distance.

24–70mm 2.8L lens @ 30mm, f/2.8, 1/640 second, –0.67 exposure compensation, aperture priority, evaluative metering.

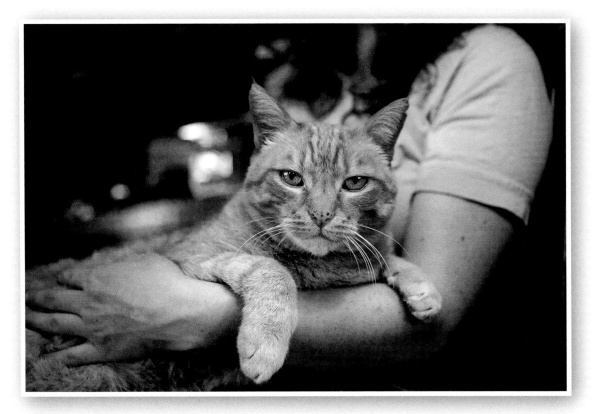

Sam got cuddles from his owner toward the end of our shoot.

24–70mm 2.8L lens @ 42mm, f/2.8, 1/50 second, ISO 500, aperture priority, partial metering

Lighting Challenges

Chapter 6 addresses the importance that light plays with pet photography (as it does in all facets of photography, really), so what do you do if you have less than ideal light in which to work? Let's take a look at some strategies to address these situations in the next few subsections.

Low Light

There will be many situations in which the light for your photo session is not entirely adequate, such as in a dark barn with a horse, in a dimly lit house with cats, in a dark back room with birds, on the side of a building late in the day with a dog, and far too many more to list. The remedy for low light couldn't be more simple, really: *more* light. There are really two approaches to accomplishing this. The first is to increase the ambient light by means of auxiliary illumination; the second is to make your camera capture more of the available, natural light. If it's a dynamic photo session done on the fly, you can add a flash into the mix to brighten things up. If it's a more controlled shoot in a fixed location, you can add freestanding studio lights. If neither of those are a good option, you will need to bump up your ISO to make your sensor more sensitive to the available light. If that fails, then you might need to couple a high ISO with a wide aperture to allow yet more light to hit the sensor when the shutter fires.

Midday Bright Sun

If you simply can't avoid photographing in the extreme brightness of the midday sun—which can be the case with some events, or commercial or editorial shoots—your two best options are to either use fill flash or fix the images in post processing by using software. Fill flash means you are using light to illuminate the areas that would normally be in dark shadows, producing a more even exposure. The first option is usually the easiest and fastest, but some pets are afraid of the flash (you'll need to gauge how your animal models will respond to it). The second option involves lightening the shadows and darkening the highlights by using software, which is a process I will walk you through in Chapter 9. The editing option is more involved, but you can apply any changes you make to a batch of images with just a couple of quick clicks of your mouse, making it a quick and easy fix if none of the other solutions are options for you.

Indoors/Mixed Light

Every professional pet photographer has a deep-seated fear of showing up to the home of a pet owner who wants photos of her kittens playing, only to find a house that is about as well lit as the inside of a windowless closet, or that the location for the shoot has multiple light sources in the same dark room. When faced with the challenge of doing a shoot in a room that is illuminated by tungsten (incandescent) and fluorescent bulbs and natural light, the best thing to do is to try to reduce the different light sources, concentrate on one, and then set up a white balance for that source. Move the pets or yourself or the camera into a position where you aren't actively capturing several different light sources all at the same time, and use the light source that will give you the brightest, most flattering light. High ISOs will be your friend for indoor shoots where the light is typically low, and using an off-camera flash bounced off the wall or ceiling can help you to create a more even white balance.

I photographed Henri using a combination of natural light (coming from the left side) and off-camera flash, bounced off the ceiling.

24–70 2.8L lens @ 70mm, f/2.8, 1/40 second, ISO 200, aperture priority, evaluative metering

Shelter Pets

So, you have decided to become a volunteer photographer at a shelter? Great! This is wonderful service to perform for animals that are in need of new homes. The first and most important thing you need to do before photographing shelter pets is read their intake paperwork. If they have had any behavioral evaluations, this will give you some insight to their temperament and how to work with them. You also need to be aware of their health status; you need to know if they have any sore spots, are they recovering from surgery, or do they have any illnesses or wounds. If the paperwork doesn't provide adequate information, you can ask the volunteers and staff members on site if they have any knowledge of a particular animal. Sometimes, there will be a certain person who has taken an animal under his wing and has some personal experience with it. If the pet is in a foster home, this part will be easier because the foster family will be able to tell you all about the animal.

Once you have some knowledge of the animal's temperament and how you'll need to move and work around it, you can then get down to actually taking its picture.

Here are a bunch of tips to help make the session go as smoothly as possible:

Think of the audience who will be viewing these photos. It's not other photographers or paying clients. For this type of shoot, it's prospective pet adopters who are looking for a new addition to their family. What appeals most to adopters is pets that look healthy, happy, and friendly. Those are the traits you want to try to capture during your shelter sessions.

Silence your camera if that's an option. Some pets are terrified by the snap of a shutter and the various beeps and noises that a camera makes. If you can disable those sounds, it can help to reduce an animal's anxiety.

Work as fast as you can. The faster you can get a few great shots, the less stressful it will be on an animal. Some rescues might be so frightened that the only place they feel comfortable is in their kennel. You might think that taking them out of it, either outdoors or even in the same room, is doing them a favor, but they might not think so. Of course, if it's a dog that loves to romp and play, give it some extra time outside during your shoot because this will be fun for it, and what's the harm in passing on a little enjoyment to something so filled with energy. If the animal simply must stay in its kennel, use a high ISO, a wide aperture, and fill the frame with its head and face. Use a pretty blanket or sheet as a backdrop.

Set your camera to manual mode. You will have challenging lighting conditions, and the best way to handle those conditions is to have full control over your camera. If you are using a camera that isn't capable of shooting in full manual, try using a semi-automatic setting such as aperture priority. The more manual control you have in challenging lighting conditions, the better your shots will turn out.

Go outdoors and use natural lighting. If you have the option and a contained, safe area in which to work, animals will look better when photographed outside the shelter. Also, the interior lighting is usually fluorescent and unflattering. It will most often be necessary to photograph cats and small animals indoors, but any animal you are able to take safely outside will make your job easier when it comes to getting great shots.

Use a shallow depth of field (DOF). In spite of the love, devotion, and caring of the shelter staff members, the interiors of most facilities typically aren't very photogenic and there are very limited choices for backdrops. So, ideally you will want to be shooting somewhere between f/2.8 and f/4.5. This will blur out the background but keep the focus on the animal. This is especially important when photographing in a cluttered environment where the background isn't doing any justice to the photos.

Keep it simple. You don't need fancy props or a pretty backdrop to create great photos of a pet. Even a solid concrete or brick wall, inside the shelter can serve as a great backdrop with the pet filling the frame. A solid grassy ground can be great for dogs. And unlike your other sessions, for these shoots, you don't need to worry about their leashes in the shot. This just makes it look like they are going for a walk with an owner, which lends more of a family-friendly appearance to a prospective adopter.

Turn off your flash. Flash can terrify already fearful pets whose lives have already been turned upside down and are now living in a shelter. Bump up the ISO setting if the lighting is poor.

Use your happy voice and talk to the animals in gentle, soothing tones. Sometimes all it takes is a loving "Hi, sweetheart…" to bring a shy dog out of his shell.

With cats and small animals, be gentle and patient. Move slowly, be kind, speak softly, and be aware of their body language.

Use towels, sheets, rugs, or fabric as backdrops. This is especially helpful for cats and small animals, which can be very difficult to photograph inside a shelter. Tucking them inside some pretty fabric while another volunteer holds them can present them in a good light for prospective adopters. The idea here is to mimic the look of a home environment.

For dogs, capture the ears in the up and forward position (depending on the breed, of course). Use your mouth or throat noises if you know some good ones. Or, use a squeaky toy, a treat, or whatever you have to do to the dog's attention and get its ears in the right position. Remember that you are trying to "sell" the animal to a prospective adopter

Remember that you can always use software to fix many problems. If you captured a happy, expressive photo of an animal, but it was next to a garbage can or some other unflattering junk, crop the image by using software and fix any other issues that you think might take away from the animal's appeal.

Use a model release form. Technically, the animals are the property of the shelter that is housing them, and they are responsible for their safety and well-being. It will be a shelter staff member who signs the model/property release form. This person will differ from shelter to shelter. Ask the volunteer manager who has the authority to do so. Instead of having a release for each individual animal, you can list a date range of shoots with names, which will reduce the paperwork for you and the shelter.

Include a clear-cut copyright clause in your model release. If you plan to use the images commercially or for promotional purposes, ensure that you have clearly communicated this to the shelter and have specified who owns the images and what rights that party has to them.

Photographing pets in a shelter can be a very rewarding way to help animals in need, and at the same time you can gain experience, build your portfolio, enhance your confidence working with animals in challenging environments, and build your skills with your camera.

Ebony was photographed using the shelter's ancient digital camera (it actually used a floppy disk instead of memory cards).

Weather Issues

I live and work in Seattle, a location that is less than ideal for outdoor photography, which is primarily what I do. Along with the abundance of rain, it's often very overcast and dark and gloomy. Even on days that are forecast to be nice and sunny, storms can hit without much notice, and often the sun plays hide-and-seek behind the clouds so fast that you find yourself scrambling with the dials on your camera.

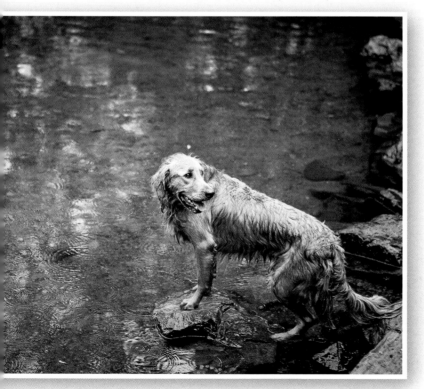

The most challenging aspect of the weather anyplace that isn't consistently sunny year-round is variability. Seattle experiences some interesting weather, to be sure, but it's far from unique in that respect. Like many people in many other parts of the world, I never really know what to expect from one day to the next. The way that I handle this is to never book my shoots according to the weather forecast; I book them according to when my client and I are free. Then, the night before the shoot I take a look at the hourly forecast to get a rough idea of what the weather will be like the next day. On the morning of the shoot, if it looks like it's going to be crummy, I will touch base with my client and discuss rescheduling if the weather is unsatisfactory.

Just because it's raining doesn't mean you can't still get awesome shots.

24–70mm 2.8L lens @ 70mm, f/2.8, 1/125 second, ISO 250, aperture priority, evaluative metering

If you intend to engage in outdoor pet photography, how you personally decide to deal with the weather will depend in large part if you will be doing it professionally for profit or as a hobby. If you are doing it for profit, it's very important to deliver results that your clients will be thrilled with, because they are paying you to create lifelong memories of a beloved family member. Often, this is the only professional photo shoot they will ever do for this particular animal, so it's important to get it right. Certain clients might not be super thrilled with muddy, overcast skies or windy weather that is messing up their show-dog's coat, so it's important to communicate with them ahead of time to understand their expectations. Also, you might have different expectations or ideas than they have when it comes to the final images. For example, I once had a client who wanted to do a shoot on a beach from which you can see down-town Seattle. I had already composed the shots in my mind and had visions of bright blue skies and puffy white clouds over a beautiful cityscape background, across the water. Instead, we had light rain and gloomy overcast skies on the morning of our shoot. I called and asked my client if she would like to reschedule to a sunny day, and she said she didn't really care. We did the shoot anyway, and she ended up being thrilled with the images, in spite of there being no cityscape in view. Sometimes your expectations as a photographer can be higher than your client's expectations. (Still, I will always wish we had blue skies and puffy clouds for that shoot!)

Bella's shoot at the beach. Even though we didn't have the blue skies I had hoped for, the overcast light provided a nice contrast to her jet black fur.

24–70mm 2.8L lens @ 52mm, f/2.8, 1/2000 second, ISO 250, aperture priority, evaluative metering

Here are some basic recommendations on how to deal with the weather:

♦ Don't let weather challenges deter you from producing great imagery.

♦ Defer to your client or model owner's wishes, provided it doesn't pose a danger to the animal.

♦ If you live in a hot climate, plan to shoot very early in the morning or late in the evening when the temperatures are lower.

♦ Never allow a client to travel in hazardous weather conditions to come to a photo shoot. This would include lightning storms, freezing rains, snow, tornadoes (of course), and any other major storm.

♦ Avoid shooting at midday in hot, sunny weather.

♦ If you're photographing in extreme conditions, communicate with your animal's owner to ensure that your subject can handle being out in those conditions for more than a short period of time. For instance, a Husky would be fine for an extended shoot in snow, but an Italian Greyhound would become cold very quickly. On the flip side, some individual animals might do great in heat, whereas for others it would be unhealthy or even dangerous to be outside in high temperatures for very long. And while we're on the subject of snow, be sure your subjects are outfitted with booties and a coat if they are a breed of dog that isn't used to that environment.

♦ If you live in an area that experiences frequent rain, invest in a weather-proof dSLR body or a rain cover for your camera. These are essentially glorified plastic bags that protect your camera from the elements but still enable you to shoot.

♦ Use pre-storm light to your advantage. The light just before a storm can sometimes be incredible.

If moisture manages to infiltrate your camera, place the body (with body cap on) in a bag of rice for 24 hours. The rice will draw the moisture out.

If you can safely photograph before any lightning strikes in your area, you can get some remarkable shots using this incredible natural light.

♦ Use wind to your advantage. Long-eared dogs can provide some fun ears-flying shots and animals with long fur, such as a horse's mane, can look beautiful with the wind blowing through it. If you have long hair, remember to pull it up or even wear a hat so that you can still see without your hair wrapping around your face, or worse, fluttering in front of the lens as you shoot what would otherwise have been the perfect photo.

♦ Use the seasons to your advantage. You might be saying, "Sure, but I can't wait until summer to get out and do outdoor photography!" You don't have to. Don't forget the fiery leaves and golden glow of Indian Summers in the fall; or the pretty pastels of flowers and soft morning dew in the spring; or the dramatic stormy skies or snow in the winter. Some of the most beautiful shots you can capture are when it's *not* warm and sunny out.

Location Challenges

No matter how much prior planning and location scouting you put into your photo shoots, things can and do go awry (our man, Murphy, once again). That perfect park you were so excited to photograph in is closed for a wedding; the fountain you had your heart set on using as a backdrop is turned off and closed for repairs; the big, beautiful tree you planned to capture the horses grazing around has been cut down.

The very best way to deal with location challenges is to be flexible. You'll need to think on your feet and quickly come up with a plan B if plan A is no longer an option. Being able to think creatively helps a lot here, as does knowledge of the surrounding area. This is one of the reasons why it's so important to location scout prior to doing a photo shoot in any location. If you know that one part of a park is closed, maybe there is another part that is still open and only a short drive away. Or maybe there is another location entirely that is not too far from the first location. Being able to communicate a description of the second location to pet owner can help her to understand that even if it wasn't what you initially had in mind, you will still be able to create great images at the second location.

Some photographers visit the planned location the day or night before a shoot to ensure that everything looks in order, but unless you have an event schedule of the location, this still won't give an idea of whether there will be something planned for it the following day. If the location does host regular events, it's a really good idea to keep the event page of the location's website bookmarked and check it before scheduling a photo shoot.

Along with events, closures, and construction, sometimes even just getting to a photo shoot can be a challenge. Things like marathons, festivals, ball games, and countless other events can create roadblocks and traffic and make it nearly impossible to get to your location on time. It's always a good idea to have general knowledge of what's going on in your city or town, so that you can be up to date about circumstances that can prevent you from getting to and from a shoot. Always have the pet owner's cell phone number on you in case you need to call for any reason. Always plan to arrive at your photo shoots 30 minutes ahead of time, which can save the day if you become delayed for any reason. Plus, when you arrive early, you can take some test shots for exposure, or grab a coffee at a nearby coffee shop and relax for moment before the excitement gets underway.

Rocco scouts the perfect location in a waterfall in Centennial Park, Atlanta.

24–70mm 2.8L lens @ 50mm, f/4.0, 1/800 second, ISO 500, +0.67 exposure compensation, aperture priority, evaluative metering

Elderly or Sick Pets

The most important thing to bear in mind when working with sick or elderly pets is that this is a very sensitive time for the owners. They have shared their life and love with an animal that will soon pass away, and the pain of this reality is usually very acute. Treat them with immense kindness and sensitivity. This isn't your usual shoot.

Call the owner with lots of questions about his pet. Ask him to tell you about their history together, what kinds of things are special to the animal; what places, which people, and what things are really meaningful in its life. Then, try to incorporate these things into your photo shoot. This can be something as simple as a collar and tag that the animal has worn most of its life, or a favorite pet bed, or a window it gazes from while waiting for its owner to come home. It might be a favorite person or animal buddy, or a favorite park, or other location that it loves to visit. Maybe it's a favorite food or a favorite activity. Anything that speaks of that individual animal and its experience here on earth should be incorporated into a shoot.

There will be times when an animal is too sick to leave the backyard or venture out of the house, or even come out of a room. When faced with these situations, you will need to be creative. You will still want to get the same kind of variety as you would in any other shoot. One way to accomplish this is to use

different lenses. For example, you can use a wide-angle lens to put the pet in a certain place and time, such as on a bed looking out of a window. You can use a macro or zoom lens to capture detail shots of its feet, ears, nose, eyes, and so on. You can photograph it surrounded by its favorite toys, its head in its owner's lap, being stroked and petted. Another great shot is capturing it nuzzling any of its animal buddies.

More ways to add variety to the shoot is to photograph your subjects from above, from the side, and even from underneath. Use interesting angles, and move around the pet. If the animal is very sick, it might be very difficult to elicit any kind of emotional response in the form of different facial expressions. The best way to remedy this is to use novel stimuli. This can be a new toy or food for a cat, an unusual sound for a dog, or a new habitat for a small animal. If an animal is interested and engaged in something new, it can perk both their eyes and ears up, which is what you really want to try to capture with an animal that's in its final days. Think outside the box; bring fun gifts to your shoots for aged and sick animals.

You will also need to allow for more time than you would a typical shoot so that you can fulfill all of an owner's requests. Remember these are most likely the very last images the owner will ever have of this pet.

Sometimes you will photograph animals who are very tired, perhaps from illness, old age, or both. Your planned outdoor photo shoot can be impacted by a dog that is slowing way down, or an indoor shoot with a kitty that continually falls asleep. It's very important to regularly verify with the owner that a pet is doing well as far as its energy levels are concerned. You should periodically ask the client, "Do you think he/she is ok? Would you like to continue moving forward? Should we take a break? Does he/she need some water/something to eat?"

Be aware of any sensitive areas on the pet's body where it might not like to be touched. Always ask the owner before picking up a sick or elderly pet. Ask pet owners if there are any parts of their pets' bodies that they prefer you not photograph. For instance, it might have an incision from a tumor or a shaved leg from a recent surgery that the owner would prefer not to appear in any photographs of the animal.

Ask the owner about any dietary constraints. Animals with illnesses that affect their digestion and elimination are likely on very specific diets, which means that your normal stock of treats are probably off limits. Ask the owner to provide treats and food that can be used during the shoot. Even if it's something as simple as canned salmon, the owner might have a specific brand to which the pet has become acclimated.

Always be cognizant of the needs of the pet and sensitive to the feelings of the owner. You might be stressed as a result of any number of things unrelated to the shoot at hand, but to the owner of a beloved pet whose remaining time is short, this shoot means the world. It's an incredible gift to give, and the memories you create will be cherished for a lifetime.

Eli is a senior dog, and I felt honored to be able to photograph him in his golden years.

50mm 1.8 lens @ 50mm, f/1.8, 1/60 second, ISO 1000, aperture priority, evaluative metering

"Stage-Mom" Owners

Some of the most challenging pet photo shoots can be those for which you are working with a difficult pet owner. Unfortunately, these folks are not uncommon in the pet industry, and we have a name for them: stage moms. In fact, there are some downright nutty pet people out there. If you have never seen the movie *Best in Show*, definitely watch it if you get the chance. It's a hysterically funny movie, and one of the reasons why is because there is so much truth in it.

Part of the problem with working with difficult owners is that it's very common for human's neuroses to carry over to their pets, which makes for a difficult human *and* a difficult pet. I have found that, in general, a neurotic or highly anxious person will have a neurotic, anxious dog. It's not always the case the other way around, but if an owner tells you that his pet is "crazy," "never listens," "barks all the time," "jumps all over people," and the pet wasn't just rescued from the shelter, this is often a red flag about what the owner will be like.

As a pet photographer, you will inevitably come across owners whose behavior will have you thinking, "Whoa, why did I accept this shoot?" They can make you very nervous; they can be demanding; they can be difficult to communicate with; they can have unreasonable expectations of you as a photographer; they can be verbally controlling and abusive with their pets; and they can be extremely anxious about you getting the shot. And that's just a handful of a laundry list of unpleasant characteristics that

can make a session difficult and uncomfortable for you. Sometimes, something as simple as the owner being anxious about her pet's performance can throw off the energy of the whole shoot.

Here are ten ways you can handle stage moms and difficult pet owners:

1. Stay calm and breathe. Slow everything down. Talk slowly. Act deliberately. Often, bad owner behavior heightens the negative energy of the shoot. Your job here is to de-escalate that energy to a calmer level, which will make for a calmer pet.

2. Communicate with the owner in a firm but friendly way. Avoid ever putting him on the defensive, and always speak in positive terms. Instead of saying, "No, please don't do that" or "We can't do that with him," say cheerfully, "I have an idea! How about if we do this…?" Ask the owner questions all throughout the shoot to identify his expectations. This way, there won't be any confusion and he will feel like he's playing a direct role in the final outcome. Some pet owners, upon realizing that you are deferring to them to make all of the decisions in the shoot, will actually back off and let you do your job because they don't really want the pressure.

3. Physically move around the location. If you are shooting in one location, such as the living room of an owner's house, and it's not going well, move to the sunroom, or the backyard. If you change the environment, you can usually change the energy in the shoot.

4. If the owner is having a hard time, and it's negatively influencing the pet, take a five-minute break. You can announce it by saying something like, "These guys are working so incredibly hard. Why don't we give our little models a five-minute break?"

5. Give yourself a break. Excuse yourself to a restroom, and take a breather. Give yourself the chance to calm down and relax. I have done this many times when dealing with difficult pet owners, and it makes a big difference.

6. Talk to your client in reassuring tones and let her know that things are going great, even if you don't feel certain that they are. Tell her you are excited about the shots you are getting and that her pet is doing a great job. Talk about how excited you are to be there and how much fun you and the pet are having. Often anxious and difficult people just need some reassurance to put them at ease.

7. Talk in your happy voice and give the pet lots of praise. Bad behavior on the part of the owner can have a very negative affect on the pet, which will show in its body language. You want to reassure the pet that it's ok as well as keep it feeling good and happy. Use gentle and soothing tones. This is especially important if the owner is high-strung and neurotic, because the pet needs you to be a grounding presence in a chaotic environment.

8. Give the owner a job. Ask him to hold your reflector or stand where the pet will look at him. If he calls the pet's name and you don't want him to do that, say simply, "Actually, I'd really like the dog looking at me because I have the *perfect* shot right now," and then get the pet's attention yourself. This can train the owner not to do it again, because he doesn't want to think he's ruining your perfect shot of his little baby.

9. If you are doing pet photography professionally, avoid working with difficult pet owners from the outset by qualifying them with your pricing. Typically, for reasons that science has yet to uncover, the most difficult pet owners seem to be those who want to pay the least for a photo shoot and products. Those who are getting them for free are notoriously bad in their treatment of a professional. By setting your prices the right way (see Chapter 12 for more on this), you can attract clients who will be very easy to work with, appreciative, respectful and trusting of you as a professional, easy to communicate with, and a joy with whom to collaborate.

 Underpricing and undervaluing your work is one sure-fire way to attract stage moms and difficult pet owners. If you are doing pet photography as a hobby, you can always qualify pet owners by stating up front that you have limited sessions available, and then go on to ask them about their pets and their relationships. You can then decide if you think a particular owner would be good to work with. If someone is getting something for free, you should at least have the final say when it comes to what you will and won't do and who you will and won't shoot with.

10. In really extreme situations, such as those in which you don't feel physically comfortable around a person, you feel the animal is being abused, and/or it's potentially a dangerous environment, you can elect to cancel the shoot altogether—no matter where you are in the shoot. This decision needs to be made very carefully, and you need to ensure that if you're a professional you will be protected from lawsuits through your insurance and your contract. In litigation-happy countries such as the Unites States, owners can threaten to sue you if you don't produce what they are expecting.

 The best way to avoid this is to diffuse the situation and communicate with the client. If you are doing a shoot that is untenable, and you know it will only get worse if you stay and continue, you can try to say something like, "I'm so sorry, but now that I am here and I see what your needs are, I really don't feel that I am the best photographer to satisfy them. I don't feel that I can capture the kinds of shots you have your heart set on, and I really don't want to disappoint you. You deserve the very best. I would like to offer you a full refund of monies paid and refer you to another photographer who I think would do a better job and that I think you would be thrilled with."

 Use a very gentle, friendly tone, and put the onus on you. Avoid blame, anger, or defensiveness, even if you genuinely feel all of those things, because they will only make the situation worse. Get out of the situation with as little conflict as possible, immediately give the individual a full refund upon returning to the office, and send a list of several other photography services to try, being sure to explain that you have never used the services but have heard good things (assuming that you have never worked with the photographers you are referring). One thing that is very important to remember here is that the photo shoot is just a small part of your experience working with a pet's owner. There will be many more weeks, if not months, of back-and-forth when it comes to prints and other products. Clients such as these will complain, even if it's just about one print, and you will bend over backward trying to make them happy. If you cancel the shoot, you aren't just saving yourself the time and stress of working with them during the shoot, you are also saving yourself from many more hours of emotional turmoil they will continue to put you through for a long time to come. Make this decision carefully, but if your physical and emotional well-being depend on you not working with a particular client, do your best to get out of it graciously so that you can move on and work with clients who won't cause you undo stress.

Working in a Studio

Working with animals in a studio can bring with it an entire set of unique challenges. You will have dogs who refuse to step foot on seamless paper, cats who are terrified of strobe lights, stage-mom owners, and events for which you have just 10 minutes to capture a great shot. Those who do studio pet photography need to have infinite patience with both animals and people. Here are some tips that can make your life easier:

Maintain a stock of backup bulbs for your lights. As I mention in Chapter 6, if you are using studio lights, it's always a good idea to have backups in case one blows right in the middle of a shoot.

Contain the animal if you break a light. Clean up any broken glass immediately and thoroughly.

Have a second and third option for those pets that refuse to stand on seamless paper. Some pets find the texture feels weird on their paws. For example, you can use a tile board or sheet of flooring. Sometimes even using a vinyl backdrop will help an animal feel more secure.

Always have high-flavor treats on hand. It's a good idea to have at least a mini-fridge on site if it's a fixed location. This way, you can store string cheese, liver, salmon, turkey, and other high-flavor treats for the pets that need extra motivation.

Engage a handler or assistant. Having an assistant will free you up to perform the technical part of the job and enable you to get more than a couple of feet away from your subject.

Have a big box of various toys on hand. You want the experience to be fun for the animal, so whether it's a group of puppies or a single cat, having some fun and novel toys for them to play with can make the experience more enjoyable for them.

Keep your studio surroundings safe for your models. Look for broken cords, unstable furniture or stands, tight or constricted areas in which a pet can become stuck, or any other safety hazard. Think about how you would baby-proof your studio from a toddler. Take the same measures to keep your studio safe for your pet clients.

If a pet isn't performing the way you want it to, take a few shots and then take a break. Take a few more shots, and then take another break.

Use classical conditioning. Sometimes you will need to spend the first 30 to 40 minutes just conditioning the animal to behave the way you'd like it to. If you can get it to the point where it understands what's expected of it, the rest of the shoot can go really well. Of course, this isn't possible when doing mini-shoots, for which you have just 10 or 15 minutes with each animal. It is a very good idea in these situations to have a handler or trainer on site who can work with the animals and help you position them so that you can focus on capturing the shots. If this isn't possible, do the best you can and be certain to stipulate that there are no guarantees for these kinds of shoots.

Use barriers to keep your subjects where they're supposed to be. A large piece of foamcore or folding doors on either side of your seamless backdrop can help prevent the animals from running off the paper. Just make sure anything you use is steady and can't be knocked over.

Have cleanup supplies ready to go. You can expect accidents to happen when photographing animals in your studio, so be sure you have an ample supply of paper towels, rags, and cleaning solution, such as Nature's Miracle, on hand and at the ready.

Send the owner on an errand or have her wait in the other room. You'll have to get creative with this, but sometimes just removing an owner from the environment can work wonders, enabling the animal to relax and you to get the shots. Of course, this tactic will never work with a dog that has separation anxiety; usually, it will make the situation worse. However, with a pet that is well-adjusted but has an overly involved owner that is distracting it, sometimes you just need to be able to work with the animal alone for a few minutes.

Stick your subject on a chair or pet bed. Sometimes, just being on something familiar is all a wary pet needs to feel at home during a studio shoot.

If you have the option, move your setup to a window. If you absolutely cannot get the pet to cooperate as a result of the studio lights on a seamless backdrop, lay something over the seamless paper on the floor and use natural light instead of studio lights.

When working with pets in a studio, be creative and think outside the box when it comes to solutions to common problems.

Ferguson sports a fun prop in this studio shoot: mirrored children's sunglasses.

24–70mm 2.8L lens @ 40mm, f/4.0, 1/125 second, ISO 100, manual exposure, spot metering

Legal Considerations

As I mentioned in the section "'Stage-Mom' Owners," we live in a very litigious time, and if some people don't get exactly what they want, they threaten to sue. Most reasonable people would never go down this road unless it was really warranted, but not everyone you work with in business will be reasonable. It's a good idea to protect yourself legally should issues arise, and prevent issues from happening in the first place. Here are some simple ways you can do this:

Make the pet's safety and health your top priority at all times. Don't take unnecessary risks; don't make animals jump farther or higher than is reasonable; and don't place them in risky situations. Mitigate risk during your shoots and you will preclude many unpleasant legal entanglements.

Communicate, communicate, communicate. Explain, detail, set expectations, and create clear, understandable policies. Ensure that the people with whom you are working understand your process and what to expect. Good communication at the beginning of your relationship can prevent a whole host of problems in the end.

Use a model release contract. For each and every shoot. A well-written contract should have a copyright term, a model/property release (pets are considered property), a liability term, a refund term, a cancellation term, payment term, and basic legal information on disputes, severability, state laws, and a warranty signed by the owner that he is the legal guardian of the pet. Of course, people can still try to take legal action against you even if you have an iron-clad written agreement, but having this document helps you make your case in court. Take a look at the book *Legal Forms for Photographers* (2010, Allworth Press; ISBN: 978-1-58115-669-0) by Tad Crawford for sample forms.

Never ask an owners to do something with their pets that you wouldn't feel comfortable doing with your own pet(s). Treat each animal you work with the same care and respect that you give your own precious animal family member.

Buy the appropriate insurance package for your business. If you are doing pet photography professionally, it's a very good idea to have business insurance, which will cover not only your equipment but also your client's property. You should be sure that your policy also provides liability coverage. You can get great coverage for as low as $500 per year. Take a look at the insurance offered by photography member associations or your current insurance company to see if it offers business insurance.

Although these situations are rare, the two main areas you might experience problems in a pet photography business are accidents and injury to the pet, and complaints about copyright and image use (for example, the owner not wanting you to use the images for anything).

The first situation can be mitigated by due diligence on your part, as I explained earlier. Scout the location (outdoors or studio), look for safety issues, always be aware of what's going on around you, never put the pet in a risky situation, and always be on the lookout for things that could create accidents or injury to the pet.

The second situation can be mitigated through communication. Use your website, your e-mail correspondence, your contract, and plain, old-fashioned verbal skills to clearly communicate what you intend to do and what the final product should be. Provide any and all copyright information necessary to the client if he inquires about you using the images. If and when you encounter a pet owner who is adamant about you not using the pet's images for anything, my best recommendation is to follow his wishes, file those images away, and never touch them again. You don't want to create a potential legal issue and a dissatisfied customer by ignoring his wishes. And there's no point in declining the shoot and giving up a paying client over an issue like this when there are, to use a poorly placed metaphor, plenty more fish in the ocean.

I have only had this situation arise twice in the nine years I've been doing pet photography professionally, and both times I've simply crossed out the clause in my contract that gives me the license to sell the images commercially and use them for promotional purposes, and initialed next to the crossed-out section. In both situations the pet owners were a little "off" in other ways and somewhat difficult to work with, so I was happy to comply to prevent future problems.

With that having been said, if you are doing free portfolio-building shoots for the very purpose of creating images to use in a gallery, if a client won't agree to let you use the images you create of their pet in your portfolio, this should disqualify them from the shoot. There will be many more pet owners who are happy to let you use the images of their pets for your portfolio. Make sure your portfolio-building clients understand your copyright term *before* signing up for a shoot, and certainly have them read and sign your agreement prior to shooting. (You can find more on portfolio-building shoots in Chapter 11.)

A Note About Copyright

Copyright laws are complex and vary depending on where in the world you live. For example, in the United States, photographers own the copyright to an image from the moment they create it . They are protected under the Digital Millennium Copyright Act (DMCA). However, in Canada, according to the Canadian Copyright Act, if a client is hiring a photographer and paying them for a commissioned shoot (that is, works that are made for valuable consideration), the client is the copyright holder of those images, unless agreed to otherwise in a signed contract. It is very important to research the laws in your country to become educated about copyright so that you can educate your clients if and when they need information, and so that you know what you legally can and can't do with the images that you capture. Take a look at the Wikipedia online for copyright information for your country.

The good news when it comes to pet photography challenges is that with a little bit of prior planning and some education and communication, most challenges can be minimized or even eliminated. Most shoots you do will be with fun pets. They will also usually involve great owners who all share one thing in common: a deep love and affection for their animals. You can expect a lot more joy than frustration doing pet photography. As I like to say, "it's not funeral home directing, it's pet photography."

Benny had a blast during our photo shoot at a park, and it showed in the smiles he gave me.

24–70mm 2.8L lens @ 24mm, f/7.1, 1/800 second, ISO 100, manual exposure, flash fired, spot metering

Exercises

1. **Black dog/white dog**

 Photograph both a black dog and a white dog by using spot metering and either manual exposure or aperture priority or shutter priority, along with exposure compensation.

2. **Location Scouting**

 Head out into your area and do some location scouting, taking photos along the way. When you return home, compile the photos along with a description of each location, and either create a PDF or JPEG file or put the images and descriptions on your website. This will make it easier to pick a location for your next shoot if it's not where the pet resides.

3. **Model Release Forms**

 Create a model release with different versions for use in different shoots: paying client shoots, portfolio-building shoots, and shoots for animal shelters. Having a model release at the ready will free you up to focus on the creative part of a shoot.

Chapter Nine

Post-Production

- ☆ Establishing Your Workflow
- ☆ Archiving and Naming Conventions
- ☆ Editing Basics
- ☆ Culling and Processing in Lightroom
- ☆ Editing in Photoshop
- ☆ Alternative Editing Software
- ☆ Common Novice Photography and Editing Errors

Establishing Your Workflow

Workflow refers to the steps you take, or the procedure you follow, as you progress through the course of creating a finished photograph, from the point at which you capture an image with your camera until you finally archive it. Some photographers consider pre-shoot preparations and how they work during a shoot to be part of their workflow, as well. Every photographer has a unique workflow, and what works in one business model might not work for another. Over time, you will develop your own workflow that is best suited to your particular business model and clients. It's better to have *some* kind of workflow than none at all because the latter will lead to more work in the long run. Time spent looking for lost files, or trying in vain to duplicate edit settings is time that you could be using to further develop your business (or maybe even take a little time off).

The better established your workflow is in the beginning of your photographic career, the easier your job will be in the long run. Workflow should be built on conventions that you can remember, that make the most logical sense to you personally, and that also fit within your schedule and the capabilities of your office and technology setup. For example, it might be logical for one photographer to organize all of her files by date, but if you aren't a numbers person and can't remember if a certain photo shoot was taken in 2007 or 2010, it might be best for you to use names to organize your files, instead. It might make the most sense for a photographer to process, edit, and backup his files the same day of a photo shoot, but that might not be practical for you because of other time constraints.

Do what works for you, what will be logical to you in the long run, and what fits in your budget and schedule. Also, your workflow process will be different depending on whether you are doing pet photography professionally, which will include editing images for prints and other products for clients, or you are doing it more as a hobby for your friends and family.

One of the most comprehensive resources on workflows ever created for photographers is the website Digital Photography Best Practices and Workflow (www.dpbestflow.org), created by the professional photography organization American Society of Media Photographers. On the site, you will find information about color, computer setups, camera setups, image editing, file formats, metadata, backups, file management, data validation, data storage, file delivery, migration, file lifecycles, copyright registration, and more. This is information assembled over five years by a leading team of researchers and photographers.

The basic steps to workflow are presented in the subsections that follow.

1. **Capture**

 Capture your images in either RAW or JPEG or RAW + JPEG (RAW is preferred over straight JPEG files). Be consistent here and be sure that don't arbitrarily change the quality or file type settings on your camera. It's best to shoot at the highest quality your camera is capable of and then shrink the files down later if you need to. It's easy to bump down quality; it's impossible to bump it up after the data is gone. I personally leave the settings at the highest quality RAW files at all times. All it takes is one shoot accidentally captured at web-sized, low-quality files to learn that lesson and never do it again.

2. Download/Ingest Your Images

Transfer your image files from your memory card to the hard drive on your computer, or to use the industry term, *ingest* your images. This can be done by using one of several methods: drag and drop the files from one device to the other in either the Windows or the Mac desktop (just as you would move any other type of file); import them by using Adobe Photoshop Lightroom; import them by using the software that came with your camera; or import them via a different type of application (such as Image Capture on the Mac). Whatever method you use, ensure that you know where the files end up on your hard drive and that you can locate those easily and readily through your operating system.

It's a good idea at this point to create different folders for different file uses. For example, you might have a RAW file folder to hold your original shots, a JPEG file folder in which you'll place the images after you have converted your RAW files, a print edits folder for any client orders, and a web folder for blog posts or facebook images. The following screen shot shows an example of what your folders might look like.

```
fergie triptych 15x30 template.psd
Gabriela Sanchez- Guenevere, Arthur, Galahad, Wilbur, Ocelot, Simba & Minnie Mouse images 7/14/11
    Gabriela Sanchez Documents
        Gabriela Sanchez contracts
        Gabriela Sanchez Invoices & Order forms
    Gabriela Sanchez JPEGS
    Gabriela Sanchez print edits
        Canvas
            psd files
            Sanchez Canvas Storyboard FINAL 24x36.jpg
        photobook
            horizontal
            photobook pages
                completed pages
                original spreads
            psd files
        Prints
            8x10
            16x20
        Proof Box cover
    Gabriela Sanchez RAW files
```

You can choose to either name your folders by the dates of your shoots or by the pet and its owner's name. If you find it easiest to remember the pet's name rather than the date or the name of the owner, ensure that you are using the pet's name in the name of every folder. If the pet has a common name like Gracie or Scout or Sam, use the pet's name and the client's last name plus the date of the shoot for your folders; for example, *Scout Harrison 5-12-12*.

3. Import

Import your image files into the software you plan to use to edit them and/or convert RAW files. If you are using Lightroom, you can use the Import dialog box to do this. Because you already have the files on your hard drive, you will want to copy them to the catalog instead of moving them.

You can also use Lightroom to import images and copy the files to an external drive at this point, if you don't need to delete any unusable files and want to make sure you are archiving *all* of the files that are on your memory cards. (You can always replace those later with the culled RAW files, as described in the following step.) You can also rename files, convert file types, and apply metadata settings and other processes to the files upon import. Take a look at the options afforded to you by Lightroom in the import dialog box to determine what will work best for you and your business.

As of this writing, if you rename files during import in Lightroom, you sever the link to the original RAW filename. This is because Lightroom doesn't give you the option to preserve the current filename in XMP Metadata upon import or export. This means that your metadata will not contain the original file number of the original file on the memory card. This can be a problem if you ever need to find an image on a memory card, which can happen more often than you think. Later in this chapter, I share an alternative naming process with you that retains the original filename in the XMP metadata.

4. Cull

Culling is the process of sorting through your image files and deleting those that are unusable. Unusable files include images that are too blurry, overexposed, or underexposed to fix. They might also include files in which a dog leash can't be removed without expending great time and effort (provided you need to remove the leash at all), or the composition can't be changed adequately by using software.

Some photographers prefer to star ratings or color code the images that they would like to keep or show the pet's owner. You can elect to use a rating system or simply delete all of the files you don't plan to show the owner/client.

Before You Click That Delete Button...

If you are starting with a lot of files—perhaps you forgot to turn off continuous/burst mode on your camera—it's a good idea to do two or three culling sessions, spaced a day or more apart. Each time you come back to your files with fresh eyes, this process will be easier. The more time you allow between culling sessions, the easier this process will be. Also, if you are doing pet photography professionally, the more you know your clients and their tastes, the easier this process will be, because you will have a good idea of what will be visually appealing to each one.

5. Archive RAW files

Now that you have your files narrowed down to the "keepers," you need to archive them (assuming you didn't already archive all of your RAW files in step 4). There are several archiving options available from which you can choose, again depending upon your needs and your budget. Some archiving methods include burning your files to DVD or Blu-ray discs, keeping them on an external storage device (such as an external hard drive), or using cloud-based online storage (I'll talk more about archiving soon).

> *Note*
>
> *Some photographers choose to archive their files as soon as they transfer them to their hard drives—unusable files and all. You can choose to do this, but remember that even if you delete your files from your hard drive, you still have them on your memory card. You should always have your original files backed up before formatting a memory card for reuse, which just provides extra insurance in the event of hard drive failure.*

6. Post-Processing

With a duplicate set of your RAW files safely archived, you can begin the process of adjusting your working set of files in your editing software. This typically involves fixing exposure, color balance, clipping, tone adjustments, and so on, depending upon the quality of the captured images.

7. Export JPEGs/TIFFs/DNG Files

After you adjust your images for quality, export or save copies of them to a new folder so that your original files remain untouched. In most editing software, you can export an image as any file type you like, which will depend largely on the kind of work you are doing, who your clients are, and how large you need to print your images. Common file types are JPEG, TIFF, PSD (a Photoshop proprietary format), and DNG files. Keep in mind that TIFF and PSD files take up *a lot* of space on your hard drive, so be sure you really need the extra data (which translates to quality) that are inherent to these file types before you fall into the habit of storing a lot of them on your hard drives. If you do need to export all of your image files as TIFF and PSD, you will want to invest some money into a great archiving system because you'll need the extra space for storage. If you are producing a few thousand image files per month on top of saving your RAW files, you'll need between 3 terabytes (TB) and 8TB of storage (more if you plan to use a RAID setup on your drives). I'll talk more about this in just a little bit.

8. Archive Exported Files

After you have made your adjustments on your original files and have them looking their best, archive those newly-edited exported JPEG/TIFF/PSD files on your external hard drives, online storage, or wherever you are storing your files (more on this coming up).

9. **Create an Online Gallery and Upload the Images**

 In this phase, you will present the images to the pet's owner so that she can select the ones she wants made into prints or other products The easiest way to do this is by setting up an online gallery that the client can access on your website. Upload your JPEG images to the new gallery and send the link to the client.

10. **Detailed Editing of Selected Images for Prints and Other Product Orders**

 After the client has reviewed the gallery and made her final choices and you have received a product order, this is the point at which you will be performing detail editing on the selected files to be processed as prints or any other products. Detail editing at this juncture includes cloning out leashes; removing cookie crumbs, eye goop, and other unflattering elements; cropping for composition; and setting up the image according to the final print dimensions.

11. **Archive Print Edits**

 When the detail editing is complete for the images your client is ordering, you now need to archive the final delivered images that you have lovingly prepared.

Archiving and Naming Conventions

For professional pet photographers, your images are your assets. And just like your client's pets, they should be protected and cherished. There are photographers out there who don't believe in archiving images; instead, they inform their clients that they will "purge" the images of their pets after a set period of time (perhaps after their gallery expires, or maybe after a period of two, three, or six months or some other arbitrary length of time). Let me state emphatically that as a pet photographer you should always archive your images. The reason is fundamental: All pets pass away at some point.

It is quite common for a pet owners to contact you after the pet has passed, asking for more prints or other products. In some cases, they didn't have the money to purchase everything they wanted at the time of the shoot. For others, life got busy and they didn't get around to ordering at all. If they don't have any photos of their pet, you become their only link to their beloved, furry family member, and regardless of the reason *why* they want the images, the very last thing you want to do is say, "Sorry, I purged them."

You are not in the business of breaking hearts; you are in the business of bringing meaning and joy and honoring the incredible bond between human and animal. Treat your image files like gold, archive them, and then back up the archives. Hold onto them for when the inevitable happens; you have a client with a broken heart who just wants a visual memory of their beloved animal. Be the person that is able to give that to them.

With that said, here are several ways that you can archive your image files, in order from least to most expensive:

1. **DVD and Blu-ray discs** Burning DVDs or Blu-ray discs is a relatively inexpensive and easy storage strategy. The downside is they take time to create, and need to be stored somewhere safe. Technology is changing at an alarming rate, so there are also no guarantees that you will be able to read either of these formats in the future. In that sense, they are the modern version of the 8-track cassette. As newer storage technologies are introduced into the marketplace, you should plan on migrating your archives to that method so that you don't find that someday you're unable to access your own files.

2. **Cloud-based online backups** Rather than maintaining your own storage at your home or office, an increasingly popular alternative is to send your files to a third-party storage service in the "cloud." Cloud-based storage is simply space on a server that you buy on a subscription basis from companies on the Internet. Backblaze and Carbonite are examples of two popular storage companies among photographers. You might also want to look at CrashPlan PRO. Costs for Backblaze and Carbonite run around $5 per terabyte, per month (a terabyte is equal to 1,000 gigabytes); unlimited storage on CrashPlan PRO runs around $4 per month, per computer, or $10 per month for unlimited storage of up to 10 computers.

 The downside to online storage is that if you need to archive a large amount of files all at once, it can take weeks if not months to upload your first batch of files, depending on the speed of your network connection and the size of the files you need to upload. Many services help you avoid this by allowing you to "seed" your initial backup. To do this, the company sends you an actual physical hard drive on which you can quickly load an enormous volume of data. You then send the hard drive (the Seed Backup) back to the service via the USPS, FedEx, UPS, or other parcel delivery service.

3. **External hard drives** External hard drives are a popular choice among photographers. They are relatively inexpensive, come in a variety of storage sizes, are easy to access, and can be stored conveniently in a fire-proof safe or off-site location. It's a good idea to invest in a Redundant Array of Independent Disks, know more commonly as a RAID. These units write data to several "mirrored" hard drives (each drive "looks" exactly the same with regard to the data that's on it) at the same time. With a RAID system, if one hard drive fails, your data is still safely intact on the other drives in the unit.

 You should employ the same strategy with external hard drives that you do with memory cards: instead of using one giant drive that holds all of your content, go with several smaller drives and spread the content out. That way you won't lose everything if—or more accurately, when—they fail.

The best way to protect your content is to mirror your drives and store one of them off site, perhaps at a relative's house, or place it in a fire-proof safe. ioSafe sells a product called SoloPRO, which is an external hard drive that is fireproof, waterproof, and impervious to impact. It comes with data recovery and enables you to lock the drive in place to prevent theft. At $350 for a 1TB hard drive, they aren't cheap, but the peace of mind alone might be worth it. Make sure you read the reviews on external drives before making a purchase, because your archives depend on them being functional and reliable.

4. **Network-attached storage (NAS)** These are external storage devices that you can connect to a network, which enables you to access files from multiple computers, whether you are on your laptop in the living room or your desktop in your office. NAS manufacturers include companies such as Synology and QNAP.

 NAS units hold multiple drives, and some are even capable of holding multiple drives of different brands and sizes. Many are compatible with Apple's Time Machine, so setting up automatic back-ups is as easy as a click of a button (if you're using a Mac). The downside to NAS is the cost, with multiple-bay storage devices easily running in the $500 range without the hard drives. Quality hard drives will run you over $100 for a TB capacity unit. The entire cost can easily run you more than the cost of online storage plus individual external drives combined.

Whatever you choose for your back up and archive strategy, make sure it provides you peace of mind. Purchase drives with the longest warranty periods (purchase additional warrantees if you can), perform multiple backups (online and NAS or external), ensure that you have redundancy in your backups. The experts I've spoken to all agree that when it comes to hard-drive failure, it's not a matter of *if*, it's absolutely a matter of *when*, and having the reassurance of a redundant architecture for when that inevitability happens is worth the extra effort and cost.

Naming Conventions

Every folder of images that you create on any of your hard drives or external media needs to have a meaningful name. There is no right or wrong way to name your folders, but the most important thing to remember is it needs to make sense to you, and be easy to remember.

If you are ingesting your images directly into Lightroom from the memory card, you might decide to import to folders named by the date of the shoot. If this makes sense to you, go for it! If dates and numbers are not your forte, choose something easier for *you* to remember. Along with naming the folders, you need to name your individual files, as well. Every photographer develops a unique naming convention system. The system I describe here I have found works best for me and my low-volume, high-quality business model.

I name my folders by using the client's first and last name, the pet's name(s), and date of the shoot. So, the main folder would look like this:

Serena Williamson- Hank and Loody- 4-27-12

Within the main folder are several additional folders

Hank and Loody RAW 4-27-12

Hank and Loody JPEGs 4-27-12

Hank and Loody print edits 4-27-12

Hank and Loody blog post 4-27-12

If the pets have common names—perhaps it's a cat named Fluffy—I will use the client's last name, as well, so the folders will look like this:

Fluffy Williamson 4-27-12

I then name the actual image files by using the pet's names, such as this one:

Hank & Loody 36.jpg

I have found that over the years this process makes the most sense and facilitates finding files later on. In most cases, because pets make such an impression on us, you might find it much easier to associate a photo shoot with a pet's name than that of the client or by using a date. It is not at all uncommon for pet photographers to still remember a pet's name but to have forgotten the owner's name a long time ago. Now, it should be said that if you are doing a large volume of work, perhaps multiple shoots every day, it might be best to name your folders by dates and times instead of names. As I said earlier, whatever names you choose to use for both your files and folders should be easy to remember, make sense to you logically, and be easy to find when searching for images in the future.

You can choose to rename files when you ingest them into your photo processing software, which gives each file a unique name that is different from the filename on the memory card. You can rename the files upon export from your software, or you can rename files as a batch in Adobe Bridge (which I detail in just a little bit). A fourth option—and I do not recommend this—is to choose not to rename the files at all.

Here is how I do it. I only rename the files after I have gone through the culling process and am ready to export them as JPEG or TIFF files. I do this because these are the files I will be showing to my client, and I don't want there to ever be a jump in filenames, (for instance, go from IMG_4077 to IMG 4094). The reason for this is that it avoids the client saying, "What happened to images 78 through 93? Do I get to see those too?" You want to avoid any conversations about *how* you chose which ones were viable and which ones weren't, which is a process that can be difficult if not impossible to explain to someone who isn't a photographer.

In the sections that follow, I'll be guiding you through sequences of mouse clicks that you'll need to do to carry out a function. To save a little time (and a lot of typing), I use a shorthand method get you from the first menu item you need to click to the last one. It looks like this:

Image → Adjustments → Brightness/Contrast

This tells you to click Image, click Adjustments in the menu that opens, and then click Brightness/Contrast. I'll also use initial capitalization for all of the labels on your computer screen to help distinguish them from the surrounding text.

I personally use Adobe Bridge to rename files. After I have gone through the culling process and I have my processed files in a new folder as JPEG files, in Bridge I go to Tools → Batch Rename → Default Preset → Rename In Same Folder → With New Filenames, such as Hank & Loody 1.jpg, and always select the Preserve Current Filename In XMP Metadata check box.

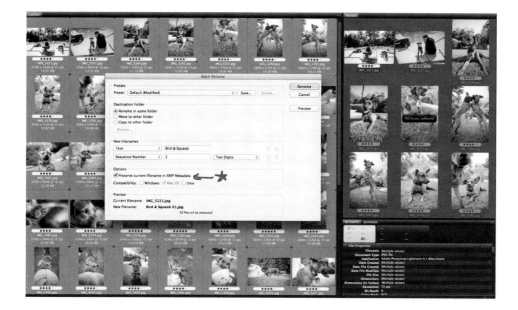

This last step is important to me for a couple of reasons. First, when I do this and I view the new JPEG image in Bridge, underneath the new filename it shows the original RAW filename. For example, for an image named "Hank & Loody.jpg," directly beneath it would be "IMG_8027.CR2." The lower name is the name of the file as it was created on the memory card. The second reason is that if I need to re-edit a new file, I can easily go back and find the original file (such as the RAW file), and work from scratch. This scenario happens all the time, and because my editing skills are constantly improving over time, I want to go back to the original RAW so that I can produce an even better product for the client than I gave him the first time. If a client orders a product three, five, or eight years down the road, I want to be able to find the original file quickly and easily by filename (not by visuals, which can be unreliable and time-consuming), and start from scratch on that file.

I have also encountered situations in which I have had to pull original files from a memory card before it's formatted (in the case where I have already deleted those files from my hard drive), to re-edit those specific files, which is why I never rename files upon import, because, again, this makes it harder to find those original files when Lightroom isn't giving you the option to preserve the current filename in the XMP metadata. Whenever I am naming, archiving, and renaming files, I always ask myself how hard it will be to locate those files years later, when they are on a DVD or external hard drive. Make sure that whatever system you use *now* will make sense to you *later*. Most important, when you do pick a system, make sure it's a good one and stick with it; use the same system for every shoot. This will save you time and heartache later on.

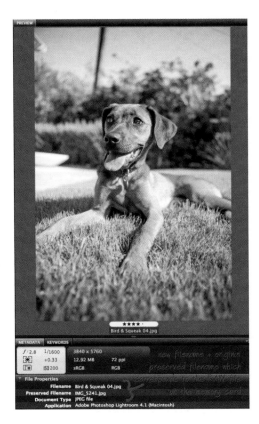

Editing Basics

There are many photographers who believe that editing digital images is cheating. I know this because I used to be one of them. I used to think that if you didn't get everything just exactly how you wanted it "in-camera," then you had no business being a photographer. I used to believe that making any changes to an image with photo-editing software was just faking greatness. Then, I amassed some real-world experience with pet photography

And all of that changed.

I came to learn that editing with photo software can help you do several things. First, it can help you to execute a creative vision that only software can do. Second, it can free you up from being overly concerned with the technicalities of photography and allow you to focus on what's most important— getting genuine, authentic, funny, awww-inspiring, spur-of-the-moment, pet expressions. And third, when you're doing pet photography professionally, clients don't care about how much or how little time is spent in Photoshop or Lightroom. Ultimately, what matters most to me is that my client is happy with my creation. If my client is happy, that means I am doing my job, regardless of the path I took to get there.

Of course, I, like most photographers, would rather spend more time actually *taking* photos than slaving away in the digital darkroom. Because editing and processing will be a big part of your workflow, it's a good idea to develop editing techniques that will allow you to complete the task quickly, unless you are spending extra time on a particular image with a specific creative end goal in mind.

Most digital files—and nearly all RAW files—can benefit from some tweaking in software. RAW files have a tendency to come out of the camera with an ugly gray haze, almost as if there is a layer of dingy plastic wrap covering them. To remove that haze you need to increase or improve the contrast and add in some clarity. There are a variety of ways to do that which I will show you a little later in this chapter. You will also need to sharpen most of your digital files because they come out of the camera on the soft side. Even if you aren't doing a drastic overhaul to any of your images, a few tweaks and touch-ups can take something *good*, and make it *great*. And don't we all want something great? Yes, we do!

As far as photo-editing software goes, programs such as these are mere tools to help you achieve your creative vision, or perhaps fix issues that are the product of your camera or lens or challenging shooting conditions. The more different tools you know how to use, the easier it will be to achieve optimal results. You might take a look at an image in Lightroom and decide in the moment that you want to straighten the horizon, fix the grass color, and increase the contrast, and then run Local Contrast on the eyes, use a multiple layer mask on the chest of the animal, and clone out a distracting element using Photoshop. You might then decide to go hog-wild and ingest that final edited image into another editing program that adds fun effects like our smartphone photography apps do. There is no one perfect tool to get the job done. It's just a matter of learning what combination of tools works for you, and working with what you have.

So let's get started with editing, beginning with Lightroom.

Culling and Processing in Lightroom

Adobe Photoshop Lightroom (or simply Lightroom as it's commonly known) has transformed the way photographers work, making the culling, sorting, and editing process quick and easy. Although there are many other excellent software programs out there for editing and organizing files, it would be impossible to overestimate the value of Lightroom in the modern pet photographer's workflow. It's 150 incredibly well-spent dollars (or you can now purchase a cloud-based subscription if you are interested in Photoshop and other Adobe applications, too, but you don't want to fork over the money for the full software programs), and it more than pays for itself in time and stress saved.

A Brief Explanation about Lightroom

You can use Lightroom to perform what's called *non-destructive editing*. Typically, when you edit any sort of digital file, you make permanent changes to the actual underlying data for that file. However, when you edit an image in Lightroom, it doesn't actually make any changes to the data that represents the image. Instead, it adds the instructions that describe the changes you make to what's called the file's *metadata* (metadata essentially means information about the information). This gives you the option to always be able to revert back to "square one" if you want to. Edits and settings never become a permanent part of the file, unless you export a file from the original, at which point they then become locked

into that exported file. If you are shooting in RAW, and exporting from Lightroom to JPEG or TIFF, you will always have an original "digital negative" of your file—untouched and unmodified. You don't have to worry about saving over something accidentally because you can always return to your file in Lightroom, and if you don't like what you did to it, all you need to do is click a little button labeled Reset, and it takes you right back to the original. Awesome!

Lightroom is also very easy to use. Lightroom 4 comprises a whole bunch of sliders that control all of the following: white balance, exposure, contrast, highlights, shadows, whites, blacks, brightness, clarity, vibrance/saturation, tone curve, hue, saturation, luminance, split toning, sharpening, noise removal, lens corrections (including distortion), vignetting (including post-crop vignetting), defringing, and grain. You can download Lightroom 4, open the application, and be up and running in no time, sliding sliders to the left or right, adjusting to your heart's content.

As far as organization goes, Lightroom is considered a *database-oriented* photo management tool. It employs a the concept of "catalogs," which are databases of images that you can organize into quick collections, or you can just keep the same folder structure you have on your hard drive. The catalogs in Lightroom tie, or more accurately, link images to their original locations on your storage device when you import them. This is an important concept (that's also employed by several other photo management applications), and one worth taking a few moments look at.

When you create a catalog of certain images—as an example, let's say you make a catalog that contains only photos of cats—Lightroom does not place the original image file (or a copy of it either) in this new catalog. Instead, the catalog is really nothing more than a group of references, or *pointers*, with each image in a catalog pointing to the location on your hard drive where the actual original image data resides. So, going back to our cat catalog, suppose each of the photos within that catalog came from different shoots for which you also have catalogs. Lightroom doesn't make another copy of the image files for each catalog, it just points to the original image for each file, wherever you imported them.

This means that you can have the same image of Fluffy chasing after a toy in multiple catalogs, perhaps one named "Cats," one named "July-2012," one named "Pet's Playing"—you get the idea—without making a single additional copy of the original file. This is a tremendously flexible system that allows you organize your images in a near infinite number of ways, without filling up your storage devices with what would otherwise be hundreds or even thousands of the same photos.

A really nice feature is that if you move the images later on (which you will, trust me), Lightroom makes it easy to "relink" the catalogs to the original folder or file. For example, when I move folders of images from my computer to an external drive for long-term storage, all I need to do is right-click the folder in Lightroom that displays with a question mark over it (this is Lightroom's way is telling me it can't find the original files), click a button labeled Find Missing Folder, and then navigate to the folder's new home and select it. The images import with the same edit settings they had when I worked on them months or even years earlier. Simple and easy. If you have a main folder on your external drives to which you export most of your image files, it might be a good idea to save a copy of your catalogs to that folder to keep them all in one place.

Because Lightroom stores images and their corresponding edit settings in catalogs, I recommend that you create a system for catalogs early on and then stick with it. You can create a new catalog every

month, every year, for every shoot, and for the different types of shoots you do (shelter pets, private clients, magazine shoots, and so on). It's entirely up to you. But just like the naming conventions, ensure that the system you use to organize your files and catalogs makes sense to you and works well for the long term. I personally like having all of my images in one place, so I create a new catalog once per year at the beginning of the year. This works well for me because I have a low-volume business model. You might find other organizational systems that are a better fit for how you work.

Lightroom also has plug-ins available for everything from metadata to options for exporting to numerous popular websites, online services, and print vendors. Plug-ins expand the already impressive capabilities of Lightroom even further.

The basic features in Lightroom enable you to do the following:

♦ Create web galleries

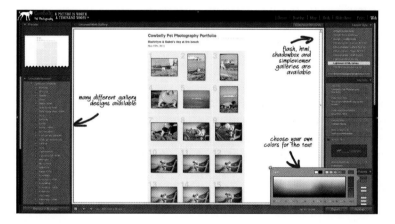

♦ Design books

♦ Make Prints

♦ Edit an entire batch of images with one click

♦ Do your laundry

Alright, just kidding on that last one. It doesn't actually *do* your laundry for you, it just frees up more time for you so that you can do it yourself (yippee!!).

Once you have gone through the culling process for the final time, you're ready to do some basic editing, or what's known as *post-processing*, on your files, before you export them as copies or new file types. You can either cull your images in Lightroom, or use your computer's file viewer, or use any other software program for culling. I personally prefer to use Lightroom because I can easily move back and forth between images by using my arrow keys, pressing the "x" key to mark a file for deletion, or pressing the number keys to apply a star ranking. There are many schools of thought regarding what qualifies for a given number of stars, but for me four stars go in the online gallery, whereas five stars are the rare "Kodak Moment" shots, and the rest have no stars applied at all. In addition to the five-star images going into the client's gallery, whenever I can, I also export them to stock folders, promotional product design folders, and art display folders to be used at a later date. However, before you do this, you need to ensure that have all the necessary permissions to do so legally (see Chapter 8 for information about releases, copyright, and other legal considerations).

Performing Basic Editing in Lightroom

Now that you have your images culled and sorted, you are ready to edit! We'll start in the Develop Module and perform some basic and essential corrections.

White Balance

In the Basic panel (the top panel in the Develop Module), use the Temp slider to adjust the overall temperature (K), or tone, of an image. Use the Tint slider to adjust the green/magenta balance. Take my advice and adjust the white balance first because it can affect your overall exposure. If you make exposure adjustments first, you might find that you need to go back and re-adjust them again *after* changing your white balance. Save yourself the time by doing the white balance adjustment first. You can make white balance adjustment really easy by using the White Balance Selector. To do so, click the eye dropper icon and then click on a spot within your image that is closest to 18 percent gray.

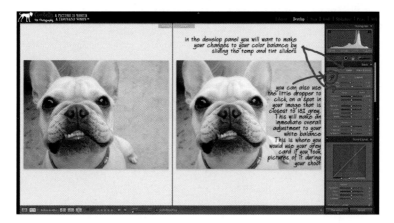

This is also where you can use your gray card that you learned about in Chapter 5. Simply open the image of the gray card, click one of the gray squares, and Lightroom will magically adjust your white balance settings. You can then copy the white balance and paste or sync it to the other images taken at the same time. Quick and easy.

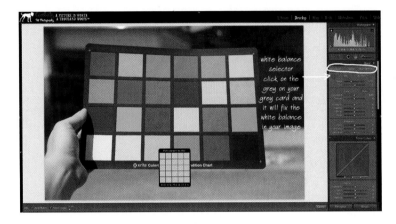

Exposure

The Exposure control slider is also located in the Basic panel, just beneath the white balance controls. The settings in this section affect the entire image. I recommend that you not increase or decrease the exposure by more than one f-stop because it can affect the quality of printed images. If you are working from a RAW file and don't have many shadows or highlights, you can get away with going up or down two full f-stops.

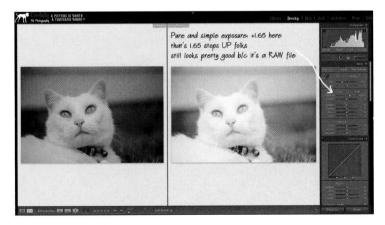

Lens Corrections

To access the Lens Corrections panel, scroll down toward the bottom of the Develop module. If you captured an image by using a very narrow or wide focal length (for instance, 300mm or 17mm), and the image suffers from either pincushion (telephoto) or barrel distortion (wide angle) and/or vignetting, you can fix these issues quickly and easily here. I personally love the look of 20mm dog photos, but they come at the high price of heavy vignetting. Here is where you can take care of that. The easiest way to use this handy tool is to select the Enable Profile Corrections check box. If your lens is in the index, Lightroom will apply automatic adjustments to your image. You can further tweak those settings in the Amount section by adjusting the Distortion and Vignetting sliders. You can also make the corrections manually by clicking the Manual tab at the top of the Lens Corrections panel. If you want to add or remove a vignette, you can do that here. Amount specifies how strong the vignette is; Midpoint is how far into the center of the image the vignette extends.

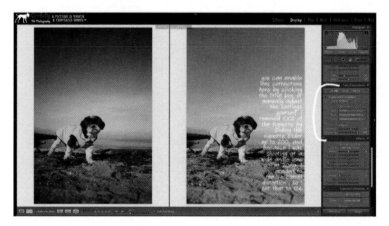

Highlight Recovery and Shadow Lightening

In the Basic panel, look for the Highlights and Shadows sliders. Highlights adjusts the detail in the white areas of an image by darkening blown out highlights or making highlights lighter; Shadows lightens or darkens shadows. If you have any clipping in your images, either on the dark or light side—which can be hard to prevent in some situations, such as shooting in bright sunshine—you will want to lighten the shadows and darken the highlights in Lightroom by using these controls. Keep in mind that when you lighten the shadows it will produce noise in those areas. Take a look at what ISO setting you were shooting at first. If it was 800 or higher and you are lightening the shadows, you will probably need to remove/reduce noise, as well.

Local Contrast: Blacks and Whites, Tone Curve, Clarity

Local Contrast refers to the contrast between smaller details in an image. Simple adjustments with the tone curve can yield great results and make your images look more professional. With most digital images, you will be increasing the contrast, but doing so deliberately and strategically so that the results are visually appealing.

A quick and easy way to do this in Lightroom is through a combination of the following: lighten shadows, increase whites, add in blacks, increase clarity, and then in the Tone Curve panel, lighten lights and darken darks. The stronger the blacks and darks, the higher the shadow number needs to be in the positive (that is, lightening shadows). Use a gentle hand with the clarity slider (usually +7 to +20 will suffice), because too much can produce HDR-like images, which generally look unnatural with pet fur and faces. A quick alternative to using the aforementioned process is to use the Contrast adjustment and increase the contrast to taste. The downside of doing this is that you are adjusting both the highlights and shadows at the same time, which gives you less fine-tuned control over contrast. It can also be very easy to clip the highlights in white pet fur when going overboard with the Contrast adjustment, so use a very measured hand here, too, unless you are going for a dramatic, artistic look.

Cropping and Straightening

In the Develop Module, directly beneath your histogram, you will find several truly awesome tools that you will use regularly when editing your pet photos. They are the Crop Overlay, Spot Removal, Graduated Filter, and Adjustment Brush. (I didn't mention the Red-Eye Removal tool because animal eyes usually glow green instead of red, and not surprisingly, the Red Eye Removal tool looks for red to remove, so it won't work on glowing pet eyes. But you won't be taking photos with on-camera flash again, though, right? Right!) Back to the Crop Overlay. If you end up with crooked horizons in your shots, you will want to correct them in Lightroom, which is a quick and easy fix. Crooked horizons are easy to spot by even the casual viewer, so if you've got 'em, fix 'em. Click the Crop Overlay tool, grab a corner of your image to rotate, or use the little angle ruler tool, and on one side of the image or the other (depending on which side you want to be the starting level of the horizon), click the horizon, drag across the horizon and drop on the other side. Lightroom will straighten and crop it to a level horizon.

Selective Color Fixes

One of my favorite groups of controls in Lightroom is the Hue, Saturation, Luminance panel (it's the one labeled HSL/Color/B&W). Here, you can make adjustments to select colors. You can change their hue, saturation, or luminance (brightness or darkness), or all three if you need to. If your grass is off, or your fur color is all wrong, or your sky needs some brightening, this is where you can fix them. I will show you more of this later in this chapter.

I wanted the bush Rocco was in to be green, not yellow, and I wanted the flowers behind him to be more magenta instead of pink. The HSL (hue, saturation, luminance) sliders made this easy

Sharpening and Noise Reduction

Scroll halfway down the Develop Module and you will see the Detail panel. Here, you can elect to use Photoshop to sharpen your images, or you can use the Lightroom sharpening tools. Just make sure that if you are applying a heavy sharpen in Lightroom, you aren't then doing any significant sharpening in Photoshop; otherwise, you will end up with "crispy-looking" images. Suggested settings in Lightroom for Amount are between 35 and 75 (this controls the strength of the effect). For Radius, adjust between 0.4 and 1.6. This adjusts the size of the details being sharpened: a larger radius is best for large details; a small radius is best for fine details, like web files. Detail adjusts how much high-frequency data is sharpened, with lower settings being good for fine edge sharpening. Masking depends on how much negative space you have that you don't want affected (Masking masks off areas you don't want sharpened). A higher masking number will mask off more of your image. If you'd like to see what exactly is being adjusted with each of these sliders, hold down the Option key (Mac) or Alt key (Windows) as you move the sliders.

In this panel you can also perform noise removal, which is important if you are shooting at high ISO settings or you have an older noisy digital image sensor in your camera. Noise affects the overall look and quality of an image; having too much noise can look, well… just plain bad, and no photographer wants that. Noise Reduction consists of Luminance, Detail, Contrast, Color, and Detail adjustment sliders. The Luminance slider reduces luminance noise, or overall noise (the noise found from light to dark tones); the Detail slider controls the luminance noise threshold; the Contrast slider adjusts the luminance contrast; Color reduces color noise and Detail (under Color) controls the color noise threshold.

Zoom in to your image at 100 percent (1:1). Start with the Luminance control and slide it up just until the image begins to look a little blurry where you don't want it to be (for instance, the edges of the pet's fur). Then, adjust the Detail slider. Higher detail can result in noisier images, but lower detail might remove some of your fine detail in your image, which you need to keep things looking sharp. If you have a considerable amount of color noise (visible as red, blue, and green dots), the Color slider will help you reduce or remove it.

Experiment with these settings and adjust them to taste, depending on how much noise you have and where it occurs in the image. Be careful not to use such a heavy hand on your noise removal that your pet fur ends up looking smooth or blurry. There always needs to be some sharpness in the detail of animal fur; otherwise, it looks fake or *Photoshopped* (a term used to describe an image that has been overly edited in Photoshop).

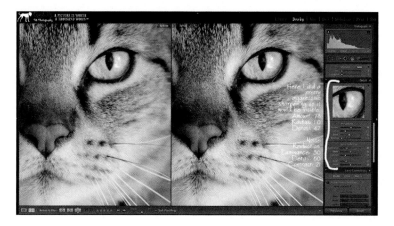

Vibrance and Saturation

You will find Vibrance and Saturation sliders at the bottom of the Basic panel. If your images are too dull, you can increase the vibrance here, or if you have unintentionally increased the saturation to an unnatural degree, you can decrease the saturation here. Vibrance is like the sophisticated cousin of saturation; you should always use it first to make colors more vivid.

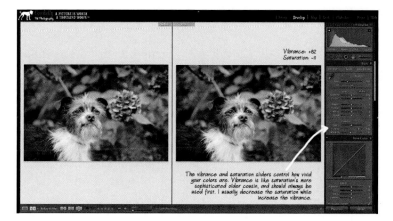

Performing Cloning and Detail Editing with the Spot Removal Tool

In the Tool panel, you will find the Spot Removal tool. This is best applied to little distractions such as cookie crumbs, grass in fur, eye goop, or other small imperfections. Although you can use Lightroom to remove leashes and other larger distracting elements, it can be far more time-consuming than using Photoshop. Later in this chapter, I will show you how to remove leashes in Photoshop.

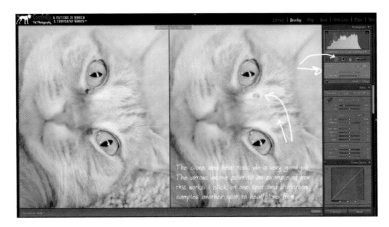

To put all of these things together, the final screen shot in this section presents an example of a Lightroom edit from start to finish.

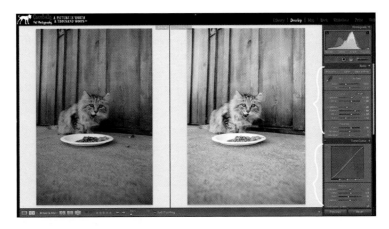

Here is what I did: Exposure: +1.20; Highlights: –29; Shadows: +60; Whites: +20; Blacks: –42; Clarity: +16; Tone Curve: Lights: +9; Darks: –15; Sharpening: 87; Radius: 2.0; Detail: 49; Masking: 34. Cloned out distractions from the floor.

The Lightroom Quick Develop Panel

One of the many great features about Lightroom is its ability to quickly and easily batch edit images. Go to the Library Module and then take a look at the Quick Develop panel. Notice that this panel offers all

of the tools that are available in the Basic panel in the Develop Module. With these tools, you can make quick adjustments to images, including white balance, exposure, contrast, highlights, shadows, whites, blacks, clarity, and contrast. But what makes the Quick Develop panel so cool is that because you're in the Library Module, in which you can select multiple images, you can apply adjustments that you make using any or all of these tools to whatever images you have selected, all at once.

For example, suppose that you photograph a horse on a bright day and you end up with undesirable shadows in every shot. In the gallery on the left, you can select all of the affected images, and then in the Quick Develop panel click the right arrow for Shadows to lighten the shadows on all of the selected images at the same time. This is also great to do for white balance issues. If all of your images are too blue or too yellow, you can select all of them and then adjust the color with the temperature arrows. It's much quicker than using a gray card in every new lighting situation. You can also apply a saved Preset (more on Presets in the next section) to a group of images, which is great when you're doing studio work or any other situation in which the lighting is constant across an entire shoot.

The double arrows indicate an adjustment of one full f-stop; the single arrows indicate an adjustment of 1/3 f-stop. So outside/double arrows equals heavy adjustment; inside/single arrows equals light adjustment.

Using Lightroom Presets

At some point in your Lightroom editing process, you will have a "Eureka" moment when all of the many adjustments you've made come together just right, causing you to pause for second and say, "Hey, that looks pretty good!" From there, you cross your fingers and hope that you can remember all of the individual settings so that you can apply them to other images in the future. If you're familiar with

Actions in Photoshop, you probably would be wishing you had something similar to it in Lightroom; a way to apply the same settings to future images. Well, guess what? You can, using *Presets*.

A Preset is a group of editing configurations that you can save all together under a name of your choosing. I keep any Presets I have created in a folder under my name, such as *Jamie's contrast*, for example. You access your Presets from a list that displays in the Presets panel, located on the left side of the screen.

One of the coolest features is that while you are in the Develop Module, when you hover your pointer over a particular Preset in the Presets panel, Lightroom shows what that Preset will look like (in the Navigator panel) when applied to your selected image—A sneak preview, if you will. You can quickly and easily see if you will like the look of a particular Preset on a particular image.

To save settings as a Preset, while in the Develop Module, click the small plus sign (+) to the right of Presets in the Preset panel, give the Preset a name, and then place it in a pre-existing folder, or create a new folder of Presets (you might need to scroll to the top of the folders list to see the New Folder option. You can choose to save all of your settings or just some of them by selecting or clearing the check boxes adjacent to each setting. Then, when you want to apply that Preset in the future, in the Preset panel, you just click the appropriate folder, and then click the name of the Preset. Lightroom will apply the saved settings to your new image. Of course, you can then further adjust individual settings if desired. Sometimes, Presets are a good place to start if you don't really know what you want to do with an image. They are also a great way to apply your own creative style to an image, which I talk about in Chapter 10. You can download a veritable boatload of free Lightroom Presets by googling—you guessed it, "free lightroom presets."

If you haven't already tried Lightroom, hopefully I have convinced you to download a trial version and give it a whirl. I think you'll find it as much fun as I do.

Editing in Photoshop

Photoshop is an incredibly powerful, complex tool. Many, many books have been written about it, and entire courses are taught throughout the world. Given its complexity and the constraints on what I can present in this book, to get you started, I will show you the simplest procedures that you might want to use for your pet-photography editing. If you own Photoshop, pick up a book, take a class, participate in a workshop, delve in, explore, and you'll be stunned at the amazing transformations this tool can apply to your images.

Adobe Camera RAW

Adobe Camera RAW (ACR) is a Photoshop plug-in with which photographers can process and save RAW files for editing in Photoshop. ACR will look familiar to any Lightroom user because Lightroom was built on the same processing engine. Lightroom is like the sexier, more modern cousin to ACR Bridge, and does all of the same things ACR does because of that shared processing. ACR does *most* of the same things as the current version of Lightroom, but not all. ACR lacks the sophisticated fine-tuning of Lightroom's Highlights, Shadows, Whites, Blacks, and Clarity sliders, and lacks manual Chromatic Aberration controls.

Levels

In Photoshop, on the menu bar at the top, click Image → Adjustments → Levels to open the Levels dialog box. Here, you can make adjustments to lights, midtones, and darks by using the blackpoint slider, midpoint slider, and whitepoint slider under the Input Levels box. (Default levels are 0 for black, 255 for white, and 128 for the midpoint, which redefines the location of the midpoint of the middle gray.) Select the Preview check box to see what the adjustments will look like on your image as you make them. You will want to make adjustments to tones without clipping your highlights or shadows. (You can tell which areas you are clipping by holding down your Option key [Mac] or Alt key [Windows] while you click the black or white point sliders.) Try dragging your black (left) slider to the right, your white (right) slider to the left, and the midpoint slider in either direction, depending on the overall exposure of your image (underexposed drag to the left; overexposed drag to the right).

Curves

A standard tone curve looks similar to the one shown in the screenshot. It forms a slight s-shape, with the top of the bar curving up, and the bottom of the bar curving down. Click a point in the middle of the curve to lock it and then drag the two ends up or down. This increases contrast and gives images some punch. It also takes care of that ugly gray haze inherent with RAW files. Curves can be a highly effective way to increase contrast and improve the look of an image. It's a much more sophisticated way of adjusting contrast than the Contrast setting found under Image → Adjustments → Brightness/Contrast.

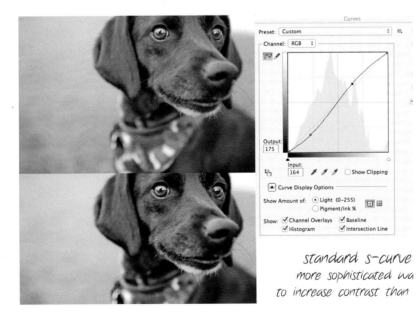

standard s-curve
more sophisticated wa
to increase contrast than

Color Balance

Color adjustments can be made in a variety of different ways in Photoshop. From the menu bar, click Image → Auto color, which works in a pinch if you need to do it quickly; Image → Adjustments → Hue/Saturation if you need to make global adjustments or quickly adjust one color; Image → Adjustments → Variations if you'd like a visual preview of how an image might look if it's more cyan, yellow, blue, or magenta; and last (my personal favorite), Image → Adjustments → Color Balance, wherein you can adjust the cyan, magenta, yellow, and black for each individual color. You can also use Curves to adjust the colors on each channel, which takes some finesse but can yield excellent results when you get the hang of it. If you are used to shooting with film and appreciate what the different colored lens filters can do for your images, you can also apply a photo filter by clicking Adjustments → Image.

Selective Color

Any of the aforementioned color adjustment tools (and more) can be used to selectively adjust color, such as if you have a dog tongue that is too magenta, or ferret fur that is too green. The two easiest ways to fix problems such as these is to select the areas of bad color with the lasso tool with a feather between 5 and 16 (depending on how soft you need the selection to be), click Image → Adjustments → Hue/Saturation, and then change the hue and saturation on that specific color. Another option is to click Image → Adjustments → Replace Color, click the offending color, and then add to it or subtract from it by using the add/subtract droppers. You can also do this *after* you have selected the areas you want to be adjusted, as I described for the tongue example. This will ensure that no other parts of the image are changed.

Leash Removal

If you are doing a lot of outdoor shoots with dogs, removing leashes will need to become one of your super-master-wizardry editing skills in Photoshop. There are a variety of methods that work, including Cloning, Spot Healing, Healing Brush, Content Aware, and Copy and Paste, (and a variant that you can apply by clicking Copy → Paste → Transform and then clicking either Flip or Warp). With some images you will need to do all of these, depending on what is behind a leash. If there is grass or bushes with a shallow depth of field, a simple cloning swipe might suffice. For more complicated leash removal, you might need to spend some time using different techniques. One of my favorite techniques is copying from a part of the image that is similar, pasting over the leash, and then clicking Edit → Transform → Warp, and pulling the edges and sides of the pasted content, pushing, stretching and pulling it to make it appear natural. I then use a soft brush and erase the areas of copied content that overlay my pet or other important element.

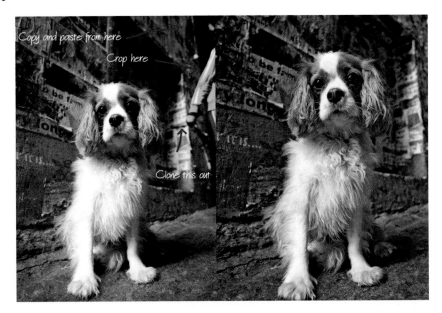

Using Cloning and the Healing Brush to Remove Distracting Elements

The cloning and healing tools in Photoshop are your steadfast friends for removing distracting imperfections that always seem to make their way into photos of every sort, and pet photography is no exception. It's nearly impossible to avoid; pet fur attracts grass, dirt, food, hay, and so on, and slobber and eye goop can be commonplace among some animals or specific dog breeds. To easily remove eye goop or cookie crumbs, use the Spot Healing Brush tool. For larger swaths of junk, try using the Healing Brush tool first. This is great on thin, black retractable leashes on dogs or long pieces of grass or hay on a horse. For larger areas that lack contrasting edges, try using the Patch tool, which can work wonders for removing distractions from images.

The Clone tool offers yet another way to cover over defects if you have a good area from which to clone. For more natural results, reduce the opacity of the Clone tool and make multiple passes over the same area, reducing and enlarging the size of the brush, and increasing and decreasing the opacity as needed. Lastly, although it doesn't always work the way you hope it will, the Contrast Aware fill tool can astound you when it does work. Simply select an element that you want to remove, go to Edit → Fill, and then from the drop-down menu, select Content-Aware. Photoshop will then analyze the surrounding pixel data and determine what needs to be removed. Occasionally, you will end up with a pet's nose or foot where it doesn't belong, but sometimes this can be an excellent option if the other tools aren't working to your satisfaction. This can also be a great place to start if you need to use the cloning or healing tools but don't have enough image to work from. Content Aware can provide that extra content for you, and you can refine the image from there with more precise tools.

Sharpening

There are as many ways to sharpen an image in Photoshop as there are ways to change colors. You can use Unsharp Mask, Smart Sharpen, High-Pass sharpening, or a variety of other sharpening tools, including those from third-party vendors. If you are using Smart Sharpen or Unsharp Mask, be sure to set your radius low (between .8 and 1.6) and your Amount somewhere between 35 and 100 (depending on how much sharpening is needed). The settings you use for sharpening are based on your intended output; the aforementioned settings are best for print. For web content, try clicking Filter → Sharpen on a new layer, and then adjust the opacity of that layer to taste.

For one of the most natural sharpening effects, try using High Pass sharpening. Here's how to do it: duplicate your background layer; click Filter → Other → High Pass; increase your Radius just enough the see the edges of the details in your image (usually somewhere between 1.2 and 5); and then set Overlay as the layer style. If you created too strong an effect, you can reduce it by lowering the opacity of the high-pass layer. This is one of my favorite techniques for sharpening images.

Local Contrast

Local Contrast increases the contrast between large details in an image as opposed to fine details. This can be useful for creating the appearance of sharpening in areas that are severely blurry as well as producing contrast in areas that are flat or washed-out looking. This is an incredible tool to use on a pet's eyes, especially if they are cloudy or blurry. The easiest way to achieve this is by using the Smart Sharpening filter. Instead of using a low Radius and high Amount, you invert these, and use a high Radius (between 30 and 50) and low Amount, (between 12 and 25).

Noise Removal

When shooting at high ISOs sometimes it's necessary to remove noise from your images. There are a variety of plug-ins available, and Photoshop has it's own noise removal tool under Filter, but my favorite noise removal is a plug-in called Noise Ninja, which both removes noise and sharpens at the same time. The effect is powerful but subtle, and works great on pet fur. It also uses the same Unsharp Mask processing that Photoshop does for sharpening, and has default values set that produce nice, natural sharpening results without needing much adjustment. You can also mask off areas you don't want sharpened if you'd like to do those separately, such as when you want to do a Local Contrast step on the just eyes, for example.

Actions

Actions are batches of Photoshop steps saved as one process that can "run" anytime in the future (these are very similar to Presets in Lightroom, minus the immediate previews). Important note: if you are running actions, make sure you go to the History panel and click the little camera icon at the bottom of the panel to create a "snapshot" of your image *before* you run the action. This way, if the action flattens your layers and you don't like the way it looks, you can simply return to the History panel and click the snapshot at the top of the panel to return to that history state (that is, *pre*-action). You can find tons of actions online, many of which are free, or you can create your own. They can open up a whole new creative world to you.

Cropping for Prints

To crop your image to the appropriate size to create print products, click the Crop tool, set your print size in inches or cm, set your resolution (usually between 250dpi and 300dpi for prints—check with your lab on this), drag the Crop tool across your image to the size you need, rotate if necessary, and then click inside the crop area to create your new cropped image.

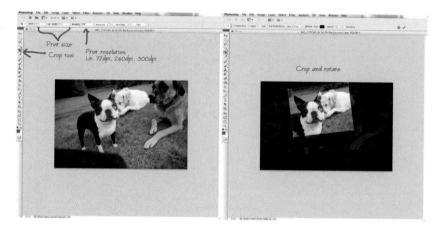

There are many, many (*many*) more things you can do with Photoshop, but the tools I listed above are the ones you are most likely to use as a pet photographer.

Adding Graphics

You can add all manner of graphics and text to an image in Photoshop, making design work fun and easy. You can design photo books with text, postcards, business cards, graphics for the web—you name it, it can be done.

"Wow, Lightroom and Photoshop are cool, Jamie, but I don't have either of those and really don't have several hundred dollars to spend on software. What do I do? Do I really need them? What if I have Photoshop but not Lightroom, or Lightroom but not Photoshop? Do I really need both?"

It really depends on what you are doing as a pet photographer. If you are donating photography services primarily for a shelter with the goal of getting the animals adopted, you'd be fine with a program such as Photoshop Express online, Photoshop Elements, Apple Aperture, or any free online photo software.

If you are an advanced amateur with aspirations of going pro, it would be a good idea to at least own Photoshop Elements, so you can spend some time learning the ins-and-outs of the software before purchasing the full-fledged version. It can take a year or two to become proficient with the tools Photoshop Elements offers (which are very similar to Photoshop), and it's pointless to jump up to the full version if you don't really need the extra capabilities it offers (check the current versions of both to see what the differences are; Adobe adds new features on a regular basis).

As far as Lightroom is concerned, it's a great software program for both beginning editors and advanced professionals, and if you can afford either the $150 full purchase price or $50 per month subscription, it will help speed up your workflow and make it a lot more fun as well as help you deal with some of the common issues that arise. Do you need Lightroom and some version of Photoshop? Ideally, yes, and it's because of the cloning/healing, layers, and sharpening tools Photoshop (and Photoshop Elements) provides, which are hard to replicate in Lightroom. Those tools are indispensible when it comes to removing leashes or other distracting elements, and sharpening animal fur so that it looks natural. It's also very hard to reproduce the capabilities of Local Contrast with respect to the eyes of your subjects that you can get by using the tools in Photoshop. Using the array of tools such as these can make a big difference in how your images look, and also help you to save blurry shots if they are all you've got.

If you need to start with just one software program, I recommend Photoshop Elements; save Lightroom for later. There are many excellent tools in Elements that can help you to not only edit images, but engage in design work, as well, such as creating collages of images for promotional materials or flyers, adding text or other design elements to images, and many more functions that you can't do in Lightroom. However, if you are shooting exclusively in RAW, the Photoshop Elements Camera RAW processor lacks many of the functions of Photoshop's Camera RAW, and that will limit how you process your RAW images. This just means that you'll probably be doing more detailed work on each image or running batch actions on sets of images. Lightroom makes this whole process easy if you don't have the full Photoshop version of Camera RAW, so it really is a trade-off. If, however, you are using a program that doesn't support RAW files at all, you can download a free DNG Converter from Adobe that will convert your RAW files to DNG format, which most software programs can read.

If you are a professional photographer and you plan or need to do any of the following, you really ought to own both the full version of Photoshop and Lightroom:

♦ Design work

♦ High-end printing,

♦ Use layer masks

♦ Produce offset printing products in CMYK

♦ Have more control over healing/cloning

♦ Run advanced batch actions

Quite simply, you have far more control over your results with Photoshop than you do with Elements, and there are many more tools available to you, as well. Photoshop was designed for the serious professional photographer and designer, Elements was designed for the consumer. Do you need the most recent versions? That's entirely up to you, your workflow, your needs, and how much you stand to benefit from new enhancements to the software. (For example, when the Content Aware tool became part of Photoshop, I upgraded immediately after repeatedly spending many long hours cloning photos for major commercial clients. It was worth the upgrade for me because of the time the newly added tool saved.) In my opinion, if you are running a photography business for profit, at some point you really need to have both the latest version of Lightroom and the most recent version of Photoshop that you can afford.

Alternative Editing Software

If you are saying to yourself, "but Jamie, I just do this for fun! I am so not spending hundreds of dollars on software that I'll probably rarely use! I don't want Lightroom or Photoshop!" No Sweat! There are many lower-cost, less-extensive editing software programs out there, some of which are free.

Most popular:

- ♦ Photoshop Elements $89.99

- ♦ Aperture $79.99 (available for Apple computers only)

Free software:

- ♦ PhotoScape (Windows)

- ♦ Photoshop Online (web-based): www.photoshop.com

- ♦ Pixlr: pixlr.com/editor

- ♦ Gimp: www.gimp/org

Other options:

- ♦ ACDSee Pro: $129.99

- ♦ Pixelmator: $29.99

- ♦ FX Studio Pro: $9.99

- ♦ iPhoto: $14.99 (Mac)

Common Novice Photography and Editing Errors

Some of most common mistakes that freshly minted photographers make stem from improper shooting techniques and applying strong JPEG settings in-camera, and some can result from heavy-handed editing. Don't let any of the issues that I describe in the following subsections afflict you, but if they do, try the recommended solutions, all of which I have described how to do earlier in this chapter.

Blown-Out Highlights

This is one of the worst offenders and, along with oversaturated images, is one of the recognizable give-aways that a photographer is new to his craft.

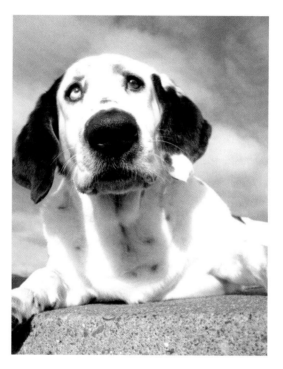

To fix this in software, use the recovery slider in Lightroom or use a multiply adjustment layer mask in Photoshop, and then selectively darken the bright areas.

Neon Colors (Too Much Saturation)

You can desaturate the image in software by using the saturation slider; increase the Vibrance setting until the colors look more natural.

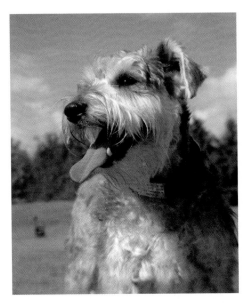

Gray, Washed-Out, or Dark Images

This look occurs if you are shooting in RAW and don't process your images before converting them to JPEGs. Increase the contrast by using Local Contrast techniques, and increase the Vibrance setting.

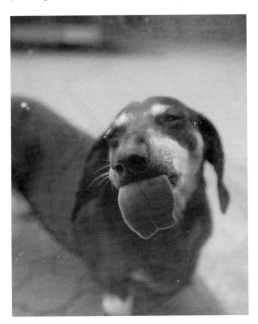

Overly Crispy

Oversharpening is a dead give-away of a new photographer. Back off on the sharpening, either in-camera or when you're working in software, or both. Try sharpening on a new layer in Photoshop and adjust the opacity of the sharpened layer until it looks natural.

Clipped Shadows

Expose your images properly by using manual exposure and spot metering, photograph at an optimal time of day or in the shade. To correct this in software, in Lightroom, lighten the shadows; in Photoshop, use curves.

Cut-Off Limbs

Be sure that when you're composing your images in-camera you aren't cutting off body parts. If you did capture an otherwise fine image but accidentally lopped off a paw or two, crop the image with software to create a new, tighter composition.

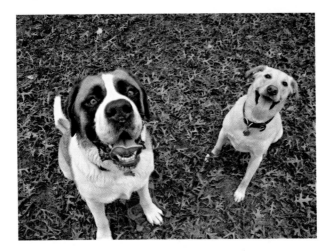

Capturing the Subject In the Middle of the Frame

Crop your image for a more interesting composition. Offset the pet toward the sides or top or bottom of the frame, depending on whether you're cropping horizontally or vertically.

Crooked Horizons

Straighten the horizon by using the crop tool in Lightroom.

Poor Composition, the Negative Space Skews the Balance

The negative space in this photo is distracting and doesn't add to the image in any way. For shots like this, do an extreme crop to create interest. If the issue is with the entire pet's body, crop in on its face and eyes.

Blurry

Perform selective Local Contrast on the face and eyes and apply high-pass sharpening on the rest of the image in Photoshop.

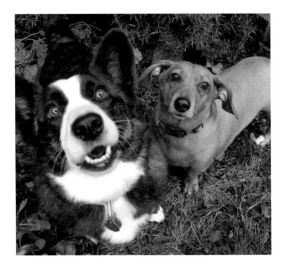

Selective Oversaturated Color

In Photoshop, select the oversaturated areas by using a feather between 8 and 12 pixels and then reduce the saturation by clicking Image → Adjustment →Hue/Saturation and decreasing the saturation on a particular color. In Lightroom, use the Adjustment brush or HSL sliders.

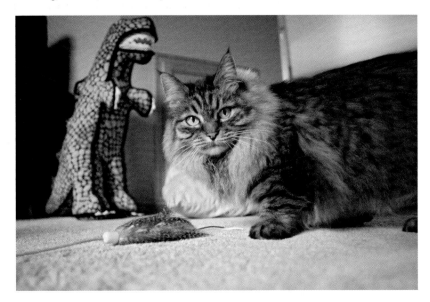

Blue Fur

In Lightroom, use the HSL sliders to desaturate the blue color. If you have a blue sky in the same image, to avoid washing out the blue in the sky, use the Graduated Filter to add saturation and vibrance to the sky.

Magenta Tongues

In Photoshop, select the oversaturated areas by using a feather between 8 and 12 pixels and then reduce the saturation by clicking Image → Adjustment → Hue/Saturation and decreasing the magenta saturation. In Lightroom, use the Adjustment brush or HSL sliders.

Muppet-Orange Fur

In Lightroom, use the HSL sliders to change the hue of the fur to a more neutral yellow color.

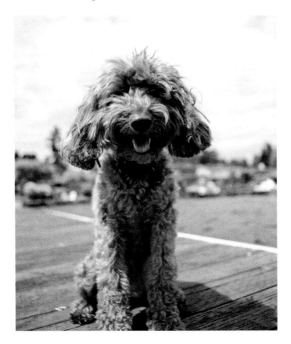

Blue Noses, Mouths, and Eye Rims

In Lightroom, use the adjustment brush and desaturate the blue areas, adding in a very transparent warm color to make the areas look more natural.

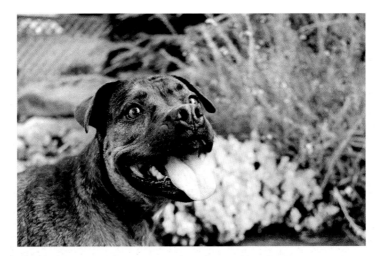

Lack of Catchlights

Lighten the eyes as much as possible by using exposure (selecting them in Photoshop or by using the adjustment brush in Lightroom). In Lightroom, increase the Clarity; in Photoshop, use Local Contrast sharpening.

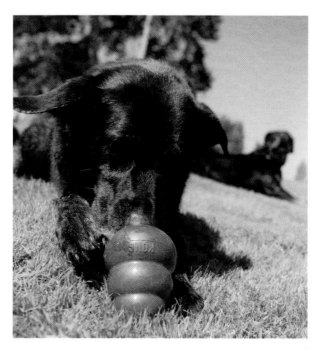

Overly Heavy Vignettes

In Lightroom, remove or reduce the vignettes by using the Lens Corrections panel.

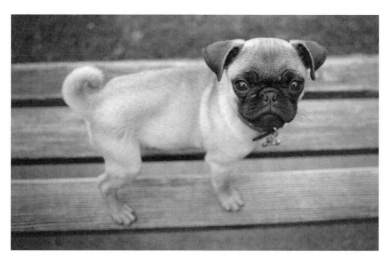

Lack of Clarity/Local Contrast

Use a Local Contrast technique on a new layer and adjust the layer opacity until the image looks natural.

Exercises

1. If you haven't done so already, think up a solid workflow. Create a checklist of steps and keep it near your computer if it helps you to remember the process.

2. Decide on a backup plan and then backup the backup. Purchase drives and/or online storage and backup the contents you have now.

3. Go through a new workflow process from start to finish.

4. Create a new preset in Lightroom and apply it to new images from a different shoot than the one for which you created the preset.

5. Try using the Copy → Paste → Transform → Warp technique for leash removal.

6. Perform local contrast on just the eyes of one of your pet photos by using the Smart Sharpening technique.

7. Check the images in your online galleries against the novice photography and editing errors.

Chapter Ten

Developing Personal Style

- ⭐ Defining Your Photodogstyle
- ⭐ Processing Techniques to Help You Attain Different Styles
- ⭐ Expressing Your Artistic Voice
- ⭐ Finding Inspiration

Defining Your Photodogstyle

Over the past 10 to 15 years, unique styles of pet photography have emerged. I coined the term "Photodogstyle" to help pet photographers define and decide which style best applies to their work so that they can begin to understand their own unique *photographic voice*. Being able to recognize a photographic trend in one's work can help you to create truly unique visions that are a personalized expression of that particular style. Do you photograph horses, cats, pot-bellied pigs, or other domestic animals but not dogs? Never fear, Photodogstyle applies to all types of pet photography, not just dogs.

Documentary

Documentary pet photography is exactly what its name implies: the pet photographer is documenting the action as she sees it play out in front of her. Photographers can be involved in the action unfolding in the shoot and engage with the animal, but in general they spend less time controlling their subjects' behavior and more time "going with the flow" and capturing what happens. Documentary pet photography is usually very dynamic and filled with Pet-Level Photography (PLP) images.

Pet photographers who are a representative of this style include me, Jamie Pflughoeft, of Cowbelly Pet Photography, Stephen Bobb of Fidojournalism, and Amanda Bradshaw of Frolic.

Photojournalistic

Photojournalistic pet photography is similar to documentary style in that the photographer is documenting the action that is playing out in front of him. The main difference is that photojournalistic photographer isn't actively engaged or involved with his subject; he is merely a fly on the wall, invisible to the subject. The key defining technique between documentary-style pet photography and photojournalistic pet photography is proximity: with the former, the photographer is close and interactive; with the latter the photographer shoots from afar with little or no involvement. Most of the time, photographers who do this style of pet photography will be photographing at focal lengths greater

than 70mm, using telephoto lenses for most shoots. These kinds of photo shoots often take place at off-leash dog parks or beaches, agility events for dogs, or competitive events for horses.

A good example of a pet photographer who exhibits this style is Claire Bow of Rouxby Photography.

Fine Art

Fine-art pet photography is created through both composition and post-processing. Composition makes up around 30 percent of this style, with the remaining 70 percent attained by software. Fine-art pet photography compositions often use pets as "still life," placing them in unique or unusual settings, such as on a couch in the forest, or in a shopping cart on the beach. Editing can include textures and vignettes or other effects to impart the

finished photo with a kind of three-dimensional look. Fine-art pet photography is often more labor-intensive than the other styles due to the shot pre-planning and post-shoot editing that's involved. It borrows heavily from modern portrait and commercial photography. This is the kind of pet photography that you might see hanging on the walls in an art gallery.

Pet photographers who exemplify this style include Jesse Freidin, Serenah Hodson, and Melanie Snowhite.

Abstract

Abstract pet photography is more about a mood or essence than a structured, posed composition. It is less about expressions and more about light, color, movement, and details; they are often taken up close and in the pet's space, without focusing on its face. Abstract shares a similar aesthetic quality to fine-art pet photography, but it's more avant-garde.

A pet photographer whose work is a good representation of this style is Anna Kuperberg.

Studio

Studio pet photography is self-explanatory, with domestic animals being photographed in a studio. But today, studio pet photography employs clean, simple backdrops and simple props. Gone are the days of puppies in baskets with fake flowers and cheap muslin backdrops. Contemporary practitioners are certainly not your traditional studio pet photographers.

Pet photographers who are representative of this style include Margaret Bryant, Sarah Beth Earnhart, Sharon Montrose, and Jason Krygier-Baum.

Modern

Modern pet photography features pure and uncomplicated lines and processing; it is more controlled than documentary style, existing somewhere between documentary and photojournalistic with regard to interaction with the subject. Modern pet photography is void of any bright, flashy colors and is focused on clean, neutral, natural light and muted colors.

Grace Chon of Shine Pet Studios, J. Nichole Smith of dane + dane studios, and Claire Baxter of fetch are all archetypal Modern Dog photographers.

Romantic and Traditional

Romantic and traditional style pet photography is similar to fine art in that it focuses on backdrops, textures, patterns, and colors as much as the subject itself. You will often find sepia-toned images, or those with soft, pretty lighting in this genre.

Pet photographers who are a good representation of this style include Jim Dratfield of Petography, and Robin Burkett of Paw Prints Pet Photography.

Processing Techniques to Help You Attain Different Styles

In the following subsections, I will provide a synopsis of what you would typically need to do to achieve the look and feel for some of the Photodogstyles that I just introduced. Before-and-after photos are presented for each style, with the procedures I used to yield the results.

Documentary

Documentary style pet photography comprises a great deal of contrast and vivid colors (without going neon!). These images are fun and engaging, both in expression and color.

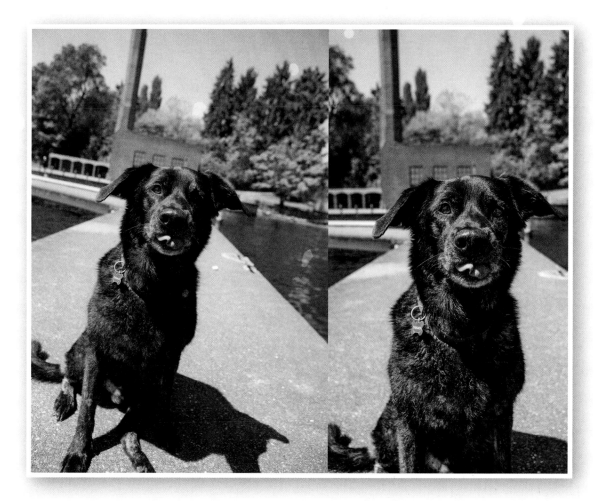

Procedure

In Lightroom: cropped and straightened. In the Develop Module (Basic pane): Exposure: –0.20; Highlights: –15; Shadows: +69; Whites: +25; Blacks: –8; Clarity: +15; (Tone Curve pane) Darks: –28; Luminance: orange: –20; yellow: –15.

Fine Art

Fine art images often include textures, vignettes, soft colors, and sophisticated design details. You can really have fun with this look because the sky is the limit in terms of what you can do. Study the fine artists and photographers who display their work in galleries for inspiration.

Procedure

In Photoshop: added new layer with texture image placed over background layer, with layer opacity set to 33%; applied green to eyes on another new layer by using the Paintbrush tool; changed style of green-eyes layer to overlay and reduced opacity to 47%; cropped for a new composition.

Modern

One common trait among modern pet photography is image sharpness. Not so sharp as to be crispy, but Sharpening and Local Contrast are definitely used here to draw the viewer's eye to where the photographer wants it to be. Keep your colors neutral, your images sharp, and your compositions clean.

Procedure

In Lightroom, in the Develop Module (Basic pane): Exposure: +0.65; Highlights: –71; Shadows: +73; Whites: –13; Blacks: –31; Clarity: +36; Saturation: –11; (Tone Curve pane) Lights: –21; Darks: –41. In Photoshop: noise removal using the Noise Ninja plug-in; Local Contrast on the face only by using smart sharpen, amount: 22, radius: 30.

Romantic and Traditional

Some ideas for Romantic and Traditional editing include incorporating sepia, soft-color washes (pink, aqua, green), and dramatic contrasts between light and dark.

Procedure

In Photoshop: adjusted curves to lighten midtones; added new fill layer with peachy-pink color; set layer style to overlay with an opacity of 38%; added another new fill layer with minty-green color; set layer style to multiply with an opacity of 22%. (Optional: Add a vignette in Lightroom with a strong midpoint for another affect.)

Vintage

Vintage effects are perhaps the quickest way to add a certain style or flavor to an image. If you are going this route, ensure that you get a lot of feedback from other photographers with regard to your editing choices before rolling them out as a trademark style (especially if you're doing pet photography professionally); it can be easy to overdo it and produce images that lack the beautiful aesthetic you are going for and instead look like "Photoshop Gone Wild."

Procedure

For this image, I downloaded the free Vintage Effect Photoshop action from the Internet and then ran the action on the image. You can find tons of free vintage Photoshop actions online. Play around with them, have fun with them, and adjust them to your own taste. Here's an important point to keep in mind: If you are posting any of these photos online where the public can view them, be sure that you offer this processing effect as an option to your clients or that you use it consistently for your style; otherwise, potential clients might be confused about your photos if some look radically different from others.

Here's another fun vintage Photoshop action result:

Polaroid

You can replicate the look of old Polaroid photos by using Photoshop actions. These would be fun to place in a printed photo album.

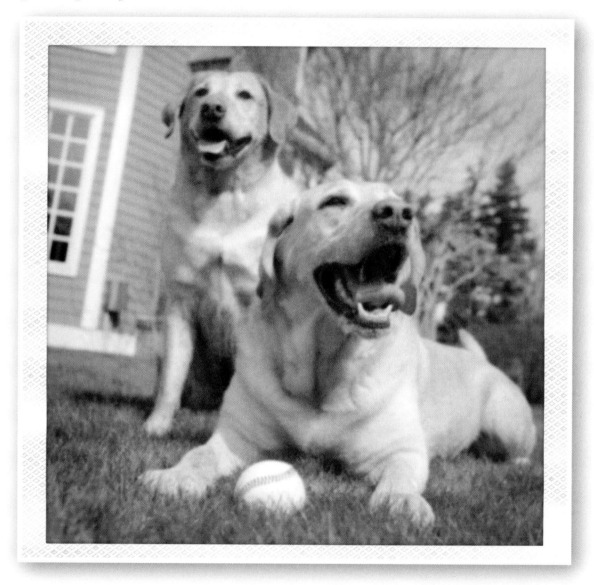

Procedure

This is another image for which just I downloaded a free Photoshop action from the Internet called Polaroid Photoshop action and then ran the action on the image.

*"I'm confused, Jamie. I like most of those styles and want to try them all.
What does this mean, do I need to pick just one?"*

Definitely not! Most highly talented photographers are capable of producing something called *range*. What this means is that they don't get stuck in a rut of taking photos that all look the same, using the same poses, taken in the same locations. They vary it up, and their expressions are only bound by their ideas. You can certainly cross style barriers, and if you really want to go above and beyond the everyday, commonplace works, break the mold and create your own unique style that can't be classified. Just ensure that if you are using editing and processing to assist in creating your style, keep it consistent or at least offer different options to the pet's owners. You don't want people getting confused by the images in your galleries and think they were taken by different photographers!

Expressing Your Artistic Voice

One of the key characteristics of highly visible, talented pet photographers is that they have their own style, or in writer's-speak, their own *voice*. The works of really successful photographers are unique, cutting edge, and easily recognizable. Whether you see it in a magazine, in a blog post, online, or in commercial or editorial work, you instantly know it's theirs. Their styles often break the mold, and they are either in a class of their own or they are the cream-of-the-crop of one of the styles I presented earlier. They have a creative vision, and enough technical skill to execute that vision. And they aren't afraid to express themselves authentically.

"How do they do this?" you ask? They do it four ways. The first way is by being technically proficient. It's no secret that the more technically inclined you are, and the better you understand the mechanics of photography, the more likely you will be to create great images. The second way is by being creative, thinking up creative ideas, viewing their subjects in a unique way. The third way is by being unafraid to take risks. They regularly try new techniques with their camera, their lenses—all of their equipment. The fourth, and most important way is by *expressing themselves authentically.*

Authentic expression is an illustration of who *you* are, without trying to emulate or copy anyone else. You can put 20 photographers in a room with the same subject, and each photographer will have a different perspective on the subject and create a different shot, based on who they are authentically. Perspectives, or *points of view*, are based on past experience, current knowledge, personality, and ideology; no two people will have exactly the same perspective because of the variance in all of these variables. In other words, each individual has a unique gift to offer. The technical part of style comes in when it comes to capturing or recreating with their camera what they see with their vision, both their physical vision and creative vision.

So, how do you best create and express your own unique style? Easy: by being authentic. Authentic in the way you express your unique perspective; authentic in the way you approach your subjects; and authentic in the ideas you express. It also helps to be confident in your authenticity and be unafraid of criticisms you might face when trying new things. You must be confident in who you are, with no shame or guilt.

It's very common practice for new photographers to compare and contrast themselves to those who are more established, and this is a very dangerous practice. Doing this is like comparing your house to the neighbor's house down the street without ever having seen the inside. You have no idea if it's messy or clean inside, if they hire someone to keep their yard maintained, how much money they invest in keeping things looking great, or more importantly, how they feel about it all. They might have studied landscape architecture for years, do all of the maintenance themselves and take great pride in their work, or they might hire services to do all of the work—the painting, the mowing, the flower planting—because they travel so much, and so they don't even get to enjoy it.

Likewise, a great photographer might be using a special software program to create mind-blowing images, or he might be incredibly insecure, thinking his work is terrible, or he might have attended 30 workshops and spends hours every day perfecting his craft. You really have no idea, so it's a bad idea to compare and contrast your work to that of another photographer. Comparing your work to someone else only serves to suppress your authentic style, and that's the last thing you want to do.

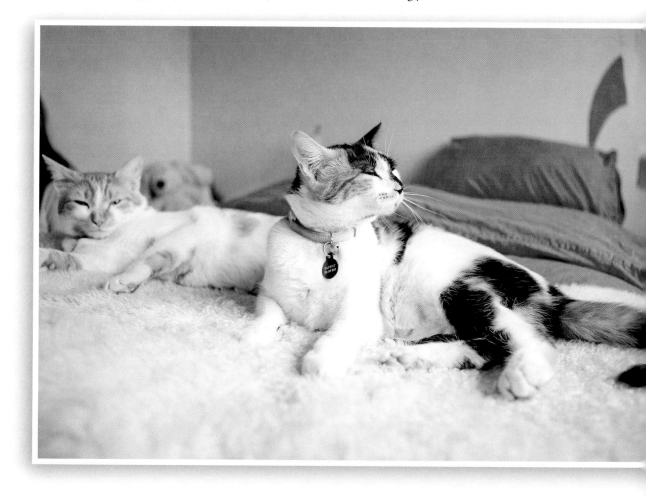

You might think that you are limited by your subject matter or location when it comes to expressing your own style, but I will tell you it doesn't have to be this way. You might be exclusively photographing shelter animals, for example, and think, "but there are only so many ways I can shoot them." I used to think this, too, until I recently saw gorgeously lit, beautifully posed studio pet photos. I assumed they had been photographs of regular pets in a photographer's studio, so I was surprised to see a behind-the-scenes shot in a cramped, dark shelter room, clearly indicating these were shelter animals up for adoption. It just goes to show, anything is possible with a little creativity thrown in the mix.

If all of this is still confusing to you, you only need to look at what you like to help you to define your style. No, I'm not talking about what you have given a thumbs-up to on Facebook (although that might help, too). I'm talking about what things in life—the colors, people, products, clothing, activities, and so on—you enjoy and appreciate. You might be a nature lover, yoga enthusiast, organic food grower who meditates every day, has a very quiet, calm personality and loves muted, earthy colors. All of these things will translate to your photographic work if you express yourself authentically.

Think outside the box, and allow your mind to wander freely. Push boundaries, try new things, create a storyboard of ideas, practice, and experiment, and you will find your own style.

There are ways to stay inspired, to help you create your own unique ideas and help foster creativity based on authenticity, and in the next section I share them with you.

Finding Inspiration

In Chapter 1, I share with you some modern day (and not so modern day) influential pet photographers. Although in the last section I talked about how dangerous I think it is to compare and contrast one's own work with that of another, I consider that as being a very different thing from being inspired by the work of another. You can glean inspiration from another photographer without copying that person; those ideas can be a springboard for your own creative ideas.

For example, you might see another pet photographer who has produced images of a horse standing in front of a barn in the snow. You might think the snowy scene looks beautiful and the light is just perfect and you want to recreate it. But you have an even better idea. You might also envision a horse in the snow, only this time it is galloping across a field buried in snowdrifts with light snowflakes falling, while being ridden by a woman with long, flowing, auburn-colored hair and wearing a long, patterned jacket. You took the original photographer's idea, enhanced it, and put your own spin on it. This is what expressing yourself creatively and authentically is all about.

Absolutely feel free to look at other pet photographer's websites and blogs, but do so with the desire to be inspired. If this process makes you feel self-critical or insecure about your own work, then stop. The process of looking at the work of other photographers should be uplifting and inspiring; if it's anything but that, turn your focus to other things that you do find inspiring. In the following subsections, I describe eight great (non-pet related) resources that you can turn to for inspiration with your photography, in no particular order.

Fashion Magazines

Although most pets don't appreciate being dressed up in lavish costumes, wearing sky-high heels, you can look to fashion photography to inform your choices when it comes to locations, lighting, and props.

Landscape Photography

If you do a lot of outdoor pet photography on location in natural surroundings, it's great to take a look at how the landscape photographers master their craft. They might use filters to enhance a blue sky, and employ lenses to produce the most flattering shots of a scene, while getting crisp detail. Essentially, an outdoor pet photograph is a landscape photograph with an animal thrown in the mix. Keep this in mind and it will help you to improve your images.

Home Product Catalogs

Home product catalogs contain some of the most gorgeous, high-quality photography in the world. Of course, most people don't live in homes that look like they were pulled from the pages of a Pottery Barn catalog, but looking at those pages can give you inspiration for elements to include in your next shoot or how to style locations, especially if you do a lot of indoor pet photography at owners' homes.

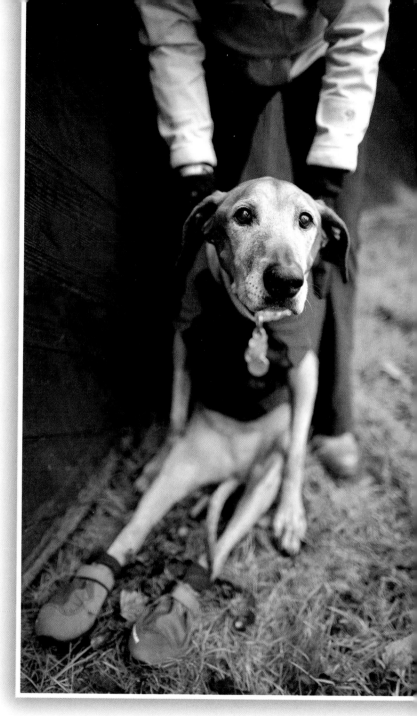

Home Design Websites and Blogs

Similar to home product catalogs, home design websites and blogs are overflowing with beautiful imagery. You will find a plethora of different colors, shapes, textures, patterns, furniture, and so on. You might see a gorgeous fabric used on a renovated chair, and think, "I have to have that fabric for a backdrop in my studio," or, "I remember seeing a similar fabric on a dog bed, I should pick one up and bring it with me to my shoots."

Commercial, Portrait and Wedding Photography

There are many immensely talented photographers out there, photographing everything from cars to celebrities to weddings to babies. Look to them to get new ideas for pet photography. Because the pet photography industry is still relatively young, there is a lot that hasn't been tried yet.

Movie Sets

Movie set designers are some of the most brilliantly talented people in the world. Take a look at the sets you see on the big screen for inspiration as to locations and styles of dress, colors, lighting, and more.

The Outside World

If you race through life without ever stopping to smell the roses, please take a moment to stop and smell them now. You can find inspiration in something as small as a flower or the color of the siding on a house or the way a skyscraper looks when lit by bright clouds.

Your Subjects

You can be profoundly inspired just by the personality of the individual animal with which you are working. "Listen" to what they are telling you, and try and capture their own authenticity. This can help drive the kinds of images you are producing of them in your shoot. Are you photographing a zany, wacky dog? Capture zany, wacky images. Are you doing a shoot with a graceful, shy cat? Create graceful, serene images.

When it comes to pet photography, let your imagination run wild. Be authentic in your expression of your creative visions, think outside the box, be inspired by the things around you, your subjects and locations, and don't be afraid to take risks and have fun.

Exercises

1. Review the definitions for Photodogstyle at the beginning of the chapter; and see if there is any one style that best describes your work.

2. Look at your second most favorite style in the list and think up creative ways you can try to reproduce that style in your next shoot.

3. Try out some fun processing in Photoshop, such as a Vintage action or texture overlay. If you like the results, try to incorporate them into the next pet shoot you edit.

4. Pick a few resources from the inspiration list that you can use to inform and inspire your next shoot.

Chapter Eleven

Going Pro

- ⭐ Self-Evaluation Questionnaire: Should I Turn Professional?

- ⭐ The Start-Up Process: Getting Started, from A to Z

- ⭐ Portfolio Building

- ⭐ Expenses

- ⭐ Working with Clients

- ⭐ Post-Shoot Client Process

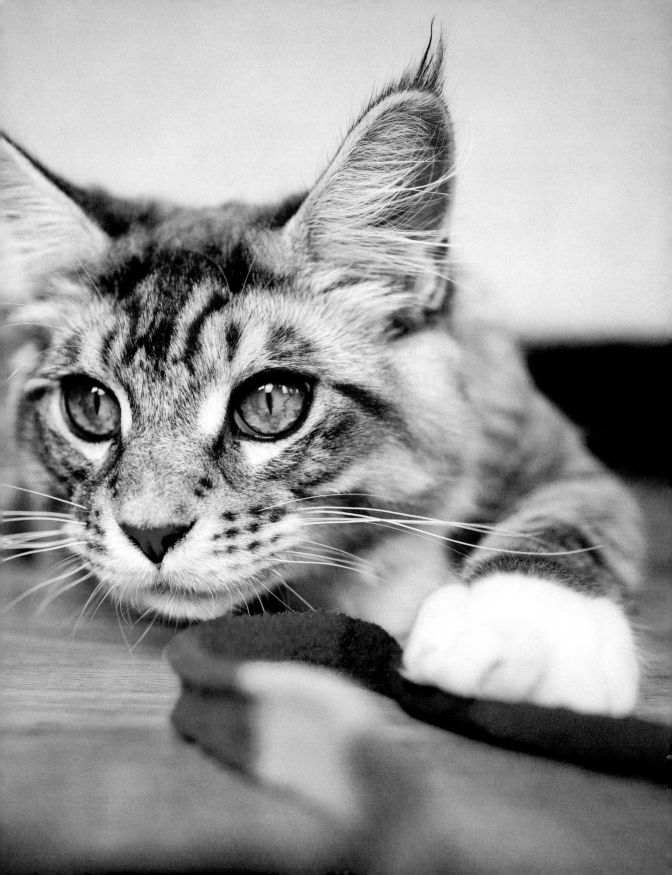

Self-Evaluation Questionnaire: Should I Turn Professional?

Many people who are passionate about photography as a hobby come to a point at which they consider turning their hobby into a business. Some wonder if the time is right for them, if they have what it takes, if they will enjoy it, or if they will even make any money at it.

There is a vast, cavernous, gargantuan, enormous (Grand-Canyon-like!) difference between doing something for fun, for which no money changes hands, and doing something as a full-fledged business. So, how do you decide if "going pro" is a good decision for you? Here's a little 12-point self-evaluation questionnaire to help you decide:

1. **Do You Have an Absolute, Overwhelming Love and Passion for Animals?**

 If your answer is no, stop right here. Pet owners can smell insincerity from a mile away; it's an intuitive trait picked up from our animal brethren. If you aren't absolutely passionate about animals, it will show in your work and ultimately in your photos. Love of animals shines through in pet photography, so if you've got it, flaunt it!

2. **Do you enjoy working with people?**

 Contrary to what you might think, only a handful of hours per week will be spent in the presence of animals. Before and after the photo shoot, all of your time will be spent working with the pet's owner, not the pet, interacting with them via e-mail and phone. You will also spend a lot of time talking to marketing partners, colleagues, vendors, and other people who are connected to your business in some way. If you don't generally like people, and you prefer to spend all of your time with animals, running a business might not be for you. If you are naturally outgoing and gregarious, you will love the social interaction that running a business can bring. If you are somewhere in between, you can learn what works for you and what doesn't and set your own rules for how you conduct your business. Hate talking on the phone like I do? Communicate primarily via e-mail. Get nervous when meeting people in person? Conduct a Skype session from the comforts of your home office. You just need to be aware that a minority of your time will be actually spent with animals, and you will need to have a decent level of skill when it comes to effectively communicating with humans.

3. **Do You Enjoy Spending Time Behind a Computer?**

 A huge fallacy among those dreaming of being a photographer is that photographers spend most if not all of their time on location or in the studio, snapping pictures, interacting with models, trying out camera gear, and so on. Although these are super fun aspects of the job, they only account for about 10 to 15 percent of the actual workload. The rest of the time (85 percent) is spent on business stuff: editing photos with software, replying to e-mails and phone calls, updating websites, creating blog posts, social networking, and so on, and so on, and so on. These tasks all take place at a computer, so you need to be prepared to be in front of your computer monitor for a large chunk of your photography career. Of course, that's not to say that your computer can't be your laptop on a sunny patio with a drink in hand and a fuzzy dog by your feet.

4. Are You Good at Multitasking?

As a pet photography business owner, you will wear many hats. You will often be your own sales team, your marketing manager, the web developer, accountant, Photoshop team, the shipping and packaging pro, supplies gopher, and many more jobs! Until you can afford to outsource these jobs—which, unless you started with a decent amount of savings to invest, often takes years to do—you will be handling them all by yourself. Some people find the challenge stimulating and far more interesting than doing the same thing every single day. For those to whom multitasking is akin to pulling their eyelashes out, it might be best to stick with pet photography as a hobby.

5. Do You Enjoy Having the Freedom and Flexibility of Setting Your Own Schedule?

One of the greatest aspects about being a freelance photographer is having the freedom to set your own schedule and generally come and go as you please. One of the greatest attractions of running a pet photography business is that there is little or no urgency involved (unless an animal is sick or dying). Nothing needs to happen immediately; the world won't come to an end if you don't wake up at 5 am to make that presentation to the East Coast. Within reason, you can decide what hours work best for you and create the kind of schedule you always dreamed of. Need to take afternoons off to spend time with your kids? Great! Work from 7 am to 3 pm, and then a couple of hours at night. Need to take a day off to just decompress and relax? Go for it! Don't want to do shoots on Sundays so that you can spend time with your family and friends? Then don't or charge a high premium to do so! You have that flexibility with this business.

6. Do You Work Well with Little Guidance?

A downside to having flexibility with your schedule is that you need to be self-motivated in order to get your work done, and it's easy to develop lazy tendencies. What is interesting is that the inverse problem is usually true of self-employed pet photographers: they typically work too hard and for too many hours, as they strive to grow their business. But if you know you'd rather eat bonbons and watch *All My Children* all day rather than send e-mails to clients or edit photos, it's probably best to leave the business as an idea instead of a reality. Starting and running a business is hard, hard work and you'll need to be ready and eager to roll up your shirtsleeves and "get'er done."

7. Do You Excel at Taking Action, Making Decisions, and Being Pro-Active?

Unfortunately, as much as we wish there were, there is nobody there to hold our hand as we begin the journey on the path from hobbyist to professional. You will be required time and time again to make executive decisions. Being the sole executive of your business, you get to make all of those decisions. Or should I instead say *must* make those decisions. If your biggest weakness is that you have crippling indecisiveness, it will take you some work to be a business owner. That's not to say you can't be the kind of person who needs to do tons of research and weigh all of the options before making a decision (like me), you just need to be able to take action and move forward; otherwise, your business will become stuck in the mire of inactivity.

8. Do You Possess Both Creative and Technical Capabilities?

The creativity comes in when it comes to envisioning interesting compositions and colors, doing design work for your website, promo materials or blog, and coming up with creative shoot locations. The technical comes in when it's time to use computer programs such as Adobe Photoshop and Lightroom, and understanding the settings on your computer. Most people are either naturally right-brained or naturally left-brained. In this business, it's a great if you can learn how to be both.

9. Are You at Ease with Uncertainty When It Comes to Current or Future Income?

One of the scariest things about being a freelance photographer is not knowing when the next paycheck is going to come in. If you do your marketing well, you can lessen some of this anxiety by ensuring that you have a filled pipeline, but some apprehension will always be there. You need to become accustomed to that anxiety and not let it overwhelm you. So, if income instability really concerns you, ensure that you have a big chunk of change in savings that you can tap, if and when necessary, before starting your business.

10. Do You Feel Comfortable Asking People to Pay You for Something You Actually Enjoy Doing?

This is a toughie. I know of many pet photographers who don't feel comfortable charging for their services. I certainly see it more in this line of business than in any other kind of business! Pet photographers by nature are generally kind and generous people with big hearts and all of the love and compassion in the world. But no matter how kind you are, you still deserve to be paid for your *work*. Everyone does. Yes, the photo shoots themselves are fun, but think of all the hours you will spend in Quickbooks, or trying to troubleshoot Photoshop issues. Wouldn't you like to be paid for that time? The photo shoot is just a small part of it. You need to be comfortable with the expectation that you will be paid for your services before you can have a profitable business. Guilt over making money has no business in business.

11. Can You Live Without Paid Time Off and Medical Benefits?

Unfortunately, you don't get either of these things when you are self-employed. You'll need to purchase your own medical insurance. And when you manage to take time off, you'll need to ensure you have double the money saved for your vacation, because you won't be generating any revenue. On the plus side, you are free to pick any medical insurance plan you like, and the timing of your vacations is up to you.

12. Are You Open to Change?

It's important to be flexible when running a business, because, as I like to say, "even the best laid plans can go awry." Things can change at the drop of a hat, and technology changes faster than we can typically keep pace. If you are rigid and inflexible in your ways, it will be hard for you to innovate, feel comfortable with things changing on you, and stay current in your industry. Adopt an attitude of "I'm rolling with the punches," and you'll do well. You *can* get through any challenge that arises with your business.

If you answered yes to most of these questions, you might be ready to go pro! If you answered no to most or many of these questions, you might be happier in the long run if you commit to your passion as a fun hobby instead of trying to turn it into a business.

The Start-Up Process: Getting Started, from A to Z

There are a million ways to start a business, but I've found that the process described here is the most straightforward and successful for a pet photography business. For information on where to get some of the stuff listed, see the resource guide at the end of the book.

Step 1. Buy the books *Small Business for Dummies* by Eric Tyson and Jim Schell (2008, Wiley Publishing, Inc.; ISBN: 978-0-470-17747-1), and *The Complete Idiot's Guide to Starting Your Own Business* by Edward Paulson (2007, Alpha Books; ISBN: 978-1-592-57584-8), and read them cover to cover.

This is one of the best investments you can make as a new business owner. You *need* to know the basics of small business ownership in order to make money at it. Terms like "profit margin," "return on investment" (ROI), "costs-of-goods-sold," and others will come up on a regular basis, and you need to know what they mean.

Step 2. Build your portfolio to ensure that you have a marketable skill and a comprehensive gallery of images.

Practice, practice, practice, practice, practice. BEFORE you start.

Step 3. Pick a business name.

If your budget allows, you should register your name with the Federal Trademark office. For information on how to do this, go to www.uspto.gov.

Step 4. Determine your business mailing address; for example, will you use a PO Box, a UPS mailbox, or perhaps your physical location if you opt to lease office space.

It is not recommended to use your home as your mailing location for safety and privacy reasons.

Step 5. Obtain your business phone number.

It is not recommended to use your personal cell number for business use. Ideally, you want to create a separation between your personal life and your business life. Look into vonage.com as an option, or ask your phone company if they can install a separate line in your house if you are operating out of a home office.

Step 6. Determine your business structure. Do some research and decide if becoming, for example, a sole proprietorship, a corporation, or a limited liability company (LLC) is right for you.

Step 7. Apply for needed licenses or business permits that are required by your municipality and state.

If you have any doubts about this process, contact a representative of your State Department of Revenue or the office of the Secretary of State. They can usually assist you with the blueprint for legalizing your business.

Step 8. Set up your office (home or studio) and procure supplies.

You'll need all the standard items, such as paper, pens, a printer and ink, stapler, tape, scissors, notepads, and so on.

Step 9. Open a business banking account that provides a debit card and checks.

Credit unions are often great for this. Although they might not have the same business services as the big banks, you can trust them with your hard-earned business dollars.

Step 10. Determine how you will track your business financials.

You might want to look into programs such as Intuit Quickbooks and Microsoft Excel, or perhaps an online program. You might even want to start out by using a paper accounting ledger system.

Step 11. Create your pricing and design a PDF file or web page to make this information available to potential clients.

It's a good idea to present your pricing on a separate webpage or online PDF that is accessible by a single URL to make it easy to send to potential clients.

Step 12. Design your logo and branding or hire a company to do it for you.

Step 13. Create/revise your legal contracts.

If you don't know where to start, a good resource to help you with this is the book Business and Legal Forms for Photographers *by Tad Crawford (2010, Allworth Press; ISBN: 978-1-58115-669-0).*

Step 14. Brand all legal documents, order forms, letterheads, and invoices with your logo and other branding designs.

Step 15. Design and order your promotional materials, including business cards, postcards, letterheads, and mailing labels.

Step 16. Set up your proofing website and include your prices.

This is where your client galleries will live.

Step 17. Purchase an f/2.8 or faster lens if you don't already have one.

Step 18. Purchase memory cards and backup batteries if you don't already have them.

Step 19. Purchase all of the camera supplies that you will need in your bag, such as lens wipes, reflectors, and so on.

Step 20. Set up and launch your blog.

Step 21. Set up and launch your website.

Step 22. Set up and launch a Facebook fan page and a Twitter account.

Step 23. Order print and product samples and decide on your order fulfillment labs.

Step 24. Purchase shipping envelopes and packaging supplies for prints and products, such as boxes, ribbons, stickers, tissue paper, thank you cards, gift tags, and so on.

Step 25. Purchase any photo processing software that you will need for your business.

> You need to familiarize yourself with the software before clients start paying you for shoots. The last thing you need is to spend hours working on a paid project that should only require minutes to complete.

Step 26. Purchase dog treats as well as dog and cat toys that you will need for your shoots.

It's a great idea to buy these in bulk ahead of time so that you don't run out too often.

Step 27. If you're unfamiliar with dog breeds and behavior, pick up the books *Dogs* by Bruce Fogle (2006, Dorling Kindersly; ISBN: 0-7566-1692-1) and *The Domestic Dog* by James Serpell.

Step 28. Scout out locations ahead of time and create a list of great shooting spots.

> Take pictures while you're there and create a page on your website or blog with recommended shoot locations, including photos.

Step 29. Market your business. Network. Promote. Hold a launch party.

> Holding a launch party at one of your new marketing partner locations (doggy-daycare anyone!) can be a great way to network and meet potential clients.

Step 30. Respond to inquiries and start booking shoots!

> Congratulations, you did it! You are now a business owner—let the games begin.

Portfolio Building

Portfolio Building (also known as PB) is a process by which you do complimentary shoots for clients for a set period of time (usually several months) in exchange for allowing you build your portfolio with the photos you take, develop and improve your photography skills, and practice for real-life shoots. The value of portfolio building cannot be underestimated.

It's always best to use the word "complimentary" or "gift" as opposed to "free." Using free in the context of your business cheapens the perceived value. (I talk more about perceived value in Chapter 12.)

The Portfolio Building Process

The following is a step-by-step list of what you need to do to build your portfolio

1. **Create a blog.**

 Ensure that you have a pretty image to use as your header at the top of your blog. This way, people can easily recognize that it is a pet-photography blog when they get there. Use your logo and your branding colors on the blog. Post regular updates about your business and PB sessions. Keep it professional and act as if you have already been in business for several years. In other words, potential clients don't need to hear about the mistakes you made with your camera on your last shoot.

2. **Design and print standard or oversized marketing postcards with the blog address, some of your photos, and your contact information.**

 These don't have to be perfect; they don't even need to have the logo and branding you end up with. They just need to have your basic information on them with the best pet photo you have so far. Even if all you have on the postcard is a great photo and your blog address, that's better than nothing. Be sure to include on your postcards that you are doing complimentary portfolio building sessions through a set date (your launch date) to encourage people to sign up right away instead of sitting on the postcard.

3. **Set the official launch date of your business to be 3, 6, 9, or even 12 months out.**

 Make sure that you give yourself enough time to get all of the things done on this list before you launch. You should have everything that you need in place when you launch (your website with photo gallery, all of your equipment, software, promotional materials, product samples, order forms, online gallery host, and so on). Here's a tip: Things usually take three times longer than you project. So if you think it will take only three months to get everything set, the chances are that it will take nine months. Be sure to tell everyone your launch date and have it on your blog.

4. **Set the pricing with which you will launch your business, including the session fee and prints.**

 Don't start too low; this is the pricing you will want to have for your first year in business, and you don't want to make it too difficult to raise prices (and switch clientele) in the future. During the

PB phase, for clients who want to purchase additional prints, consider pricing yourself at 25 to 30 percent less than your normal prices (for suggested prices, go to Chapter 12). I recommend gifting your PB clients with one 8" × 10" print, and then offering them additional prints to purchase if they are interested. If they'd like other products I'd use cafepress (www.cafepress.com) or zazzle (www.zazzle.com) until you have the time and money to order product samples from multiple companies and decide what to sell.

5. **Create a model release contract and put the value of your sessions in the release so that each recipient of a PB shoot understands that your time is valuable.**

 You need this for every single shoot that you do to reduce liability, to claim your copyright of your images, and to give you the right to use and sell them and also communicate expectations with the client. You should always include what they are getting with the shoot; for example, if you are gifting them with a print. And always put the dollar value of what they are getting in there, too. This last step is very important for reasons you will soon see in the pricing section of this book!

6. **Distribute postcards to pet businesses in your area, and get the word out about your PB sessions: Generate "buzz."**

 Leave them far and wide, but not so far and not so wide that you can't handle the PS session inquiries that come in.

7. **Do at least one PB session per week (two is ideal), and post your best five to eight photos from the session on your blog. Also, e-mail the post to your client as a "sneak-peek."**

 Treat the PB sessions just as you would if the client were paying you $150 or more. But you can also select the location to be a park or someplace near to your home to keep your time and travel to a minimum. Be very friendly and give excellent customer service. Arrive on time, listen to their needs, and engage with their pets. Provide the best customer service you can, and be really open-minded to learning. This is your opportunity to experiment and to get to know your camera. Take advantage of the challenges afforded by the different lighting situations present, and learn what it's like to work alongside dogs with different temperaments—and also different types of pet owners. Throughout the session, think about how you can problem solve to apply lessons learned to the next shoot and your business once you formally launch.

 Plan to do 60 to 120-minute shoots, depending on the pets and location and other circumstances. Show the client only the very best images that came from the session. Fifteen to twenty images are totally adequate here (when you launch, you will want to show them more like 40 to 85 images). Decide on an online photo host/gallery provider that your client can easily access in which to house those images. Ensure that they sign your model release when you arrive and that you answer any questions they have about additional prints or other products. Ideally, you will have done 15 to 20 PB shoots by the time you launch so that you have your best 20 to 40 shots for your portfolio and website. Keep in mind that each shoot you do is training you to become a professional photographer who expects to be paid for rendering skilled, high-quality services.

8. **Provide stellar customer service to your PB clients and be as friendly as possible.**

 Be professional but do not be a doormat! Unfortunately, when people get things for free they have a tendency to take advantage of the offer. So, you need to be clear and remain firm about what they are getting, nothing more and nothing less. You can also hand-pick who you'd like to work with based on how friendly they are to you. Remember, you're doing this for free; you get to call the shots!

9. **Post frequent updates about the business on your blog and remind your readers of the date for your formal launch.**

 Use that new fancy blog of yours to promote your images in their full-size, beautiful form. Ensure that those images don't have problems, such as exposure issues or color balance concerns, or that they are too dark, too light, blurry or processed poorly. This is your ongoing portfolio and its ultimate purpose is to sell your work. You want only the cream of the crop on your blog. If that means only posting two images from a session instead of seven or eight, so be it! This is your time to make decisions for yourself; you have more flexibility than you will when you are charging for your services.

 Keep your new readership up to date about any events you are holding after you launch. Inform them if you have limited dates free for sessions or of any news that you have with this new biz. When you have your website online with the very best images, your pricing set, and all of your ducks in a row, create a post when you launch and make it official!

10. **When you are ready, formally launch your business, make your website live with your new portfolio, and then start charging your regular prices.**

 Contact one of your marketing partners and ask if you can have the party at their place (a dog daycare is ideal). On the big day, bring a physical portfolio, get some bottles of wine, announce it on your blog, or even make new postcards just for the party. Get people together and celebrate!

Congrats! You have just completed the portfolio-building part of your business. By now you should be feeling confident in your skills, knowledgeable about animals and animal behavior, understanding of the ins-and-outs of your camera, and you are ready to kick it into high gear and start making money.

Expenses

What do you really need and when, and what can you work up to? Unfortunately starting and running a photography business is one of the more expensive small businesses you can start. I hear people talking about how photography is "sooooo expensive," but they might need to sit down before I show them the following list.

In an ideal world you will start out with everything on this list, but not everyone has $50,000 to invest into starting a photography business, and for most photographers, by the time they have invested in a fancy camera, lenses, accessories and a few good software packages, their bank account is crying out for more money. Use your best judgment when it comes to purchasing items for your business, and do what is reasonable for you. The following are merely guidelines. My business is now nine years old. Do I have all of these things? Absolutely not! But hey, you might as well reach for the stars, right?

Start-Up to One Year: $2,695–$8,355

Camera gear, computer gear and software make up the biggest initial expenses, so if you already have these things, you're golden.

- **Camera gear** Digital single-lens reflex (dSLR) camera body and one zoom lens, lens filter, cleaning cloths, memory cards, and batteries: $950–$4000

- **Computer gear** Quality monitor, medium-sized hard drive, small travel drive, and fast memory card reader $80–$1500

- **Software** Adobe Photoshop or Lightroom: $300–$650

- **Printers** One for regular prints and one that will print CDs: $85–125

- **Office supplies** $50

- **Business mailbox** $135

- **Web hosting** $45

- **Flash website or cheap HTML template website and ProPhoto Blog** $250

- **Proofing site for galleries** $150

- **Promotional materials** Business cards, postcards, thank you cards: $75–$150

- **Product samples** Canvases, photobooks, mounted prints, greeting cards, and so on: $250–$600

- **Packaging materials** Photo mailers, boxes, tissue paper, CD holders, ribbons: $125–$350

- **Logo design via logosauce.com or similar** $200–$350

Note

Prices are averages and can vary considerably. Monthly expenses are shown in annual amounts. Items with an asterisk () are purchases that I recommend you make as early on in the business as possible.*

One to Two Years in: $3,905–$7,790

As you get more time under your belt, you'll start to expand a bit. Some of the items you will be looking to acquire are the following:

- **Professional graphic design for branding** Logo, postcards, contracts, promo materials: $450–$850*

- **Framed photography for art displays** $500–$750

- **Flash plus an off-shoe cord** $485–$550

- **Additional lens** Wide-angle or telephoto: $500–$1,600

- **Monitor calibration device** $300–$400
- **Noise Ninja or Noiseware** $50–$65*
- **Photo-editing plugins, actions, and design templates** $45–$500
- **Physical portfolio** $125 (good for events)
- **Wacom graphics tablet** $200–$475*
- **Reflectors, flash modifiers, lights** $50–$850*
- **Separate business phone line** $600
- **Additional memory cards, batteries and camera accessories** $150–$225*
- **Additional software** Photoshop or Lightroom (whichever is still needed)*: $300–$650
- **External hard drive** $150*

Three Years in: $8,375–$13,275

- **LLC formation fees** $350–$500
- **Lawyer fees** $850–$2,500
- **Third lens** Shallow DOF or high-quality L-series lens: $1,500–$1,850
- **Custom (DIY) HTML or higher-end flash website** $400–$850
- **Larger print display with bigger prints** $1,250–$1,500
- **Better camera body** $3500–$5000
- **Accounting software** Quickbooks or similar: $100–$200*
- **Time management software or monthly account with Tave, ShootQ or similar** $275–$300*
- **Backup external hard drive for mirroring** $150–$225*
- **Design templates for albums, greeting cards, storyboards, and so on** $250–$350

Five Years in: $22,000–$38,250

Now you're starting to pick up speed. Here are some more items that you will probably want to add:

- **Part-time assistant** $9,000–$15,000
- **Additional "fun" lens** Macro, 50mm 1.2, or tilt-shift: $1,000–$1,750
- **Additional computer and/or Apple computer if using Microsoft**: iMac or Macbook pro: $2,500–$3,500*
- **Additional pro backup camera body** $3,500–$5,000 (by now you should have two very good quality camera bodies)
- **Updated high-end graphic design rebranding** $2,000–$4,000
- **Large canvas display** $1,500–$2,500

- **Editing outsourcing** $2,000–$4,000
- **Trademarking of all marks** Business name, tag line, and so on: $500–$2,500*

Seven Years in: $45,350–$96,150

You're pretty well established now, but there is always something that you can spend money on to expand the business further.

- **Second assistant** Graphics and editing: $15,000–$25,000
- **Studio or storefront rental (if interested)** $10,000–$30,000
- **Apple G5 tower and Cinema Display** $5000–$7500
- **PR person** $5000–$15000
- **New replacement Wacom tablet** $400–$800
- **Custom promotional materials** $450–$850
- **Replacement camera body** $3500–5000
- **Custom-designed HTML website and blog** $4000–$8000
- **Magazine advertising** $2000–$4000

Keep in mind that your expenses will be based in large part on how big you want to grow your business, how much overhead you want to take on, what you are starting out with, and what you value. Do you want to become like one of the big wedding studios, employing an administrative assistant and editing person, operating out of a studio? Do you prefer to keep things small and personal and be the sole photographer for your business? How much are you into DIY? How much hands-on do you want to have with your business in the long run, and how much time off do you want to have? How comfortable do you feel assigning others be in charge and delegating work? How well do you work with the equipment you have currently, and how well does it work for you? These are all elements that will factor into how much money you actually need to invest in your business.

There will be many more little, additional things to spend your money on, but it's the big things that require the most careful thought and pre-planning. However, in the first five years, don't spend money unless you have to. Once you have a solid pipeline and are generating more revenue, you'll have more freedom to buy whatever you like. But in the beginning, remember: KISS! (Keep it simple stupid!).

Working with Clients

"Ok great. So now that I have this awesome new business started, what do I do next? How do I book clients? I mean, I've done the marketing to get them, but what does the process look like to actually work with them?"

Every photographer has their own process for working with clients, but the following steps are what I have found work best for a pet photography business.

1. **Book the Shoot**

 When you book the shoot, you need to communicate with the client to be sure you both have a full understanding of what to expect. The following is a list of questions that you should include in e-mail correspondence upon booking a shoot. And always remember to confirm that the client understands your pricing and what is included.

 - How did the client find out about your business?

 - What kind of pet does the client have? What is the pet's name and age? What is the pet's behavior and activity level like?

 - Where did the pet come from? Is it a rescue?

 - Where would the client like to do the shoot?

 - Is the client's pet friendly with people and other animals? Does it become aggressive under any circumstances (to people and/or animals)?

 - Does the client have any special requests for the photo shoot? Is there anything specific that the client wants you to capture?

 - What does the client plan to do with the images? Are there any products in mind?

 - Would the client like to be included in any of the shots?

 - Are there any deadlines for prints/products that need to be met?

 - Is this for the client's personal enjoyment or is it a gift?

 - Where does the client live, or where will the client be coming from for the shoot?

2. **Establish the Date and Location**

 Throw out free dates and ideal locations based on the client's pet. Schedule the date and set the location. This often takes some back and forth, and it's a good idea to be flexible when it comes to scheduling because people are busy these days—very busy.

3. **Confirm the Shoot**

 Send an e-mail confirming all of the details and spelling out what the client needs to do to prepare. Attach your contract. Ask the client to mail you the contract within one week along with a retainer payment for the shoot (usually 50 percent of the shoot fee).

4. **Confirm Receipt of the Retainer**

 Ensure that you have received the retainer payment, contract, at least seven days prior to the shoot.

5. **Pre-Shoot Reminder Call**

 Call two to three days before the shoot date to remind the client and confirm cell phone numbers. Be sure to let them know how excited you are.

6. **Pre-Shoot Paperwork**

 Fill out your shoot schedule form and be sure to include the client's cell phone number!

"Cool! So we've done the shoot. Now what do I do?"

Post-Shoot Client Process

With the shoot complete, you now have a whole new list of tasks to carry out.

1. **Contact the Client**

 E-mail the client the day of or the day after the shoot to let them know how great a time you had at the shoot and how much you loved their pet.

2. **Ingest the Images**

 Download the photos from your camera's memory card—a process known as *ingesting*—into Lightroom or Photoshop (or the photo management software of your choice). During ingestion, rename the files by the pet's name. Back up the images to your external drives, online storage or DVDs, both your original RAW files and your edited JPEGs.

3. **Post a Teaser Preview of the Shoot**

 Three to five days following the shoot, post a sneak-peek of your favorite eight to ten images to your blog post and e-mail the link to the client, encouraging them to show it off to family and friends.

4. **Assemble a "Private Proof" Gallery**

 Seven to ten days following the shoot, create a private proofing gallery for the client and upload the JPEGs. Include the gallery expiration date as a note in the client's gallery along with a link to your price sheet and policies, right there with your images.

5. **Notify the Client About the Gallery**

 Seven to ten days following the shoot, send a gallery notification e-mail to the client. Attach your price list, order form, and policies, or provide links for those items online on your client services website. Include the gallery expiration date and plan your order session (if applicable). Walk the client through the process of ordering online if you offer online fulfillment. Again, encourage the client to forward the link to family and friends.

6. **Acceptance and Confirmation**

 Accept and confirm the client's order when you receive it. Include a due date on the invoice, and politely remind them that your pricing is good for only a certain number of days from the invoice date. Request and accept payment.

7. **Prepare the Images for the Print Order**

 Once you have received payment, edit the images in detail according to the client's print order. Clone, crop, sharpen, remove noise, remove leashes, eliminate eye boogers (that's a highly technical term used in the pet photography industry), and any other junk, and then perfect and prepare the images for print.

8. **Upload the Images for Final Approval**

 Upload the detail-edited photos to a new gallery for the client's approval before you place the order with your labs. Do not skip this step! Gaining the client's approval releases you from liability in case they aren't satisfied when they receive their prints and ask you to edit something else. Any requests for alterations at this point (after they have approved the print edit) should incur an additional editing fee. Make sure that you get paid for your time.

9. **Send the Images to Your Lab**

 Once you have the client's final approval, place the order with your lab(s).

10. **Package and Ship the Order to the Client**

 When you receive the order back from the lab, package it in a pleasing and professional manner. Include a thank you note, referral cards, and your client gift, and then ship it to the client via the United States Postal Service (priority), UPS or FedEx, or hand-deliver it if you have a low-volume, high-price business model and your clients are nearby.

11. **Send a Follow-Up E-mail**

 E-mail the client a few days after the order is received to ensure that they are happy and ask for referrals. Send them a link to your mailing list for your e-mail newsletter and promise to be in touch.

That's it! You have now completed the entire process with a paying client. Whoopee!

As you can see from all of the information in this chapter, there is a lot more work (and cost!) involved in running a pet photography business versus doing it as a hobby. Although it *is* hard work, it's also fun, and incredibly rewarding to be paid for something that you love to do. Every business has its pitfalls, and with every business, there are things the business owner doesn't enjoy doing. But with pet photography, the rewards of providing such a meaningful service outweigh most any downside to running a business.

Next up, I'll teach you how to price your services for profitability, what products to sell, how to market and brand your business, and how to expand your revenue-producing products beyond standard prints. You will also learn the five biggest keys to success that you should accomplish on your way to achieving your dreams of becoming the next great pet photographer!

Exercises

1. Complete the self-evaluation questionnaire to determine if starting a business is right for you.

2. Complete the Portfolio Building process step-by-step, from start to finish.

3. Book your first client and go through the pre-shoot and post-shoot process. Record anything that needs to be changed along the way.

Chapter Twelve

Business Essentials

- ★ Pricing
- ★ Products
- ★ Branding
- ★ Marketing
- ★ Strategies to Increase Revenue
- ★ Competition and Colleagues
- ★ The Top-Five Biggest Keys to Success

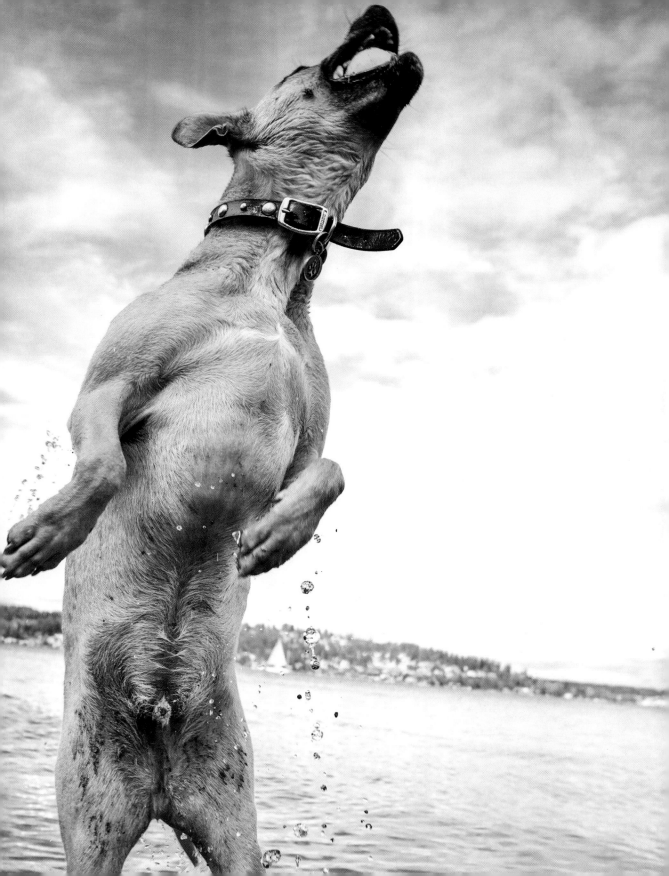

Pricing

Pricing yourself for profitability is one of the most important things you can do as a business owner. Without profit and a solidly booked pipeline, you don't have a business; you merely have a very expensive hobby. All of that fancy camera gear, software, Photoshop actions, product samples, camera accessories, website, mailbox rental, studio rental, accounting software, pretty packaging, and promotional materials doesn't pay for itself. As is true with any industry, being overworked and underpaid is one of the quickest routes to burnout. If you only plan to do pet photography part time on the occasional weekend days, profit isn't as important as when you need to make a living at it, but you still need to generate enough to cover all of your expenses. If you plan to do pet photography as a full-time career, it's critical that you price your products and services to optimize profit. So, how do you price yourself for profitability? What are competitive rates for pet photography? What are the industry standards?

To begin, I'd like to talk about something called *perceived value*. I have learned a very valuable lesson over time with my business, one that resulted from a lot of unpleasant experiences, trial and error, and general research over the years. That lesson is this: Clients don't spend money based on what they make; they spend money based on what they value.

Many people in this world say they can't afford to buy X, Y, or Z, yet they will not blink an eye over spending $4 for a latté at Starbucks, several times per week. If you pointed out to these people that they were investing nearly $800 per year on gourmet coffee beverages, they'd probably be shocked. It certainly shines a light on why they feel they can't afford to pay for cable or buy that new couch they've been lusting after. For most consumers, how they invest their money is a choice. They choose to buy one product versus another. And often times, if not normally, that choice is based on the concept of perceived value. Your perceived value will be different when buying products at K-Mart, as opposed to buying products at Barney's New York or Pottery Barn. When consumers see cheap prices, they expect cheap quality. Ironically, it is these same consumers that will think that your cheaply priced services are in their words, "wayyy too high." (More on that in a minute.)

Next, I'd like to talk about how *not* to price your business for profitability, with an explanation of why these methods are undesirable.

"Jamie, what should I not be doing when pricing my pet photography products and services?"

Don't offer every product under the sun, except the kitchen sink. Don't promote yourself as a one-stop source for pet photo–related products such as prints, mugs, mousepads, keychains, books, t-shirts, pillow covers, coasters, canvases, and so on. If your products scream "gimmicky," your clients will expect them to be cheap and will expect to pay accordingly. It's a sure-fire and quick way to lower the perceived value of your business. And if your product lineup is so extensive that your clients don't even know where to start, they might not end up ordering anything at all.

Don't offer pricing that includes products with your sitting fee as part of a "package." Including products with your sitting fee is a no-no even if you aren't calling it a package; and here's why:

First, you are creating a finite value for your time. Because you are not separating out your time (sitting fee) from your products, it's hard for a client to value your time, which is just as valuable as your products. And more often than not, once you subtract the retail value of the products you are including in your packages, you are telling your client you are really only charging $100 (or whatever) for your time, which might amount to be eight or more total hours invested when you factor in the pre-shoot prep, the shoot itself, post-shoot editing, any meetings and client communications, and other work that needs to be done. Divide the price you are actually charging for your time (after you subtract the retail value of your products), by the total number of hours you are investing (usually between 8 and 12), and you might be shocked at how little you are selling your services for per hour.

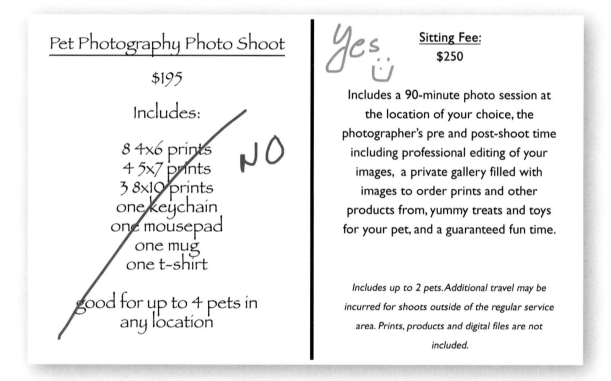

A second issue is that most of the time clients won't buy more products on top of the package because the package already includes products. Once you remove that price ceiling, the sky is the limit when it comes to products they might want to order. The psychology of sales changes, and they will be far more inclined to spend double, triple, even quadruple what they would have had you set a package price for them that included the sitting fee and products.

Another problem is the word "package" itself. This term is used by the big box store portrait studios and other high-volume photography studios that you can't emulate on a smaller scale. Package is also an outdated term used by high-volume studios that haven't changed much since the days of muslin backdrops and cheesy family portraits. Do you really want to be the pet photographer taking photos of puppies in baskets with fake flowers, bad lighting, and ugly backdrops? Instead of using the word package, use the term "collection'" and refer to your *product collections*, not a collection of your sitting fee plus products.

Clearly, based on what I have outlined above, you shoot yourself in the foot by including products and/ or images with your sitting fee. You might think you are undercutting the competition or doing your clients a favor, but really you are just undermining your own ability to create a good revenue stream and run a profitable business. Let your clients decide how much they want to invest; don't set the limit for them. Again, people buy based on what they value. Keep the perceived value high and your bank account will thank you.

Don't charge $75 to $150 for a photo session without expecting to do extremely high volume. First off, you'll likely end up needing to do multiple shoots per day in order to be profitable. Also, selling well over $1,000 in products per client would be highly unlikely at those low sitting fees. If you needed to generate $3,000 per month to be profitable, for example, you'd need to do around 26 photo shoots per month, or 6.5 per week. Once you finished spending the time you'd need on marketing and advertising to book 26 clients per month (which is *a lot*), every single month of the year, you'd barely have time to do the photo shoots, let alone edit and process the images. And with that kind of volume you'd need to have employees, further (significantly) reducing your net profit, because employees are a very large expense. At those kinds of prices, more realistically you'd need to be doing more like 40 or more shoots per month. This is definitely not feasible or sustainable for one person, not at any decent level of quality, anyway.

Don't sell prints for $5, $8, $12, $15. I think you get the idea. Again, this goes back to the concept of perceived value. Again, the client is thinking, "cheap prints, cheap value." Sure, those prices are even higher than what you'd pay at a wholesale club chain, but never forget that you are creating custom artwork for your customers. Custom work that is labor-intensive should always come with a higher price tag, regardless of the product. The employees at the big box stores aren't investing many hours of time into doing custom work like you do; they are "shooting and burning," sending their customers out the door with minimal effort in terms of product quality. If you do some research on print permanence ratings of digital prints, you will quickly come to understand why clients should pay more for archival products from top photography labs. And looking at it from the revenue perspective, at those low prices, you'd need to sell a ton of prints to be profitable. And at those print prices, those kinds of clients aren't the ones likely to invest in tons of prints.

The next topic I'd like to address is why it's a bad idea to price your products and services based on what the competition is charging.

"Jamie, why should I not price myself according to what my competition is charging?"

You don't know what's underpinning its prices. You don't know what kind of work a competitor put into determining its pricing or the logic it used to get there. Perhaps the competitor's structure is based on working with 20 or more clients per month to attain profitability, and you just don't have the ability to do that kind of volume. Perhaps it has years more experience that can justify higher rates, or are knowingly undercharging for their work because it's desperate to make a buck. You are playing a dangerous guessing game when you copy a competitor's pricing.

You don't know what products your competitor is selling or what its costs of goods sold are (the hard costs involved in creating a product). Maybe it is selling products inexpensively because it's selling non–archival-quality products. Or maybe it's selling at a premium because it sells only top-of-the-line premium archival-quality products from the best labs. Maybe it does its own printing or pays to outsource editing, which will affect the price of each print. Without knowing the exact details of a competitor's products, you can't reasonably compare.

You don't know if a competitor's prices are based on those of another competitor. This is one I think most people don't consider when evaluating a competitor's pricing. Your competitor might be arbitrarily setting its pricing without really knowing why. This means that you could end up copying a competitor that copied another competitor, and so on, and so forth. Price yourself according to what makes sense for *your* business and *your* client base, not based on what any other photographer is doing.

I should take a moment to qualify all of this by stating that it's always a good idea to be *aware* of what your competition is charging, and you definitely need to be able to justify your prices to clients if they are significantly different from the average in your market, but your ultimate pricing decisions need to be based on your specific business model.

Also, there are some industry average prices for photographing pets, and along with them, the commensurate competitive rates. These rates have trickled down from the portrait photography industry, although just as with portrait or wedding work, you will find rates ranging across the board, from the studio charging $49 for a photo shoot to the one that charges $1,500 for the same shoot.

A pet photography industry standard for a sitting fee is $250 for a 90-minute session. Some photographers bill by the hour, some provide two-hour sessions, most shoot until they feel they have a great selection of images. There is something magical about the $225 and up price range for a sitting fee in that it attracts higher-end clients who are willing to invest more in custom photography. More established and skilled pet photographers and talented pet photographers in major metropolitan areas like Los Angeles, San Francisco, and New York can get away with charging $300 to $450 or more for a sitting fee.

Here are some industry-standard sell-prices for prints:

- 5" × 7": $25

- 8" × 10": $45

- 11" × 14": $75

- 16" × 20": $150 and up.

You need to decide whether to call it a "sitting fee" or "creative fee." Creative is a term borrowed from commercial photography. It carries a certain caché because it infers there is time spent making the final product beyond just the photo shoot; however, sitting fee is also acceptable because it is familiar and clients understand what it means. Use the term sitting fee until and unless you feel confident explaining to a client what creative fee means and all that it entails.

Canvases are generally double that of prints for the same size, and photobooks are priced according to how many hours of time are invested and the costs of goods sold, but they usually run several hundred dollars to well over a thousand dollars. A very important point to keep in mind is that you are not only charging for the ink and media on which the image is printed, you are charging for the time you expend toward making that image look absolutely perfect. You are sharpening, cloning out drool and cookie crumbs, making eyes sparkle, and generally working magic with software to perfect those images. Those skills must be taken into consideration and reimbursed commensurately.

One strategy you can employ when it comes to pricing your products is to double, triple, or quadruple the cost-of-goods-sold (COGS) on the products, with the resulting number being your retail price. For example, suppose that the COGS on a 16" × 20" gallery-wrapped stretched canvas is $125. If you apply the 3× pricing strategy, your retail price would be $375.

Always round up to numbers that are easy for your clients (and you) to remember. Nobody remembers $74.50 or $127.95, so keep it simple.

The 3× strategy is commonly employed by retail businesses because they look at it this way: one-third of the price pays for the product, one-third of the price pays me, and the final one-third of the price gets reinvested into a new product to replace the old one (or reinvested back into the business). You can exercise flexibility here depending on how much experience you have and what your business is like. If you are just starting out, maybe a 2× model is better suited for your business; if you are very experienced and do exceptional work, you can move into the 4× or 5× range.

A great way to encourage clients to purchase multiple products instead of just one 8" × 10" is to create collections of multiple, different products. Price your single items high and then discount them when you put them together as a collection. This is a strategy wedding photographers have been employing for years, and it works. This might be easier after you've been in business for a year or more, because by then you will know what your clients buy the most, and you can put the special or big ticket items that

most of your clients buy in really attractive collections. Whether you are selling collections of products or single-priced items, it's important to keep things simple so as not to overwhelm or confuse your clients. Begin by offering three different simple collections. You can also offer a set percentage off if your clients purchase over a certain dollar amount, and then increase the discount as the amount spent rises. There are many different strategies you can employ when it comes to pricing your work.

To sum up, keep perceived value in mind when pricing your work; don't price based on what the competition is charging; ensure that your pricing fits with the quality of your work; pay attention to revenue killers; try to sell clients on multiple products instead of just one; and it's perfectly acceptable that your pricing might be somewhat arbitrary, just make sure that whatever decisions you make you can easily explain to your clients, and that the prices can sustain your business model. When you are confident with your pricing, it shows, and your clients will have more respect for you if you can back up your pricing with sound logic. Although, ideally you'll want clients to whom you don't have to justify anything to at all.

Products

Here's a tip for you: pricing your products can be pretty easy if you keep it simple. I mentioned in the preceding section that you shouldn't be selling everything but the kitchen sink. Keep it simple and clients will be inclined to purchase more. It will be less overwhelming for them and it will make the process more fun. It's also easier for you to remember what you sell if you keep it simple; ideally, you want to be able to remember the price of every product you sell, and it will be easier for you to remember if you are selling five different products instead of nine or ten.

So, what types of products can you sell as a professional pet photographer?

♦ Prints, from 5" × 7" to 16" × 20" or larger.

Be sure that you understand cropping ratios. 5" × 7", 8" × 10", 11" × 14", and 16" × 20" prints require cropping. Professional labs also sell 8" × 12", 11" × 16", and 16" × 24" prints, which don't require cropping. You can offer these to your clients if they don't want a shot cropped, but it will usually require custom framing, which is yet more expensive. It's a good idea to educate your clients on this point so that they can make their own decisions.

> *You can sell 4" × 6" prints, as well, but generally the type of clients who purchase custom pet photography are buying 5" × 7" or larger prints.*

♦ Greeting cards and notecards

These are a fun way to make thank you cards. They can be particularly popular during the holidays when clients love mailing them to friends and families. There are some great holiday card templates online for professional photographers. You can let the image shine and take up the entire card, or go hog-wild on design elements. As always, make sure you are being paid commensurately for your design time by including it in the price.

♦ Gallery-wrapped, stretched canvases

These are a premium product that clients of custom pet photography love. They come in a large array of sizes, including squares and long panoramas, and you can choose to do a single image on one canvas, or multiple images as a composite.

♦ Fine-art prints

These are perfect for the fine-art pet photographer or someone doing more traditional work, particularly if you tend to use effects to simulate a hand-painted look. Images can be printed on a variety of fine-art papers, including velvet and watercolor.

♦ Photo albums, photobooks, or coffee-table books

There is an infinite array of options when it comes to albums, photobooks, and coffee-table books (these are often interchangeable terms). You can provide albums with slip-in prints; albums that you assemble yourself; photo books that are printed on paper in either hard cover or softcover; or coffee-table books with seamless margins. Do your research and get some samples, and then decide what your clients would love. You'll also need to determine how many hours it will take you to design a custom book. Be as accurate as you can because these might become one of your best sellers.

Note

It's generally a good idea to have some experience producing the products you want to sell before offering them to your clients because the pricing and design are not for the faint of heart. It's an investment in time and money, both on your part and that of your client, but the results are worth it and can last a lifetime and beyond.

♦ Proof boxes

These are custom-printed boxes with proofs (small, low-quality prints) inside, usually in either 4" × 6" or 5" × 7" size. You can choose to do a set number of prints, or all of the prints from the client's gallery. Keep in mind the costs can really add up on this product, so be sure that you are charging for it.

♦ Framed prints

Some clients are busy and appreciate being able to pick up a finished product. More and more labs are now offering framing services along with their printing services, realizing that it's a valuable service to provide to their photographer clients. The downside to doing this is in the shipping costs and limited style options. Framing is about as individual as the person making the purchase, and sometimes an individual can have different ideas in mind than what your lab offers. It's up to you to decide if you want to go down this route and whether it makes sense for your client base.

♦ DVD of the image files

This is a hot topic among professional photographers. Some think it's a horrible, evil, awful idea to *ever* relinquish digital files to anyone; others give them away like free candy at a carnival. Most photographers take a stand somewhere in the middle. Here are a few logical things you need to think about when it comes to selling digital files. Once you hand over digital files to a client, it's highly unlikely he will ever come back to you for future orders of other products from the same session. It's normal for a client to purchase a collection of products, yet still be lusting after that one premium product (maybe a photo album) and come back to you in the future for it when the budget allows. Return clients/repeat buyers can account for as much as 10 to 15 percent of your overall gross revenue, which is a pretty decent chunk of change to be giving up. You need to ensure that you are pricing your DVD to make it worth the potential loss of revenue, both from that session and in the future.

Another thing to keep in mind is that your clients are unlikely to print your images. Most of your clients don't know the first thing about printing. More often than not, those images will sit on a hard drive for ages. Isn't it sad to think all of that work you did never amounted to a beautiful framed print hung on the wall or a stunning photo album? And when it does come to clients who do print their images, they don't know where to go to get quality prints, and would just as likely head to a kiosk at a local pharmacy or big box store to get low-quality prints with a permanence rating of two to seven years (as opposed to the print permanence rating of 200+ years on the archival products you purchase from a professional photography lab).

The last thing you need is for your work to be displayed as a shoddy product on someone's wall. Low-quality prints are prone to color shifts, fading, and other issues after just a couple of years. You want the work that hangs in your client's homes to be the very best representation of your business possible for two reasons: first because it reflects on you and your brand, and second, because it's also the ultimate marketing device, promoting your business as it hangs in a client's home. When a client's pet-owner friend visits and sees your gorgeous canvas, it might lead to "Oh wow, I have to have one of those!" BAM! Just like that, you have a new customer.

Most often, your clients don't have the ability to purchase the same high-quality products that you can, because most photography labs sell only to verified professional photographers who can show proof of their professional business status via a website, UBI number, or other criteria. These are the labs that sell the supreme, archival products that far surpass the quality of consumer-printed digital images. Your clients deserve the best quality they can get because these animals mean so much to them. They are going to have your images for many years; don't you owe it to them to provide them with gorgeous prints and other products? (A long list of professional and consumer labs is available in the online bonus content at www.beautifulbeasties.com/books.

Finally, if you price your image DVD lower than your highest priced product, you will likely never sell that product. Think about it. If a client can get a DVD of all of the images in your gallery for $500 and then go somewhere and pay $200 for a canvas, whereas the client would have to pay $1,500 for the same canvas from you, why would this client pay you for what is (in her mind) the exact same thing.

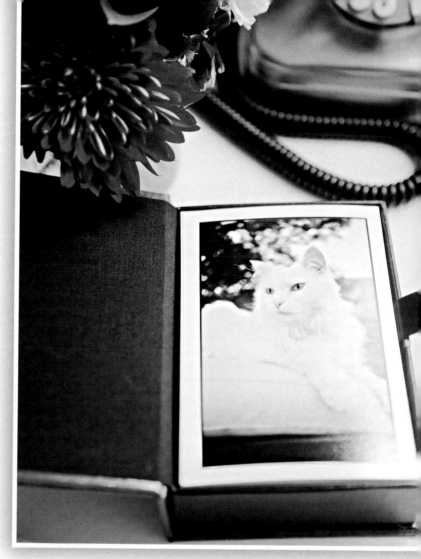

"So, how in the world do I price these things?"

First, I recommend not selling single-image files for the reason I mentioned earlier; sell them only as a group (the entire gallery on DVD) for a set price when bought alone, or include the DVD in a collection with other products, or sell it for a discounted price if the client orders a minimum in other products. For example, if the client buys at least $500 in products, you will sell her the DVD for $350. Or, for another example, you can create a collection that is priced at $1,250 that includes prints and greeting cards and a DVD of their 25 favorite images.

Second, I recommend not selling DVDs for $250, or $400, or even $500 if sold separately. Ideally, you want to price the DVD higher than your highest-priced product; otherwise, you have shot a hole in your own logic. Think somewhere in the range of $850 to $1,500, and now we're talking. The goal is to have the client walk away with some really killer archival products that they can actually enjoy on a daily basis in addition to having rights to print the images on the DVD.

Let me tell you a secret: clients who are investing good money into professional custom pet photography aren't looking to have the images to print; most merely want them for archival purposes. It's the penny-pinchers who don't value you as a professional who want the DVD so that they can go make their own cheap copies. You don't want to work with those folks anyway. And if you are pricing your work right, this becomes a moot point.

As I said earlier, keep it simple with your product lineup, choosing a handful of these products to sell instead of all of them. It will make your life easier in the long run. If a client asks for something you don't have on your product list, respond by saying, "I'd love to be able to provide that to you! Let me do some research on the top vendors and I'll get back to you with some pricing." You then do just that and provide the client with some options. Ideally, if you expect that your clients might regularly ask for a product that you don't have on your price list (perhaps a print size), it's a good idea to already have your

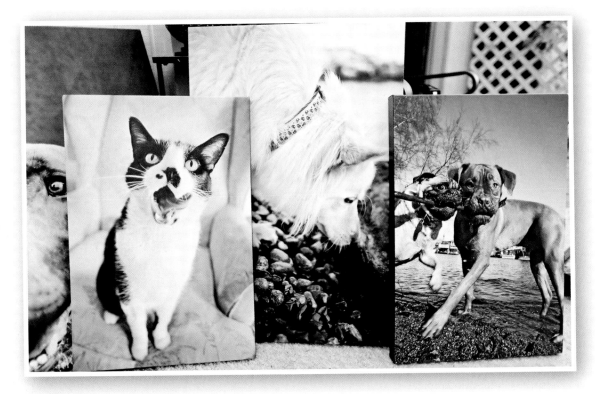

pricing done for that item so that you can send it to them quickly. Just because you don't have everything but the kitchen sink listed on your product list, doesn't mean you can't still offer it.

Also, it's a very good idea to have a sample of every product you offer on hand to show to clients. This is another reason why it's a good idea to keep your product list simple (certainly in the beginning). This way you don't break the bank investing in samples alone. Most professional vendors offer discounts on product samples, sometimes as much as 50 percent, and often they'll send you proofing prints for free so that you can check the color calibration against your monitor.

Branding

My own personal definition of branding is as follows:

The process of creating a unique, positive, and recognizable identity for a product or service. Branding is the messaging work a company does to encourage consumers to feel a certain way about their product. It's the attitude, look, and feel of a business.

Branding is an oft-overlooked but critical component in the success of any business. Branding includes but is by no means limited to:

♦ The look and feel of your website and blog, including colors and design

♦ The look and feel of your logo

- The personality of your business name, mission statement, and tag line (slogan)

- The style of your photography

- The way you speak and communicate with your clients and fans

- The look and feel of any printed advertisements and/or promotional or marketing materials you have produced

When you look at the website of any of the highly visible pet photographers, you are seeing branding in action. You can view the more traditional aesthetic of Jim Dratfield's brand, the clean and modern appeal of Amanda Jones' brand, or the colorful and playful style of my own Cowbelly Pet Photography brand. The one thing these brands share in common is consistency. Whenever you see a magazine ad, a photograph, or webpage that any of these photographers have done, you know who did it, just by the branding. So, a strong brand is one that is consistent and easily recognizable. For example, if your website is meant to convey a soothing feel, washed in natural greens with lots of soft tones and vintage processing on your images in your web galleries, don't make your marketing materials wild and crazily colorful or use wacky language on your blog. Alternatively, if you are doing a magazine ad that is all black and white with a black-and-white photo, don't host a website that contains only color photography. Keep it consistent with every single thing you do to present your business.

The best way to define what the brand of your business will be is to let it be a reflection of you. The number one asset you have that sets your business apart from your competition, and will always do so, is you: your personality, your essence, your artistic viewpoint, and how you experience the world.

Consistent Branding

It's how you express yourself to others, and how you project your inner values. Nobody can ever really compete against you because, well... they aren't you. There is only one of you in this world. Don't be afraid to express that in your brand. Ideally, your business image will project who you are on a personal and emotional level. It should express how you feel when you work with animals. Is it calm and Zen-like? Is it energized and playful? Is it artistic and contemplative? Remember that your business image is the first impression potential clients will see along with your photography, and you rarely have a second chance to make a first impression!

When determining what you want your brand to be like, ask yourself what your own personality is like. What are your favorite colors? What kind of language speaks to you? Again, ideally you want to be attracting clients to your business who are similar to you, or as I often like to say, similar to me but with a lot more money. Ha! If you are being authentic in truly expressing who you are through your brand, you will naturally attract kindred spirits who you can relate to and appreciate who you are.

Not surprisingly, pricing and branding are joined at the hip, and you can increase your client's perceived value just by improving your brand. And as I mentioned earlier, it's pretty much axiomatic that increased perceived value equals increased revenue. In other words, don't neglect your brand.

Marketing

Marketing is quite different from branding. Branding addresses how you appear to clients, marketing addresses how you attract them. Although there are many different definitions of marketing, I define it as the following:

The tactical or strategic techniques and processes a company uses to promote its products and services in order to attract potential clients to buy what it sells.

Marketing for any business, whether the business is new or old, is absolutely crucial to its success. And you need to be smart with your marketing decisions, because you can be putting all of your marketing eggs in a basket that doesn't produce revenue without even knowing it.

In the subsections that follow, I'll describe some strategies to get you started.

Networking and Complementary Marketing Partnerships

I always tell my workshop attendees that getting out into your community is the single most important thing you can do to market your pet photography business. Get out there, meet people, shake hands, shop at the stores, and go to events. Start networking with other like-minded business owners who can help to spread the word about your business. You can even create formal complementary marketing partnerships, exchanging business cards to give to each other's clients. A really effective marketing strategy is to do a complementary shoot of a business owner's pet in exchange for the owner displaying the work in her store or business. Think outside the box when it comes to ways that you can help each other reach your respective target markets.

Similar to how it's important to have a written agreement in place when photographing pets, it's important to have a written agreement in place with other business owners anytime expectations are involved, especially if any products or services change hands.

Some parallel and related businesses to pet photography with which you might explore mutual marketing opportunities include the following:

- Dog daycare centers
- Boutique pet stores
- Dog trainers or large training centers
- Veterinary hospitals and spay and neuter clinics
- Dog-walking or pet-sitting services
- Dog trainers or large training centers
- Pet clothing, product designers, and retailers
- Grooming shops
- Breeders and breed clubs
- DIY dog washes

A business doesn't need to be pet related in order to be a successful marketing partner. Marketing relationships with non–animal-related businesses can translate into success if the owners really love you and they have pet-owning clients. Examples of these can include:

- Hair salons
- Medical offices
- Cafés and coffee shops
- Art galleries and artists' studios and art walk opportunities. (Art walks are monthly events taking place in a set neighborhood in a city, usually taking place on a weekday evening after regular business hours, wherein galleries, art studios and other nearby shops hang a new art display, and patrons go door-to-door, viewing each display and chatting with the artists.)

Leave your printed promotional materials at these locations, and/or hang several pieces of photography, to help spread the word about your business.

Word of Mouth

Long before there was the Internet, television, radio, or even movable type for that matter, there was word of mouth (WOM). This if the best marketing method to grow a business and create a solid client base. All you need is one satisfied client to start. They tell two friends, those friends tell four friends, those friends tell six friends, and it grows exponentially from there.

How do you create and maintain solid WOM? Here's a few suggestions:

♦ Produce excellent-quality images that they will rave about and show off.

♦ Provide outstanding customer service.

♦ Be professional.

♦ Be friendly and personable and love your client's pet(s) as if they were your own.

♦ Be memorable.

♦ Offer referral rewards (more on that soon).

♦ Gift your clients (every single one).

♦ Be accommodating. This is easier if you aren't underpricing your work, as I pointed out earlier in the chapter.

♦ Don't be shy; ask for referrals.

In short, you want to create an experience that your clients will laud. They'll tell all of their friends about it, and then their friends will book you, too. When working for each client, treat them as if they have four of their friends along with them, mystery shopping, looking over everything you do. It will keep your motivation up and make you more inclined to go the extra mile.

Website and Blog Presence

These are a given in this day and age, because gone are the days when photographers carry around physical portfolios to show every potential client. Your portfolio will exist online, and it's important to make a good first impression. These days, many people will search online for a local pet photographer, and you want to ensure that they can find out about your products and services through your website. Arrange with your marketing partners and vendors to provide links on their websites to your website, and to add them to any blog or Facebook posts they do on your business so that people can find you from other sources that they might have stumbled upon. Also, ensure that you list your website on your business card and any other promotional products you have printed for your business.

Social Media

Although social media tools such as Facebook, Twitter, LinkedIn, and Google Plus can be baffling for some, others thrive on them and can use the power of social media to propel their word of mouth. It's very important to use these tools strategically so as not to get sucked into a big time drain that ends up hurting your business. Create a fan page for your business on Facebook and a Twitter profile, and plan to devote no more than a total of five to eight hours per week working with these tools. You can use them to promote new products, show off new images, announce news or accomplishments, find models for projects, and just generally keep in touch with people who support you. Social media can be an awesome tool for a small business, just be sure that you know what you are using it for, set goals for its use, limit the time invested in it, and always be professional in everything you say and do.

Newspaper Articles and Blog Press

The great thing about this type of marketing is it's free! Contact writers of blogs and local papers to see if they'd be willing to do a story on your business. Pet photography by nature is fun and interesting, and most papers would be more interested in doing a story on a local photographer who rolls around in the grass than a local dentist explaining the coming trends in fillings for kids. If someone is doing a story on your business and the article will go online, be sure to ask to have the article include a link to your website and blog. Write up a press release on a new product or service you are offering and send the release to your local news outlets.

E-Mail Promotions and Newsletters

Once you have that WOM ball rolling and have any kind of client list going, keep in touch with them about any special events, new products, or promotions you have going on. For your e-mail subscribers, implement *double-opt in*. This is a technique by which a recipient must confirm that he has willingly and actively signed up for your mailing list, and you then acknowledge the confirmation via e-mail and confirm that he is officially signed up. If you don't do this, not only might the unsolicited e-mails leave a bad taste in a potential client's mouth, but you risk being banned by your ISP for sending spam. If you use a service such as MailChimp or Constant Contact, they will help you navigate the murky waters of e-mail newsletters.

When doing promotions or sales, it's best to offer an added-value incentive (that is, something the client gets in addition to your regular offerings), such as a complimentary 8" × 10" print with a standard session fee, instead of arbitrarily reducing your fees by a certain dollar amount or percentage. The latter only serves to lower your perceived value and harms your eventual sales. Ensure that whatever added value you are including is of nominal cost for you to make it worth your time.

Referral Programs for Clients

You can create a formal referral program and make it as fancy or as simple as you want. If you know you are averaging high sales per client, why not try gifting your client with a complimentary 11" × 14" gallery-wrapped canvas whenever they refer a new client who books a session with you. Give the same gift to the new client. For a very good client who manages to refer three, four, or five new clients to you, offer to make the referring client's next session on the house.

Get creative when it comes to what you think your very best clients might like. More often than not the best clients don't need or expect any kind of gifts of appreciation from you in order to sing your praises, but it certainly doesn't hurt to offer it.

Art Shows and Gallery Displays

If you live in an area that has an artistic community, you can pitch your photography to be included in an upcoming art presentation or gallery opening. Even better, if you have a community that has a monthly art walk as I detailed earlier, you can get involved by hanging your work and chatting with buyers as they come through your location. This is a great way to network with your potential clients, show off your work, and collect names for your e-mail newsletter. And if you are doing traditional or fine-art pet photography, this will be a natural fit and potentially be where you will meet a lot of your client base.

Events, Donations, Rescue Organization Work, and Mini-Shoots

Some other marketing strategy options you might want to explore include hosting events, donating to auctions, performing rescue organization work, and doing mini-shoots, but I'm placing them in a separate category here because generally they are not the best strategies for directly producing appreciable revenue. However, although you can't expect to help pay for your business expenses doing events, donations, and mini-shoots, ideas such as these are great for increasing visibility, which is important for any new (or established) business. Following are some thoughts on what you can do and what you can expect (this is based on my own personal experience and anecdotal experiences of many of my colleagues over the years).

Events

These are events such as "Furry Fun Runs," "Pug Galas," "Walk for the Dogs," or fundraisers for a breed group. Although these are generally fun experiences that enable you to chat with a large group of pet owners and have fun with the animals, events, as far as revenue and bookings go, often draw the "gimme-gimmes," the "lookie-loos," and folks who are just generally out to score something cheap. A colleague had a booth at an event and a woman approached her and immediately asked what she

charged. To my colleague's reply the woman inquired incredulously, "Two dollars and fifty cents??". "Uh, no...," my colleague responded, "Two-*hundred* and fifty *dollars*." You will get a lot of people who start the conversation by asking, "what do you charge?" Usually, anything over big box store prices will be too high in their eyes. Depending on the event, you might have contact with more serious buyers, but generally you will find them in other ways. Products that do sell well at events are low-priced greeting cards sold as singles, (offer to discount them when purchased as multiples,) and other very low-priced products such as matted 5" × 7" prints sold for $8 to $10, or postcard-sized refrigerator magnets. You'll obviously need to sell some volume to make it worthwhile, but if you have a few hundred to invest in products you can get a little buzz and name recognition in return for your investment.

Donations to Fundraising Auctions

It's hard to translate a donation winner into a buyer of extra goods, but it all depends on how you go about it and what you include in the donated collection people are bidding on. Some pet photographers choose to only include the sitting fee in a donated gift certificate, although I find this to be a bit misleading; clients might not understand that even though they won the product bid—or in other words, they "bought" the product—they then have to spend yet more money to get an actual photograph. A better strategy is to include a nice product with only one image in your gift certificate, and then knock their ever-loving socks off by presenting an astounding array of images, increasing the chances that they'll want more. You can also create special collections of products that you think might appeal to those who attend this particular event, in the hope that you sell more after the session. One problem with donations is that it's not uncommon for winning bidders to never contact you at all. There is also the issue of expiration dates, or lack thereof, which might fall under the auspices of state laws (check the laws in your state regarding gift certificates and expiration dates), because in many states, it's now illegal to place an expiration date on a gift certificate (laws vary). Keep your expectations low when it comes to donations, and remember that your primary goal is to give back to the organization you are supporting, with your donation ultimately serving to help the animals more than you.

Work with and for Rescue Groups

Don't expect to make a killing donating your photography services to Fluffy Friends International. Most rescue groups are far more concerned with trying to find Fluffy and Fido a new home and being able to buy ink for their printer than they are trying to help you market your business. Far down on their list of priorities is being concerned about whether you get new business from your donated services. And that is as it should be.

But it's certainly no imposition and not to much to ask that a link to your website be included on the organization's website. To make things official, get involved with an organization such as HeART's Speak, which can help you maximize the benefit of your relationship with your local rescues. Like donations, keep your expectations low and remember you are doing this work primarily to help the animals.

Mini-Shoots

Mini-shoots are short, abbreviated sessions, often between 15 and 30 minutes, held in one location for multiple clients and pets who sign up ahead of time. Mini-shoots are popular among new pet photographers, although they are very tricky to get right. Unfortunately, because of the price of the

mini-shoots (often in the $25 to $50 range), the perceived value of the product and service is very low. These events naturally attract people who want to spend less—often a lot less—than your regular rates. They will be happy with their single, included 8" × 10" print and be on their merry way, never to be heard from again. It is also difficult to create great quality when you are working with so many different animals in a short period of time, forcing them to sit on seamless paper, and trying to create great shots in only a few minutes time. It's imperative that you have an assistant, really great lighting, a solid (and stable!) backdrop setup, and have really dialed in your pricing for these types of events. One strategy you can employ to try to increase your revenue is to offer different product options. Create collections with different session lengths for each. Bundle an inexpensive 10-minute session with two 5" × 7" prints, but also offer a 30-minute session plus two 11" × 14" prints, plus greeting cards for quite a bit more money. Offer three different collections and let your clients choose. Sometimes you will get regular bookings out of it later on, or the mini-shoot clients might tell their higher-spending friends about you. There are ways to make this viable, but it can be tricky.

> ### *"What are the three most important methods that I can use to market my pet photography business?"*

WOM, web and blog presence, and networking in your community. (Social media follows in a close fourth.)

Strategies to Increase Revenue

Many people assume it's impossible to make a full-time living as a professional pet photographer. Obviously, as you can see from everything presented up to this point in this chapter, whether you make money depends on many different factors, but it is absolutely possible because pet owners will spend an inordinate amount of money on their pets. I remember the first time I had a client place an order for products over $3,000. My jaw hit the floor. Now it's commonplace and I don't blink an eye. One way to make it more likely that you succeed is to expand your offerings to increase your revenue.

In the subsections that follow, I'll lay out some strategies for moving more product and thus increasing your revenue.

Create Special Art Products

Call it fine art, digital art, pop art, or whatever you like. If you enjoy creating art, you are creative, and you can make something clients really love, you can add an additional stream of revenue to your business. Perhaps it's printing on fine art paper that you then embellish with mixed media, or it might be pop art designed in Adobe Illustrator or Corel Pro that you print on canvas, or perhaps it's collages or shadowboxes designed from your printed photos, or paintings derived from the photos you take. Price it as a premium and you will have clients who not only want "all that and a bag of chips," but also, that "cool art," too. Pretty soon you'll be seeing sales in the thousands.

Web or Graphic Design for Your Pet Business Clients and Partners

If you are adept at Photoshop, Illustrator, and Adobe InDesign, you might have a valuable skill that other small business owners need. You can help them design their business cards, logo, website and

more. You need not have gone to school to study these things; you just need to have the skills to produce quality work and charge adequately for your time. Ensure that you have an excellent understanding of printing processes if you go this route, because most labs printing promotional products require files created in the CMYK color space and prepared in specific ways. Also, invest in Adobe InDesign if you plan to do graphic design work.

Stock and Commercial Work

If your work is of commercial quality and you are being solicited by businesses to use your images for their promotional purposes, perhaps it's time to look into doing custom commercial photography and/or stock work for corporations. One of the advantages of commercial work is that it usually entails a much higher payout than private-client work; disadvantages are that it can be confusing when it comes to pricing and hard to know where to begin or with which stock agency to align yourself. And, of course, it carries much higher legal risks. Join the American Society of Media Professionals (ASMP), a professional association for commercial photographers, and buy the latest issue of the book *Photographer's Market* for tips. Consult with an attorney familiar with intellectual property and corporate contract law before doing any commercial work. Having solid commercial contracts is not just a good idea, it's absolutely critical, and having someone in your corner should you have contract term issues can be a lifesaver.

Self-Printed, Mass-Produced Products for Stores

Greeting cards and small matted prints are the perfect example of products you can mass-produce and wholesale to local stores. Do some research on short-run versus large-quantity print jobs and compare costs of each to determine what the best investment will be.

Craft Goods

Do you enjoy working with your hands? Are your clients the kind who would love little handmade key chains or lockets embellished with their pet's photo? Are you *totally* into Etsy? Make that a selling point of your business by creating a really unique handmade product that you know your clients would love.

These are just a few options that you might consider to increase your revenue. Think outside the box and try to incorporate your pet photography into other things you like to do that might lead to yet new revenue streams.

Competition and Colleagues

Most photographers have connections with other photographers in their area. If they aren't connecting in person, often they're at least connecting online via forums and e-mail. There are ways that you as a professional can make this a good thing—and ways you can make this a bad thing. Colleagues can become some of your most trusted and cherished friends, or they can become some of your worst enemies. To help you navigate the waters, I've put together the following Do's and Don'ts lists:

Do's

♦ Respect your competition. They are working in the same industry as you and probably working just as hard on their businesses. You never know what kind of struggles they have had to go through to get their businesses off the ground.

♦ Be friendly toward them. You never know when a kind word, a smile, and a handshake at an event might come back to benefit you. Remember that they are forming their own opinions of you at the same time.

♦ Network with colleagues and competitors via e-mail or online so that you can both pass on information about opportunities and events, and tip one another off to potential problem clients and community members. You can also refer work to them if it's something that you can't or don't do. I don't do any studio or fine-art work, so I'm always happy to refer clients looking for more traditional posed portraits to my local colleagues who specialize in that style.

♦ Reach out to them. It can be a simple e-mail introducing yourself and telling them how much you love their work. It shows you know who they are and respect them as a professional. Tell them where you saw their work, mention any friends or partners you have in common, and point out that you just wanted to reach out and say, "Hi."

♦ Be aware of what your colleagues are doing, what they are working on, who their marketing partners are, what their style is, what projects they have created that are unique to them, and what their pricing is. Being informed about what your colleagues are doing can help you be a better business manager because you will know what to do to set yourself apart.

With a positive approach, some respect, and patience, you can create rich, rewarding relationships with your colleagues, even if they live right down the street and practice the same style of photography as you. Some of my best friends are also my biggest competitors!

Don'ts

♦ Avoid saying anything negative about the competition to potential clients when selling your services. This would include making negative comparisons or claims on your website (for example, making negative comments about the competition's pricing saying "I'm cheaper/better"), saying something derogatory about studio pet photography if you're a location photographer, implying something negative about a competitor's services to a potential client, and so on. Confident photographers don't need to compare themselves to others to sell their own work. The work should be good enough to speak for itself.

♦ Never copy the wording or pricing from a competitor's website, especially the information on pricing, frequently asked questions (FAQ), and process pages. This is a sure-fire way to show the competing photographer that you have no respect for her, and bridges once burned are hard to repair. Copying written content found online or in printed form, even when edited to make changes, is a copyright violation and can get your website pulled down for violating the terms of use of your web host. Create your own written copy and your own ideas for pricing off the top of your head; don't look at other websites to see what your competition is saying.

Your business should be a reflection of you, and you alone. Clients can smell inauthenticity a million miles away, and if a potential client is comparison shopping and spots something you have on your website on another photographer's website, it's usually pretty obvious to them who the more experienced photographer is and whose content came first. Copying a colleague only makes you look bad in a potential client's eyes. If it's hard for you to know what to write for your website at first, keep it very simple and short, and add to it as you learn more about your clients and have more experience.

♦ If your competition has been in business considerably longer than you, don't ask them for anything (for example, advice or counsel) when you first talk to them or contact them. Although there might be a photographer who has free time and the inclination to help, many busy, successful photographers will think, "I've spent many years figuring all of this stuff out the hard way, why should I just hand it over to this person just because they asked for it? What's in it for me and why should I take time away from my paying clients?"

Be respectful of their time, knowledge, and experience. Not everyone is in a position to give you something you are asking for. And remember, they might even want to help but are just too busy. Try not to take it too personally. There are many other resources for help out there.

♦ Do not copy a direct competitor's unique creativity. This can include unique compositions, branding, designs, logos, or project ideas. You can use another photographer's idea for inspiration, but always ensure that you are giving credit to them and linking to their work in any blog post or webpage where you show your inspired work.

♦ Do not interfere with any of your competitor's promotional material or assignments. This would include asking a store owner or manager to remove a competitor's promotional material so that you can display yours, instead; approaching event organizers about doing work for them when a

known competitor is already photographing the event; or trying to undermine a client by telling her you are the better photographer. There is enough work to go around that doesn't involve negatively impacting another's business.

Most of the items in this list are just basic common-sense practices and good business ethics. But good or bad ethics can make or break your business. The pet industry and photography industry are very small, and people talk. You want your reputation among your peers to be a good one.

The Top-Five Biggest Keys to Success

I often get the same question in interviews or e-mails from photographers: what in my opinion are the biggest keys to success? Although no single aspect will make you successful—there is no secret recipe for success, and ultimately it's based on enduring drive, determination, time, and hard work—the following five characteristics are really crucial to achieving it.

1. **Creative and Technically Skilled Photography**

 Create great photography and people will hire you. It's as simple as that. Chapter 11, looks at the process of determining if you should go pro. The discussion emphasizes creating a solid professional skill that is based on good raw talent. Clients hire photographers who do good work, and those who do outstanding or unique or creative work, are more likely to win more business and make more money. If you are great with business but technically lacking, it would be a good idea to take some photography classes, read books, take workshops, and study and practice as much as possible to really refine your skills.

2. **Outstanding Customer Service**

 Earlier in this chapter, I talked about great customer service as it pertains to word of mouth. We've all read bad reviews on Yelp, talking about poor customer service consumers have received. Providing poor customer service is a quick way to kill your success. Let your desire to serve your clients be your guide, and leave your ego at the door. As a photographer, your goal should always be to please your clients first, and yourself second.

3. **Aggressive Marketing**

 By aggressive, I don't mean nasty. I mean consistent, determined, and passionate marketing. You can have a great product, but if nobody knows you exist, you will never be successful. Aggressive marketing increases the chances that your business will be seen. Try setting marketing goals for yourself on a Microsoft Excel spreadsheet, complete with deadlines, and then track your progress. This is a great way to stay on top of your marketing effort.

4. **Pricing Accurately**

 As you learned earlier in this chapter, pricing is so crucial when building and growing a profitable pet photography business. You can shoot yourself in the foot with prices that are too low (or too high), or by including images and products with your sitting fee, or selling too many products or tacky products.

5. **Networking**

 Get out from behind the computer. Get seen. Meet people. Show off your awesome personality. Flirt, charm, cajole (yes, the guys, too; of course you might have a some 'splainin to do with your significant other…). Make people fall in love with you. Become popular. Make a name for yourself. Shake hands and smile. Find out what is going on in your industry. Become an industry "insider." Some of the most famous, successful modern-day photographers are not necessarily the ones who do the best quality work, they are the ones who know how to promote themselves.

So to sum it all up, the five biggest keys to success are providing creative and technically skilled photography; providing outstanding customer service; pricing your products and services appropriately; aggressive marketing; and personal networking. If you follow these tips, and put in practice the information you've learned from throughout in this book, you can go very far indeed as a professional pet photographer.

Don't let anybody tell that you can't do it. Don't let others (or your inner voice), tell you that you're crazy, unless they are trying to offer some advice that might be useful as a startup. Don't become discouraged or let circumstances, or challenges, or self-doubts get you down. Just take one step at a time, one foot in front of the other, and you will get there, my pet photographer friend. Be the tortoise, not the hare, and remember to always have fun. Pet photography is not funeral-home directing. It *should* be fun. And always keep in the back of your mind that you are doing it for the animals and the owner's who love them dearly. The gift of a lifelong memory of a cherished family member, preserved in a beautiful photograph is one for which you simply cannot measure the value with earthly tools. It is a good, good thing you are doing, whether as a fun hobby or a serious business, and you should be very proud of yourself. Ultimately the only limits you have are self-imposed, and any dream you have is worth trying to attain.

Reach for the stars, baby!

Exercises

1. Set a sitting fee for your photo shoots and list what it includes and what it doesn't.

2. Create a price list for your business and create three collections of products that you can include on it.

3. Decide which products you plan to sell and order samples of each product.

4. Brainstorm branding for your business.

5. Develop a game plan for the marketing strategies that you intend to use.

Index